LOUIS VUITTON
MARC JACOBS

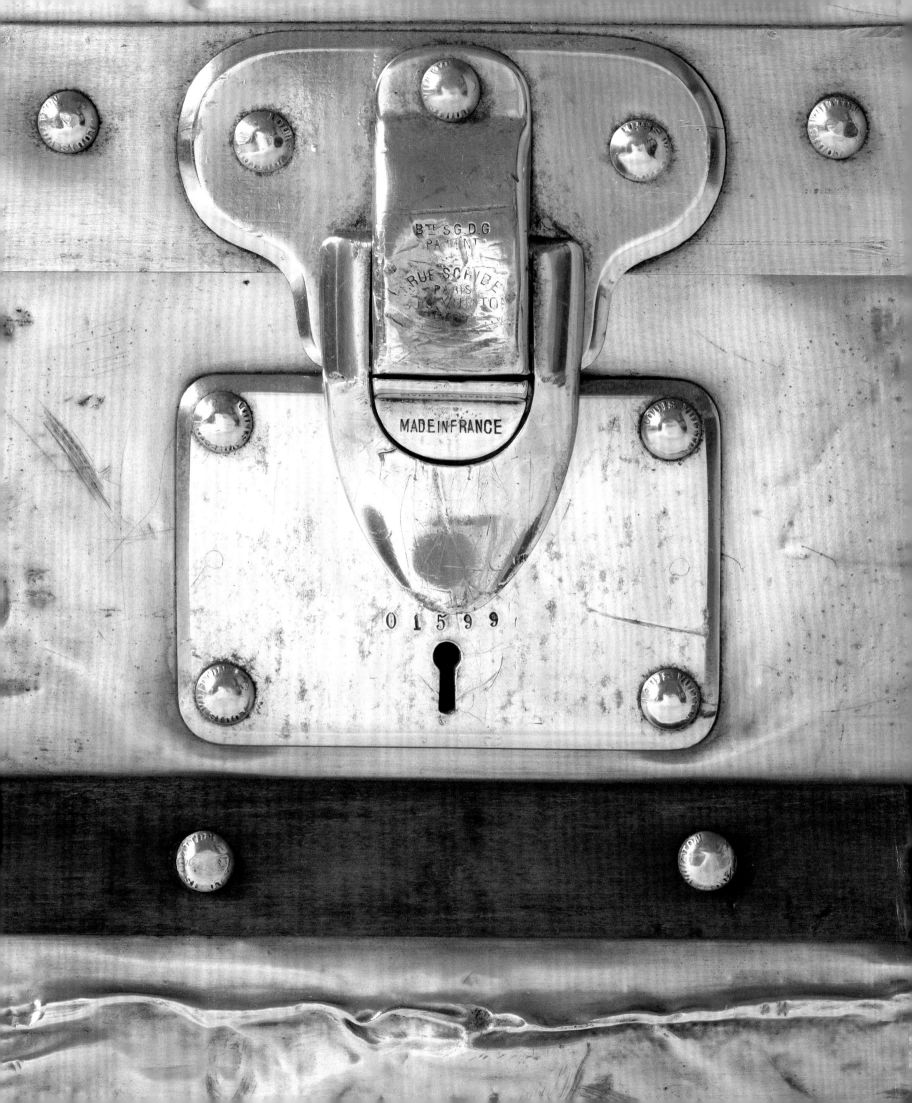

412359

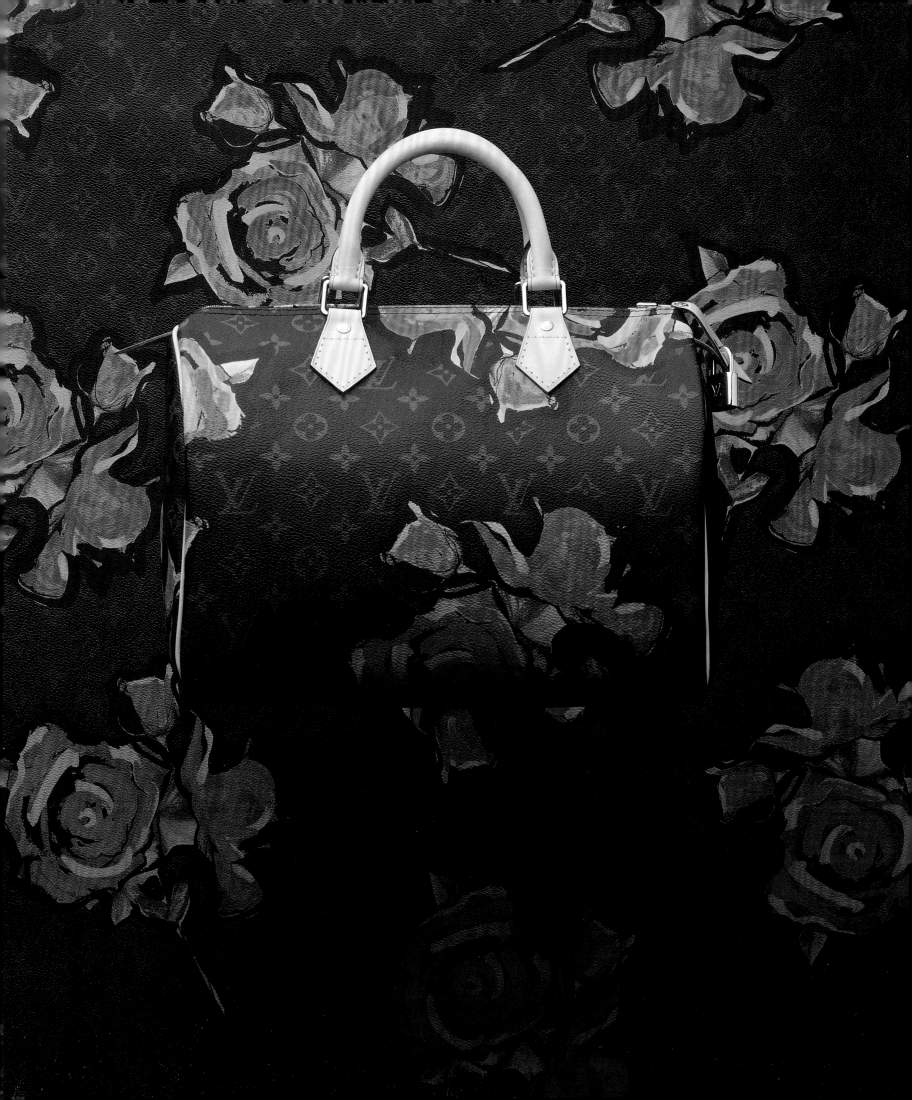

Capucines,4

65,Avenue des

ue de la Paix

Succu

ce Vendôme

près la ma

à l'Héotville, rue du Congrès à A

OUIS VUITTO

EMBALLEUR

ns pour recevoir les marchan

avec sureté	Caisses en Ferblanc	Expédi
Objets	et en Zinc	pour la
us fragiles	Toile Goudronnée	et l'é

écialité p.^r les emballages de m

Pap. G. Coutar

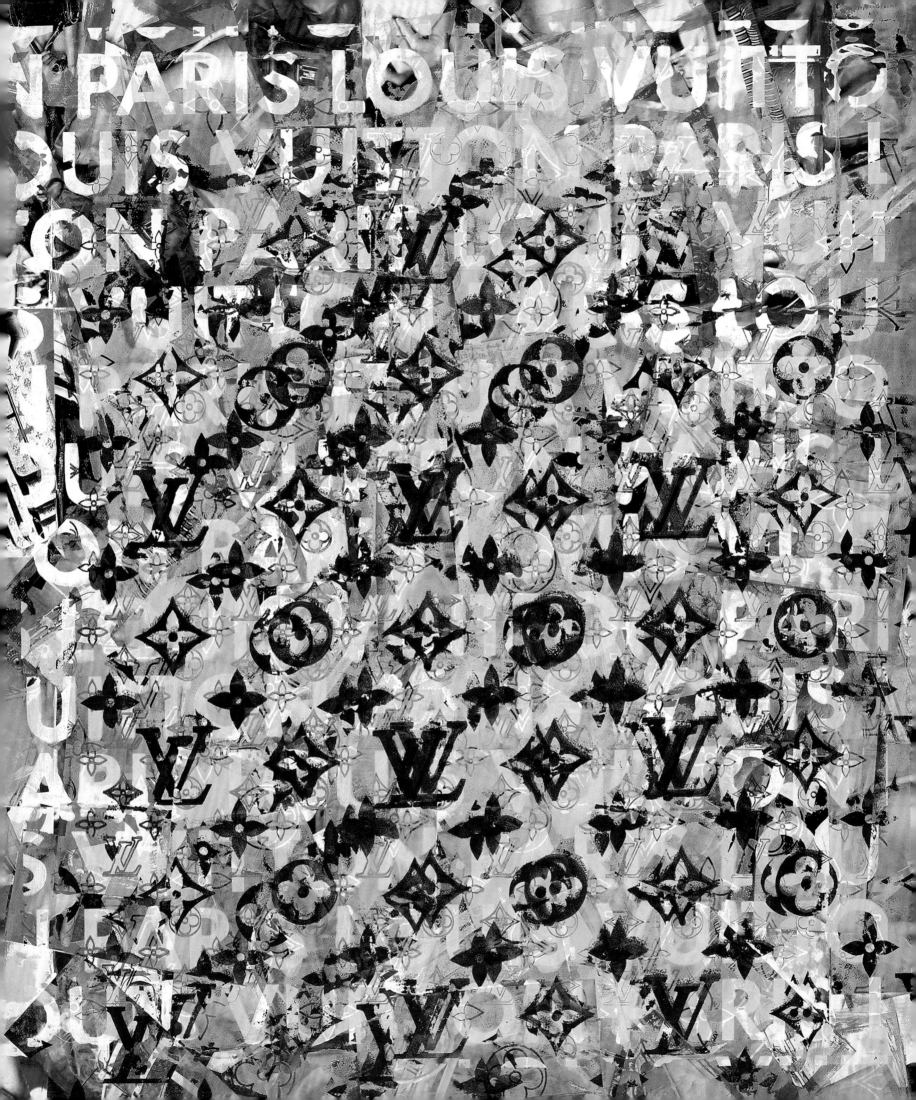

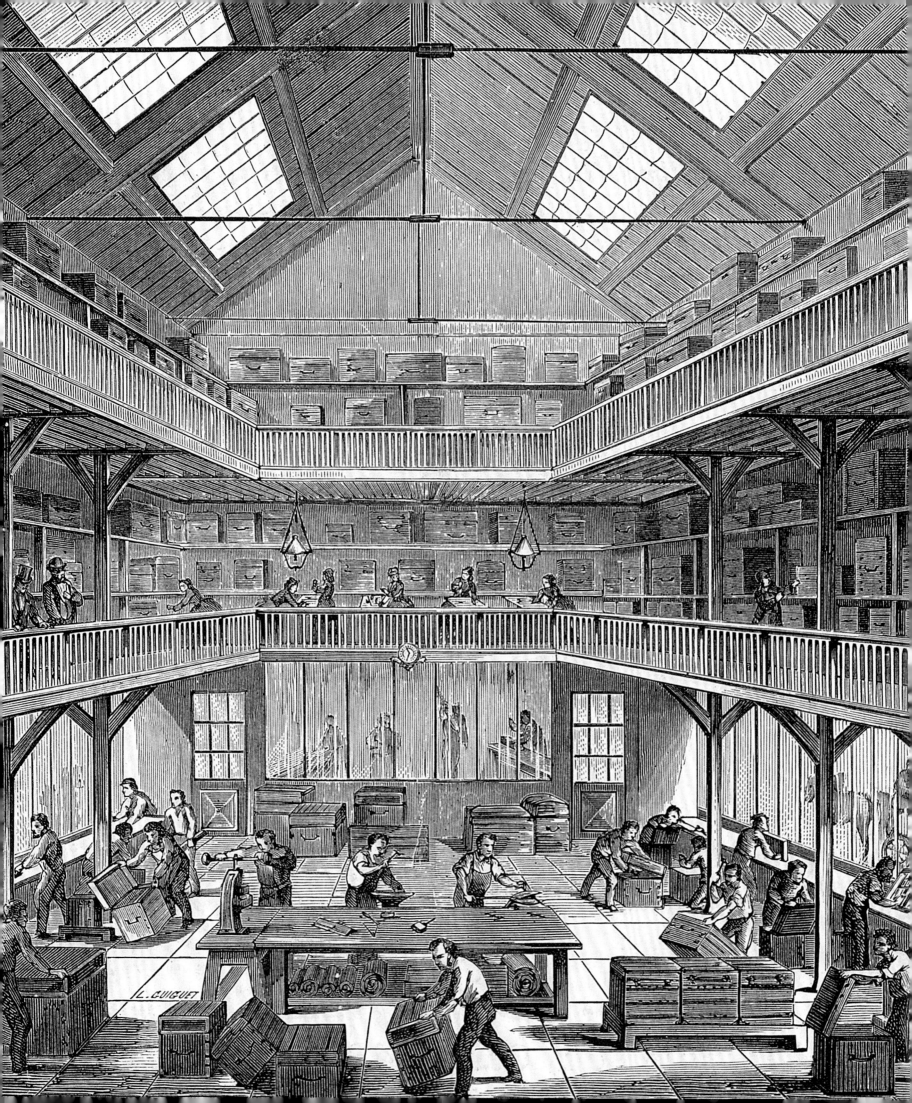
L. GUIGUET

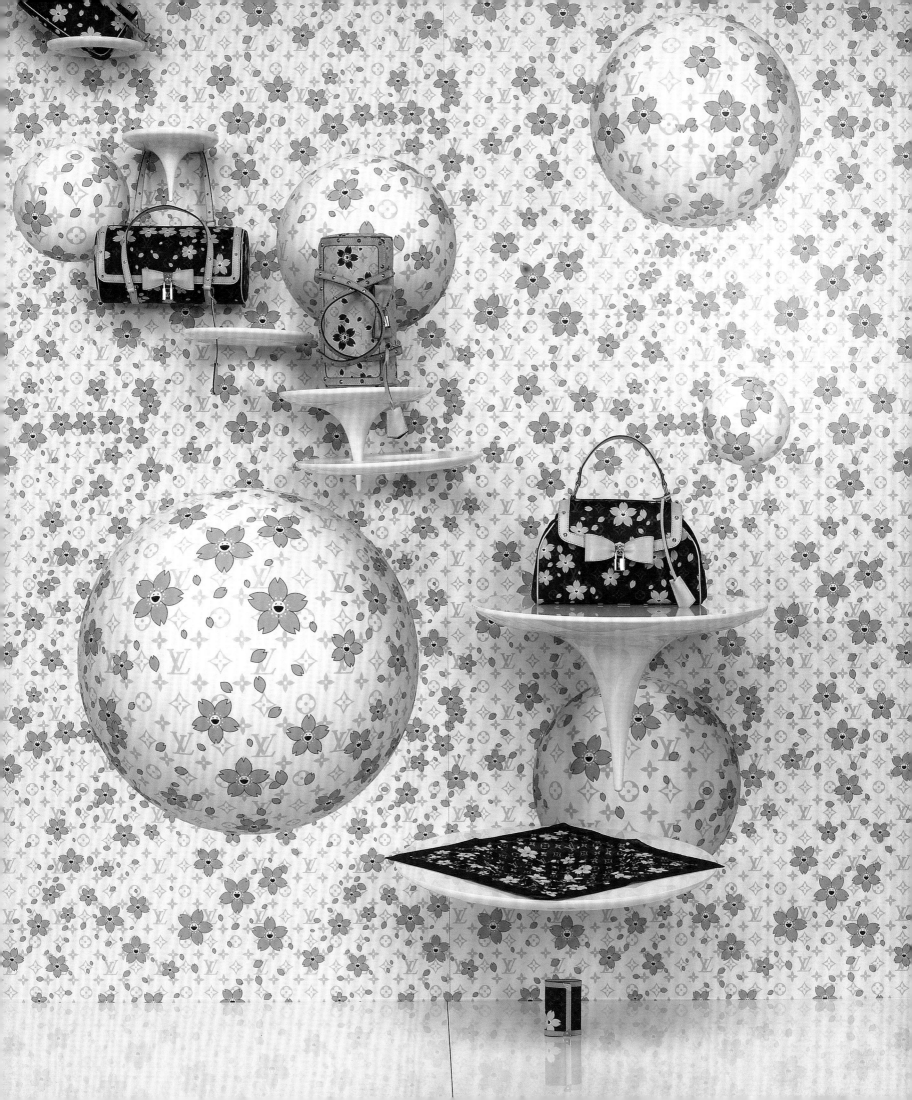

For

BERNARD ARNAULT, YVES CARCELLE, ISABELLA CAPECE GALEOTA, ROBERT DUFFY, SAM GAINSBURY,
PAMELA GOLBIN, KATIE GRAND, FAYE McLEOD, MAUREEN PROCUREUR, AND ALL OF THE
LOUIS VUITTON TEAMS PAST AND PRESENT – THANK YOU FOR EVERYTHING!

Always

MARC JACOBS

LOUIS VUITTON MARC JACOBS

Edited by

PAMELA GOLBIN

LES ARTS
DECORATIFS

RIZZOLI
NEW YORK

New York Paris London Milan

LOUIS VUITTON

MARC JACOBS

Louis Vuitton was born in Anchay, a small hamlet in the Jura Mountains of eastern France, in 1821. At the age of thirteen, he left his native village and, without a penny in his pockets, undertook a long journey to Paris. Scarcely had he arrived when he began long years of apprenticeship with Monsieur Maréchal, a packager (*layetier*) and packer (*emballeur*) renowned in the capital. In 1854 Louis decided to found his own firm. He set himself up as a trunk maker (*malletier*) and opened his first store on rue Neuve-des-Capucines. His trunks and luggage would quickly win the favor of high society across Europe, and soon throughout the world.

Louis and his descendants, visionary designers, made the art of travel a true art of living, turning the small family firm into a big name in luxury goods. In 1996 Louis Vuitton celebrated the centennial of the Monogram canvas, although people had nearly forgotten that it was a century old. That Monogram is so modern that seven fashion designers each created a unique design from it, a lovely birthday gift announcing the luggage maker's fashion debut.

A year later, in 1997, Marc Jacobs left his native New York and joined the firm, becoming its creative director and accepting the challenge of launching the first Louis Vuitton prêt-à-porter collection. Marc breathed new life into Louis Vuitton without denying its roots. Indeed, he made multiple references to the firm's heritage. Within a few seasons, Marc Jacobs had reinterpreted the codes of the brand, introduced a contemporary dimension, and definitively established Louis Vuitton in the fashion world.

For the first time, Les Arts Décoratifs is placing side by side the creations of these two pioneers, Louis Vuitton and Marc Jacobs, who, each in his own way, managed to invent and reinvent the firm's style. This exhibition offers an unprecedented glimpse, an exploration and illustration of the modern vision of these two men, who in different eras succeeded in anticipating the fashions and developments of their time.

—

Yves Carcelle
PRESIDENT OF LOUIS VUITTON

Louis Vuitton, a man of his time—and a raucous time it was, as a result of the succession of political regimes and the profound changes that the Industrial Revolution would bring—understood that, with the advent of steam, the very notion of travel would be radically transformed. More and more aristocrats, bourgeois, and wealthy tourists began to travel, and the huge increase in the number of items of dress they brought with them made transporting their wardrobes a tricky matter. Both an artisan and an entrepreneur, Louis Vuitton introduced into the realm of packing fashions a balance between functionality and aesthetics that was close in spirit to that of the founders of the Central Union of Decorative Arts—industrialists, collectors, and enlightened amateurs who were seeking a place that would embody their faith in labor and in the beauty of the object.

It was in the Saint-Honoré district, not far from the Palais du Louvre—which today houses Les Arts Décoratifs—that in 1837 Louis Vuitton began to work as an apprentice. In 1987 the exhibition Invitation au Voyage, held at the museum on the occasion of a large Louis Vuitton donation, sealed the patrimonial relationship between the Vuitton firm and the institution, which are both now more than one hundred years old.

The exhibit we now offer is the fruit of that common history as well as the echo of more recent times. By the turn of the twenty-first century, when Marc Jacobs took over as creative director at Louis Vuitton, the seeming shrinking of the planet had placed faraway lands within everyone's reach. By instilling the spirit of fashion into the Vuitton firm, Marc Jacobs introduced a decisive shift.

The expertise of Louis Vuitton and Marc Jacobs, their obsession with a job well done, their penchant for innovation, and their influence over their respective ages are at the heart of this exhibit, which invites us to penetrate the intimacy of their imaginations.

—

Hélène David-Weill
PRESIDENT, LES ARTS DÉCORATIFS

Béatrice Salmon
DIRECTOR OF THE MUSEUMS, LES ARTS DÉCORATIFS

Louis Vuitton / Marc Jacobs *is a story of two personalities and their contributions to the world of fashion: Louis Vuitton, founder of the house of Louis Vuitton in 1854, and Marc Jacobs, its artistic director since 1997. Two innovators, both rooted in their respective centuries, advanced an entire industry. Two creators, each in his own language, appropriated cultural codes and trends in order to shape the history of contemporary fashion.*

More an invitation to analysis than a traditional retrospective, the parallel stories of Vuitton and Jacobs permit an in-depth look at the fashion industry during two decisive periods, one beginning with nineteenth-century industrialization and the other peaking in twenty-first-century globalization. Theirs is also a story of French craftsmanship, technological progress, stylistic creation, and artistic collaboration.

With this exhibition and catalog, Les Arts Décoratifs celebrates the achievements of the house of Louis Vuitton. It is a symbolic homecoming for Louis, who established himself only minutes away from the Louvre—indeed, a wing of this palace, once a residence of Napoleon III, a great advocate of the luxury industry, houses the museum and this exhibition. Bridging the century that separates them, the names Louis Vuitton and Marc Jacobs stand for boldness, excellence, and creativity.

—Pamela Golbin

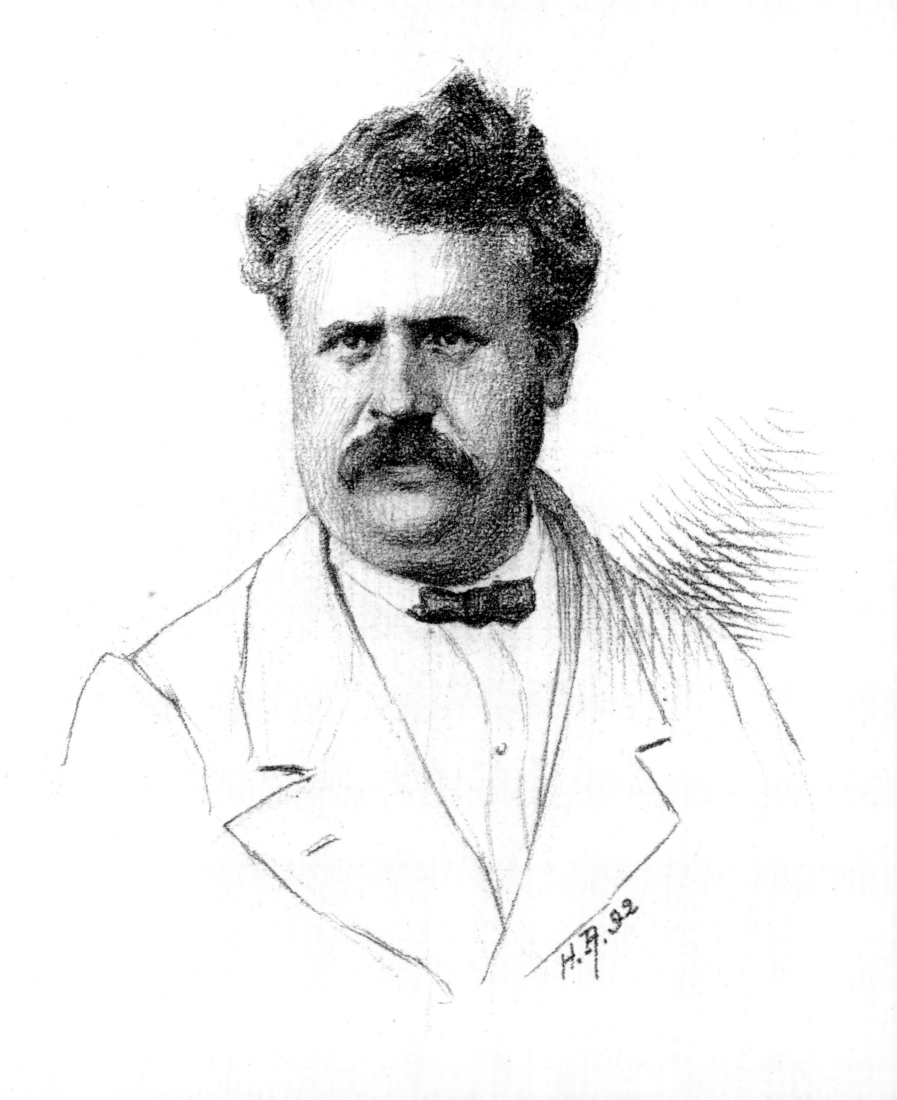

V
FOR VUITTON

PAMELA GOLBIN

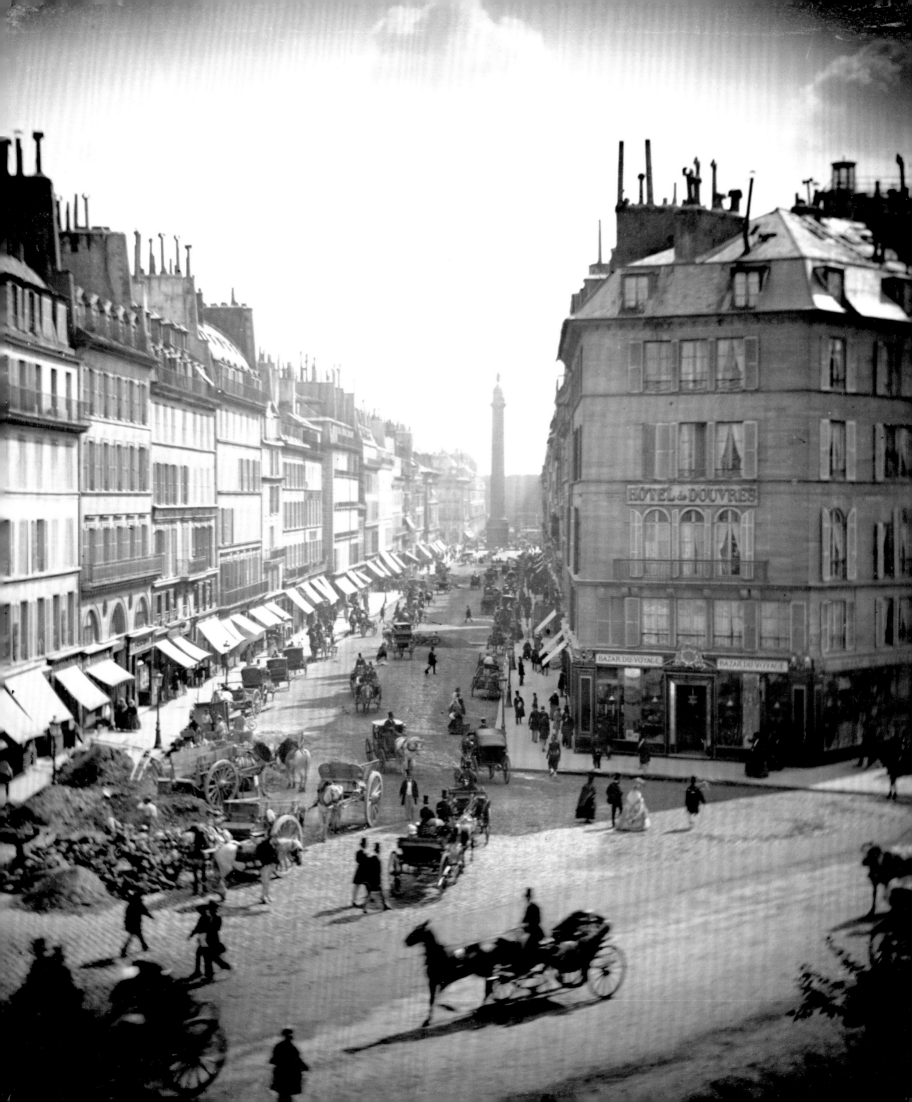

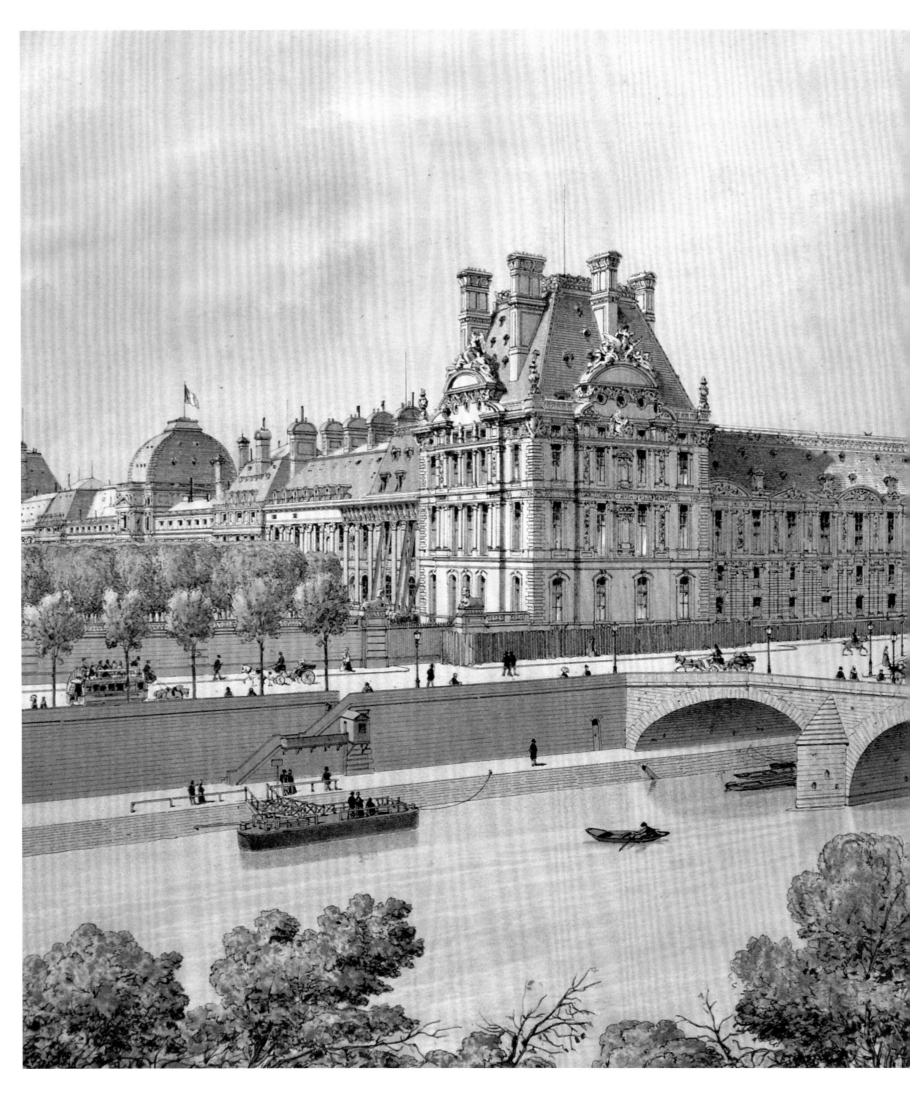

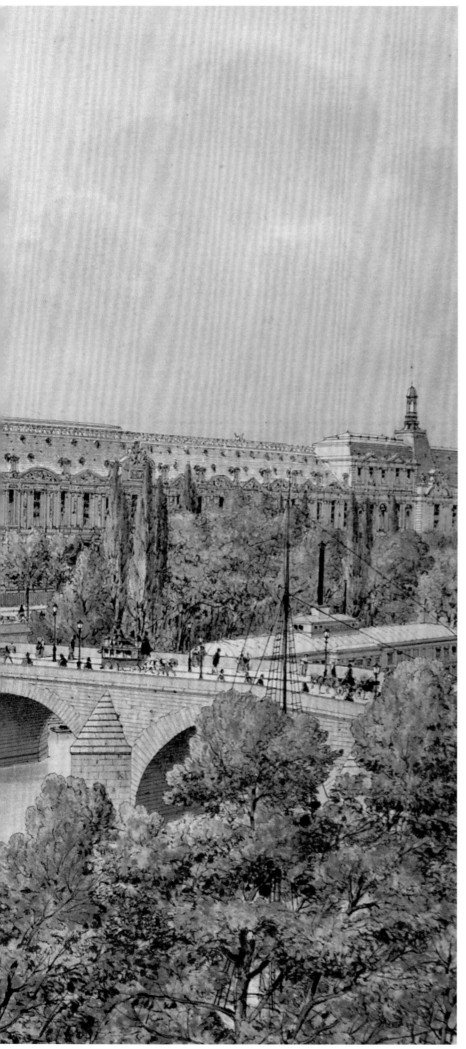

PAGE 17
Portrait of Louis Vuitton, H. Rozier, 1892.
Louis Vuitton Archives.

PREVIOUS SPREAD
View of rue de la Paix, c. 1860, with the Bazar du
Voyage storefront in the foreground.

THIS SPREAD
The Palais des Tuileries and the Palais du Louvre
in 1869, Fedor Hoffbauer, *Paris à travers les âges*,
1875–1882. Bibliothèque des Arts Décoratifs, Paris.

Louis Vuitton was a man of his time, a resolute entrepreneur who weathered the upheavals and profound changes of the nineteenth century. He lived through three revolutions, two republics, and one empire—that of Napoleon III—not to mention the five foreign wars that France waged and that would lead to a series of crises and recessions.[1] But with a perfect sense of timing, he made the most of the great industrial transformations that governed his age. A highly skilled, intrepid, hard worker, Louis Vuitton was of modest origins but made a lasting place for himself through intuition and perseverance and established sound foundations for future generations. Born in the Jura but Parisian by adoption, it was in France's capital that he prospered and forged a name that was to become known worldwide.

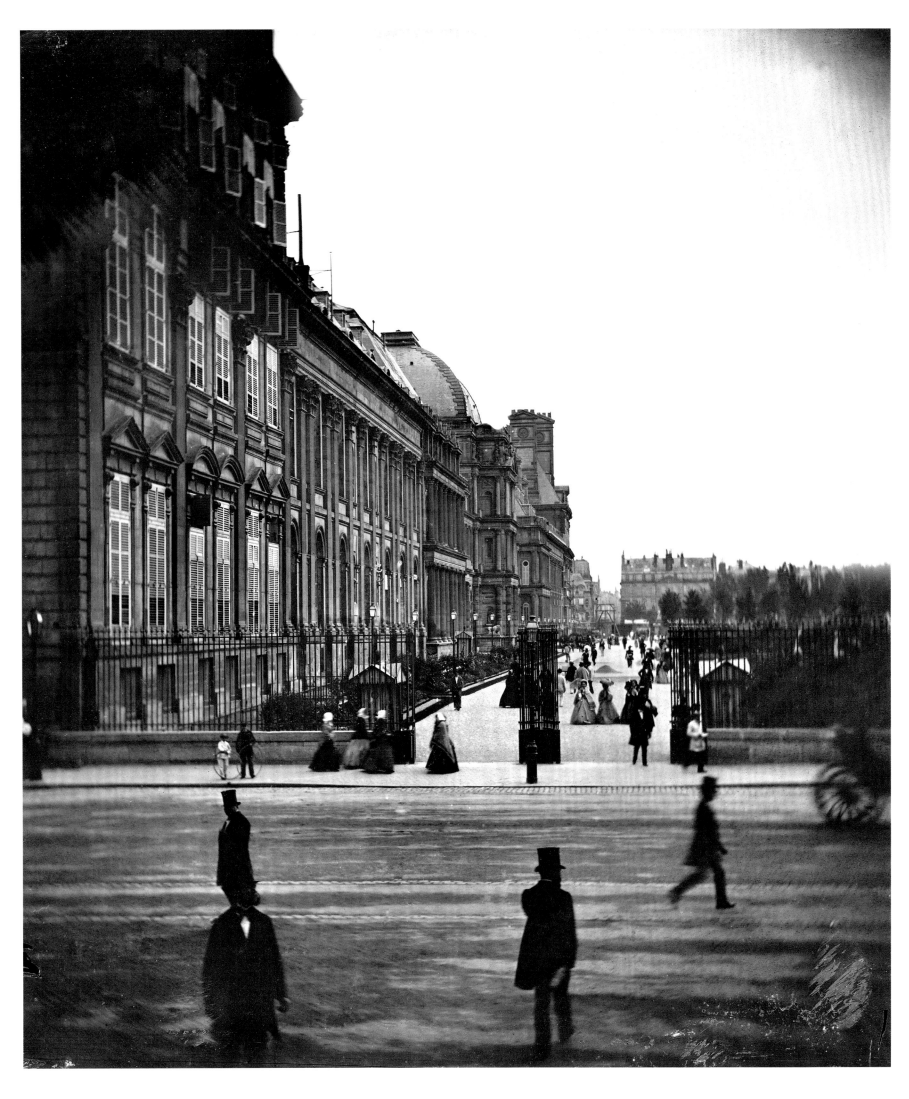

"THE SECOND EMPIRE WAS NOT A MERE BYWAY BUT A MAJOR ROAD LEADING TO MODERN SOCIETY." —*Duke of Persigny*[2]

It was at the workshop of Romain Maréchal, located at 327, rue Saint-Honoré, a short walk from the imperial residence at the Palais des Tuileries, that Vuitton learned in minute detail the inner workings of the trade of "Packager, Trunk Maker and Packer" (*layetier-coffretier-emballeur*).[3] For seventeen years, he perfected his knowledge of the complexities of his future profession. On his invoices, Maréchal listed all the services he offered (in English on the original): "Sells, Chests Boxes, Trunks, Cloakbags, Ninght [*sic*] bags of all kinds, he packs up moveables, Mirrors, Cloks [*sic*], China, Crystal and all brittle things: he cases also Lady's dresses, such as bonnets, Flowers and gowns. He packs up with linen and straw, with wax linen; he takes upon himsels [*sic*] declarations and sealing at the custom office, and the arriving of the wares to the destination."

Vuitton mastered every aspect of the manufacturing, packing, and logistics of his job. The two decades he spent at Maréchal's enabled him to sense the needs and demands of his future clientele, as well as to save up funds to start his own business. Vuitton could have become his

employer's partner or taken over his business, but he had other plans. Just after marrying Émilie Parriaux in 1854, Louis left Maréchal to open his own establishment a few hundred yards away, at 4, rue Neuve-des-Capucines, near the rue de la Paix.[4] At the time, fifty-eight other fellow tradesmen worked in the same neighborhood, and so the competition was fierce.[5]

From the start, Louis Vuitton positioned himself differently from the other "packager-trunk maker-packers." He abbreviated the title and defined himself simply as "Packager." His letterhead added a decisive detail: "Specialty in the Packing of Fashions." That choice proved to be both original in relation to the trade and astute regarding the future; Parisian haute couture was soon to enjoy a meteoric rise thanks to its founder, Charles Frederick Worth, who was also to open his fashion house around the corner on the rue de la Paix.

In his *Encyclopédie*, its final volumes completed in 1772, Diderot spells out the precise duties of packagers: "Formerly, picklocks & jacks-of-all-trades provided that service in customs offices; but now, in those of Lyons & Paris, there are packagers with that title, who pay the *paulette* tax to the king, have fees regulated by a rate schedule, have a community chest, & form a corporate body with its syndic & other officers.

In Paris, they number sixty, divided into two groups, one of which performs its services at customs, & the other at their office in the rue des Lombards, the two groups rotating every eight days."[6]

Packagers were also responsible for marking the merchandise: "It is the packagers who write on the packing canvas the numbers of the bundles belonging to the same merchant & being sent to the same correspondent, the names & titles of those to whom they are sent, & the places of residence. They also have the task of drawing a glass, mirror, or hand on the boxes of fragile merchandise, to admonish those who will move them to be cautious."[7]

"There are several ways to package merchandise; some are packed only with straw & coarse linen; others in wicker or chestnut baskets, large or small, or in crates made of fir wood, which are covered with an oily, hot-wax canvas; others in large crates, which are wrapped in dry waxed canvas."[8] Louis Vuitton was familiar with these practices and commonly used all three techniques.[9] His first trunks were covered with a waxed canvas, called Gray Trianon, for the purpose of waterproofing. The owners' coats of arms and monograms were then applied over the coat of paint. Through the years, Vuitton looked very closely into different

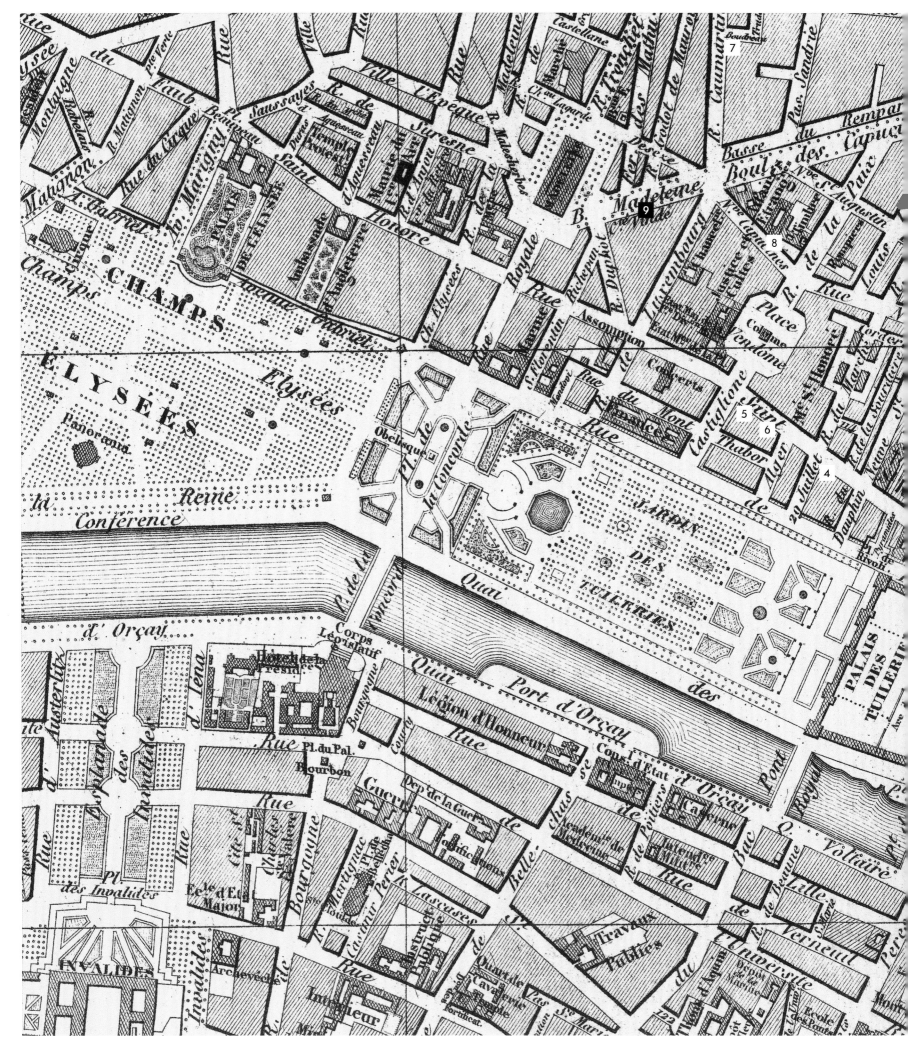

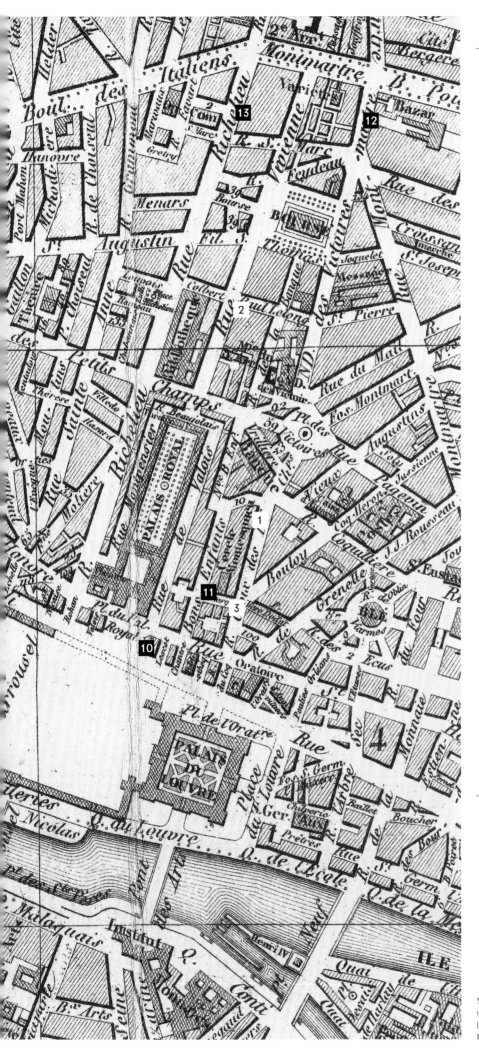

PACKERS

AVENET
BACHELARD ET BEQUET
BATTÉ
BELLET
BERTEAUX
BLATRIER
BONNEAU
BONNETÉE
BONNEVILLE
BRIDON
A. BROU
BRUNEAU
CHENUE (1)
COMMISSAIRE
COTEL
DASTÉ
DATIN
DELASSUS ET LEDOUX
DEMAY
DEVILLE
DUBOIS
DUNET
DUPIERRIS
DUVAL
FANON (2)
FONTAINE
GALLOT
GROMANS
GUIGNOT
HENRY
HESSE
JACQUINOT
JANKOWSKI
LAGESSE
LAMPOZ
LAURENT
LAVOLAILLE (3)
LEGUAY
LERAT
MARÉCHAL (4)
MARTIN
MAUGER
MOREL [GÉRANCE GOYARD] (5)
NOLIN
PHILIPPE
POTTIER
RABUTEAU
REMAUD
RENAULT
ROQUANCOURT-BOLLÉ
ROUSSELLE (6)
ROYÉ
TRION FILS
VICTOR VIGOUREUX
CONSTANT VUITON (7)
LOUIS VUITTON (8)

FASHION SHOPS

AUX TROIS QUARTIERS (9)
GRAND MAGASINS DU LOUVRE (10)
AU PAUVRE DIABLE (11)
À LA VILLE DE PARIS (12)
MAISON GAGELIN (13)

Map of fortified Paris, J. Andriveau-Goujon & Pierre Rousset, 1852, showing
the location of all the packers and the principal *magasins de nouveautés*
[fashion shops] within proximity of the Place Vendôme and the Palais Royal.
Bibliothèque Historique de la Ville de Paris.

Ci devant Rue Neuve des Capucines, 3.

1, RUE SCRIBE, 1

Ancienne Sellerie du Jockey-Club

FABRIQUE À ASNIERES

Rue du Congrés, 14

—Seine—

LOUIS VUITTON EMBALLEUR

BREVETÉ S.G.D.G.

EMBALLE AVEC SÛRETÉ

les objets les plus fragiles

SPÉCIALITÉ

pour les Emballages

DE MODES

EXPOSITION DE PARIS 1867

MÉDAILLES D'ARGENT & DE BRONZE

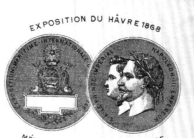

EXPOSITION DU HÂVRE 1868

MÉDAILLES D'ARGENT & DE BRONZE

PARIS, le 11 Aout 187

Louis Vuitton

Packer

1, rue Scribe, Paris

Silver and bronze medals at the

exhibitions of Paris 1867 and

Havre 1868

Manufacturer of a patent trunk

Indispensable for long voyage as

security against dampness

Manufacture of trunks and

portmanteaux of every descrip-

tion for the use of Ladies and

Gentlemen

Speciality for packing of Dresses

Pictures, Chinas, Pianos and brittle

things

Packing done of every

description

8 AZ 717

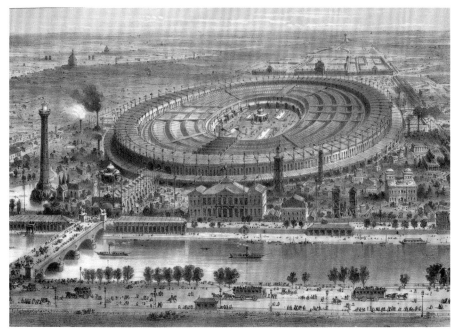

OPPOSITE PAGE

Invoice, Louis Vuitton, packer, August 11, 1876.
Archives de Paris, inv. 8AZ 25 717.

THIS PAGE, LEFT TO RIGHT

Layout of the Champ-de-Mars and the Palais
Elliptique, Universal Exposition of Paris, Provost,
c. 1867. Bibliothèque Nationale de France, Paris.

Emperor Napoléon III, Franz-Xaver Winterhalter, 1857.
Musées et domaine nationaux de Compiègne.

Empress Eugénie de Montijo, Ange Tissier after Franz-
Xaver Winterhalter, 1854–1858. Musées et domaine
nationaux de Compiègne.

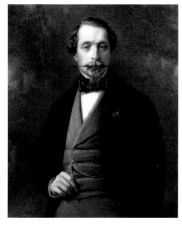
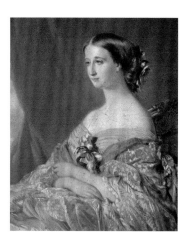

kinds of trunk coverings and patented patterned canvases, which allowed him to differentiate his trunks from other makers and protect his wares from the increasingly common practice of counterfeiting. In 1877, Louis Vuitton filed a patent for a striped canvas, available in several colors. Eleven years later, he filed a new patent, this time for the more sophisticated "Damier Canvas," which integrated his name into the decorative pattern—the first time his name appeared as a signature on the outside of his trunks. His son Georges Vuitton, pursuing the same logic, created the now-famous "LV" monogram in 1896.

> "THE UNIVERSAL EXPOSITIONS WERE
> THE POPULAR SELF-PORTRAITS OF THE
> NINETEENTH-CENTURY INDUSTRIAL
> BOURGEOISIE, OF ITS WEALTH OF IDEAS AND
> CREATIVE SPIRIT."[10]

Beginning in 1855 and held every eleven years throughout the second half of the nineteenth century, the Universal Expositions were venues for Napoleon III to promote progress in industry, commerce, communication, urban planning, and the arts. The emperor was particularly interested in "what contribut[ed] toward putting luxury within reach of the common people, toward democratizing the arts of industrial."[11] Elevated to the rank of temples for international culture, "the Universal Expositions were places of pilgrimage to honor the fetish of merchandise."[12]

Louis Vuitton immediately seized the opportunity offered by these expositions. In 1867, he was selected to participate for the first time. In that year, the Exposition hosted 52,200 exhibitors who gathered for 217 days on the Champ de Mars in Paris. Vuitton's wares appeared in an entirely new category, "Travel and Camping Articles," which included diverse accessories intended for tourists as well as explorers. The jury's report explains: "This is the first time in a Universal Exposition that this group of objects forms a distinct category, which is a clear indication of the importance that their production has assumed in recent years. This growth can be explained, on the one hand … by the facilities in locomotion provided today for the public … and, on the other … by the movements of the armed forces that have been occurring for some time."[13] There were 247 exhibitors in this category, only 47 of them French, which seems a rather low figure considering that more than three hundred workshops were plying that trade in Paris. With an attendance ranging between 11 million and 15 million visitors, this Universal Exposition was considered a resounding success.[14] Vuitton could not have dreamed of better publicity for his first appearance, especially since he was awarded a bronze medal. He exhibited his "packing and travel trunk," whose merits he detailed: "For a trunk to be useful indeed, it should be light yet resistant; its contents need to be protected from shocks and above all from the effects of water… This last property is the most difficult to obtain… I have devised a trunk that is entirely free of these serious disadvantages."[15] He was awarded more prizes at the expositions in Le Havre in 1868 and Paris in 1889. All these medals proudly decorated the letterheads of his invoices. Already at this point in his career, Vuitton had the support of the press: "The Exposition of 1889 will leave a strong impression in the memories of all those who visited category 39, where the latest improvements in travel articles are on display. The Louis Vuitton firm, whose exclusive models are causing a sensation and must always be cited first, appears to have solved the problem of irreproachable manufacturing, of a

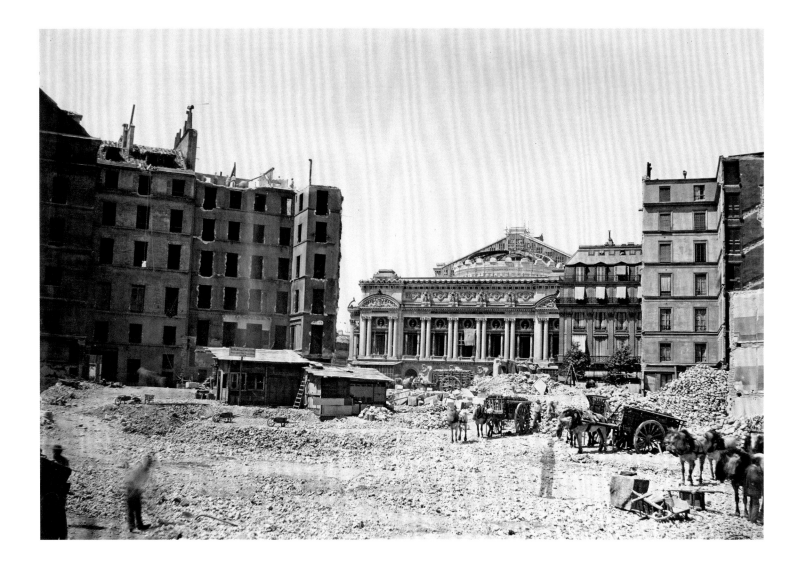

ruggedness that withstands every test; it offers without a doubt the most beautiful specimens of French manufacture, which Louis Vuitton exports to England and America, and which delight the many visitors to his stores in the rue Scribe [where he moved after 1871]."[16]

Vuitton's participation in various exhibitions between 1867 and 1889 both set the pace for his technical innovations and helped establish his personal signature. For each event, he perfected and patented an invention, securing an extremely wide distribution network of high visibility while legally protecting his creations.[17] During these spectacular events, most of the thousands of exhibitors displayed unique items, masterpieces produced especially for the occasion. In contrast, Vuitton, who was endowed with an intuitive business sense, made sure that every innovation he exhibited was available for purchase. To alert his potential clientele, he had a note included in the Universal Exposition catalog: "The Louis Vuitton firm exhibits only its current articles, which articles can be acquired at the Paris establishment."[18]

"FIRST TRANSFORMED INTO A CITY AT THE HEART OF PARIS, THE OPÉRA DISTRICT WAS NOT LONG IN BECOMING THE UNCONTESTED HEART OF THE CAPITAL ... WHICH RAPIDLY BECAME A MODEL FOR EUROPE."[19]

With the proclamation of the Second Empire in 1852, Napoleon III launched a massive urban-renewal program to modernize the capital, with the aim of making the city safer and cleaner, facilitating train travel, and conferring a unique prestige on the new regime. Baron Haussmann, prefect of Paris at the time, was put in charge of these unprecedented transformations, which continued until 1870. The Opéra district would be delimited by three monuments: the Palais des Tuileries, the Gare Saint-Lazare, and the Palais de la Bourse, with, at the heart of that triangle, architect Charles Garnier's Opéra, recognized as one of the most significant monuments of the century. Very quickly, the Paris upper crust rushed to this brand-new district. A palpable excitement was in the air night and day, especially in the majestic luxury hotels and

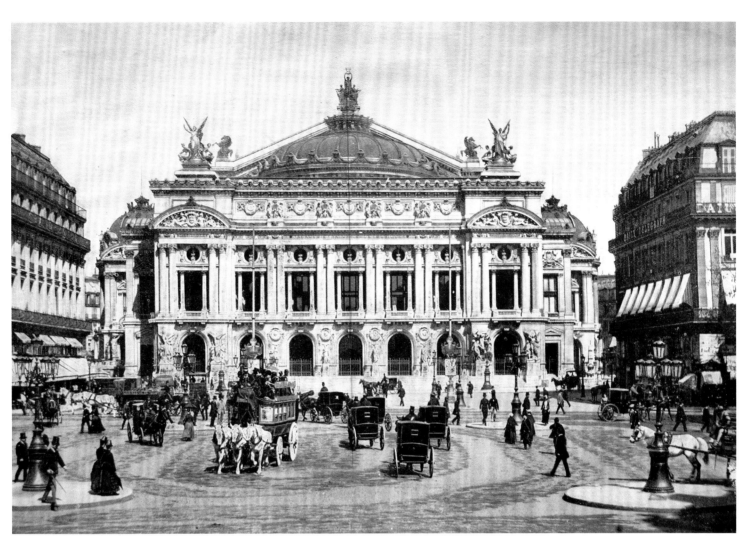

famous cafés. The Palais de la Bourse gave a central location to banks and insurance companies, and heavyweights of the press jostled for position to establish their head offices there.

When Louis Vuitton opened for business at his new location at 1, rue Scribe, in 1871, he placed himself at the epicenter of this metamorphosed Paris. Located in the former saddlery of the very prestigious Jockey Club, the Louis Vuitton storefront faced the entrance to the Grand Hôtel de la Paix, considered at the time to be on the leading edge of French architectural modernism. A short walk from the Gare Saint-Lazare, the Grand Hôtel profited in particular from the growing stream of rich international clients.[20] Vuitton became the obligatory stop for French aristocrats, cosmopolitan businessmen, and

wealthy tourists. His neighbor and client was the famous photographer Nadar, whose studio hosted the first Impressionist exhibition in 1874.

The Café de la Paix occupied a prestigious corner of Place de l'Opéra. The boulevards that converged there, having been recently opened to traffic or widened during the public works projects, encouraged walking and leisurely strolls. Electric lights, a recent innovation, made store windows blaze, dazzling passersby. The area became an open-air shopping center whose watchwords were pleasure and luxury. Located between the Place de l'Opéra and the Vendôme Column, the rue de la Paix was one of the favorite promenades of Parisian high society and attracted the most famous names in fashion and design. Jewelers and perfumers were well

established on the ground floors, while couturiers, milliners, and photographers took over the upper stories. Worth, Paquin, and Doucet, recognized as the definitive couturiers of the day, gave the district its ultimate cachet. At his first workshop in the rue Neuves-des-Capucines, Louis had become friends with the now famous Charles Frederick Worth. Certain Vuitton trunks bear a plaque from Worth, attesting to the close collaboration between the two men.[21]

As a founder of haute couture, Worth imposed new sartorial codes and practices that multiplied the number of items in the bourgeois wardrobe. Clothing for indoors, morning dress, town attire, afternoon gowns, dinner gowns, ball gowns—not to mention the endless layers of undergarments that filled out the enormous

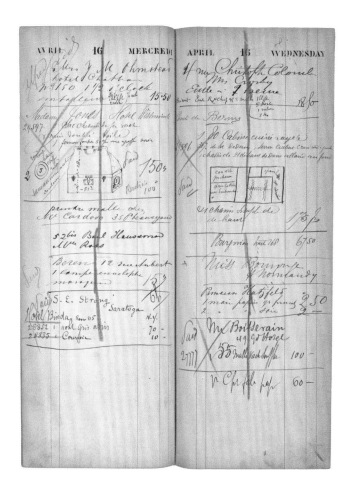

crinoline silhouettes—and of course the infinite variety of hats and accessories made the number of objects necessary for a complete wardrobe virtually astronomical. This was a boon for Louis Vuitton, who, as a specialist in packing fashions, was the best placed to cater to the exponential demand.

"IN THE MID-NINETEENTH CENTURY, THESE MEN WHO HAD BEGUN WITH MODEST MEANS WERE ABLE TO USE THEIR OFTEN LARGE PROFITS TO DEVELOP THEIR INDUSTRY."[22]

The daybook of the Vuitton firm from 1872 on have survived and provide valuable information on Louis Vuitton's activities. Carefully recorded details about packing, shipments in France and abroad, the sales of new and used trunks, and the repairing or painting of trunks mark the rhythm of daily activity. The packing lists describe the usual items: paintings, clocks, porcelain, hats, and gowns, as well as more surprising pieces such as a piano, a kitchen, and toys. The journals are teeming with details, providing even the quantity of supplies and the amount of time spent on each operation. The annotation "M. Vuitton himself" appears again and again in the ledgers—some clients demanded that the work be performed by Mr. Vuitton in person.

Throughout his life, Vuitton remained a man of practice. He traveled only between Paris and Asnières, where he had set up his workshops. But through his cosmopolitan clientele and the shipments that are recorded in his books, his work made journeys that one can follow by retracing the clients' places of residence: London, Liverpool, Frankfurt, Rome, Naples, Constantinople, Cairo, New York, Boston, Chicago, San Francisco, Rio de Janeiro.

Scores of names of barons, counts, marquises, and princesses parade by in these order books. Not to be outdone, there are also stars, as attested by the prominent Paris newspaper *Le Figaro* in 1886: "Sarah Bernhardt's trunks, which have attracted so much notice, are from Louis Vuitton's at 1, rue Scribe."[23] It was not uncommon for an actress of such renown to purchase ten or more trunks at a time. For her first tour of Brazil alone, she needed more than two hundred!

Despite the constant changes of the tumultuous nineteenth century, Louis Vuitton remained true to his hardworking roots throughout his career. In 1891, Vuitton shared his thoughts in his application for his last patent, one of his rare written texts: "In the course of my never-ending experimentation to achieve a greater measure of practicality for the articles that I manufacture, I have often been struck by the considerable weight of the metal parts, fittings, covers, latches, clasps, & c. that are used for their manufacture as the case may be. I have sought various means of eliminating or at least reducing this inconvenience."[24] To the end, he remained faithful to the three motivations that drove him: to improve and master his savoir faire; to give his clientele full satisfaction; and to continue innovating. In January 1892, a month before his death, Louis printed a statement in his first published sales catalog that implicitly summarizes his philosophy: "Being constantly on the look out for making new improvements to his trunks, to give his customers more and more satisfaction [he] begs them to excuse this catalogue for being incomplete, as new models are always in preparation." [in English in the original].

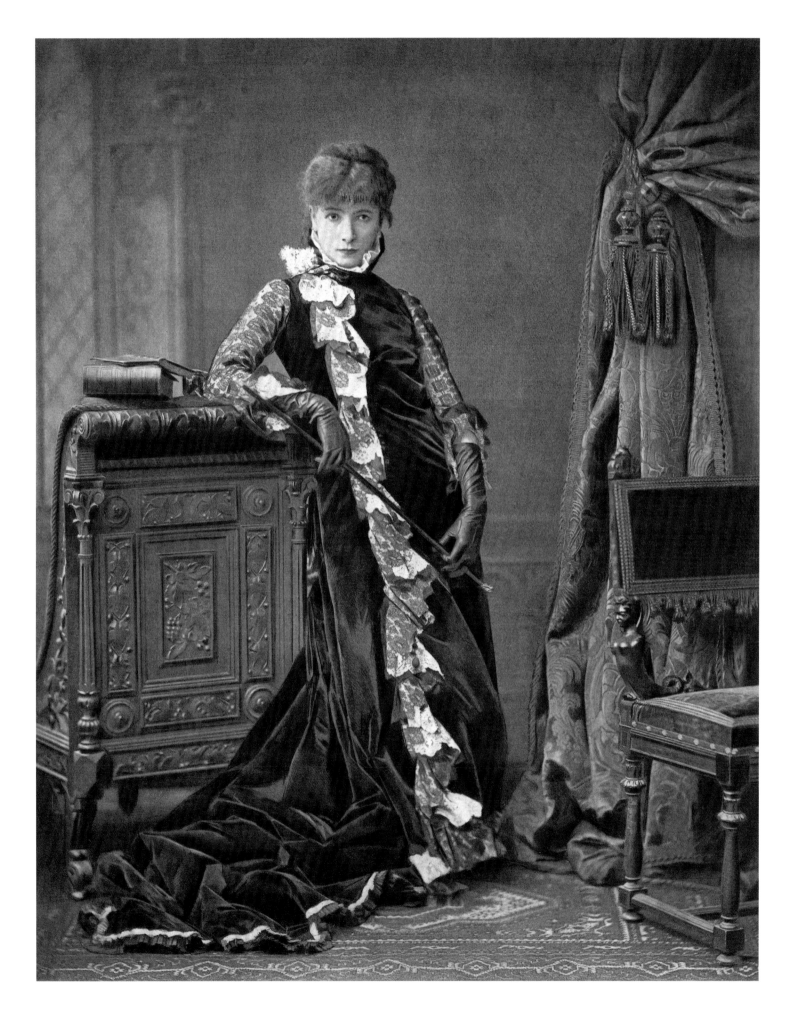

THE PROFESSION OF
THE PACKER

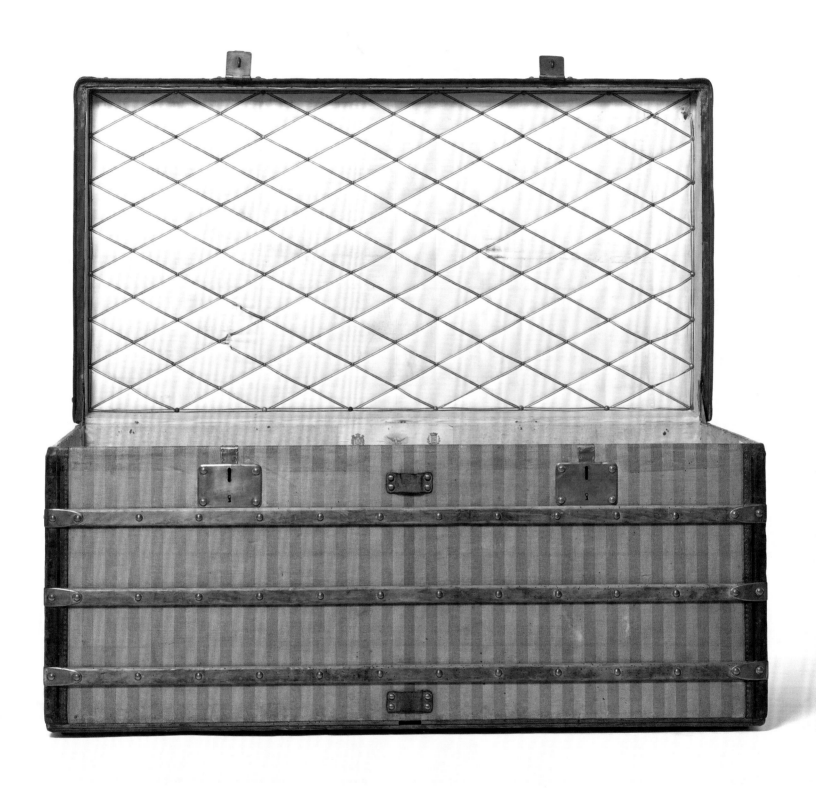

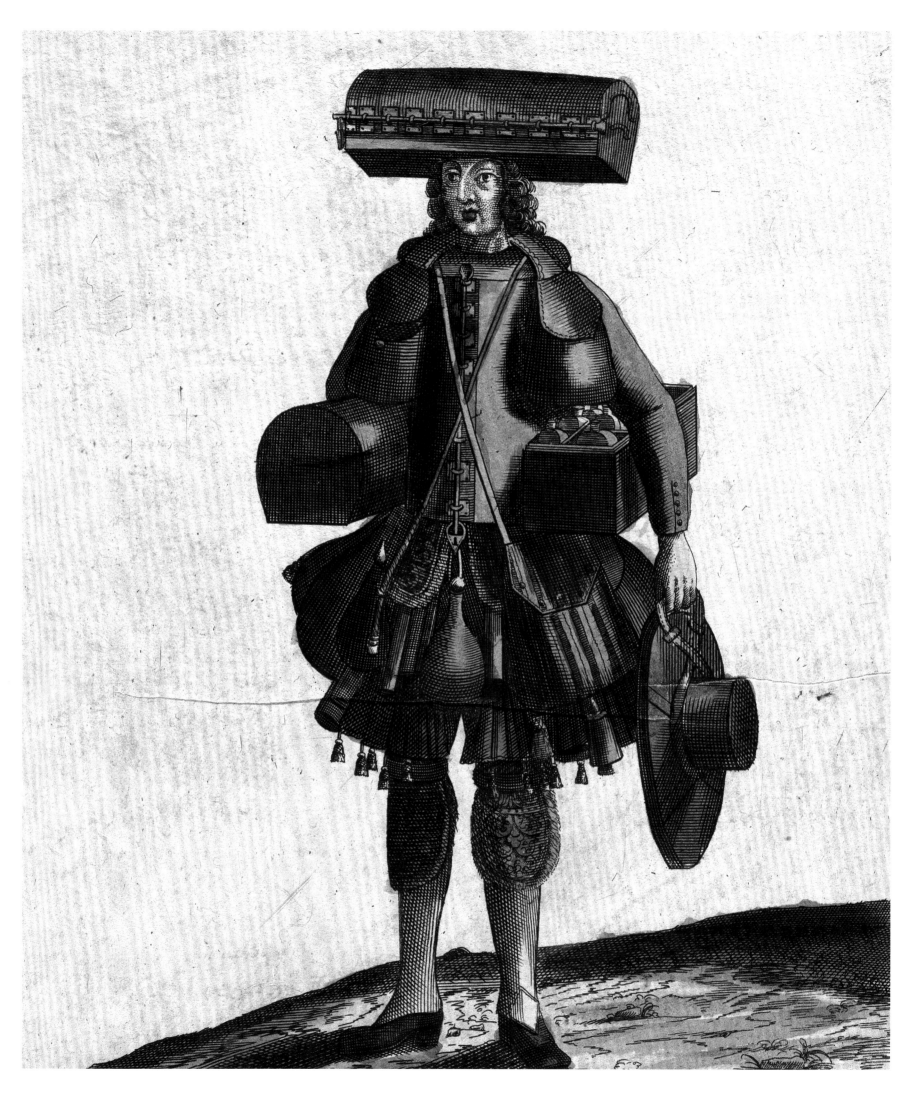

LAYETIER-COFFRETIER-EMBALLEUR

THE SOURCES OF A SPECIALIZED KNOWLEDGE

By

DENIS BRUNA

In the first decades of the nineteenth century, Romain Maréchal—who took on the young Louis Vuitton as his apprentice—defined himself as a "packager, trunk maker, packer" (*layetier-coffretier-emballeur*). In 1854, when Vuitton opened his own company, he declared himself simply a "packer." These occupations, under various names, all belonged to a tradition dating back centuries, that of the *layetiers*.

Let us make clear from the start that Maréchal's and Vuitton's labors did not consist solely of folding up clothing and packing furniture and precious objects for a well-to-do clientele. It also lay in the manufacture of *layettes*. But we must not imagine that *layetiers* made linens and other effects for newborns. The term *layette* comes from *laie*, which in the Middle Ages—and for the most part up to the eighteenth century—designated a small chest or drawer in which documents and precious items were stored.[1]

Old dictionaries provide much more precise definitions. Jean Nicot, though better known for introducing tobacco to France, was also the author of the *Trésor de la langue française, tant ancienne que moderne (Treasury of the French Language, Both Ancient and Modern)*. In that book, published in 1606, layette is given as the Latin translation of *capsa* or *capsula*, meaning box, case, or casket. In his *Dictionnaire universel de commerce (Universal Business Dictionary)*, Jacques Savary des Bruslons (1657–1716), inspector general of the Manufactures Royales, writes that a *layette* is "a small box or chest made of light wood, usually beech, used for various products of master *layetiers*." It was not until the seventeenth century that the word *layette* came to refer to the swaddling clothes of a newborn. In a sense, the container had become the contents: babies' trousseaux were a modern extension of the practice of storing effects in a case.

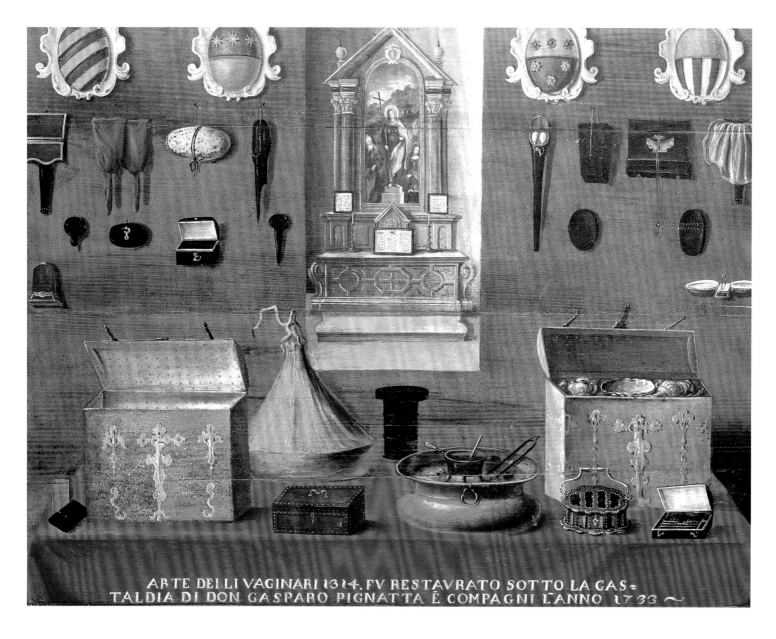

ARTE DELLI VAGINARI 1314. FV RESTAVRATO SOTTO LA GAS=
TALDIA DI DON GASPARO PIGNATTA É COMPAGNI L'ANNO 1733 ~

In ancient times, and in professional and commercial circles, a *layette* was thus a box or chest, and *layetiers* were artisans who made and sold such objects, many of which date to the end of the Middle Ages. *Layettes* are so numerous in the texts of that time that it is likely that an association of *layetiers* had come into being in the fifteenth century. Unfortunately, information on box-maker guilds does not appear before the reign of Francis I. Before the sixteenth century, however, several trade associations were responsible for the manufacture of boxes of all kinds. There were *gainiers* (sheath makers), *coffretiers-malletiers* (packing case and trunk makers), and *écriniers* (case makers), whose development it is possible to trace in the austere administrative texts dating from the thirteenth to eighteenth centuries.

In his collection of bylaws for Parisian occupations, known as the *Livre des métiers (Book of Trades)*, Etienne Boileau, *prévôt des marchands* (head of the merchant's guild) in the thirteenth century, lists the regulations of the association of "*gainiers*."[2] It is clear that these

medieval "sheath makers" were the ancestors of the *layetiers*, since in addition to scabbards they provided wood cases, boxes, and caskets, covered in leather and adorned with ferrules, rivets, and other metal trim.

Let us also mention the *coffretiers-malletiers*, a particular branch of the association of saddlers that appears in a few articles of the bylaws from the fourteenth, fifteenth, and sixteenth centuries. These artisans produced wood chests, trunks, and other boxes, covered with leather and trimmed in tin plate and iron.[3]

Finally, let us make note of the *écriniers*, a term that can be traced back to the late thirteenth century.[4] Even more than the artisans previously mentioned, they were at the origin of the community of *layetiers*, since they reappeared in the early sixteenth century under the double name *écriniers-layetiers*. At that time, and more precisely in 1521, they appealed to the king for certain privileges. It was not until June 27, 1527, that they won their case, through the

promulgation of specific bylaws. That legal text, composed of twenty-nine articles, was the official founding document of the association of *layetiers*.[5] In addition to precise regulations on the training of apprentices, the document provides a list of the products made by these men, namely beech-wood bins, cases, boxes "both large and small for holding any merchandise," leather sacks, studded wooden caskets, boxes for storing pan balances, scales, and musical instruments, small salt containers, writing desks, and writing cases, but also mousetraps and cages for squirrels and nightingales.

On January 7, 1582, Henry III expanded the twenty-nine articles to thirty-four.[6] No major evolution is apparent in the inventory of the objects manufactured, except that *écriniers-layetiers* now produced, in addition to boxes of all sorts, mirror frames. Nevertheless, *écriniers* had undergone a certain decline in favor of *layetiers*. In the document of 1582, in fact, they are given second billing, since it is now a question of the association of *layetiers-écriniers*. In the

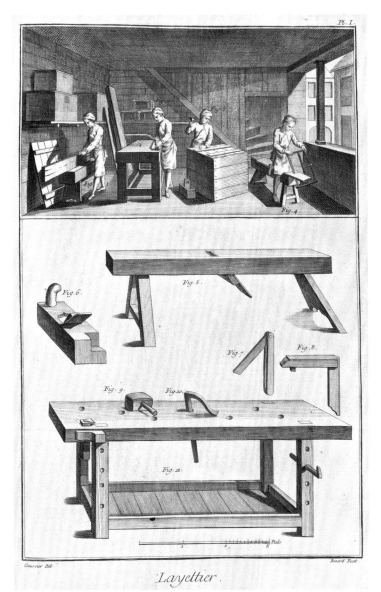

Layettier.

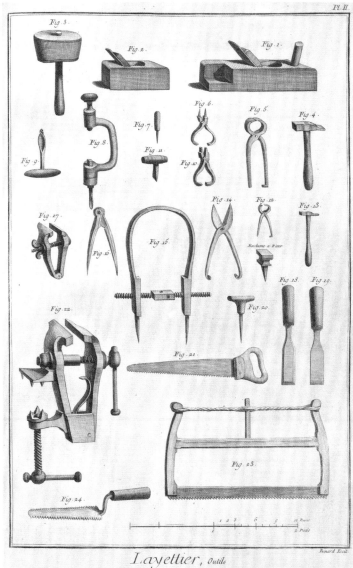

Layettier, Outils.

seventeenth century, the word *écrinier* disappeared, and *layetiers* appears by itself on association documents. The manufacture of *écrins*, cases, was taken over by *gainiers* and *coffretiers*. At that time, *layetiers* acquired a few privileges. They now had the right to install the locks on their boxes themselves: that operation no longer required locksmiths.[7] These sixteenth-century bylaws governed the association of *layetiers* until the Revolution.

For the eighteenth century, the *Encyclopédie*,[8] and especially of *L'art du layetier (Art of the Box Maker)*, published in 1782 by the cabinetmaker André-Jacob Roubo,[9] provides additional information about what the spare prose of the legal documents leave out. Roubo's treatise supplies valuable details about the tools and materials used by box makers.

The cabinetmaker describes the occupation of box maker as a "diminutive" form of the joiner's craft. With a few exceptions, both types of artisans manipulated the same tools and worked the same woods. Box makers used workbenches, scissors, squares, hammers, planes, and so on. But they also used a few tools specific to their trade, such as the cooper's plane (*colombe*), the awl for making holes in wood, a bit brace of sorts, and two anvils. The woods they used were equally diverse. In the first place were the woods indispensable for cabinetmaking: oak and beech, employed for their hardness. Box makers also used fir, a soft and lightweight wood suitable for making crates. Roubo mentions as well the thick fir called "boat wood," since it came from boards salvaged from destroyed boats. That coarse, inexpensive wood was used in the manufacture of large packing crates, designed especially to transport furniture. Nevertheless, the wood of choice for packagers in the eighteenth century and following was poplar: it was a soft wood, easy to nail together, and ideal for the manufacture of light packing crates and therefore of travel trunks.

André-Jacob Roubo adds that only the manner of assembling products differentiated joiners

PAGE 33

Large, flat trunk in yellow-striped canvas, 1882. Les Arts Décoratifs, Paris, gift of Gaston-Louis Vuitton, 1989, inv. 987.51.

PREVIOUS SPREAD

Costume of a trunk maker–chest maker, from Nicolas II de Larmessin's *Costumes grotesques (Grotesque Costumes)*, c. 1700. Musée Carnavalet, Paris.

OPPOSITE PAGE

"Art of the corporation of sheath makers, 1314, restored by Gasparo Pignatta and Company in 1733." Museo Correr, Venice.

THIS PAGE, LEFT TO RIGHT

Interior of a packager's shop and tools, *Encyclopédie, ou Dictionnaire raisonné des sciences, des arts et des métiers (Encyclopedia, or a Systematic Dictionary of the Sciences, Arts and Crafts)*, 1767, vol. 5. Bibliothèque des Arts Décoratifs, Paris.

Packager's tools, *Encyclopédie, ou Dictionnaire raisonné des sciences, des arts et des métiers (Encyclopedia, or a Systematic Dictionary of the Sciences, Arts and Crafts)*, 1767, vol. 5. Bibliothèque des Arts Décoratifs, Paris.

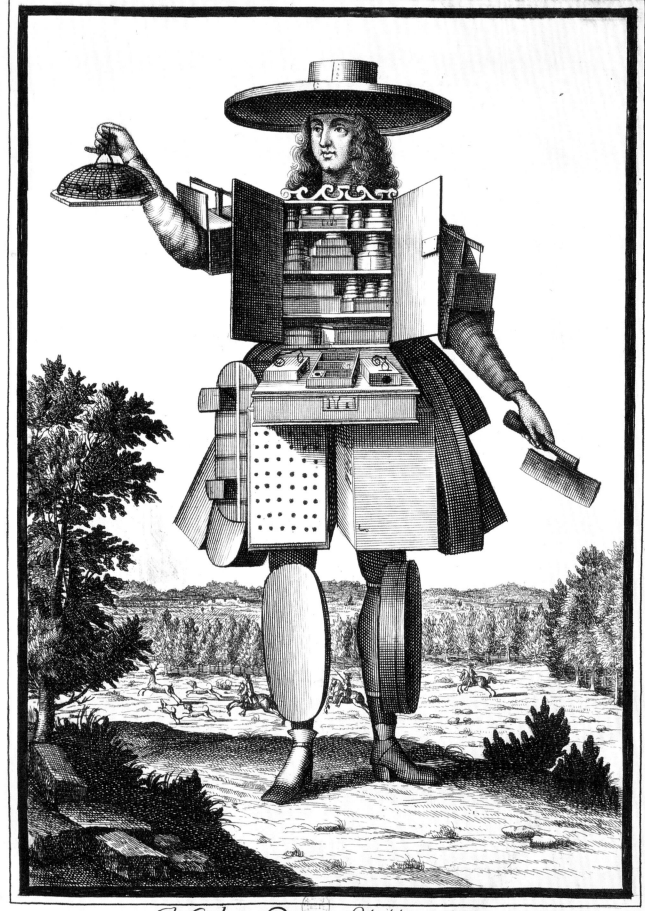

Habit de L'Aÿettier;

A Paris, Chez N. de L'Armessin, Rüe St. Jacques, á la pôme d'Or, Auec. Priuil. du Roy,

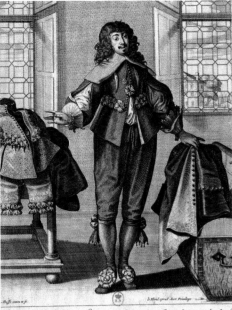

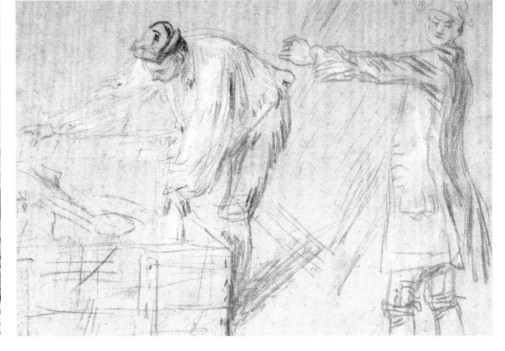

from packagers: joiners used tenon-and-mortise joints, whereas box makers employed nails or other iron fittings. Roubo also mentions a notable change the profession had undergone since its beginnings. In the eighteenth century, *layetiers* no longer manufactured small boxes, caskets, and other cases; the manufacture of these products was taken over by *gainiers* and *coffretiers*. Conversely, *layetiers* continued to produce larger boxes of all kinds and especially "crates to hold goods that one wishes to transport safely from one province to another."

In Roubo's time, the products of the Parisian packagers were divided more precisely into two categories: first, those that the box makers made themselves; and second, those they sold but that were made by provincial artisans.

Despite the reduction in the number of products made by the Parisian packagers in the eighteenth century, the list is still long. Roubo notes caskets of various sizes, bed boxes, all sorts of other boxes, wig boxes, slotted cartons,[10] various small boxes, school cupboards, shelves for holding books, writing desks, hat cases, bed warmers, foot warmers (*chancelières*), parakeet and squirrel cages, crates for orange trees,

packing crates, and even coffins. For their part, provincial box makers produced and exported all sorts of mousetraps and rat traps.

Boxes and cases coming from packagers' workshops were used to store the most diverse objects, but some were designed especially to hold garments, wigs, and fashion accessories. Roubo indicates in particular the use of bed boxes for storing "various rags, and especially, men's clothing." He also mentions that boxes taken on journeys "were used to transport … hats and other small accessories for ladies." And let us not forget that *layettes* were still used at that time to hold the linen of newborns.

The Revolution brought radical changes to the history of the trade associations of the ancien régime. On March 2, 1791, the Allarde decree eliminated corporations. It was reinforced a few months later by the Le Chapelier Law, which prohibited the formation of any professional group. Now everyone was free to practice a trade, open a workshop, and choose his own labor force.

The packager trade took advantage of that new freedom of enterprise, undergoing a major evolution at that time. In fact, the

nineteenth-century *emballeur* (packer) replaced the *layetier* of olden days. As proof, we have two manuals published in the 1830s. The first was written by Bien-Aimé (1836), the second by Nosban and Maigne (1838). In his *Notice historique sur les layetiers-emballeurs (Historical Note on Packagers–Packers)*, Bien-Aimé traces the history of packaging—which he unfailingly links to the history of commerce and travel— in preference to the manufacture of boxes and crates. That shift is also perceptible in Nosban and Maigne's *Manuel du layetier (Packager's Manual)*. "*Layetiers* are confined to work related to packaging," they proclaim in the introduction. Although the authors do devote several chapters of the manual to the technical aspects of the trade, they dedicate a chapter in full to the packing of furniture, marble, paintings, art objects, and so on. The era of the *layetier* was vanishing in favor of that of the *emballeur*.

126.

La Gazette des Salons.

Bonnet de M.^{lle} Delatouche, r. Vivienne, Fichu paysanne de M.^{lle} Minette, r. de Rivoli, Robe redingote de M.^{me} Camille, r.

Choiseul, 15, Champignon de Fanon, breveté, r. Montmartre 170 & 172, Livré genre anglais de Bencist, & de Grement, r. Vivienne,

Chapeau d'Ambrois, r. du Montblan, Capote de gros de Naples & tul des magasins de Jeanne Gray B.^d Bonne Nouvelle 9.

On s'abonne Rue de la Jussienne, N.^o 11.

et à LONDRES au B.^{au} du Panorama de Londres, 25, Welbeck street Cavendish Square.

FASHIONS ARE SO FRAGILE!

CARTONS, BOXES, AND TRUNKS FOR GOWNS AND ACCESSORIES: A CHALLENGE FOR NINETEENTH-CENTURY PACKAGERS

By

FRANÇOISE TÉTART-VITTU

Parisian commerce at the beginning of the nineteenth century developed within a context that had undergone both administrative and political changes. The packager-packers, like any member of a traditional professional body, maintained the regional ties and shared knowledge and innovations of their craft. Nevertheless, a sort of flexibility came into being in the "freedom of enterprise" in line with new business aspects. The general reorganization effected by the Convention, the Consulate, and then the Empire sought to promote new industries in any branch capable of improving France's domestic and foreign trade. Beginning in year VI (1798), exhibitions of industrial products were held on a regular basis, accompanied by the awarding of medals and other prizes, which served as marks of quality for a regional and international clientele. French—and, over time, foreign—manufacturers, inventors, merchants, and retailers participated in these gatherings, which would be called Universal Exhibitions starting in 1851.

Also in year VI, Jean de La Tynna launched his *Almanach du commerce de Paris (Almanac of Parisian Commerce)*, which was taken over by Sébastien Bottin in 1819, and then by the printer and publisher Firmin-Didot in 1857. *L'Almanach-Bottin du commerce de Paris, des départements de la France et des principales villes du monde (The Bottin Almanac of Commerce in Paris, in the Departments of France, and in the Principal Cities of the World)* became an indispensable directory at that time and was updated every year. Thanks to its breakdown into professions, we are able to follow the evolution of particular businesses and see under what rubrics they wanted to appear (sometimes encompassing rather different professions), thus defining the field of a presumed clientele. Hence, "packagers-trunk makers-packers" (*layetiers-coffretiers-emballeurs*)—of which 219 were listed in 1842 and 376 in 1872—were listed only under the rubric "packers"

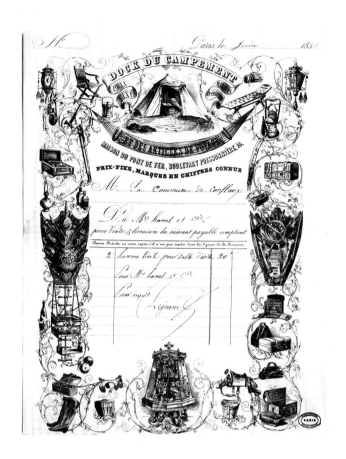

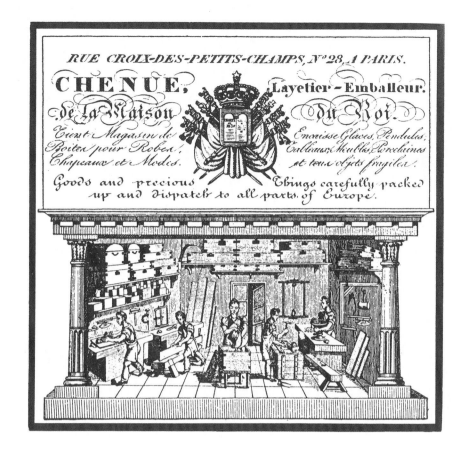

starting in 1888. In 1890, the same category was subdivided into "packers" and "travel articles," the latter being the heading under which they had been listed for the registration of patents since the 1820s. Indeed, on the fifth day of the month of Vendémiaire in year IX (September 27, 1800), the Ministry of Agriculture and Commerce had implemented means to protect and disseminate innovations. Although "in granting a patent without prior inspection, the government [did] not intend to guarantee in any way an invention's priority, merit, or success,"[1] a great many artisans applied for patents at the *Bureau des Manufactures*, including sketches and lithographs, and then, after 1865, photographs with their applications. In the following years they were allowed to add improvements. From 1820 on, represented by specialized agencies that took care of the administrative formalities, inventors registered patents for five years, then, after 1852, for fifteen years. These patents were a step toward the recognition of trademarks, which came in 1857.[2]

French fashion items had been growing in significance since the beginning of the nineteenth century. Supported by manufacturers in the provinces (silk was produced in Lyons; cotton goods, lace, and shawls in Alsace, Nord, and Normandy), the city of Paris took on a central place in the sale of fashions, which were exported and imitated throughout Europe and across the Atlantic. However, gowns and elegant accessories were fragile and required careful handling, and this is where the specialized trade of the packer came in.

In the eighteenth century, *layetiers* took their name from *layettes*, oblong and fairly flat boxes made of white wood that came to be called *cartons* in the nineteenth century. Used for silk, millinery, veils, and gloves, these boxes were also known as *étuis*, or cases, since they were given the shape of the objects to be contained. They were triangular for three-cornered hats, rounded, high, and with a rim for men's hats, narrow for fans, and cylindrical for muffs. These

boxes protected merchandise on the shelves in the shops and were used for transport after their purchase. In the 1820s, among the many types of boxes with compartments available, the headings of packers' invoices mention in particular those designed for gowns and hats. This was the case for three long-established houses, created, respectively, in 1763, 1792, and 1795: Chenue, "packager-packer for the King's Household, at 23, rue Croix-des-Petits-Champs," Martin, "supplier to the duchesse de Berry, at 4, rue Neuve-des-Capucines," and Fanon, "certified by the King, at 172, rue Montmartre." Having registered many patents and often presented their innovations at exhibitions, the packers distributed flyers to attract a clientele that could buy directly in their stores trunks, cases, and boxes made for hats and gowns "that ladies can pack themselves." Special efforts were made to keep the delicate trim—flowers, ribbons, and lace—on the hats and ball gowns from being crushed. Ribbed and horsehair stays were invented for

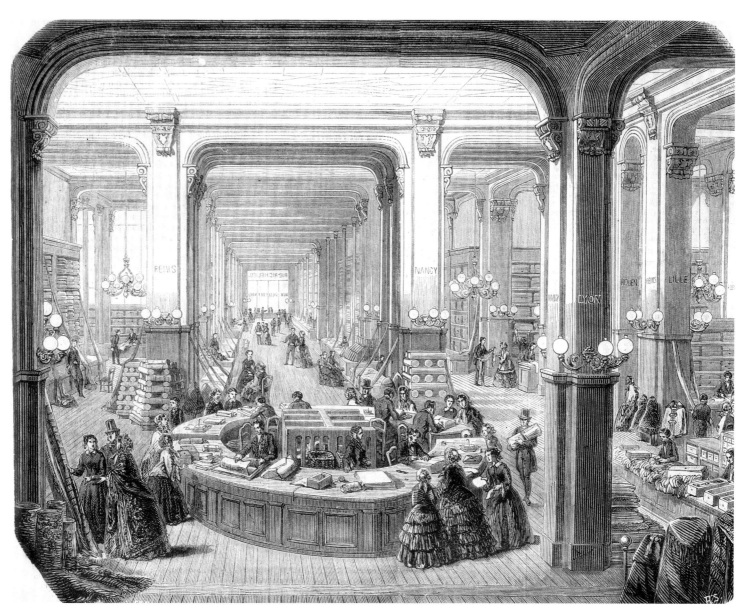

gauze sleeves, as were strap devices mounted on roller frames to be placed in false-bottom trunks, where the gowns were folded in two and held by pins.[3] Fanon even did without pins, inventing in 1839 the "mechanical mushroom," which was mounted on a foot and equipped with pads for fastening hats and caps.

Packers followed in the wake of the famous fashion stores established in Paris.[4] At first, they set up shop between the boulevards, near the Palais Royal, the rue Richelieu, rue Vivienne, and rue Saint-Honoré—where fashion was concentrated until about 1850—and in the vicinity of the customshouse near Canal Saint-Martin and the freight companies. Fanon and Godillot were located in the rue Saint-Denis, Grandjean in the rue de Cléry, Censier in the Faubourg Poissonnière, and Cherre in the rue du Caire. The packers then followed the commercial center of Paris as it moved westward, closer to the hotels between the rue de Rivoli, Place Vendôme, the Madeleine, the new

Opéra, and the Saint-Lazare Station. They offered their services to a wealthy clientele that came to make their purchases in Paris on the occasion of the Universal Exhibitions of 1855 and 1867, or during a tour of Europe. This was the case for rich American women who patronized the new houses of haute couture, such as Worth & Bobergh and Émile Pingat, which became famous in the United States as early as 1860.[5] Many invoices include the cost of the packaging box; for example, 32 francs for two gowns costing 300 francs was a going rate. No packer's name is mentioned, but it is likely that the fashion houses had special relationships with some of them, especially those businesses that were certified by the royal court and established near Place Vendôme and the rue de la Paix, with addresses tending to remain constant: Morel, for example, was Martin's successor at 233, rue Saint-Honoré (where his former apprentice and employee François Goyard would also set up business), and Louis Vuitton was at Martin's previous address, 4, rue

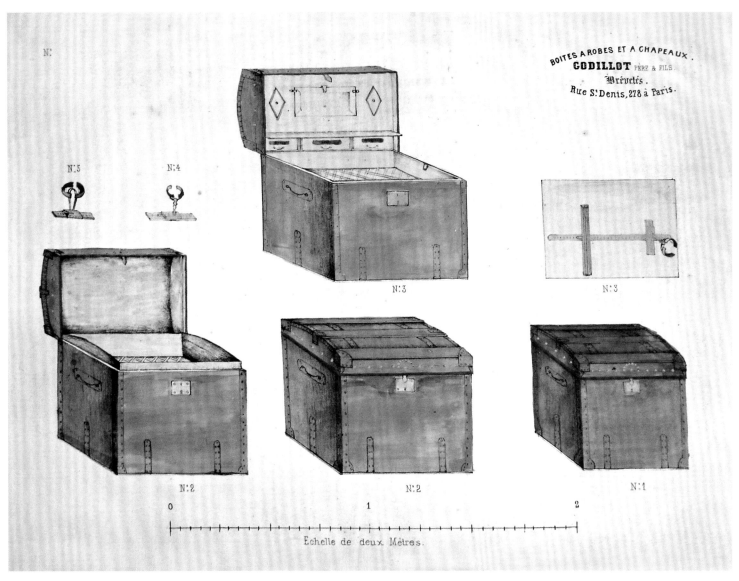

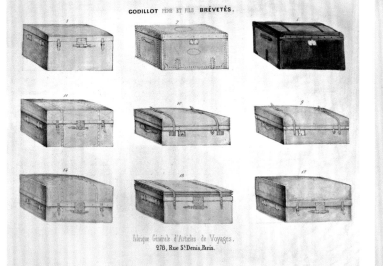

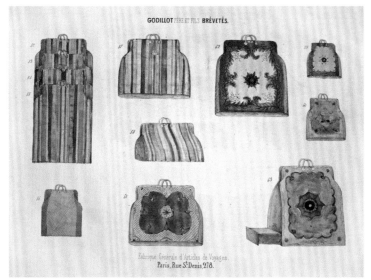

Avis aux Dames.

FANON,

BREVETÉ DU ROI,

LAYETIER, COFFRETIER, EMBALLEUR,

Rue Montmartre, Nos 170 et 172, à Paris.

Depuis long-temps les Dames désiraient que l'on inventât le moyen de transporter des chapeaux en province, sans être obligé de les assujétir avec des épingles, ce qui a l'inconvénient d'y laisser des marques. Aussi, M. FANON a-t-il inventé les *Champignons mécaniques* servant à l'emballage des chapeaux de Dames.

Le mécanisme de ces *champignons* évite l'emploi des épingles et tout le désagrément qu'il en résulte. Il a aussi des boîtes à robes et à chapeaux que les Dames peuvent emballer elles-mêmes par le genre de distribution qu'elles possèdent.

M. FANON a été breveté du Roi ; le jury de l'exposition de 1834, et celui de Valenciennes, 1836, lui ont accordé une mention honorable ; il possède un établissement connu depuis nombre d'années et qui présente sur tous les autres du même genre des avantages incontestables. — On y trouve un très grand choix de tous les articles de voyage, tels que malles en cuir de toute espèce, étuis assortis pour chapeaux et parapluies, sacs de nuit, porte-manteaux, musettes, chancelières et chaufferettes, tabourets et bassinoires à eau bouillante pour appartemens remplaçant la chaufferette, ronds de siéges, cabas, etc., etc.

Et se charge de la confection des emballages pour les objets les plus fragiles, tels que pendules, groupes d'albâtre, glaces, porcelaine, candélabres, lustres, cristaux, tableaux, meubles, robes et chapeaux, en général tous les objets les plus délicats.

Emballe également en toile cirée, toile grasse, toile et paille.

NOTA. *Se charge de toute Expédition de douane et de roulage.*

En s'adressant à M. FANON, on ne redoutera plus les excursions lointaines ; on ne manquera donc pas de visiter son Etablissement.

Neuve-des-Capucines. These trusted firms offered boxes and crates adapted to the new needs of maritime and railroad transport, for merchandise but also for travelers' clothing. The packers diversified their luggage products: for example, Dock du Campement, at 14, boulevard Poissonnière, advertised tents and military and hunting kits, in addition to boxes for hats and toiletries. In 1865 Le Bazar du Voyage, at 25, rue de la Paix (next to Doucet), catered to the needs of explorers as well as to those of ladies going to the seashore. One of Godillot's advertising brochures gives an idea of the variety of articles available.[6]

The travel trunk became an indispensable item for transporting—without wrinkling—the five outfits that a fashionably dressed lady on vacation needed each day. Between 1855 and 1880, packers sought to improve waterproofing and the security of locks, filing patents and participating in exhibitions. The patent for a gutta-percha covering dates to December 9, 1854, the drawered trunk of the trunk maker Sormani to 1863, and Vuitton's grooved closing mechanism for packing and travel trunks to 1867. These Parisian firms opened branches in the major ports and adopted distinguishing marks for their own protection, like the new French houses of haute couture, which were beginning to use boxes bearing the company's name and address, along with signature labels.[7] Packers also sought to make their products distinctly recognizable by registering the type of canvas used in their packing: at first striped or checked, and finally opting for the manufacturer's initials (registered by Vuitton on January 11, 1897), as the textile mills and fashion shops were already doing.

OPPOSITE PAGE, CLOCKWISE FROM TOP

Dress and hat boxes, *Album d'articles de voyage (Album of Travel Articles)*, Godillot Père et Fils, c. 1840.

Overnight bags, *Album d'articles de voyage (Album of Travel Articles)*, Godillot Père et Fils, c. 1840.

Trunks and suitcases, *Album d'articles de voyage (Album of Travel Articles)*, Godillot Père et Fils, c. 1840.

THIS PAGE

Fanon advertising flyer, mechanical mushrooms for packing women's hats, 1836–1849. Collection Debuisson, Paris.

LOUIS VUITTON

(1821–1892)

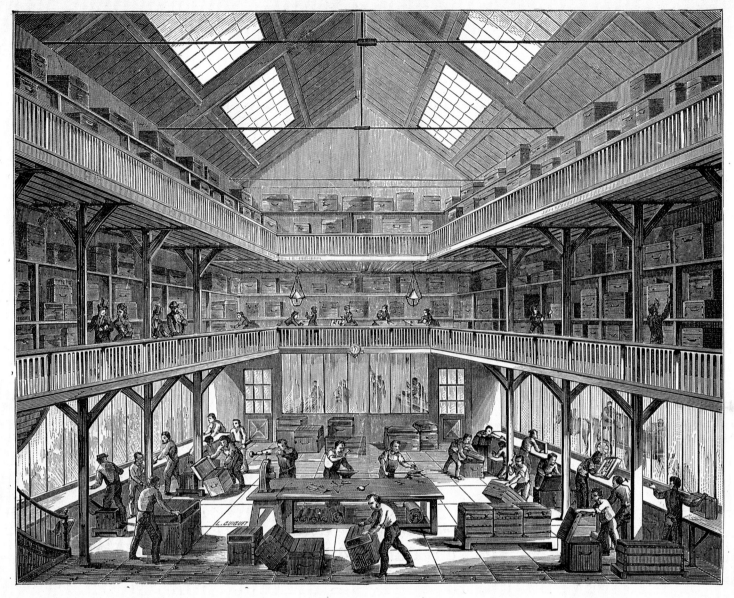

Vue de la Fabrique à Asnières

LOUIS VUITTON

BREVETÉ S. G. D. G.

Paris — 1, rue Scribe, 1 — Paris

MAISON DU JOCKEY-CLUB

CI-DEVANT 3, RUE NEUVE-DES-CAPUCINES

PARIS 1867

HAVRE 1868

FABRIQUE A ASNIÈRES

14, rue du Congrès, 14

La Maison Vuitton emballe avec sûreté les objets les plus fragiles

SPÉCIALITÉ POUR LES EMBALLAGES DE MODES

LOUIS VUITTON

PARIS

1, Rue Scribe, 1

ARTICLES DE VOYAGE

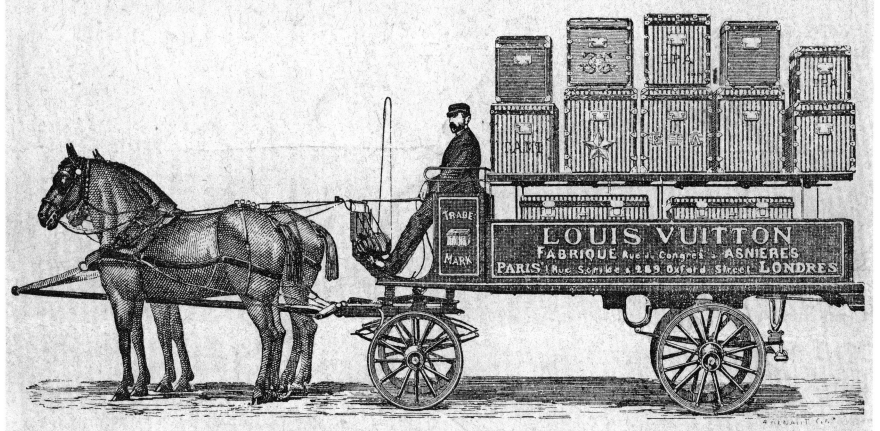

TRUNKS & BAGS

LOUIS VUITTON
A BIOGRAPHY

By

DELPHINE SAURAT

Louis Vuitton was born on August 4, 1821. His father and grandfather were millers from Anchay, his maternal grandparents, millers from Vouglans, two communes in the Jura lying some ten kilometers apart. The Vuitton family had long been mill owners: Louis's father and uncles Claude and Cézard were the fourth consecutive generation of millers in Anchay; his great-uncle owned the Lantenne mill and distant cousins had inherited that of Isle, of Bua, and, farther away, of Bienne.[1] His parents married in 1813, just as they were both entering their twentieth year. Louis was their fourth child of six, and was given the name of a brother who had died at eight months. In 1831, Louis's mother, Marie Coronnée Gaillard, died; she was only thirty-seven. Eleven months later the widower, François Xavier Vuitton, after becoming the miller of Les Clayés, a mill in the neighboring village of Cornod, took a second wife. That marriage was marked by four births and the death of three children in infancy.

None of Louis's personal documents survived the events of the Commune. Family history indicates that he left the Jura in 1835. It may have taken him two years to travel on foot the 450 kilometers to the capital, working as a day laborer to provide for his needs. At the time of his departure, he may not yet have met his cousin Laurent, a Vuitton from Villette, a village six kilometers away from Anchay. Even before Louis was born, Laurent had moved to Versailles, and he settled in Paris between 1826 and 1828. The succession of coalition wars had impelled Laurent Vuitton to leave the Jura, in order to serve in the imperial army of Napoleon I. After he was demobilized,[2] he remained in the Paris region, where he was joined by his younger brother Claude Joseph and

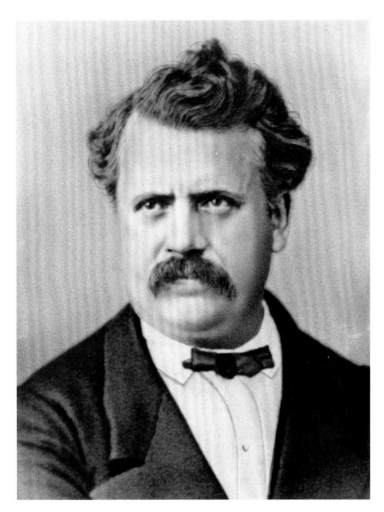 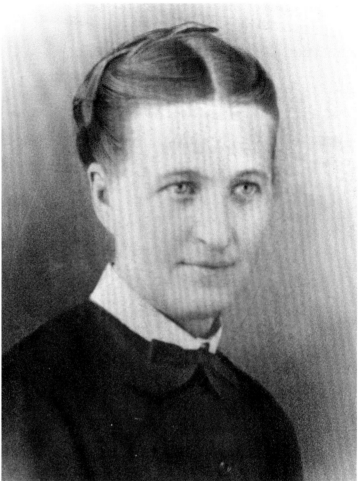

his young nephew Constant, who had lost his father at the age of six. Though the three came from a family with an agricultural background, Laurent became a servant, right-hand man and caretaker, Claude a coachman, and Constant a packer (*emballeur*).

Louis chose a trade into which his family had already gained entry: Constant, five years his senior, was already a "journeyman packer" (*ouvrier emballeur*) in 1840.[3] Constant started his own business in 1846, taking over the shop located at 45, rue Caumartin, which he moved to no. 32 under the business name "Constant Vuiton packer, former Dubois House, founded in 1816."[4] In Paris the Vuittons of Anchay and those of Villette saw one another socially, and in 1839 Louis's elder sister Victorine united

the two families by marrying Laurent, whose previous wife had died.[5] The following year, Louis became the godfather to their firstborn child; the baptismal certificate refers to him as a packer residing at 21, rue de la Ferme des Mathurins (now rue Vignon).[6]

Louis probably apprenticed at the Maréchal firm in 1837. Romain Maréchal was thirty at the time, a "packager, trunk maker, and packer" (*layetier-coffretier-emballeur*) on the corner of the rue Saint-Honoré and rue du 29 Juillet. Like Louis, he was a native of a different department, the Yonne, and did not benefit from paternal support.[7] In 1831 Romain took out a lease from the comtesse de Bourke at an extraordinary location adjacent to the Hôtel Meurice, which had opened fourteen

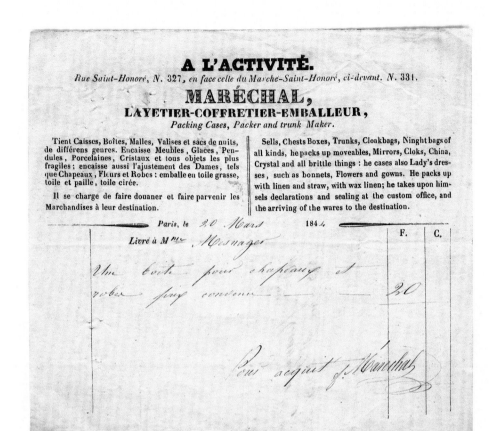

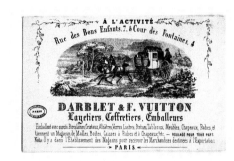

years earlier on rue Saint-Honoré. Although
the business moved to the rue de Rivoli in
1835, it remained the supplier of the hotel's cli-
entele, which the guide *Paris-Illustré* of 1855
called "the 'high-life' of London." Romain
rented the second floor for his personal use,
as well as the main shop looking out on the
rue du 29 Juillet, but he would not become its
owner until 1840.[8] Since Louis's apprentice-
ship lasted a long time—four years were nor-
mal under the Ancien Régime—the young
Vuitton became a journeyman only after the
premises had been expanded. Romain pros-
pered, though he never participated in any
of the expositions. He died at age sixty-five.
The inventory of his shop describes the first
workshop in which Louis worked: "four work-
benches set on wooden crates, three cooper's

planes (*colombes*), one jointer plane, eight
other planes, one lot of saws, compasses, and
joiner's tools, one bit-brace vise, one lot of
movable type and brush, a grindstone and its
trough, two pairs of shears, one iron-cutting
machine, one lot of rods, one lot of drawer
bodies; in the cellar, one lot of wooden laths."[9]

Another cousin set up business as a packer at
7, rue des Bons-Enfants, in the Palais-Royal
district. Frédéric Vuitton, Laurent's eldest son,
who was born in 1821—like Louis—succeeded
his employer, Jean Baptiste Louis Darblet. In
1850, he bought up half the business for 1,000
francs.[10] The business grew, and the number of
workers increased from two to ten, but "mis-
management" led to bankruptcy, which was
declared in 1853. Frédéric was sentenced to

three months in prison and ordered to pay the
court costs for "accommodating actions for the
purpose of delaying bankruptcy."[11]

Constant and Frédéric both married and set-
tled down when they were twenty-nine. Louis
could not follow his cousins' example, having
neither Constant's capital base nor Frédéric's
opportunity to take over someone else's busi-
ness.[12] He founded his own firm. Like Romain,
who married two months after obtaining a lease
on the rue Saint-Honoré, Louis took on a wife
and a business in the same year.

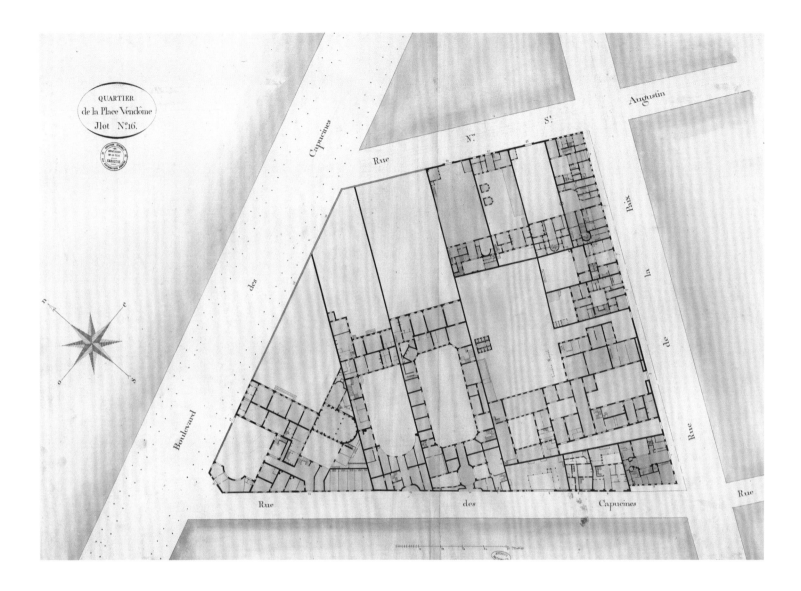

ESTABLISHMENT

The young packer set up business during the prosperous times following the coup d'état of December 2, 1851. The Second Empire was basking in the euphoria of business and public festivals. High-society parties, at the Tuileries and also at Saint-Cloud, Fontainebleau, Compiègne, or Biarritz, fostered a modern and mobile elite. On April 22, 1854, Louis married Clémence Émilie Parriaux, who was fifteen years his junior. Émilie was the daughter of an atypical miller. A cabinetmaker from Franche-Comté, Nicolas Féréol Parriaux, had acquired the old Créteil mill in 1834. Half the time the mill was used by a miller, and Parriaux used it to pulverize alabaster for calendering paper. In 1848, the building was sold at court auction by the Tribunal de la Seine.[13] Despite the lengthy procedure that followed, Nicolas did not give

up on his new plans: between the long-drawn-out sale and his death in 1852, Nicolas filled the mill's outbuildings with his latest inventions for preparing and revitalizing plasterwork.[14]

Émilie inherited her family's taste for enterprise and innovation, but she married without a dowry: being minors, she and her younger brother were precluded from inheriting in 1853.[15] Since they had no property of their own, the future husband and wife did not have a marriage contract drawn up. Louis lived above the Maréchal workshops at 10, rue du 29 Juillet, where he rented "the hearth room," seventh floor on the right. The tenant's name was listed as "Viton."[16] With his father's consent, he was married in the presence of witnesses from the Jura: Laurent and Constant.

After remaining with his master for seventeen years, Louis left the Saint-Honoré district, which, between the rue du 29 Juillet and the rue de Castiglione alone, was home to the packagers Maréchal, Rousselle, and Goyard. Louis had aspirations for the future Opéra district, in which the bankers Péreire had been massively investing since 1853. Louis's intuition about the location was confirmed by Alexis Godillot, who moved there in 1855.[17] Also from Franche-Comté, Alexis was five years older than Louis, and he transferred to 25, rue de la Paix the largest store of the era: Le Bazar du Voyage, with its "travel, camping, hunting, and gymnastic equipment." Alexis, the son of a saddler, was a brilliant and influential competitor who employed more than a thousand workers in his different activities at the time. His participation in

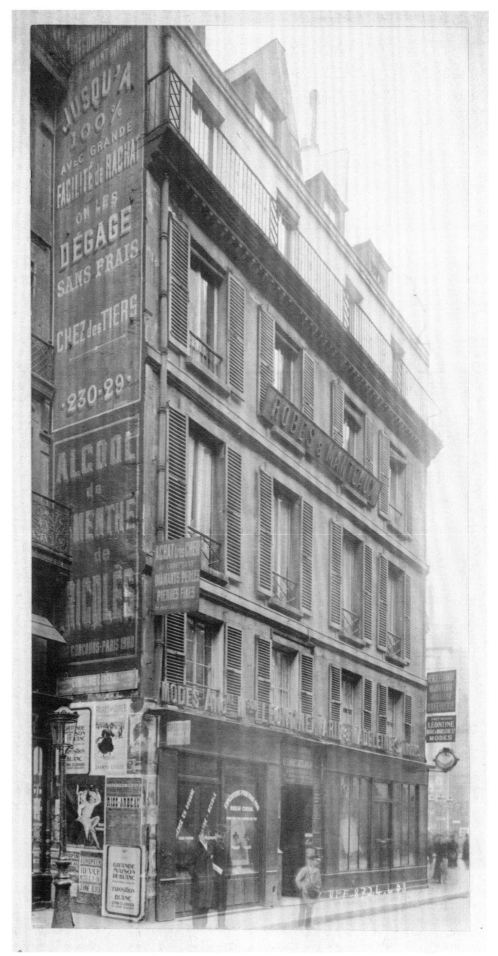

Napoleon III's electoral campaign earned him special favors, in particular a business license for public festivals.

Louis moved to 4, rue Neuve-des-Capucines (now rue des Capucines). The proximity of Place Vendôme put him close to the Hôtel du Rhin and the Hôtel du Bristol. Competition was fierce: Jean Laurent, "Packer and packager for Her Majesty the Queen of England," had a shop at no. 18 on the same street. The establishment at no. 4 was well-known: the owner, Pierre François Martin, was the packer, packager, and trunk maker for the duchesse de Berry until 1834, at which time he abandoned his first shop for premises at the present-day 233, rue Saint-Honoré, where the Morel and Goyard companies would succeed him.

The management of the building, which was auctioned at court order in 1853, was entrusted to a law clerk.[18] Within that narrow building, whose façade was only a dozen meters wide, Louis rented the smallest of the shops, the one to the left of the vestibule. Leaving behind the ancient trades of packager and trunk maker, he became known from the start under the business name "Louis Vuitton packer," the exact counterpart to his cousin "Constant Vuiton packer." Details about the site are known through the lease signed by the man who took over his business in 1868: "Shop facing said street with back shop and a cellar under the back shop."[19] After renting a furnished apartment at 32, rue Neuve-des-Mathurins, Louis and Émilie later moved to a mezzanine apartment, where Louise Élisabeth was born in 1855 and Georges in 1857. Louise Élisabeth's godfather was Laurent Vuitton; George's was his young cousin Ludovic Martial, while his godmother was Constant's wife. Over time, all of Louis's siblings had moved to Paris: Victorine married there in 1839, Colette in 1855, Claude Régis in 1858, and Rosalie died there in 1900. Their half-brother, Joseph Armand Timoléon, set up business as a joiner, while Claude Régis was employed as a constable then as a packer and packager.

EXPANSION

"At first, Louis Vuitton had to have the trunks he sold made for him,"[20] reports his first biographer, but Louis had the ambition of becoming a manufacturer himself. For that, two conditions were required. He had to own an adequate workshop and he had to create his own network of suppliers: locksmiths, curriers, leather dealers and tanners, buckle makers, manufacturers of canvas and twill, of sawn timber, rivets, and sheet metal, of tacks, cardboard, brushes, and crystal glass. In 1859, the commune of Asnières offered the conditions for carrying out that plan: Louis and Émilie purchased from their aunt and uncle, as a life estate, a piece of land there with an area of 1,080 square meters, of which they took possession on the following January 1. In exchange for a cash payment of 4,500 francs, the sale included two plots "planted with fruit trees."[21]

As the notion of recreational travel developed, Louis had a clear idea of his profession, which was undergoing enormous changes. He did not seek to expand his main shop, as Maréchal and Godillot had done; six years after starting his business, he outdistanced his competition by opening a second shop in Paris. He again chose a new district, that of the Champs-Élysées, anticipating his son, who in 1914 would open a business at 70, avenue des Champs-Élysées. At no. 65, Louis signed a lease extending from 1860 to 1875 with an annual rent of 2,600 francs for a shop and its outbuildings.[22] The avenue had no fewer than ten carriage manufacturers, six coach builders, seven horse dealers, and a carriage rental service, businesses catering to

the well-to-do classes, who were taking up the new pleasures of tourism. Four saddlers had set up business, but until then there was no packer-packager.

The factory in Asnières was devoted to the manufacture of trunks, bags, and straps. The production of boxes and crates, the reception of merchandise to be packaged, and shipments to Customs required a site near the shops. Rue du Rocher was at an equal distance from the main shop and the branch. From the ladies of the Saint Sacrement, Louis rented "a shed with three bays converted into a workshop at the far end of the courtyard," at no. 76 on that street.[23] The cramped retail shop on the rue Neuve-des-Capucines also had the advantage of a rented annex a hundred meters away, at 3, rue Saint-Arnaud (now rue Volney).

In 1865, Louis acted as witness to the marriage of a young twenty-three-year-old employee, Émile Rabec,[24] whose father lived at 4, rue Neuve-des-Capucines. Émile, who had grown up in the building, probably did his apprenticeship at the Vuitton shop and earned his employer's trust: his signature appears on invoices in place of Monsieur Vuitton's. Louis entrusted the branch to him, and in the year following the marriage, Émile's firstborn child was born at his parents' home at 65, avenue des Champs-Élysées. The names of the Rabec children attest to the young couple's attachment to the Vuitton family: their daughters were Émilie and Louise, their eldest son, Louis.

Preparations for the Universal Exposition of 1867 energized Louis, his request for admission having been approved by the Imperial Commission on June 21, 1866. Five months later, he turned to his family for a loan of 7,000 francs. Laurent Vuitton would be his creditor. Louis and Émilie mortgaged their only property, in Asnières: "a main building constructed of stone covered with slate, with a second story and attic built above the ground floor. Building for use as shed, constructed of plaster and wood, covered with tiles. Small building for use as stable with lodgings above, large shed, courtyard, and garden," a structure they declared "having built out of their own pockets without granting a license to a contractor or architect."[25]

After winning a bronze medal in Paris, Louis participated the following year in the Maritime Exposition in Le Havre. In a unique occurrence, both Louis and Frédéric Vuitton (who had moved to Le Havre after his bankruptcy in Paris) were chosen to participate and given awards: on October 26, Louis won a silver medal and Frédéric a bronze medal.

After returning from the exposition, Louis gave up his first shop when the lease expired on December 31, 1868, and made do with premises across the street, at no. 3, which he sublet. A year before the war with Prussia broke out, he sought a new location for his main shop.

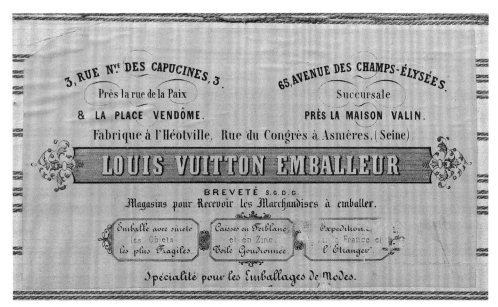

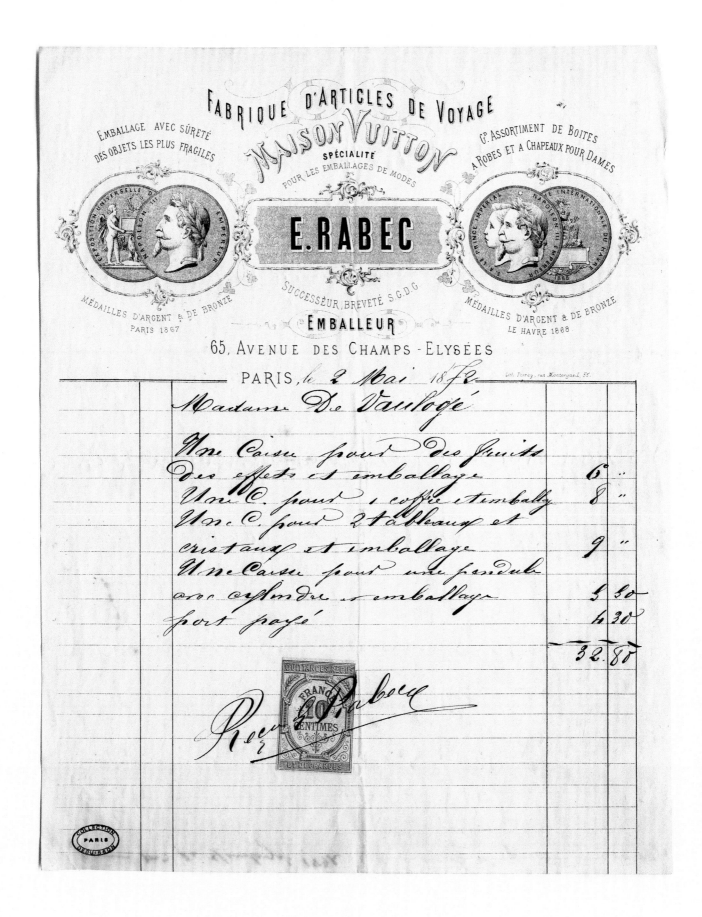

THIS PAGE

Plan of the shop on rue Scribe, appended to the lease, March 27, 1872. Archives Nationales, Paris, inv. ET/VIII/1872.

OPPOSITE PAGE, CLOCKWISE FROM LEFT

Rue Scribe daybook, Sunday, February 21, 1875. Louis Vuitton Archives.

Trunk label, Constant Vuiton, packer, 1871–1876. D'Antona Rossella Collection, Rome.

Trunk label, Louis Vuitton firm, E. Rabec successor, 1885–1895. Louis Vuitton Archives.

Louis Vuitton trunk label, 1887. Louis Vuitton Archives.

THE RUE SCRIBE

The Franco-Prussian War, followed by the Commune of 1871, caused great upheaval among the merchants: the Bazar du Voyage was ousted from the Place de l'Opéra, and Louis's younger brother Claude Régis ceased to do business as a packer. His grandson René Gimpel attested to that in a letter of August 5, 1926: "My grandfather's name was Vuitton. My mother often told me that, together with his elder brother Louis Vuitton, he had come to Paris as a young man, and both had built and sold trunks there. The Franco-Prussian War bankrupted my grandfather, because many people did not pay him, whereas he made good on his debts. He did not have the strength or the courage to start over" (*Journal d'un collectionneur*). Louis did not give up, assisted, perhaps, by the inheritance he had received from his father, who died in 1868. The factory in Asnières, which

had been used for barracks during the siege, had deteriorated and was now empty of tools and wood. The Vuittons were obliged to partially rebuild: the factory was expanded; the house, in better shape, was brightened up with a winter garden. Saving the business meant letting go of the branch, which Rabec took over. After moving to 53, avenue des Champs-Élysées, then to 62, avenue de l'Alma, Émile settled permanently at 57, avenue Marceau in 1884.[26] The new luggage labels would sport the two names "Vuitton House, E. Rabec Successor" until Émile's death on July 9, 1895.

In the wake of the unrest, Louis leased for six or eighteen years "a shop occupying the third, fourth, and fifth bays to the right of the carriage entrance, known as the Jockey Club

& having a storefront on rue Scribe of about eleven meters fifty centimeters in length," with a basement. The building, which housed the Hôtel Scribe, faced the prestigious Grand Hôtel Café de la Paix, inaugurated by Empress Eugénie in 1862. It took over the site acquired by Marie Charles in 1865. That saddler–harness maker had obtained a reduction in his rent in 1868, and Louis took advantage of the events to obtain the same price, that is, 5,000, 6,000, and 8,000 francs a year, respectively, for the three stories, for a period of six years.[27]

The shop's daily books were kept from the day he moved in, recording orders, labeling, the dimensions of the boxes, the packaging work to be done, and supplies. They give information about the different models of luggage (as

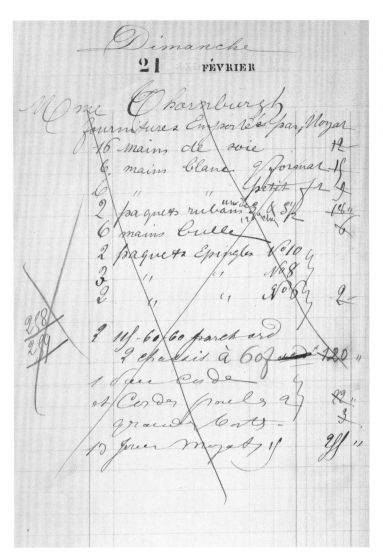

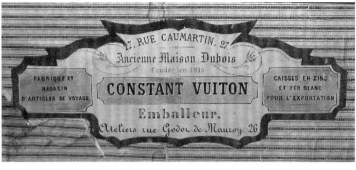

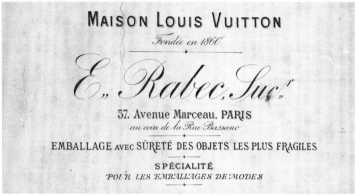

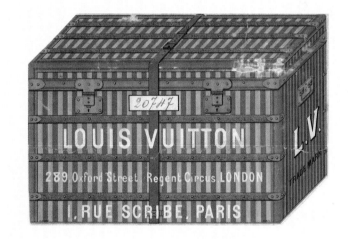

well as more unexpected items, such as dog collars and leashes, umbrellas and luggage racks) and make it possible to follow the synergy that linked Asnières to the shop, as well as the shop's autonomy, especially regarding repairs. There are few notations that inform us about the business, but the entry "November 21, 1874, have the lease on rue Saint-Arnaud registered," concerns the annex kept on the neighboring street. The use of the term "Travel Articles," which appears on luggage labels and invoices from the 1860s on, is confirmed at the time of the address change, notably in the *Annuaire-Almanach*, in the formulation "Vuitton (Louis) art of travel."

Georges, sent to Jersey to study English at the start of the insurrection in March 1871, was called back in December 1872.[28] As the only male heir, he became the designated successor at the age of fourteen.

The rue Scribe had no lodgings, and so the family was domiciled entirely in Asnières. In 1875, Louise Élisabeth married a shopkeeper from the city, who "sold hardware, plumbing supplies, metals, and household goods" at 1, rue de Paris (now rue Maurice-Bokanowski).[29] He had acquired the business the previous year. The following autumn, Georges received his notification of "conditional enlistment for one year in the 30th artillery regiment."[30] His father had arranged for his son's military service—usually performed at the age of twenty—to be moved up by two years; otherwise Georges would have been called up between 1877 and 1878, the year of the Universal Exposition. In November 1876, when Georges returned to assist his father, he was a corporal.

His return coincided with the death of Constant Vuitton, who passed away at 27, rue Caumartin, where he had resided since 1871.[31] Louis made all the funeral arrangements. The business was taken over by a cousin, Léon Constant Lombard, and Henri Isidore Billot, under the name Billot & Lombard.[32] The piece of land adjoining the workshops in Asnières, which had been acquired by Constant, was sold to Louis and Émilie. With an area of 1,050 square meters, it was "planted with fruit trees, with 1) a small pavilion 2) a small building 3) a well."[33]

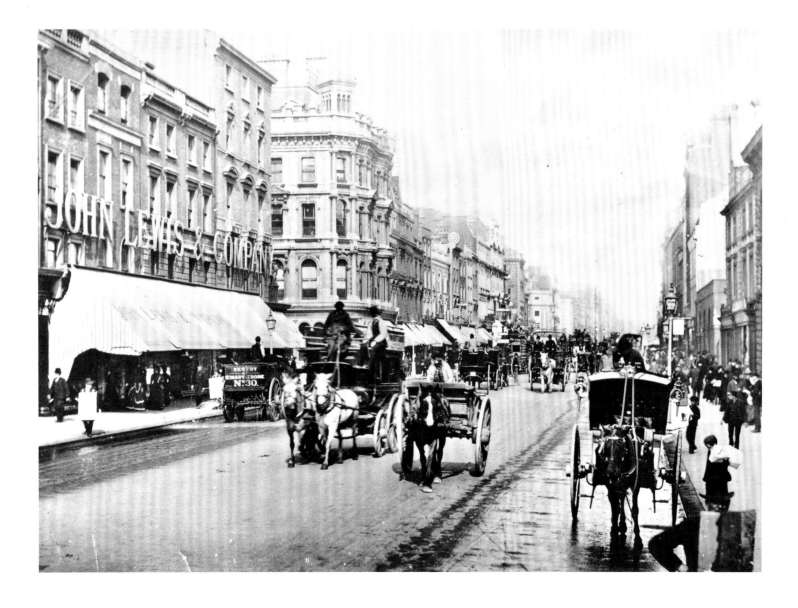

THE SUCCESSION

Georges married in 1880. The family of the betrothed happened to have some things in common with that of Émilie: Joséphine was the daughter of the late Louis Alexandre Falve Patrelle (1821–1877), a pork butcher of the Place de Clichy who became an industrialist in Romainville in 1852 thanks to his flavoring based on burnt onions, the most famous of the Patrelle products.[34] As custom dictated, the wedding was accompanied by the transmission of assets. Three days before the ceremony, Georges succeeded his parents in the rue Scribe; the sales price of 60,000 francs corresponded to the combined dowries of the future husband and wife. The inventory gives a glimpse of the shop's interior: "Three oak display cases, an oak desk, a gas heater, an oak table desk, an oak counter,

another oak counter, five workbenches, one lot of various tools & a clock."[35]

The following Saturday, the couple's union was celebrated in Les Lilas. After having served as witness for Louis and Louise Élisabeth, the nonagenarian Laurent Vuitton acted as a witness one last time for Georges. This patriarch from the Jura of such decisive influence died four years later. More unexpected was Émilie's death in 1882; she passed away at the age of forty-six, having seen her three youngest daughters die in infancy, in 1864, 1869, and 1879.

Five years after taking over the rue Scribe, Georges introduced the last changes to the company that Louis would ever see. In March 1885, he opened a branch in London, on the already very

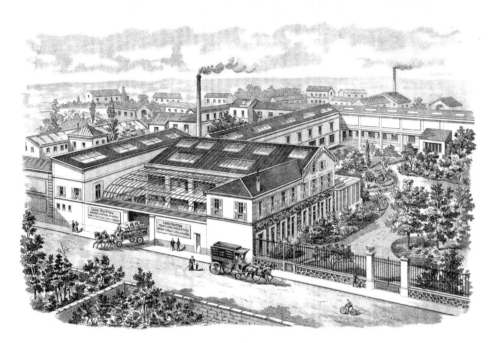

USINE LOUIS VUITTON, 18, RUE DU CONGRÈS, ASNIÈRES, (Seine)

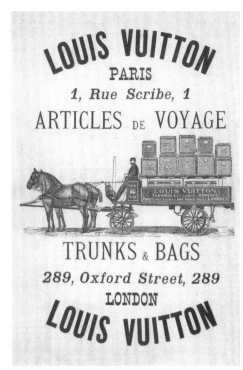

commercial Oxford Street (between Harewood Place and Regent Street, site of the large London Crystal Palace Bazaar). Beginning at that time, the in-house system for recording the numbers of goods manufactured in Asnières was modified: the "London" and "Rabec" stamps placed on orders allow us to follow meticulously the deliveries to the rue Scribe, the avenue Marceau, and Oxford Street. Proud to have obtained an award on British soil, Georges identified himself in the Post Office London Directory as "Vuitton Louis 289 Oxford Street W; only prize medal for trunks International Exhibition 1885." Like the city of Paris itself, the profession was evolving, and it underwent a name change: whereas in 1885 only seven businesses were listed under the rubric "Trunk & Portemanteau Makers," by the next year the number had swelled to 172.

Furthermore, Georges consolidated the Asnières property: in addition to the plot adjoining the workshops, which he had purchased from his father and mother in 1882, he obtained a lease on workshops near his co-heirs.[36] These precautions give an indication of the troubles his sister was facing. Accused of misconduct, she had returned to her family to live, before obtaining a divorce in her favor on the grounds of unsubstantiated "serious offense."[37]

Finally, a contingency fund for the Louis Vuitton workshops was set up for forty-two share-holders, including four women. Louis and Georges were, respectively, its honorary chairman and chairman.[38]

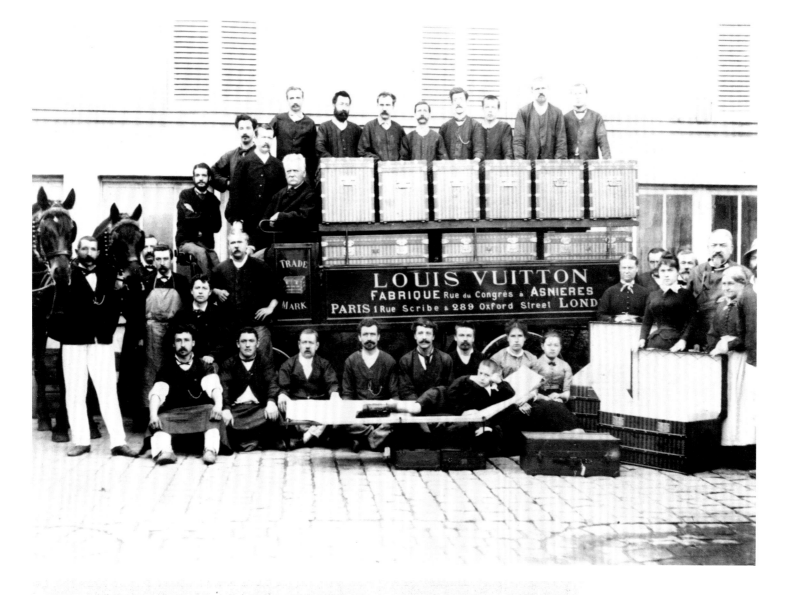

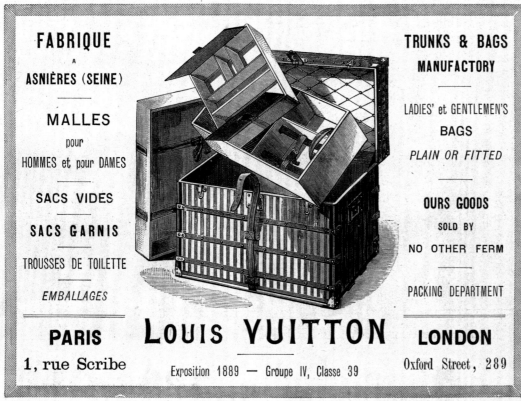

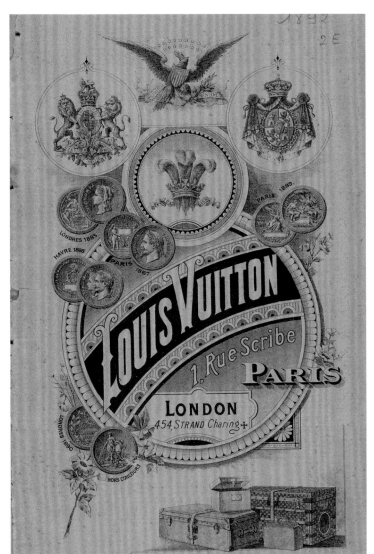

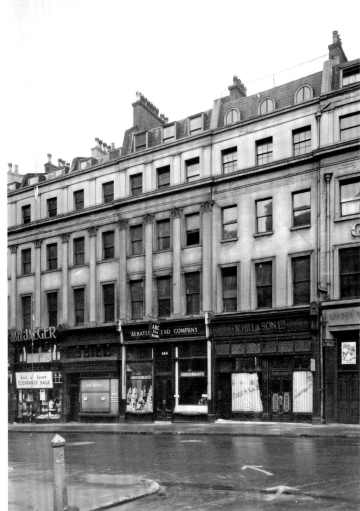

OPPOSITE PAGE, TOP TO BOTTOM

Louis, Georges, and Gaston-Louis Vuitton and workshop employees, c. 1888. Louis Vuitton Archives.

Louis Vuitton advertisement, published during the Universal Exposition of Paris, *Panorama Le Tout-Paris*, 1889. Louis Vuitton Archives.

THIS PAGE, LEFT TO RIGHT

The Louis Vuitton commercial catalog, 1892. Louis Vuitton Archives.

The building at 454 Strand in London, c. 1930. National Archives UK, Kew, inv. CRES 43/259.

THE TESTAMENT

In 1887 Louis participated in the International Maritime Exposition in Le Havre; two years later, he was awarded the gold medal at the last Universal Exposition of the century held in Paris.

The London shop moved to 454 Strand Street, near Charing Cross Station, in the building of the Golden Cross Hotel, and, in January 1892, Louis completed work on his first business catalog, which he printed in English. The forty-four pages of the booklet retrace the long way he had come from being a packer in 1854 to becoming a manufacturer of travel goods.

He died on Saturday, February 27, 1892. In the nearby workshops, the last in-house number affixed on a product that afternoon was 37932.[39] The funeral took place the following Monday and was reported in the *Journal d'Asnières* of March 6, which underscored Louis Vuitton's impressive career: "He built his enterprise in the middle of nowhere [the then rural Asnières] now it is known everywhere."

THE FAMILY CONSTELLATION OF LOUIS VUITTON

GENEALOGICAL RESEARCH BY DELPHINE SAURAT,
WITH THE ASSISTANCE OF BERNARD OGLIASTRO, GRANDSON
OF GASTON-LOUIS VUITTON

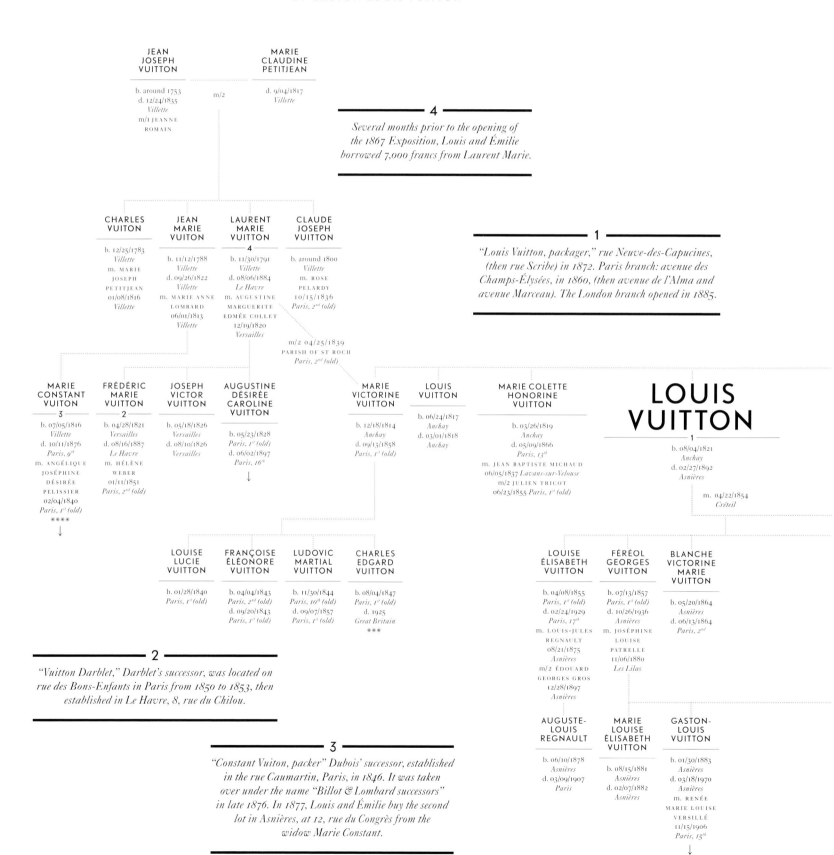

JEAN JOSEPH VUITTON
b. around 1753
d. 12/24/1835
Villette
m/1 JEANNE ROMAIN

m/2

MARIE CLAUDINE PETITJEAN
d. 9/04/1817
Villette

— **4** —

Several months prior to the opening of the 1867 Exposition, Louis and Émilie borrowed 7,000 francs from Laurent Marie.

CHARLES VUITTON
b. 12/25/1783
Villette
m. MARIE JOSEPH PETITJEAN
01/08/1816
Villette

JEAN MARIE VUITTON
b. 11/12/1788
Villette
d. 09/26/1822
Villette
m. MARIE ANNE LOMBARD
06/01/1813
Villette

LAURENT MARIE VUITTON
— 4 —
b. 11/30/1791
Villette
d. 08/06/1884
Le Havre
m. AUGUSTINE MARGUERITE EDMÉE COLLET
12/19/1820
Versailles

CLAUDE JOSEPH VUITTON
b. around 1800
Villette
m. ROSE PELARDY
10/15/1836
Paris, 2nd (old)

— **1** —

"Louis Vuitton, packager," rue Neuve-des-Capucines, (then rue Scribe) in 1872. Paris branch: avenue des Champs-Élysées, in 1860, (then avenue de l'Alma and avenue Marceau). The London branch opened in 1885.

m/2 04/25/1839
PARISH OF ST ROCH
Paris, 2nd (old)

MARIE CONSTANT VUITTON
— 3 —
b. 07/05/1816
Villette
d. 10/11/1876
Paris, 9th
m. ANGÉLIQUE JOSÉPHINE DÉSIRÉE PELISSIER
02/04/1840
Paris, 1st (old)

FRÉDÉRIC MARIE VUITTON
— 2 —
b. 04/28/1821
Versailles
d. 08/16/1887
Le Havre
m. HÉLÈNE WEBER
01/11/1851
Paris, 2nd (old)

JOSEPH VICTOR VUITTON
b. 05/18/1826
Versailles
d. 08/10/1826
Versailles

AUGUSTINE DÉSIRÉE CAROLINE VUITTON
b. 05/23/1828
Paris, 1st (old)
d. 06/02/1897
Paris, 16th
↓

MARIE VICTORINE VUITTON
b. 12/18/1814
Anchay
d. 09/13/1858
Paris, 1st (old)

LOUIS VUITTON
b. 06/24/1817
Anchay
d. 03/01/1818
Anchay

MARIE COLETTE HONORINE VUITTON
b. 03/26/1819
Anchay
d. 05/09/1866
Paris, 13th
m. JEAN BAPTISTE MICHAUD
06/05/1837 *Lavans-sur-Velouse*
m/2 JULIEN TRICOT
06/23/1855 *Paris, 1st (old)*

LOUIS VUITTON
— 1 —
b. 08/04/1821
Anchay
d. 02/27/1892
Asnières

m. 04/22/1854
Créteil

LOUISE LUCIE VUITTON
b. 01/28/1840
Paris, 1st (old)

FRANÇOISE ÉLÉONORE VUITTON
b. 04/04/1843
Paris, 2nd (old)
d. 09/20/1843
Paris, 1st (old)

LUDOVIC MARTIAL VUITTON
b. 11/30/1844
Paris, 10th (old)
d. 09/07/1857
Paris, 1st (old)

CHARLES EDGARD VUITTON
b. 08/04/1847
Paris, 1st (old)
d. 1925
Great Britain

LOUISE ÉLISABETH VUITTON
b. 04/08/1855
Paris, 1st (old)
d. 02/24/1929
Paris, 17th
m. LOUIS-JULES REGNAULT
08/21/1875
Asnières
m/2 ÉDOUARD GEORGES GROS
12/28/1897
Asnières

FÉRÉOL GEORGES VUITTON
b. 07/13/1857
Paris, 1st (old)
d. 10/26/1936
Asnières
m. JOSÉPHINE LOUISE PATRELLE
11/06/1880
Les Lilas

BLANCHE VICTORINE MARIE VUITTON
b. 05/20/1864
Asnières
d. 06/13/1864
Paris, 2nd

— **2** —

"Vuitton Darblet," Darblet's successor, was located on rue des Bons-Enfants in Paris from 1850 to 1853, then established in Le Havre, 8, rue du Chilou.

— **3** —

"Constant Vuiton, packer" Dubois' successor, established in the rue Caumartin, Paris, in 1846. It was taken over under the name "Billot & Lombard successors" in late 1876. In 1877, Louis and Émilie buy the second lot in Asnières, at 12, rue du Congrès from the widow Marie Constant.

AUGUSTE-LOUIS REGNAULT
b. 06/10/1878
Asnières
d. 03/09/1907
Paris

MARIE LOUISE ÉLISABETH VUITTON
b. 08/15/1881
Asnières
d. 02/07/1882
Asnières

GASTON-LOUIS VUITTON
b. 01/30/1883
Asnières
d. 03/18/1970
Asnières
m. RENÉE MARIE LOUISE VERSILLÉ
11/15/1906
Paris, 15th
↓

* Eleven children were born of their marriage: Angélique (b. 01/01/1783 d. 01/02/1784), Marie Reine (b. 03/26/1785 d. 10/14/1814), Angélique (b. 01/10/1788 d. 05/24/1850), Marie Rose (b. 05/14/1790), François Xavier, Marie (b. 04/18/1795), Claude Joseph (b. 12/31/1796 d. 04/18/1861), Marie Virginie (b. 10/12/1800), Jeanne Baptiste (b. 04/28/1803), Marie Rosalie (b. 05/03/1805 d. 02/28/1833), Cézard (b. 09/05/1807 d. 01/18/1831)

** Twelve children were born of their marriage.

*** Information on his family tree provided by Gaston-Louis Vuitton.

**** Of their five children, two were heirs: Joseph Constant (b. 12/15/1846 d. 02/05/1886) and Adèle Amélie Marthe (b. 05/15/1852 d. 11/29/1899)

Municipal sources: Paris archives, town halls of the 8th, 9th, 15th, 17th arrondissements of Paris, archives of Boulogne-Billancourt, Les Lilas, and Neuilly-sur-Seine

Departmental sources: Chaux-Neuve, dept. archives of the Doubs; Asnières, dept. archives of the Hauts-de-Seine; Anchay, Coisa, Cornod, Lons-le-Saunier, Saint-Hymetière, Villette, dept. archives of the Jura; Le Havre, dept. archives of Seine-Maritime; Créteil, dept. archives of the Val-de-Marne; Urville, Vrécourt, dept. archives of the Vosges; Versailles, dept. archives of the Yvelines

National and international sources: Sidi-Bel-Abbès, Archives Nationales d'Outre-Mer; London, England, General Register Office

CLAUDE VUITTON
b. 09/10/1758 *Anchay*
d. 11/20/1807 *Anchay*

m. 02/01/1780 *Coisia* *

LUCE GOIVANNIER
b. 12/11/1765 *Coisia*
d. 08/10/1834 *Cornod*

— 5 —

In 1859, Louis and Émilie buy the first lot in Asnières from their uncle and aunt (life annuity).

FRANÇOIS GASPARD VAUMEREL
b. 06/13/1771 *Paris*
d. 11/14/1847 *Vrécourt*
m/2 MARGUERITE MARIE ROY 11/18/1812 *Urville*

m. 09/20/1798 *Vrécourt* **

MARIE CATHERINE VERLOT
b. 11/23/1777 *Vrécourt*
d. 08/05/1812 *Vrécourt*

MARIE CORONNÉE GAILLARD
b. 04/02/1793 *Vouglans*
d. 02/16/1831 *Anchay*

m. 05/14/1813 *Anchay*

FRANÇOIS XAVIER VUITTON
b. 02/17/1793 *Anchay*
d. 11/24/1868 *Cornod*

m/2 01/16/1832 *Cornod*

MARIE CORONNÉE ROCHET
b. 09/11/1803 *Cornod*
d. 02/13/1873 *Cornod*

NICOLAS FÉRÉOL PARRIAUX
b. 10/11/1798 *Chaux-Neuve*
d. 03/08/1852 *Créteil*

m. 02/16/1826 *Paris*

ÉLISABETH CATHERINE VAUMEREL
b. 06/12/1799 *Vrécourt*
d. 04/23/1873 *Créteil*

MARGUERITE VAUMEREL
— 5 —
b. 12/31/1802 *Vrécourt*
d. 12/28/1860 *Paris, 19th*
m. FRANÇOIS GUISLAIN LENGLET 08/26/1824 *Paris, 3rd (old)*
m/2 MICHEL JÉRÔME CHALIMBAUX 04/02/1853 *Montmartre*

MARIE ROSALIE VUITTON
b. 02/01/1824 *Anchay*
d. 09/19/1900 *Paris, 1st*
m. JOSEPH BUISSON

CLAUDE RÉGIS VUITTON
b. 03/27/1827 *Anchay*
d. 12/11/1902 *Saint-Hymetière*
m. MARIE ELIZA ADÈLE EMMONET 02/13/1858 *Paris, 12th (old)*

JEAN LOUIS VUITTON
b. 10/22/1832 *Cornod*
d. 09/19/1834 *Cornod*

ÉLIE ARTHUR VUITTON
b. 02/19/1834 *Cornod*
d. 07/17/1834 *Cornod*

ZÉNON VUITTON
b. 08/20/1835 *Cornod*
d. 04/17/1836 *Cornod*

JOSEPH ARMAND TIMOLÉON VUITTON
b. 08/20/1837 *Anchay*
d. 04/10/1910 *Lons-le-Saunier*

ROSE ÉSTHER SUZANNE PARRIAUX
b. 05/05/1827 *Paris, 8th (old)*

EUGÈNE ALEXANDRE PARRIAUX
b. 03/20/1830 *Paris, 8th (old)*

CHARLOTTE ÉSTHER PARRIAUX
b. 08/16/1832 *Paris, 8th (old)*
d. 02/11/1909 *Asnières*
m. THOMAS ALFRED GAIN 04/26/1851 *Paris, 8th (old)*

CLÉMENCE ÉMILIE PARRIAUX
b. 06/26/1836 *Paris, 8th (old)*
d. 11/06/1882 *Asnières*

ALPHONSE ALÉON PARRIAUX
b. 12/15/1837 *Paris, 8th (old)*
m. MARIE HENRIETTE JOSÉPHINE VAILLIER 01/27/1880 *Paris, 11th* ↓

BLANCHE AMÉLIE VUITTON
b. 06/01/1869 *Paris, 1st*
d. 06/18/1869 *Asnières*

ÉMILIE ÉLISABETH VUITTON
b. 08/25/1874 *Asnières*
d. 01/09/1979 *Asnières*

MARIE-JUSTINE BUISSON
b. 06/07/1855 *Sidi-Bel-Abbès (Algeria)*
d. 1940-1945
m. ABRAHAM WILLIAM GARCIAS 05/12/1900 *Boulogne-Billancourt*

ÉMILIE HÉLOÏSE VUITTON
b. 03/06/1858 *Cornod*
d. 04/18/1929 *Paris, 17th*

CONSTANCE LOUISE VUITTON
b. 02/17/1859 *Paris, 2nd (old)*
d. 07/04/1933 *Neuilly-sur-Seine*
m. CHARLES PHILIPPE FÉLIX DELACQUIS 04/11/1885 *Asnières*

CAROLINE JEANNE VUITTON
b. 01/09/1861 *Paris, 17th*

CLARISSE ADÈLE VUITTON
b. 01/14/1862 *Paris, 17th*
d. 11/26/1915 *Paris, 8th*
m. ERNEST NATHAN GIMPEL 04/11/1889 *Asnières*

TIMOLÉON VUITTON
b. 04/10/1882 *Paris, 7th*
d. 02/29/1884 *Paris, 14th*

MARIE VUITTON
b. 07/18/1885 *Paris, 15th*

LÉONTINE VUITTON
b. 07/18/1885 *Paris, 15th*
d. 10/26/1886 *Paris, 15th*

BERTHE VUITTON
b. 03/08/1888 *Paris, 15th*
d. 04/11/1973 *Lamballe*

PIERRE EUGÈNE VUITTON
b. 06/20/1889 *Asnières*
d. 09/28/1917 *Billy-le-Grand*

JEAN ARMAND VUITTON
b. 06/20/1889 *Asnières*
d. 09/22/1909 *Asnières*

MARCEL ACHILLE VUITTON
b. 06/12/1892 *Asnières*
d. 03/20/1893 *Asnières*

JOSEPH WILLIAM GARCIAS
b. 01/14/1875 *Paris, 8th*
d. 04/01/1963 *Paris, 15th*
m. EVA LUCIE RÉBECCA MOLINA 06/21/1900 *Bordeaux*
m/2 EMMA CHAUDEZ 11/09/1908 *Paris, 17th* ↓

MARTHE ÉMILIE DELACQUIS
b. 12/18/1885 *Paris, 9th*
d. 12/15/1971 *Randan*
m. HENRI EUGÈNE LEMONNIER 10/03/1908 *Paris, 8th*

RENÉ ALBERT GIMPEL
b. 10/04/1881 *Paris, 11th*
d. 01/03/1945 *Neuengamme (Germany)*
m. FLORENCE DUVEEN 11/25/1912 *London, Paddington (Great Britain)* ↓

DISTRIBUTION AND PROTECTION

THE RELATIONSHIP BETWEEN EXHIBITIONS AND PATENTS

By

DELPHINE SAURAT

For nearly four decades Louis Vuitton established his signature through national and international exhibitions. The patents, registered trademarks, patterns and models that he filed on these occasions made it clear what he claimed as his own and high-lighted his best products.

All the patents filed during this period were qualified "s.g.d.g." (*Sans Garantie Du Gouvernement*; without government guarantee). The filing was limited to the application and involved no verification, nor did it guarantee the priority or legitimacy of the procedure. Starting in 1887 most of the patents were filed by his only son, Georges, who always called upon the services of an engineering consultant. Two Vuitton patents prior to 1892 were formulated without the intermediary of representatives: the descriptions, signed by Louis, record his wording and bear witness to his invention. He mentions the professional stakes involved, his difficulties, and his ideas. They are dated 1867 and 1891 and are all the more valuable and significant as they limit his activity from packing trunks to aluminum trunks.

Louis was issued his first exhibitor's card in 1867, at a key period when traveling articles were grouped into a class of their own. This new section included a large variety of accessories intended both for tourists and explorers, and it was geared to the needs of the garden as well as to those of train travel and seaside vacations: comfortable foot heaters, folding chairs and tables, all kinds of trunks, picnic baskets, basket trunks boxes, tents, parasols, hammocks, and rainproof cloth-ing. Louis, a newcomer to the exhibitions, filed his first patent and presented improved trunks for travel and for fashions in his two-meter-long showcase. In this way he promoted his activity as both manufacturer

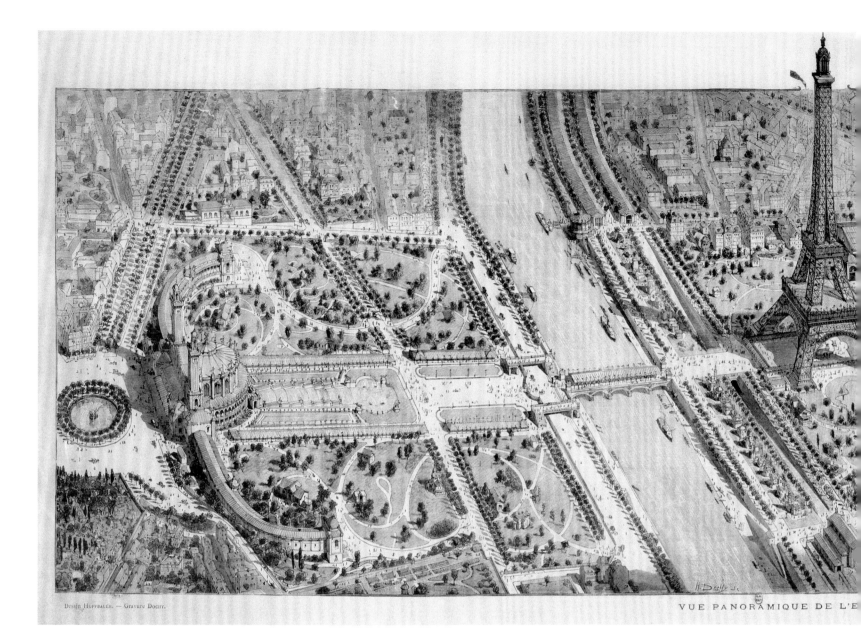

Dessin Hoffbauer. — Gravure Dochy.

VUE PANORAMIQUE DE L'E

PREVIOUS SPREAD

Awards ceremony, with the imperial couple in attendance, Universal Exposition of Paris, Palais des Industries, July 1, 1867.

THIS SPREAD

Panoramic view of the installations at the Universal Exposition of Paris, Neudrein Frères, 1889. Bibliothèque Nationale de France, Paris.

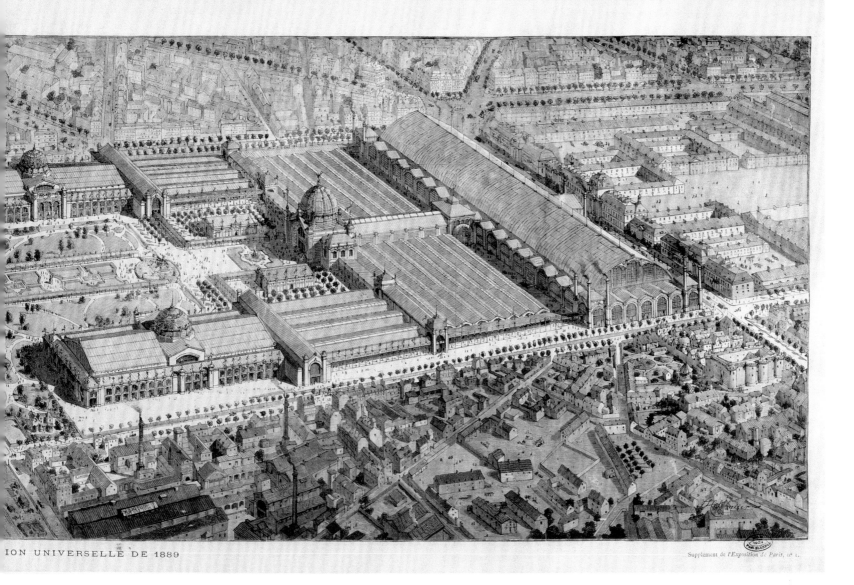

ION UNIVERSELLE DE 1889

Supplément de l'Exposition de Paris, n° 1.

and packer, which he underscored in the slogan "Specialized in packing for fashions" that decorated the letterhead of his invoices.

In 1889, on the occasion of his second participation in a universal exposition, Louis was no longer a mere exhibitor but was elected by his peers to sit on the installation committee for travel and camping accessories, participating for the first time in the meeting of June 20, 1888. The house was well prepared and many patents were filed: two inventions, a trademark, and three patterns and models were submitted between 1888 and 1889. They speak for the equal attention that

Vuitton gave to communication, technology, and the protection of the new Cannage and Damier canvases. The stand measured four by five meters. Louis, then sixty-eight years old, obtained the highest prize awarded for travel articles: a gold medal—a consecration. The exhibition report declared: "Behind the glass front of a showcase of monumental aspect is a display of the magnificent leather goods of the Louis Vuitton house."

As far as opportunities for visibility were concerned, Louis gave preference to the shows in France, with the exception of two events in London: the International

Inventions Exhibition of 1885 (where he won a silver medal) and the Exposition Française in London of 1890 (not in competition). The organization of this last event reveals the new status that he had acquired: in the year following the 1889 exhibition, "Mr. Vuitton" was nominated to sit on the jury, replacing his main competitors from the Bazar du Voyage, Alexis Godillot and his successor Alphonse Wilhelm Walcker, who had occupied this important position before him. The last Parisian Universal Exhibition of the century opened for him the doors to this exclusive world, a privilege that the aging founder passed on as a legacy to his descendants.

68

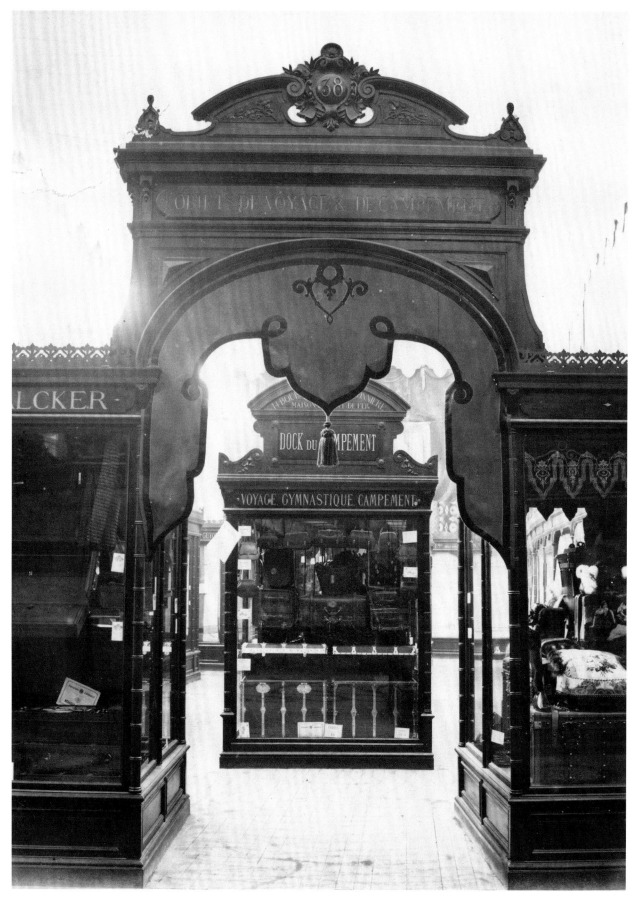

THIS PAGE

Entry gate to Travel and Camping Items, Universal
Exposition of Paris, 1867. Archives Nationales,
Paris, inv. F 12 3237.

OPPOSITE PAGE, LEFT TO RIGHT

Photograph, patent no. 74 557, March 23, 1867.
Institut National de la Propriété Industrielle, Paris.

Louis Vuitton's application for admission to the
Universal Exposition of 1867. Archives Nationales,
Paris, inv. F 12 3049.

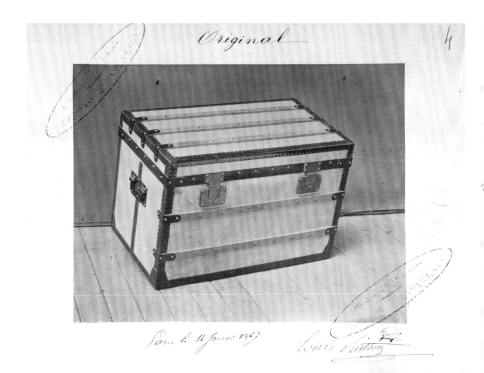

UNIVERSAL EXPOSITION

1867

LOCATION Paris
DATES April 1–November 3, 1867
NUMBER OF EXHIBITORS 52,200
NUMBER OF VISITORS Between 11 million and 15 million

—

With forty-one countries represented, this second Universal Exposition held in Paris was much larger than the London exhibitions of 1851 (14,000 exhibitors and 6 million visitors) and 1862, or the one in Paris in 1855 (23,954 exhibitors and more than 5 million visitors). The imperial decree that instituted it on June 22, 1863, explicitly intended it to be "more completely universal than all of its predecessors."

—

LISTING IN THE CATALOG *"Vuitton (Louis), à Paris, rue Neuve-des-Capucines, 4 — Malles de voyage"*
GROUP IV *Clothing and other personal accessories*
CLASS 38 *Travel and camping articles*
PLACE *Elliptical Palace on the Champ de Mars, Gallery IV*
AWARD *Bronze medal*

PATENT (S.G.D.G.)

JANUARY 18, 1867
NO. 74,557, *valid for fifteen years*
For a "packing and travel trunk"
APPLICANT *Mr. Vuitton (Louis)*

DESCRIPTION: "The manufacturing of travel articles in general and of trunks in particular has developed in considerable proportion of late and until now there have been very few improvements worth speaking of. For a trunk to be useful indeed, it should be light yet resistant; its contents need to be protected from shocks and above all from the effects of water. This last property is the most difficult to obtain. However well fit the parts of a trunk may be,

water can always penetrate the lid when the trunk is to be closed, owing to rain or because the baggages on board ships can take on seawater.

I have devised a trunk that is entirely free of these serious disadvantages. Here is how I make it: I use very dry wood, on the outside faces I apply sheets of metal, zinc, or copper, or oil-coated canvas to cover the corners, and in order to keep water from penetrating, I put a natural rubber rim all around the groove that frames the lid. This groove is made of a thin strip of metal or canvas on the inside, and one on the outside of the lid, thus creating a groove that is deep enough

to let me to place said rim between the two metal strips forming the groove, and when the lid is closed, it fits in place at the bottom.

Supposing that the wood of the body of the trunk or of the lid warps, this pipe-shaped lip fills the space with its natural pliability and keeps water from entering. In this way, I have kept some trunks completely immersed in water for eight days with the interior remaining completely intact.
I would like to adapt this rubber or canvas groove system to all of my trunks generally.
Sheets of metal as thin as possible applied to the wood can be very effective, and they are

protected by hardwood slats that are attached with rivets along their entire length and consolidated at the ends by metal brackets—steel, copper, or malleable cast iron—as the photograph shows. The locks for my trunks have been improved in a way that I include in my patent, so as to avoid cutting into the wood, which is a serious drawback, since very often the cut for the lock makes a square-shaped hole. The lock that I use consists of a closed unit and is simply attached with rivets. I protect the body of the lock with the projecting slats, which add that much more elegance to my trunk. Paris, 14 January 1867, Louis Vuitton."

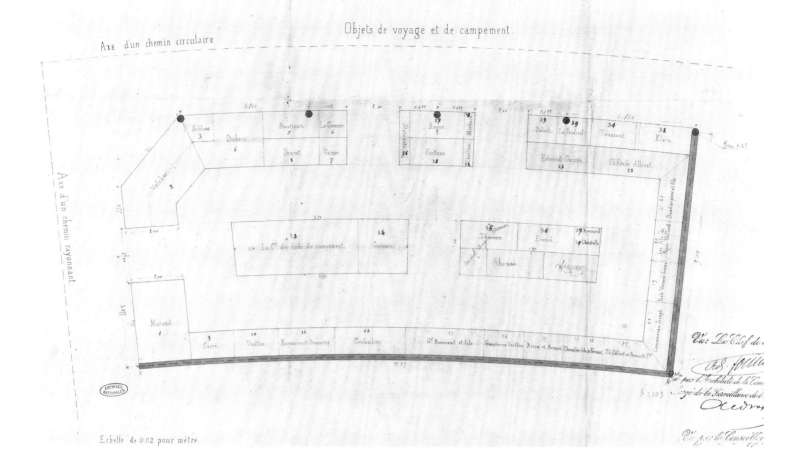

INTERNATIONAL MARITIME EXHIBITION

1868

LOCATION Le Havre
DATES June 1–October 31, 1868
NUMBER OF EXHIBITORS More than 5,000

—

The first Maritime Exhibition, which, in the words of the official catalog, was "to immediately follow the one in Paris and be, so to speak, its competent." It is devoted to seafaring, "as well as to the arts and industries that supply seafaring with services and furnishings." This event was all the more outstanding because it was the largest exhibition organized in the provinces.

—

LISTING IN THE CATALOG *Louis Vuitton does not appear in the official catalog published in May 1868. This might have been due to an error on the publisher's part or to the assignment of a stand too late to be included in the publication.*
GROUP 11 *Seafaring and export*
CLASS 10 *Travel and packing articles, weapons*
AWARD *Silver medal for "Article d'emballage, bonne confection. Well-made packing cases"*

THIS PAGE
Site of category 38 at the Universal Exposition of
Paris, 1867. Archives Nationales, Paris, inv. F 12 3049.

OPPOSITE PAGE
Samples of striped canvas and their storage box,
designs and models, no. 8239, July 24, 1877.
Archives de Paris, inv. D6U10 595.

PATTERNS AND MODELS

JULY 24, 1877, *Conseil des Prud'hommes de Paris, Industrie des Tissus*
NO. 8,239, *property in perpetuity (expired in 1960)*
For a "flat square box, tied with gray string folded diagonally and sealed with two red wax seals bearing the initials L.V. which he declares to contain four drawings of canvas designs."
APPLICANT: *Mr. Vuitton (Louis)*

UNIVERSAL EXPOSITION

1878

LOCATION Paris

—

As Louis Vuitton prepared for the 1878 exposition, the patents for designs and models that he filed show what needed to be protected at the time: his striped canvas. In July 1877, as applicant, he signed and sealed a box containing four samples of canvas at a time when his participation in the upcoming Universal Exposition had still not been decided.

Travel and camping articles were grouped in Class 41 of this third Universal Exposition held in Paris. The deadline to apply for a stand was January 15, 1877. The list of exhibitors fluctuated, with fifteen withdrawals being recorded at the Installation Committee's meeting of November 5, 1877, and three provisional admissions (names unspecified) approved at the following meeting on November 28, but there is no mention of the firm in the rue Scribe in the records.

It is not known what was lacking for him to complete the procedure: support (although one of his chief competitors, Alphonse Wilhelm Walcker, director of the Bazar du Voyage, sat on the Installation Committee for the class) or financial means (the patent was filed ten days after the purchase of the second lot in Asnières. Financial difficulties due to the War of 1870 and the Commune of 1871 were unavoidable: in 1876, he still had not been able to reimburse the loan made by Laurent Marie Vuitton and was given an extension until 1881).

The patent for the striped cloth filed nine months before the inauguration of the exposition does not mark the beginning of the use of this design as covering; already in 1874, the mention "striped" appears in a correction in the daybook of the rue Scribe and became a standard material in the following year. In his 1914 commercial catalog, Georges Vuitton attributed the creation of the canvas in 1872.

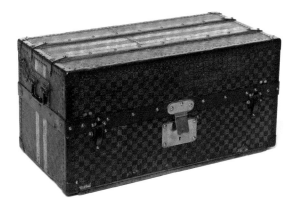
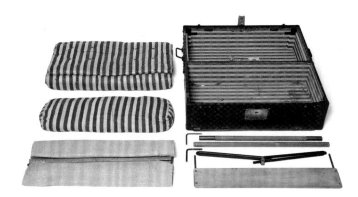

INTERNATIONAL MARITIME EXHIBITION

1887

LOCATION Le Havre
DATES May 1–September 30, 1887
—

This second Maritime Exhibition confirmed the preeminence of the port of Le Havre at a time when the North Atlantic could be crossed in six days. When a train terminal was built directly on the pier for the steamers, the newspapers proudly claimed that "it is through Le Havre that the United States come into France. The great seaway of the steamers, busier than a country road."
(*Le temps*, September 24, 1887)

PATENT (S.G.D.G.)

JANUARY 17, 1885
NO. 166,496, *valid for fifteen years*
For "a type of trunk with hermetic closure"
APPLICANT *Mr. Vuitton (Georges),*
represented by Mr. Chassevent
Published in the *Bulletin Officiel de la propriété industrielle et commerciale*, 1885, vol. 1

PATENT (S.G.D.G.)

JANUARY 19, 1885
NO. 166,513, *valid for fifteen years*
For "a tin-trunk system with folding camp bed"
APPLICANT *Mr. Vuitton (Georges), represented by Mr. Chassevent*
Published in the *Bulletin Officiel de la propriété industrielle et commerciale*, 1885, vol. 1

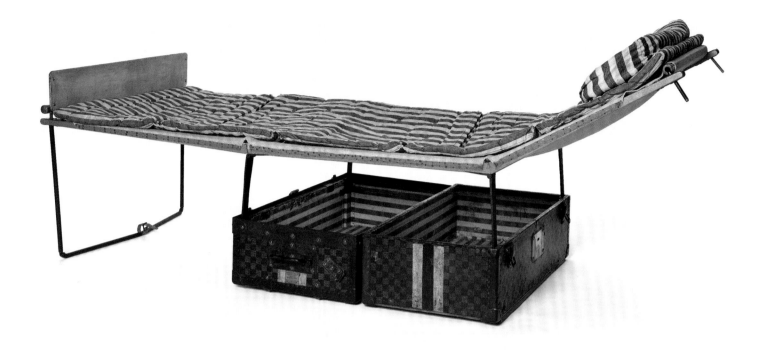

OPPOSITE PAGE TOP, AND THIS PAGE

Bed trunk in Damier canvas with yellow stripes, 1891. Les Arts Décoratifs, gift of Gaston-Louis Vuitton, 1989, inv. 987.53.

OPPOSITE PAGE, BOTTOM

Drawing, patent no. 166 496, January 17, 1885. Institut National de la Propriété Industrielle, Paris.

Drawing, patent no. 166 513, January 19, 1885. Institut National de la Propriété Industrielle, Paris.

LISTING IN THE CATALOG *"VUITTON (Louis) manufactory, 18, r. du Congrès (Asnières); store, 1, rue Scribe, Paris. Camp beds and special trunks for the colonies and long ocean crossings, safe from humidity and insects. Store in London, 289, Oxford Street W."*
CLASS 16 *Exhibition in the colonies*
GROUP 4 *Textile industry, semi-manufactured materials. Furnishings, clothing, finery, household articles*
LOCATION *Palais des Expositions, at the West Gate entrance*

—

ARTICLE BY E. DELIO, "THE EXHIBITION OF MR. LOUIS VUITTON," IN THE WEEKLY *Havre-exposition*, JUNE 25, 1887: "A visitor entering the exhibition by the gate at the quai d'Orléans cannot help noticing to the left of the clock a sybaritic traveler lounging on a camp bed with immaculate sheets. This camp bed can be folded into a portable trunk while leaving room to spare for many other objects. For tourists who subscribe to the type of peregrinations advocated by Jean-Jacques, nothing could be more practical than this trunk thanks to which one can avoid fraudulent innkeepers in civilized countries and doze at leisure in lands which Providence has not yet graced with auberges.

...The zinc trunks with hermetic closure have already been appreciated by many of our explorers, most of whom have adopted it, since it alone responds to the demands of their ventures. As for the trunks intended for the great travelers in Europe and Africa, they do not look like their precursors—the inconvenient hatboxes and long and narrow trunks of thirty years ago—any more than a steam engine looks like an *aeolypile*. See Mr. Vuitton's articles and compare.

Let us remark in closing that Mr. Vuitton submitted to the Exhibition only the trunks, bags, suitcases, etc. of current manufacture that can already be purchased in his stores in Paris and London. Competitor firms were able to submit to the judgment of connoisseurs and the public products especially destined to honor them; the merchandise of the establishment in the rue Scribe is of exactly the same quality as that of the samples on display."

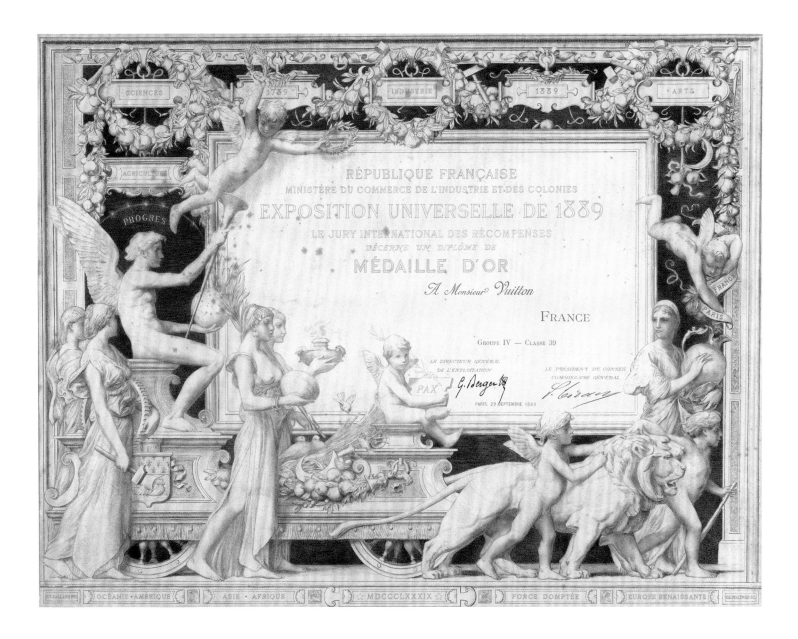

UNIVERSAL EXPOSITION

1889

LOCATION Paris
DATES May 5–October 31, 1889
NUMBER OF EXHIBITORS 61,722
NUMBER OF VISITORS 32 million

—

The program of the fourth Universal Exposition coincided with the first centennial of the French Revolution. In spite of the polemics that crystallized around the construction of the Eiffel Tower and the displeasure of monarchic countries at the revolutionary celebration, this was the best-visited exposition of the nineteenth century.

Louis contributed two handbags with the inscription "Gift of Mr. Vuitton" to the national lottery, which financed the event; these were the lot numbers 3,611 and 3,613 of the drawing that began on January 27, 1890.

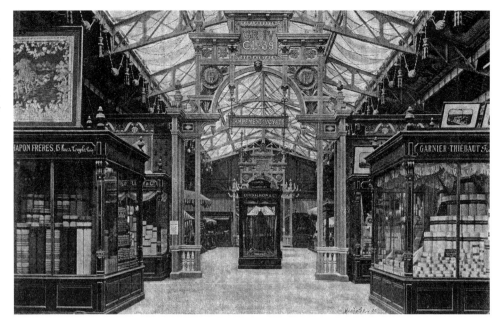

Fabrics area and entry gate for Travel and Camping Items, Universal Exposition of Paris, *Livre d'or de l'Exposition*, 1889. Bibliothèque des Arts Décoratifs, Paris.

LISTING IN THE CATALOG *"VUITTON (Louis) in Paris, rue Scribe, 1—Trunks, travel bags, camp beds. The Louis Vuitton house exhibits only current articles that can be bought at the stores in Paris and in London. None of the articles made by Louis Vuitton are sold on the open market. To be bought only at Paris, 1, rue Scribe; at London, 289, Oxford Street."*
GROUP IV *Fabrics, clothing, and accessories*
CLASS 39 *Travel and camping articles*
LOCATION *Champs de Mars, Palais des Industries, fifth aisle*
AWARD *Gold medal*

—

CITATION IN THE
RAPPORT DU JURY INTERNATIONAL
WRITTEN BY ALPHONSE SCRIBER

"In this showcase we found a superb selection of leather articles conscientiously made and perfectly finished in all respects. We were able to note the scrupulous care with which even the smallest details were executed. Mr. Vuitton also produces the wooden trunk, and his models of this type are just as well-made and as well-cared-for as his leather products. We also noted a camp bed that could be entirely dismantled and stored in a small trunk."

PATTERNS AND MODELS

JULY 2, 1888, *Conseil des Prud'hommes de Paris, Industrie des tissus*
NO. 12,946, *property in perpetuity [expired in 1960]*
For *"a square flat box tied with a wine-colored red braid folded diagonally, sealed by six red wax seals without perforated initials which he declared contained three designs for fabrics used for travel articles (sketch)"*
APPLICANT *Mr. Vuitton (Georges), represented by Mr. Robelet*

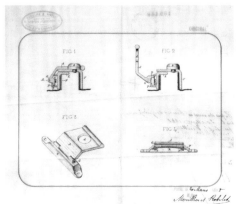

PATENT (S.G.D.G.)

MARCH 20, 1888
NO. 189,468, *valid for fifteen years*
For *"a spring clasp to close trunks, suitcases, travel bags, and similar objects"*
APPLICANT *Mr. Vuitton (Louis), represented by Messrs. Marillier and Robelet*
Published in the *Bulletin Officiel de la propriété industrielle et commerciale*, 1888, vol. 2

OPPOSITE PAGE

Gold medal certificate awarded to Louis Vuitton, Universal Exposition of Paris, 1889. Louis Vuitton Archives.

THIS PAGE, TOP TO BOTTOM

Fabrics area and entry gate for Travel and Camping Items, Universal Exposition of Paris, *Livre d'or de l'Exposition*, 1889. Bibliothèque des Arts Décoratifs, Paris.

Plan of category 39 at the Universal Exposition of Paris, 1889. Archives Nationales, Paris, inv. F 12 4055C.

Stamp appearing on the registration of designs and models, no. 12 946, July 2, 1888. Institut National de la Propriété Industrielle, Paris.

Additional drawing, patent no. 189 468, March 20, 1888. Institut National de la Propriété Industrielle, Paris.

75

PATENT (S.G.D.G.)

SEPTEMBER 10, 1889
No. 200,662, *valid for fifteen years*
For *"a lock for travel and camping articles"*
APPLICANT *Mr. Vuitton (Georges), represented by
Messrs. Marillier and Robelet*
SEPTEMBER 6, 1890, *a certificate of addition to the
patent was issued to complete this one*
Published in the *Bulletin Officiel de la propriété
industrielle et commerciale,* 1889 and 1890, vol. 2

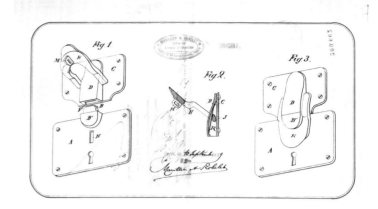

PATTERNS AND MODELS

AUGUST 21, 1888, *Conseil des Prud'hommes de Paris,
Industrie des tissus*
No. 13,008, *property in perpetuity [expired in 1960]*
For *"a flat oblong wooden box tied with a wine-red
braid folded into a cross, sealed by seven brown wax
seals with the initials M.R., which he declared to contain
a Cannage design [a caning pattern] applicable to
canvas or other materials intended to be glued onto the
outside of travel articles"*
APPLICANT *Mr. Vuitton (Georges), represented by
Mr. Robelet*

PATTERNS AND MODELS

OCTOBER 12, 1888, *Conseil des Prud'hommes de Paris,
Industrie des tissus*
No. 13,068, *property in perpetuity [expired in 1960]*
For *"a flat cardboard box tied with gray string folded
into a cross, sealed with six brown wax seals bearing
the initials M.R., which he declared to contain a fabric
design intended to cover travel articles"*
APPLICANT *Mr. Vuitton (Georges), represented by Mr.
Robelet*

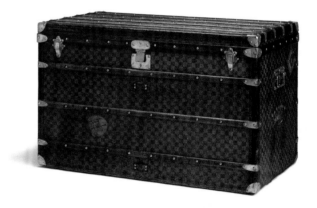

TRADEMARK

OCTOBER 26, 1888, *Greffe du Tribunal de commerce
de la Seine*
No. 29,100
For a *"trademark to be put on travel and camping
articles"*
APPLICANT *Mr. Vuitton (Georges)*
Published in the *Bulletin Officiel de la propriété
industrielle et commerciale,* 1888, vol. 1

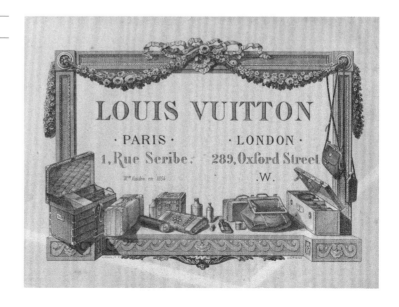

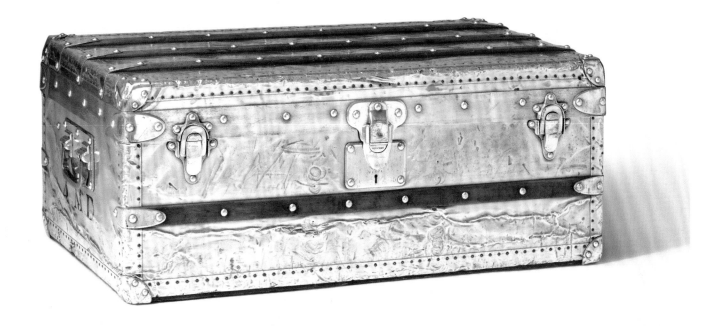

THE LAST PATENT —PATENT (S.G.D.G.)

OCTOBER 19, 1891
No. 216,823, *valid for fifteen years*
For a "new aluminum application for the construction or covering of travel articles"
APPLICANT *Mr. Vuitton (Louis)*
Published in the *Bulletin Officiel de la propriété industrielle et commerciale*, 1891, vol. 2

DESCRIPTION *"In the course of my never-ending experimentation to achieve a greater measure of practicality for the articles that I manufacture, I have often been struck by the considerable weight of the metal parts, fittings, covers, latches, clasps, & c. that are used for their manufacture as the case may be.*

I have sought various means of eliminating or at least reducing this inconvenience & the results of this research led me to the idea of replacing steel, iron, copper, zinc, and generally all the metals used until then with aluminum. Indeed, the weight of aluminum is considerably less than that of zinc, for example,

since a square-meter plate of the first metal weighs 0 K 850 gr while the second weighs 2 K 300 gr for the same surface area & resistance.

Under these conditions, the use of aluminum is to be recommended for the making of articles that we should endeavor to purchase with the least possible weight.

On the other hand, aluminum is five times more solid than zinc.

In short, I claim in the most formal & absolute way, for a duration of fifteen years, the use of aluminum for the manufacture:
1° of the fittings on trunks, travel bags, suitcases, hatboxes, in a word, all travel articles
2° of the lining and covering of said articles
3° of their construction
4° of closing devices for, lock, bolts, clasps & c. of the aforementioned articles

I also reserve for myself the right to line all luggage articles, cases, & c. as well as the outside with aluminum metal.
Paris, 17 October 1891."

FASHION DURING
THE TIME OF LOUIS VUITTON

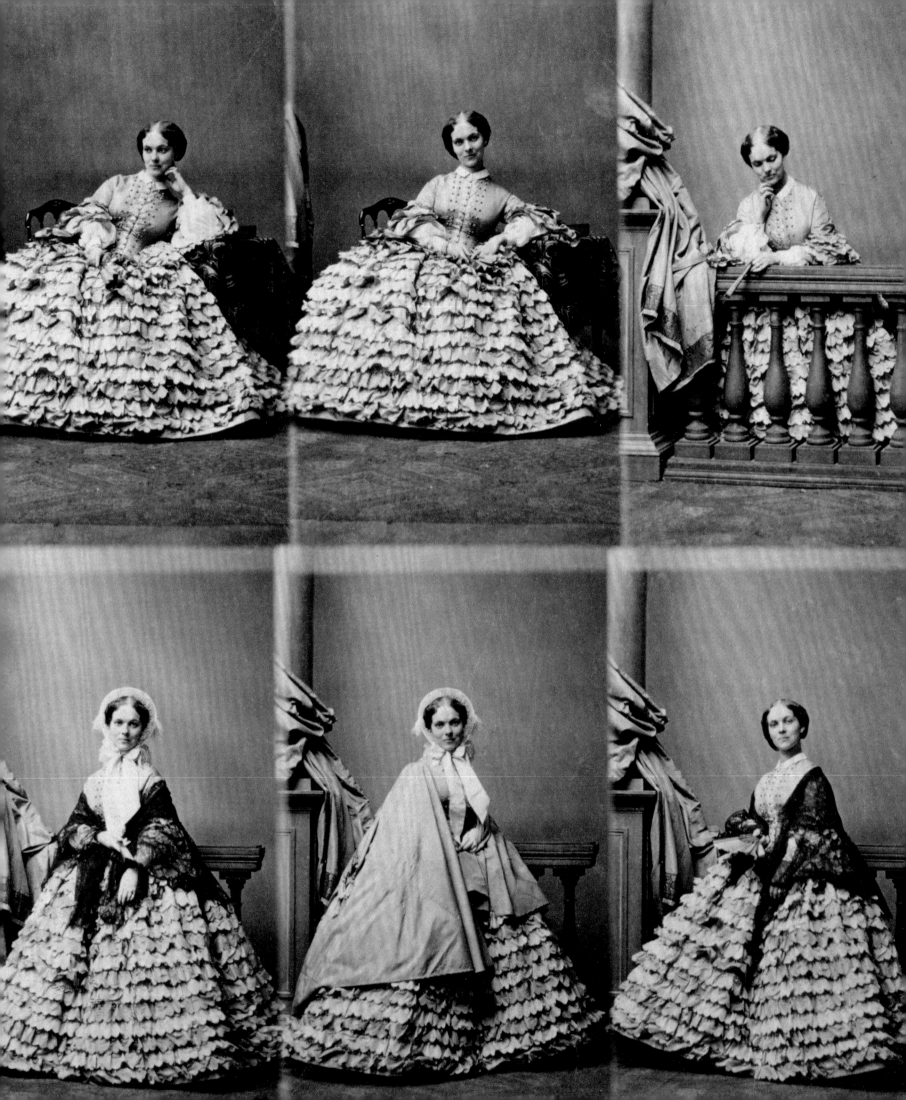

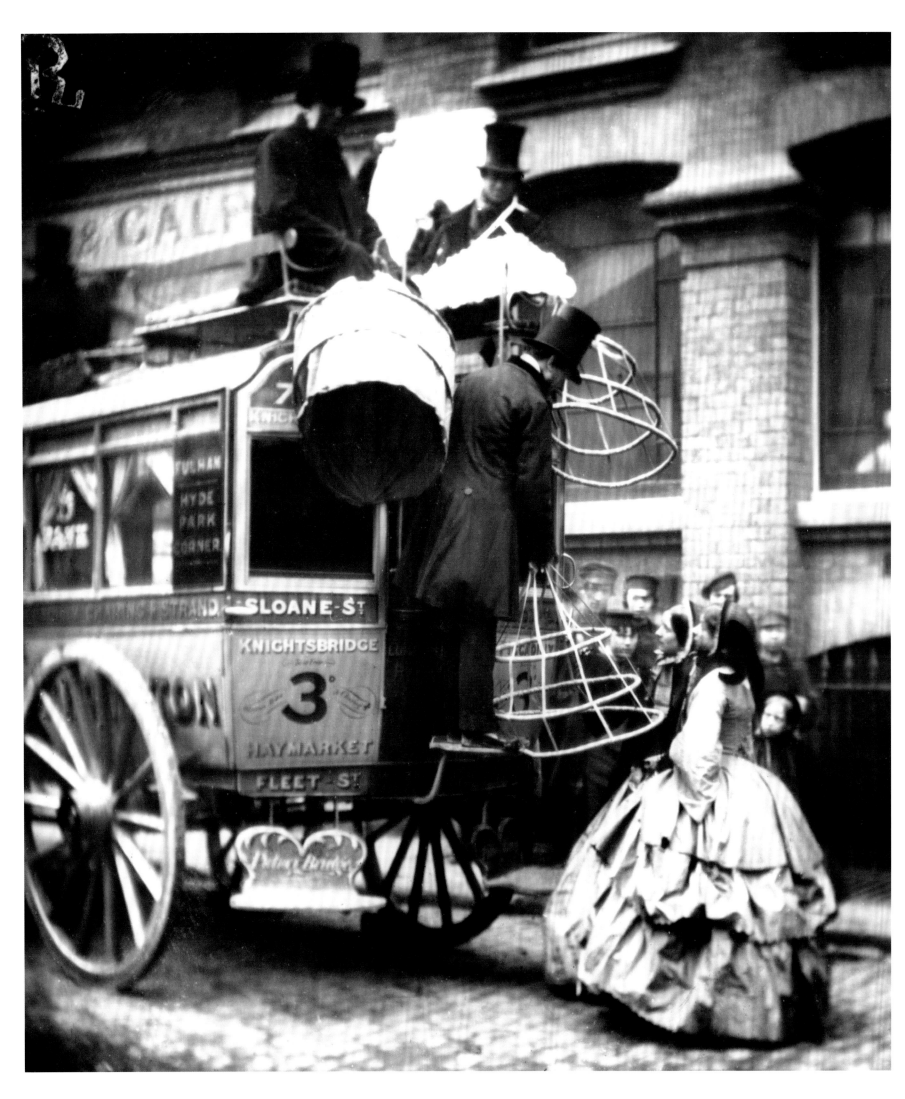

FASHION
ON THE MOVE!

By

VÉRONIQUE BELLOIR

"TO DRAPE THEIR MODESTY, THIS FOLIAGE DOES NOT SUFFICE;
…THEIR VANITY, TURNING TO PRETENSE, PUFFS UP IN THE DRESS WITH FLOUNCES.

…IT IS WORN EVERYWHERE, FROM PARIS TO JAPAN, FASHION CHAMPIONS THE
RUFFLED PETTICOAT; WHETHER LADY OR MISSUS, WORKER OR MISTRESS,
THIS FURNITURE IS A MUST FOR EVERY TOILETTE."

— *Auguste Barthélemy*
Robes à volants, Boutade, PARIS, IMPRIMERIE DE SCHILLER AÎNÉ, 1856

In 1854, when Louis Vuitton established himself in the rue Neuve-des-Capucines, crinoline was at the height of fashion throughout society. Great changes were in the making at the time, not only in the area of the manufacture and distribution of clothing in general but also in modes of behavior. The appearance of *magasins de nouveautés* (fashion shops) and then department stores made it possible for women to dress at lower cost and to have larger wardrobes, the number of articles increasing apace with the new dress codes and customs. These stores offered an unaccustomed selection of articles of all kinds grouped into specialized counters. Among them was a counter for new fabrics, one for ready-to-wear clothing in standard sizes, for semi-tailored clothes, etc. Some also offered custom dresses made in their own workshops.[1]

After the years of antique-style fashions and seminudity, skirts gradually filled out in shape and crinoline took on a major function in the feminine wardrobe. Originally made of superimposed petticoats, it was given its name in June 1840 when Charles Oudinot-Lutel filed the first patent for a stiff petticoat combining horsehair and linen or cotton. It was not before the mid-1850s that new structures made of whalebone and then

steel hoops appeared, making it possible for the bulk of the dress to be carried more lightly. New models were regularly developed, such that on the day of its opening in 1852, Le Bon Marché could offer its clients more than fifty-four different models. The famous cage crinoline was patented by W. S. Thompson in 1862, but other types regularly earned prizes at the universal exhibitions. The amazing exuberance of this fashion was equaled only by the number of caricatures, satires, poems, and songs that it inspired: there were as many advocates who celebrated its rule as detractors who never tired of announcing its decline.[2]

To sublimate this improbable architecture, some dresses required as much as twenty meters of cloth, as can be seen in the sketches in the sample books of textile manufacturers. Cut from heavy moiré, taffeta, muslin, or diaphanous gauze, the skirts had a circumference of up to ten meters, in stark contrast to the narrowness of the tight-fitting bodices. The form of these disproportionately large dresses varied over the years—draped, with frills, with a gathered overskirt or a long train sweeping along the floor—but always called for extravagant amounts of material.

Stimulated by mechanization and the modernization of means of production, the textile industry offered seamstresses an unprecedented range of products. The designs on the silk and printed fabrics were no less varied: eighteenth-century-style flowers, palmettes, paisley, stripes, interlaced arabesques, or huge geometric patterns accentuated the excesses and disproportions of the figure. The decoration was composed according to the placement of the pattern on the finished article of clothing, prefiguring the dress before it was made. The profusion of trim that could be applied, such as bead fringes, braids, ribbons, and the like, offered a near inexhaustible store of ornaments that were easy to apply thanks to the spreading use of the sewing machine. They underscored the contours, edges, skirts, belts with long, floating skirts, or boatneck decolletés.

This opulence, the sense of overabundance that marked the feminine silhouette in general during the Second Empire, increased with the diversity of toilettes that were required starting in this period. Wardrobe customs were codified according to season, time of day, and activity, as well as by precise and strict rules of decorum. Specialized magazines giving advice and recommendations were created to do justice to this etiquette. Their pages reveal scores of subtle distinctions: morning toilette, demi-toilette for private visits, ensemble for a walk or fancier occasions, and dinner toilette or ball gown, as well as clothing for the seaside and activities of all kinds: riding or skating costumes, or the "petit costume" so well liked by the Empress Eugénie—shorter than the others and leaving the feet free for mountain excursions. As one periodical put it, "The secret of the Parisian woman consists in not having any dress that has more than one function."[3] The women of the middle class changed clothes no less than five times a day, and some up to seven or eight times. Wives were a symbol of their husband's status and owed it to themselves to display a conspicuous luxury directly proportional to his social ambitions.

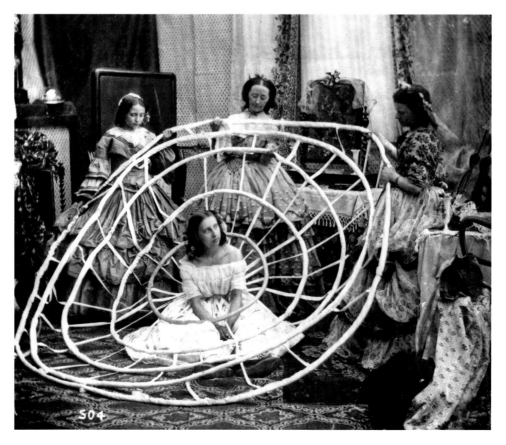

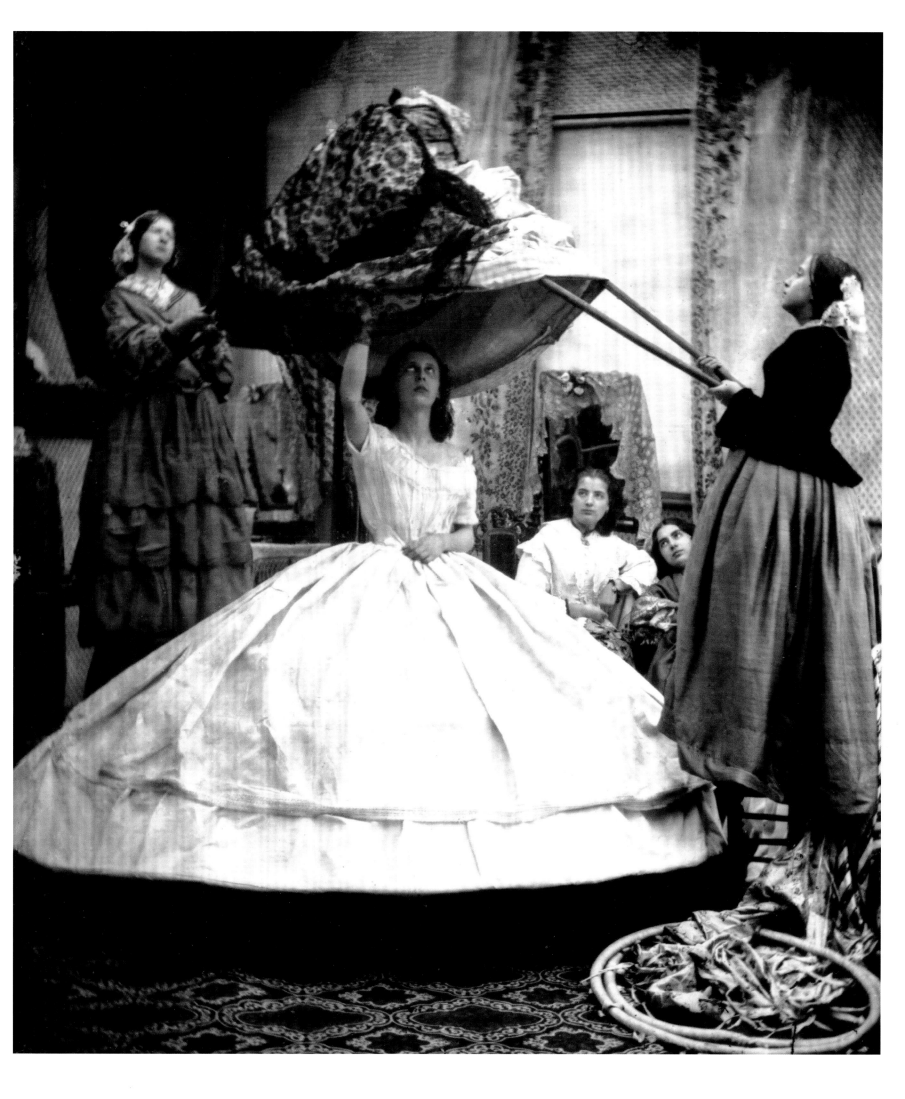

Journal des Demoiselles

Paris. Boulevart des Italiens. 1.

Imp. à la Vapeur de Th. Dupuy. 3, Pass. du Désir.

32.^e année. Juillet. 1864. N.° VII

Bruxelles Desterbecq. Rue du Casino 10^{bis} Porte de Cologne. S.B. Fuller 34 Pall Mall. London. Amsterdam Desterbecq Vyzelstraat X 549

The host of attendant accessories and their use according to the degree of formality of the toilette increased accordingly. No one ever went outdoors without a hat, however small, like the high-perched boater or, at the opposite extreme, the hood, whose straps framed the face and could be tied under the chin. More often than not they were decorated with little flowers, sometimes with feathers. The fragile parasols made of Chantilly lace were also a must. They were tiny and added a touch of color that matched the headgear. Their carved ivory handles were articulated so that they could be tilted as needed for shade.

As for footwear, there were ankle boots with low heels made of drill or golden brown morocco keeping the silk or cotton stockings out of sight. Shoes for the ball were generally made of white satin. From the morning on, one wore light-colored suede gloves decorated with two or three buttons; for evening occasions, they were of a darker color and had three or four buttons. A fan was another indispensable article in the image of how femininity was perceived at the time.

The movement for hygiene and the concern for cleanliness generated new practices; recommended was a weekly change of underwear, and lingerie began to take up an important part of women's wardrobes. Its typology consisted of many elements, each adapted to a part of the anatomy to constrain the body or shape the figure. Their layering and cleanliness implied a sort of distancing of the body. The chemise de jour, corset, stockings, pants, under- and over-petticoats, camisole, collar, dickey, and batiste or cotton-muslin sleeves all had to be immaculate. These many pieces were also adapted to the different times of the day—plain in the morning, then more or less decorated with discreet embroidery or lace insertions. For demi-toilettes, the trim was not supposed to project more than three-quarters of a centimeter, as stipulated in an article in the May 1864 issue of *La Mode Illustrée*. The care brought to all of these details endowed even the simplest costumes with an aura of distinction. The maintenance of all this clothing was entrusted to laundresses and pressers, its quantity a measure of one's prosperity.

"All this linen was a subject of great pride to her; nothing, in her eyes, could give a better idea of her social standing." [4]

The manner of keeping and preserving clothing was an art in itself and one in which nothing was left to chance. The clothes were laundered and ironed, then carefully put away according to type and stacked up in piles of a dozen. The pieces were also arranged according to their combination; for example, the camisoles were next to the shirts and the shirts next to the petticoats. They were put into a wardrobe or commode and covered with a piece of cloth to protect them from dust. The more fragile dresses were hung in a "wardrobe by sliding the sleeves over a squarish stick about a foot and 3 inches long, rounded off at the ends and suspended in the middle by a metal hook, then on a strong metal rod or wooden staff that spanned the width of the wardrobe. The dresses on these clothes hangers (as these instruments are called) should not be hung too close together…" [5]

OPPOSITE PAGE
Illustration of lingerie, *Journal des Demoiselles*, July 1864. Les Arts Décoratifs, Paris.
THIS PAGE
Outfits from the Fauvet house, *La Mode Illustrée*, September 18, 1861. Les Arts Décoratifs, Paris.

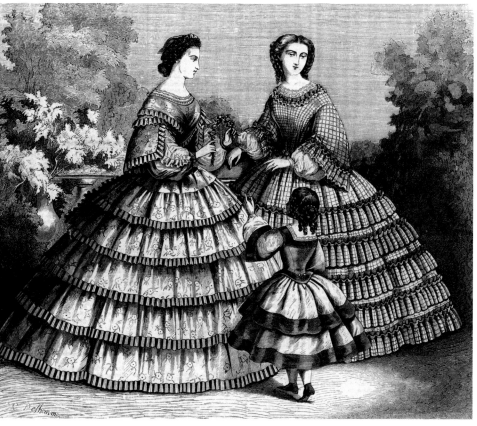

2e tour sont posées à cheval, — une maille simple dans chaque maille en l'air.

3e tour.* Dans la maille du milieu de la plus proche feuille, on fait 4 brides séparées les unes des autres par 3 mailles en l'air; ceci représente un groupe de brides; — 3 mailles en l'air après la 4e bride, une double bride sur la plus proche maille simple du tour précédent, — 3 mailles en l'air. Recommencez 3 fois depuis *.

4e tour.* Un groupe de brides (voir l'explication du 3e tour) sur le premier vide formé par les mailles en l'air du groupe de brides du 3e tour, — une maille en l'air, — 1 groupe de

PLIAGE D'UNE CHEMISE
POUR HOMME.

SERVIETTE-ESSUIE-MAINS DÉPLOYÉE.

PLIAGE D'UNE SERVIETTE-ESSUIE-MAINS.

mailles en l'air; ces doubles brides sont posées à cheval, et par conséquent enserrent à la fois et les mailles en l'air du 6e tour, et les mailles simples faites sur ces mailles en l'air dans le 7e tour; — 3 mailles en l'air, — 4 brides suivies chacune de 3 mailles en l'air sur les deux plus proches mailles en l'air du tour précédent, — 3 mailles en l'air. Recommencez 7 fois depuis *.

9e tour. Dans le vide du milieu de chaque groupe de brides du tour précédent, on fait 2 brides séparées par 2 mailles en l'air, puis 8 mailles en l'air.

10e tour. Dans chaque maille on fait une bride.

PLIAGE D'UNE CHEMISE
POUR HOMME.

CHEMISE POUR HOMME AVANT LE PLIAGE.

CHEMISE DE JOUR POUR FEMME AVANT LE PLIAGE.

CHEMISE DE JOUR POUR FEMME AVANT LE PLIAGE.

brides dans le dernier vide, formé par les mailles en l'air, — une maille en l'air. Recommencez 3 fois depuis *.

5e tour. Une double bride sur chaque maille en l'air, isolée du tour précédent, — une double bride sur le vide du milieu de chaque groupe de brides, et entre deux doubles brides toujours 7 mailles en l'air.

6e tour.* Sur chaque côté de la plus proche double bride, 2 brides séparées par 2 mailles en l'air, — 12 mailles en l'air, sous lesquelles on passe 13 mailles. Recommencez 6 fois depuis *.

7e tour. Une maille

PLIAGE D'UN PANTALON
POUR FEMME.

PANTALON
POUR FEMME
AVANT
LE PLIAGE.

11e tour.* Sur chacune des deux plus proches mailles, une maille simple, — entre ces 2 mailles simples 2 mailles en l'air, — 7 mailles en l'air, sous lesquelles on passe 5 mailles. Recommencez 26 fois depuis *.

12e tour.* Sur les deux plus proches mailles en l'air du tour précédent, 2 brides séparées par 5 mailles en l'air, — 3 mailles en l'air, — une maille simple dans le milieu du feston composé de 7 mailles en l'air. Recommencez 26 fois depuis *.

13e tour. Sur les 3 mailles en l'air séparant 2 brides dans le tour précédent, on fait 3 brides, suivies chacune de 3 mailles en l'air, — dans la plus proche maille

PLIAGE D'UNE CHEMISE DE JOUR
POUR FEMME.

PLIAGE D'UNE CHEMISE DE NUIT POUR FEMME.

CHEMISE DE NUIT POUR FEMME AVANT LE PLIAGE.

dans chaque maille, en laissant toujours intactes les 2 mailles du milieu de chaque feston, composé de 12 mailles en l'air, au-dessus desquelles on fait toujours 2 mailles en l'air.

8e tour. Dans le plus proche vide du 6e tour, formé par 2 mailles en l'air, on fait 4 doubles brides, suivies chacune de 3

simple 2 brides, séparées par 6 mailles en l'air. Recommencez 26 fois depuis *.

14e tour. Sur chaque feston de 6 mailles en l'air, on fait 2 mailles simples, suivies de 9 mailles en l'air.

15e tour. Dans chaque maille, on fait une maille simple.

16e tour.* 2 brides

PLIAGE D'UNE CHEMISE DE JOUR POUR FEMME.

Puis trente metres de dentelle pour donner quelque tournure à l'étoffe.. Quelques cachemires et quelques bijoux, ce sera pour ne pas jurer avec la dentelle.

Journal des Demoiselles

OPPOSITE PAGE

Linen-folding instructional; drawings of templates displaying examples of before and after folding, *La Mode Illustrée*, January 13, 1867. Bibliothèque des Arts Décoratifs, Paris.

THIS PAGE, LEFT TO RIGHT

Fashion victims, Charles Albert d'Arnoux, known as Bertall, *L'Illustration*, July 30, 1864. Bibliothèque des Arts Décoratifs, Paris.

Outfits for young girls, young women, and little boys, *Journal des Demoiselles*, March 1866. Les Arts Décoratifs, Paris.

It was not recommended that dresses be turned inside out and hung with a cord sewn at the belt, as many women still did. White cotton dresses were pressed before being worn again. Those in merino or cashmere were cleaned with a soft brush; the more fragile ones were cleaned with an ostrich feather duster.

The same care was given to the storage of accessories: hats were kept in cases made of light wood rather than in their boxes; the fringes of the shawls were carefully disentangled; humid gloves were dried with a goffering iron.

All of these precautions did not really fit in with the increased mobility that came with the development of public means of transportation—in town with the double-decker buses since 1853 and especially with the trains to faraway destinations, as facilated by the extension of the railway system. One can easily imagine the effort involved in transporting all of these items indispensable for a woman to maintain her status and keep up with decorum, yet having to bear the discomforts of the early train compartments.

Already in 1833, when all trips were still being made in horse-drawn carriages and coaches, Madame Celnart devoted an entire chapter to travel in her *Manuel des dames ou l'art de l'élégance* (*Manual for Ladies or the Art of Elegance*). Her detailed description of the preparations and manner of packing each object is prefaced by these words: "I assume the trunks have now been packed, no detail being necessary in this respect, everyone knowing how to pack linen."

How trunks were packed could be learned, it is said, in other books on *savoir-vivre* (good manners). It involved several principles that she cited for novices: "Put the heavier objects at the bottom first, then pack them in as tightly as possible, but without wrinkling or twisting."[6]

Intimate and toilet articles were among those to be handled in this way: there was a special way of folding each type of clothing, and it had to be used. Shawls, for example, were to be stored by folding them in squares, always along the same folds, without any particular handling. Hats and more delicate effects were another matter altogether. The manner of packing them oneself was precisely described by Madame Celnart. After beginning with profuse explanations about the making of a hatbox, she made this recommendation: "But instead of going to all this trouble and risking inconvenience, use a travel case like those made by any *layetier*." An engraving shows the box open and empty, and it gives valuable details about packing cases for fashion articles:

"The support or cardboard stay is supposed to be put inside the hat. This support is attached to a board that slides in on the front side of the box such that if the shape and side of the hat were to make it more cumbersome than useful, it could be put aside… The plaited loops attached inside can be used to hang the hat up with pins or ribbons. The box is lined with paper and the lid with wax linen, the edges of which cover the sides by about six inches. It is closed with a lock…

"The frame of five-inch-high sides and a bottom made of crossed metal bands… is the inner cover that is placed on the hat with the help of the slat. This cover can be used to hold collars and other light articles that should avoid damage or damaging the hat, and in this way one can pack in less than twenty minutes all manner of fragile items which, without the benefit of a case, would have required more than two hours."[7]

Although this manual is very detailed and precise, as the example shows, it never mentions the option of entrusting these delicate operations to a packer. Yet a decade later, the song of the packer-packager shows how much the development of traveling had made the profession and individual practices evolve.

"In olden days, the tasks of our craft were few: Packing trunks was about the whole of it; Today, a good packer can pack a fragile crown and ship it even to Peking without a scratch…"[8]

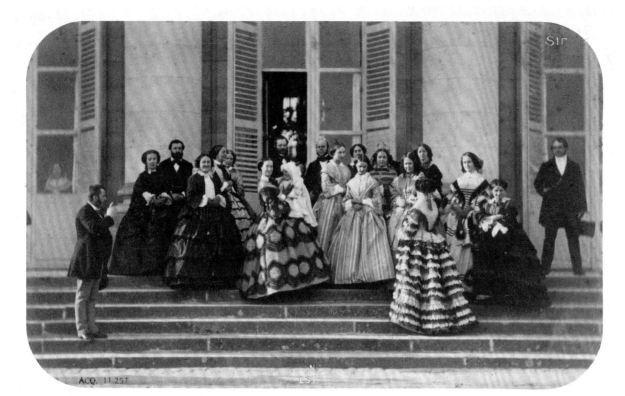

THIS PAGE

Empress Eugénie and the Prince Imperial
surrounded by her guests during a series at the
Château de Compiègne, Olympe Aguado, 1857.
Bibliothèque Nationale de France, Paris.

OPPOSITE PAGE, TOP TO BOTTOM

Travel outfit, catalog of the Grands Magasins du
Louvre, 1867. Les Arts Décoratifs, Paris.

Louis Vuitton advertisement, c. 1875.
Louis Vuitton Archives.

FOLLOWING SPREAD

Doll trousseau and trunk, c. 1865. Les Arts
Décoratifs, Paris, gift of Maurice Bisson, 1945,
inv. 35336.

As the number of women with a large wardrobe increased, one can imagine that this trend fostered the growth of firms specialized in the transportation of luggage filled with delicate and valuable costumes and accessories.

The distinction between trunks and packing cases is always explained preliminary to all preparations. There were apparently the trunks and bags that one packed oneself and checked in at the train station, and then there were the cases that were packed entirely by the packer-packagers. Chambermaids had to see to the luggage, for it contained the clothes and necessary articles. Dresses made of light fabrics and those that were fragile or whose trim might get wrinkled were always transported in cases. Their packing was increasingly entrusted to professionals.

Thus, in her book titled *La femme hors de chez elle* (*The Woman Out of the House*) from 1878,[9] after giving advice about the choice of itinerary and schedules, Marie de Saverny's first recommendation concerns attending to the cases:

"If many toilettes have to be taken along, the best thing to do is to put them in the large costume case with a length of 1 m. 30 cm. Just call for a packer to fold them and put them in the compartments. This will spare much fatigue and one can learn a great deal, for these good people have great skill and, thanks to them, every article arrives without a wrinkle."[10]

Packing techniques do not seem to have changed much since the end of the eighteenth century. At that time, Madame Éloffe, seamstress-laundress to Marie-Antoinette, wrote in her diary about all the cases, boxes small and large with double bottoms or compartments needed to transport the dresses and other clothing articles. She mentions all the materials needed to protect them from deterioration: cotton, tissue paper, brown paper, shredded paper, fat- or wax-impregnated cloth, wire and ropes, or straw for shipping abroad.

In 1787, she noted, "January 10—Madame Adélaïde…to pack a mourning costume; two handfuls of tissue paper," and in the same year, "shipped to the wardrobe three large paper-lined cases to pack fashions, dresses, and linen; shredded paper to pack them."[11]

In 1872 and 1875, in the registers of the Vuitton firm we can find the same supplies: padded boxes, large quantities of tissue paper, packages of plain ribbon, packages of pins in three sizes, drawstrings, wrapping string, tar paper, etc. The packing times were also recorded. On August 29, 1891, for example, it took packers three hours to pack two ball gowns; in another case, they spent no less than eight hours packing dresses and various items.

To keep each dress from being shaken up during transport and avoid unwanted folds, it had to be carefully attached with pins to the net of crossed ribbons on which it was delicately stretched. The same went for hats in order to preserve their freshness.

For each trip, women did not fail to take scores of headgear and toilettes along depending on their rank in society, and this meant many cases and bags. Some say that it required no less than a baggage car for Madame de Metternich, the witty and elegant wife of the Austrian ambassador to France. Her description in her memoirs of the organization and proceedings at the famous Compiègne series,[12] to which the empress invited the most well-known women of the day, does not belie this claim:

"The baggage car arrives! This was a show that no one wanted to miss. About twenty minutes after the arrival of the masters came the cars! It was an extraordinary and unique spectacle, for it seemed as if the city of Paris itself were moving. Incredible how many cases were unloaded! We counted as many as nine hundred! The fact is, each woman had her evening gown put into a separate case of light wood, like the seamstresses use for their deliveries, and packed by the marvelous Parisian packers, so that they would arrive fresh at their destination. As it is, I could boast eighteen cases of my own, while others, more

elegant than myself, had twenty-four, and since we were about sixty all told, women and men, the number of nine hundred I just mentioned should not sound too improbable."[13]

In addition to cases, the apprentice travelers were advised to make the acquisition of pieces of luggage. The corresponding list was long and detailed, comparing the advantages and disadvantages of each model and giving the shape, materials, and use of each type of travel article or accessory.

"A good closed traveling trunk of medium size, about 85 centimeters long, with a spacious bottom, two compartments, and a rounded lid.

"The American trunk, which has wheels, is made of wood covered with canvas and has protective slats, and the inside is padded.

"More expensive is the leather trunk with shiny nickel fittings and closed by heavy locks. The trunk with drawers is quite practical; the front can be dropped and the compartments pulled down, instead of having to be lifted with some effort. It may be a bit heavier.

"There is the light basket trunk known as the English trunk. It is a large wicker basket lined with black canvas consisting of two chassis lined with unbleached linen. It can hold a very large number of things. It is not as heavy as the others but also much less resistant to the exertions of a long trip."[14]

Once the trunk model has been chosen, one still needed a bag and a toilet set of waterproof double canvas, or, more luxuriously, red Russian or morocco leather. To this could be added a moleskin Gladstone bag. The author ends this methodical list with the conclusion:

"The important thing is to take as few cases and luggage as possible."

In his *Comédie du voyage*, the journalist Pierre Véron wrote in 1863 that there were 195,000 ways to travel.[15] Each person, according to his social class, means of transportation, and purpose—whether a long crossing or a slow train ride—wanted to take with him what he considered essential and absolutely necessary. In this very special context, Louis Vuitton constantly expanded his activities to respond to the expectations and needs of a society that was rapidly changing. Starting in the early 1860s, he specialized in "packing for fashions" and subsequently offered in his stores all manner of leather goods to accompany travelers—male and female—on their trips and expeditions.

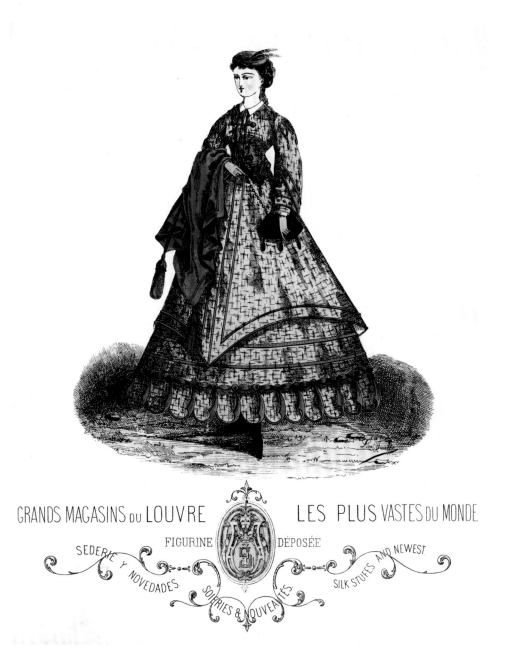

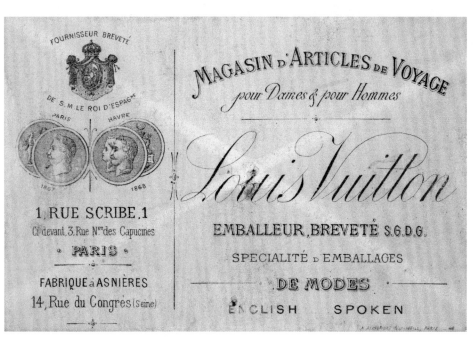

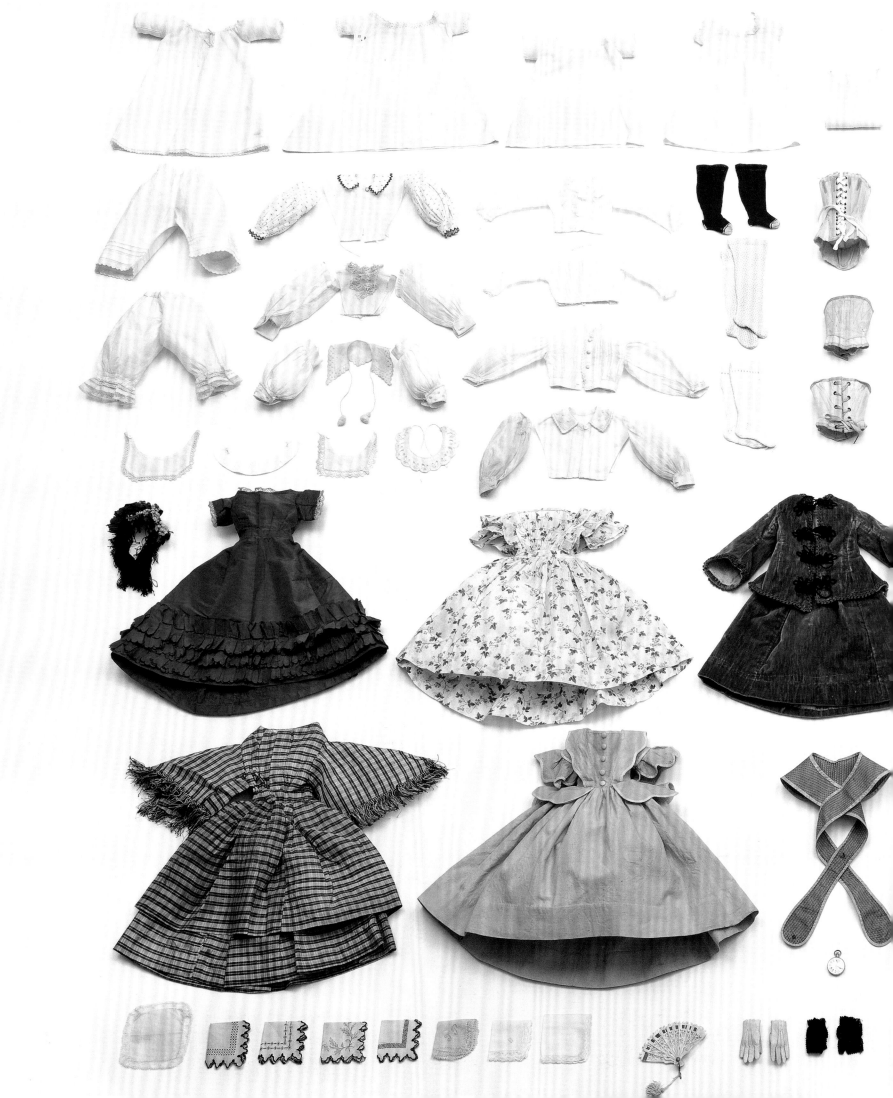

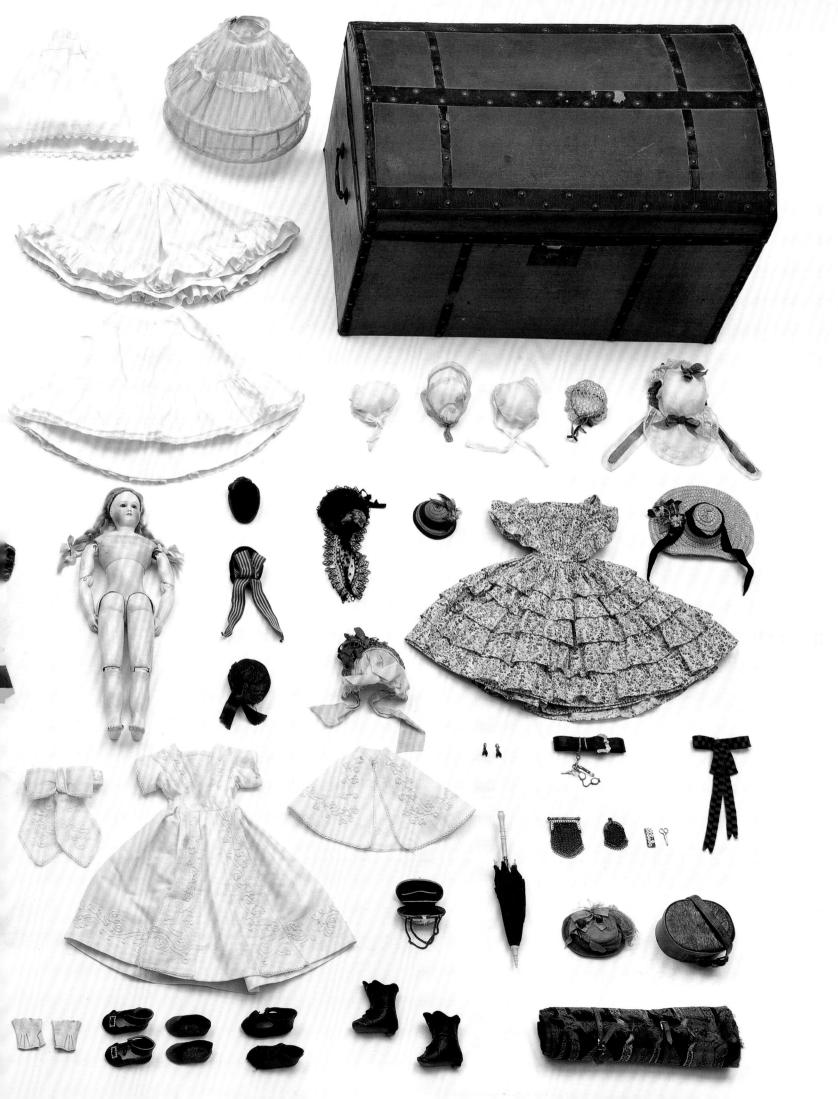

THE ESSENTIAL WARDROBE

By

VÉRONIQUE BELLOIR

"ONE WOULD BE AT QUITE A LOSS IF SUMMONED ABSOLUTELY TO DEFINE
THE CHARACTER OF CONTEMPORARY FASHION: IT IS A MISHMASH OF DIFFERENT
AND OPPOSING STYLES, A BIZARRE ALLIANCE OF LOUIS XV PANNIERS, THE 'WATTEAU GENRE,'
AND TRIMMINGS FROM THE FIRST EMPIRE; GOWNS WITH TRAINS FROM THAT SAME ERA, AND
FAIRLY LONG WAISTS DATING TO 1820. IT IS CLEAR THAT FASHION HAS SEIZED
UPON A DISCONTINUED SYSTEM OF PHILOSOPHY AND HAS APPLIED TO ITSELF ALL
THE BENEFITS, ALL THE EASY OUTS THAT ARE TO BE FOUND IN ECLECTICISM."

—*La Mode Illustrée*
JANUARY 12, 1863

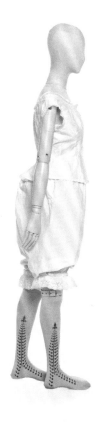

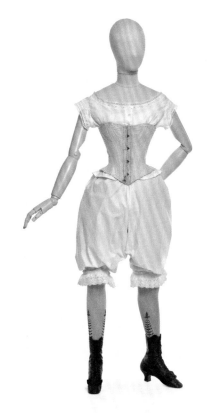

STOCKINGS

"Young women wear white silk stockings—more or less fancy ones—to the ball; or if they find that item too expensive, lisle openwork stockings. Young girls put on only lisle stockings; in town, that is, when women venture out on foot in rainy weather, the current fashion allows them to wear striped wool stockings in bright colors, or else checked or argyle stockings."

—*La Mode Illustrée*
FEBRUARY 17, 1862

COLLARS AND SLEEVES

"A word on linens, then. Small collars, like those for which you have such a nice selection on the catwalk, are utterly stylish; they can be worn up or turned down. There are also others composed of an entredeux and a gathered band, either in mousseline brodée or in lace. Next to these miniature collars can be seen new, contrasting undersleeves. Over a wide puffed pleat is slipped a batiste double-edge cuff, straight as those on men's shirts and at least ten centimeters tall, that is rather original but lacking in grace."

—*Magasin des Demoiselles*
FEBRUARY 1861

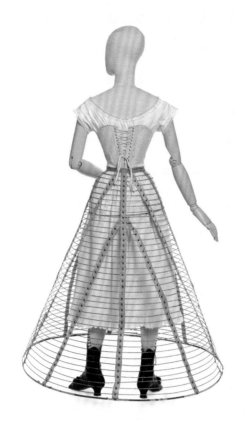

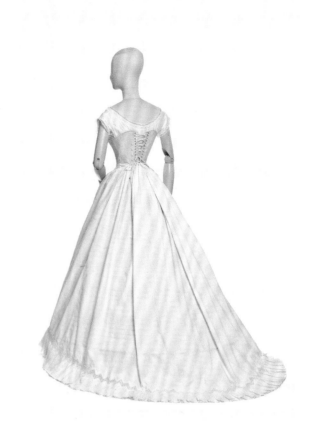

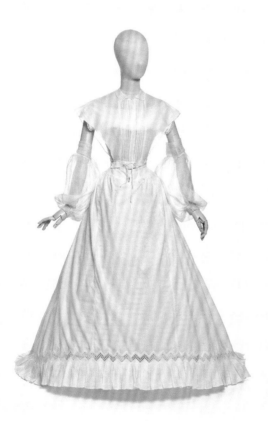

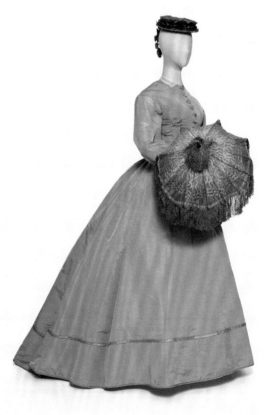

CRINOLINE

"This petticoat is composed of thirty light, flexible hoops spaced three centimeters apart and attached to perpendicular cords. Of these thirty hoops, only seventeen go all the way around the petticoat; the upper hoops meet only in front, leaving a gap of eighteen centimeters. Placed inside the petticoat are two bands equipped with eyelets and sewn onto the cords that are on the hips. Laces are threaded through these eyelets to tighten the bands, which hold the petticoat in place and prevent it from bunching up in the front."

—La Mode Illustrée
JUNE 23, 1860

PARASOLS

"One carries them in every shape and size. The marquises are embroidered or in solid colors, covered with lace or trimmed with lace on a cut-taffeta flounce; a few are bordered with a marabout fringe that forms a vaporous cloud, others with a rabbit-skin fringe, and that fashion is not pretty. Then come the parasol handles, long or short; in the latter case, they usually end in a ring placed at the top of the parasol, used for carrying them handily when they are closed. The colors in fashion are: first and always, white; then lilac; all tones of violet, with a white lining; and finally, brown, for modest parasols and small, 'just in case' umbrellas."

—La Mode Illustrée
MAY 25, 1862

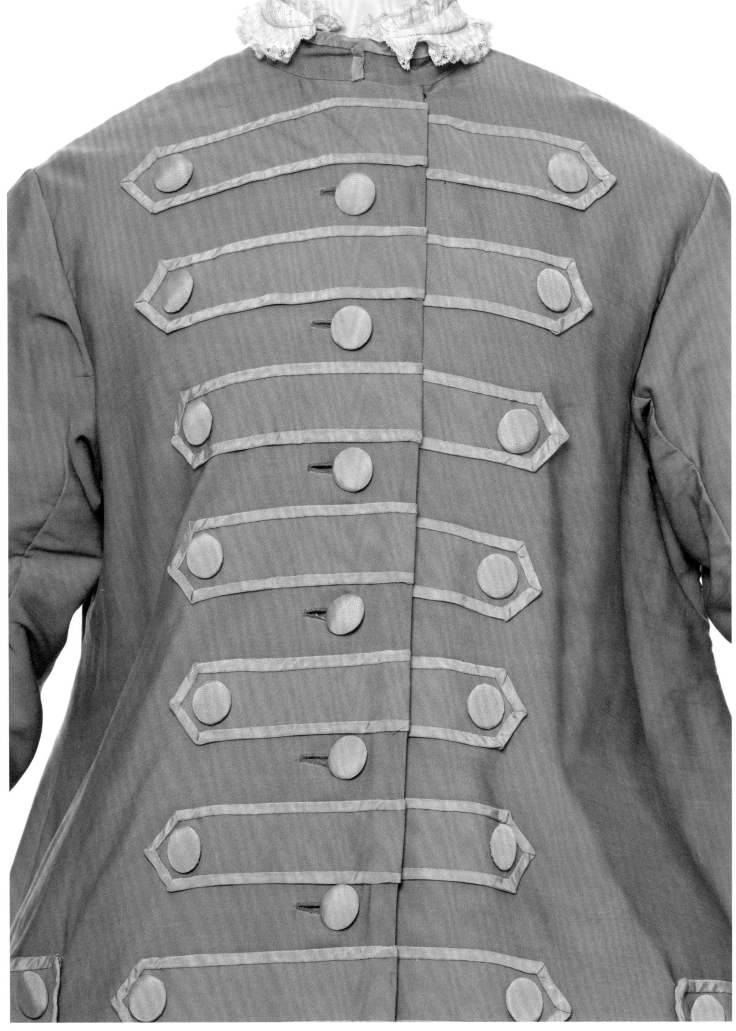

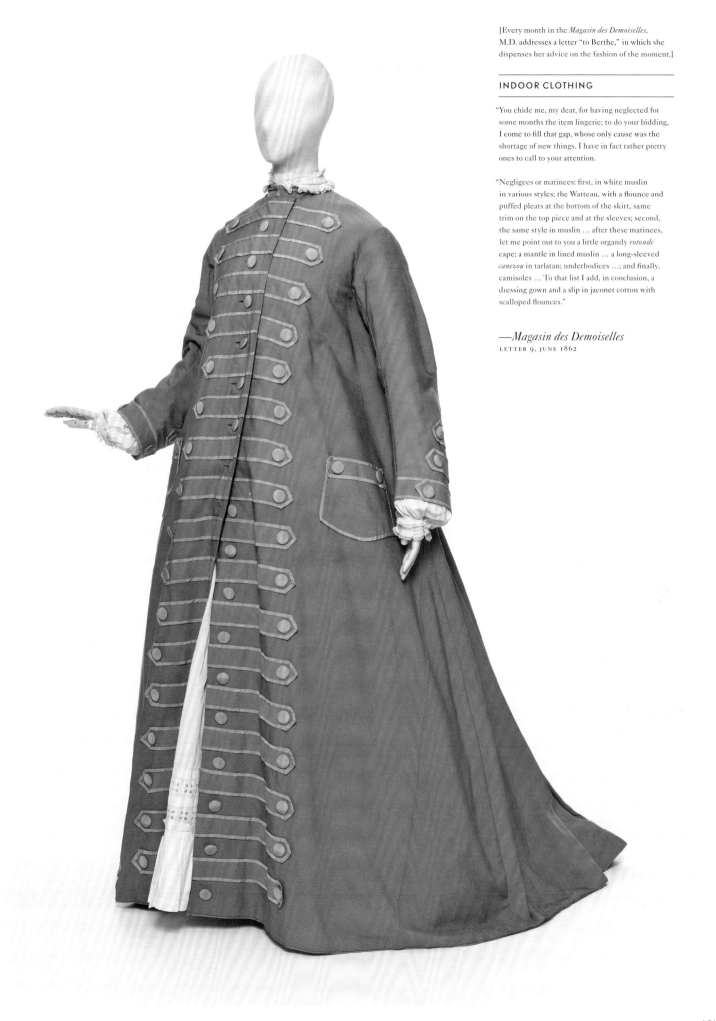

[Every month in the *Magasin des Demoiselles*, M.D. addresses a letter "to Berthe," in which she dispenses her advice on the fashion of the moment.]

INDOOR CLOTHING

"You chide me, my dear, for having neglected for some months the item lingerie; to do your bidding, I come to fill that gap, whose only cause was the shortage of new things. I have in fact rather pretty ones to call to your attention.

"Negligees or matinees: first, in white muslin in various styles; the Watteau, with a flounce and puffed pleats at the bottom of the skirt, same trim on the top piece and at the sleeves; second, the same style in muslin … after these matinees, let me point out to you a little organdy *rotonde* cape; a mantle in lined muslin … a long-sleeved *canezou* in tarlatan; underbodices …; and finally, camisoles … To that list I add, in conclusion, a dressing gown and a slip in jaconet cotton with scalloped flounces."

—*Magasin des Demoiselles*
LETTER 9, JUNE 1862

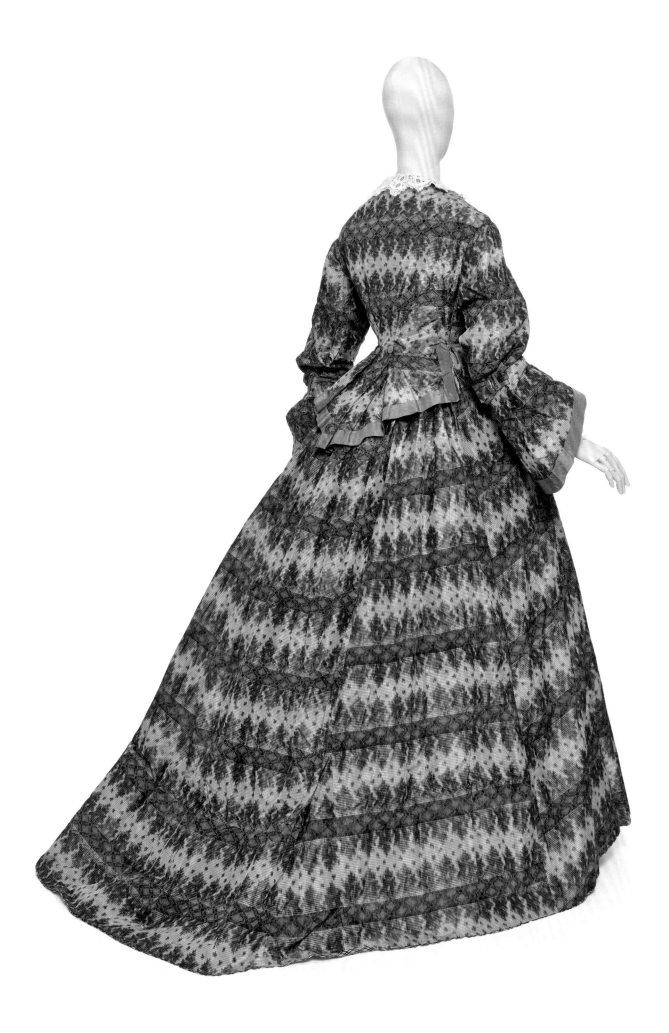

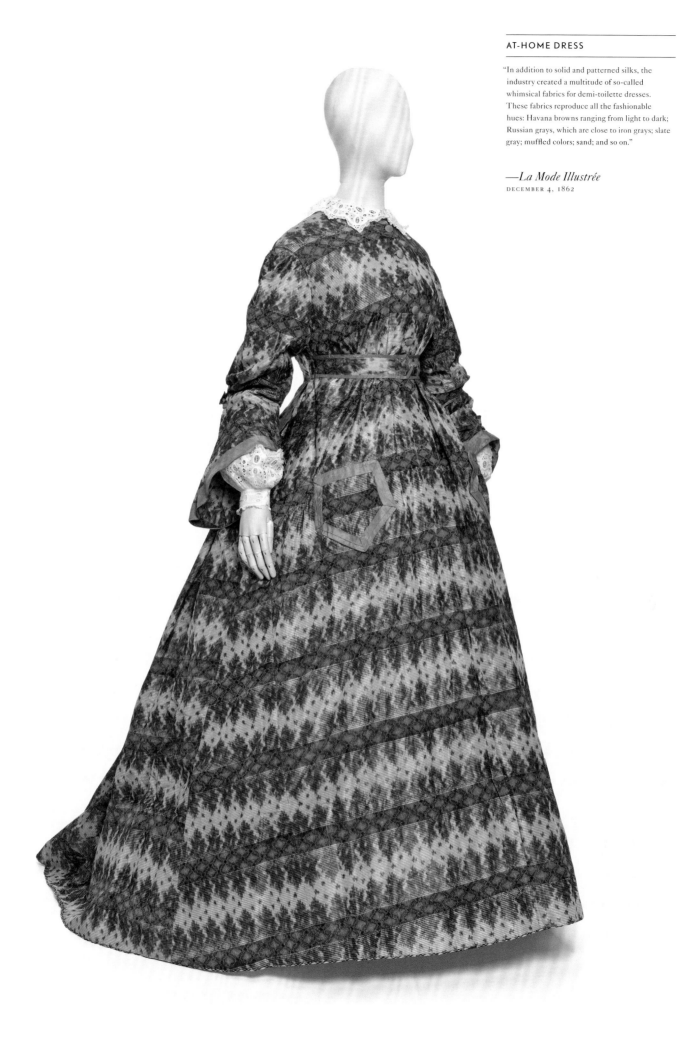

"In addition to solid and patterned silks, the industry created a multitude of so-called whimsical fabrics for demi-toilette dresses. These fabrics reproduce all the fashionable hues: Havana browns ranging from light to dark; Russian grays, which are close to iron grays; slate gray; muffled colors; sand; and so on."

—*La Mode Illustrée*
DECEMBER 4, 1862

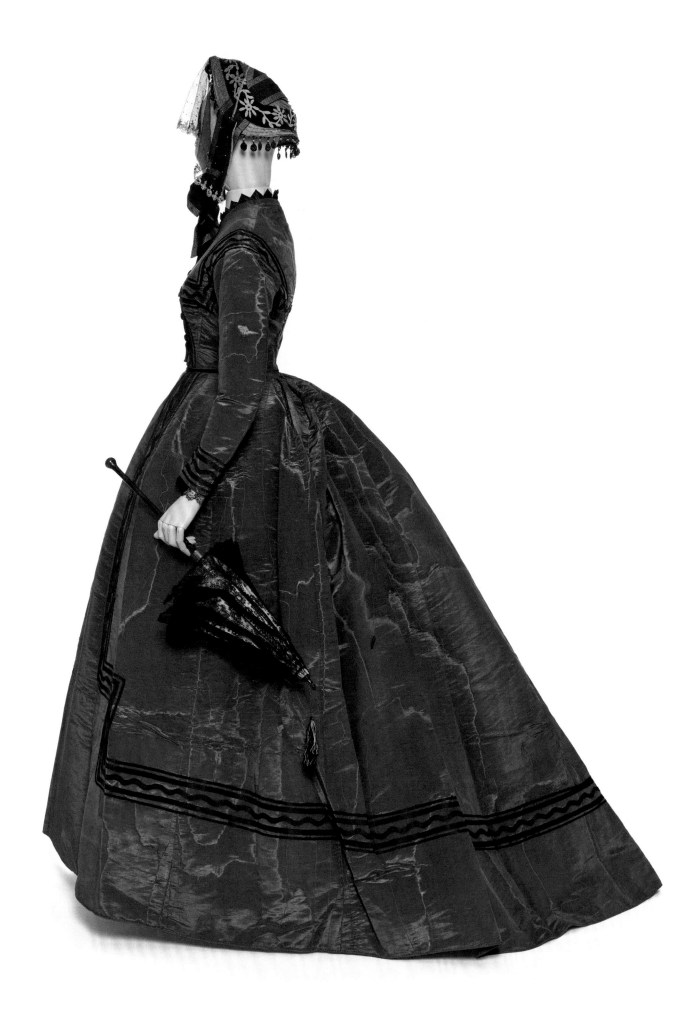

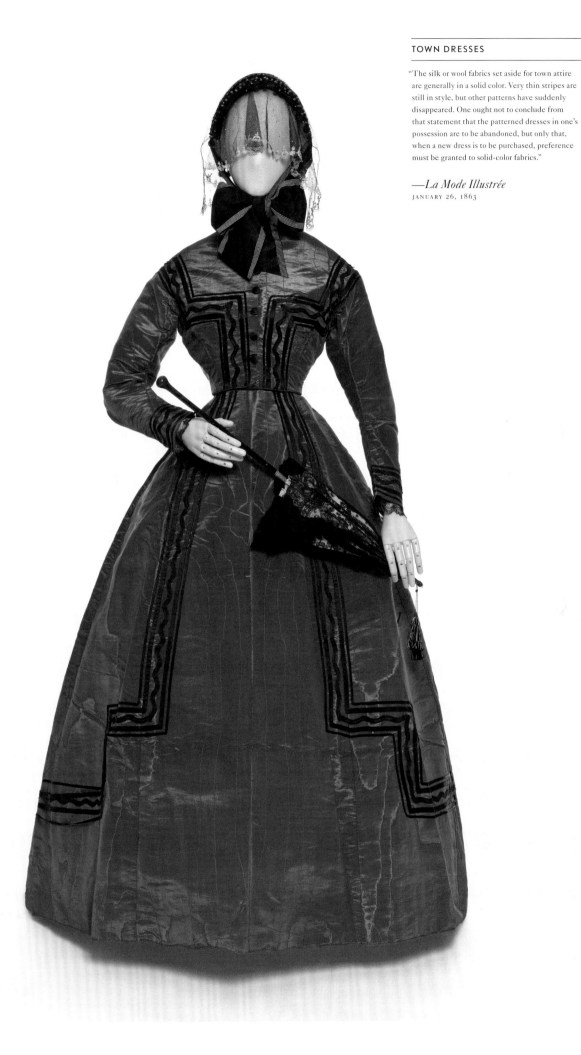

TOWN DRESSES

"The silk or wool fabrics set aside for town attire are generally in a solid color. Very thin stripes are still in style, but other patterns have suddenly disappeared. One ought not to conclude from that statement that the patterned dresses in one's possession are to be abandoned, but only that, when a new dress is to be purchased, preference must be granted to solid-color fabrics."

—*La Mode Illustrée*
JANUARY 26, 1863

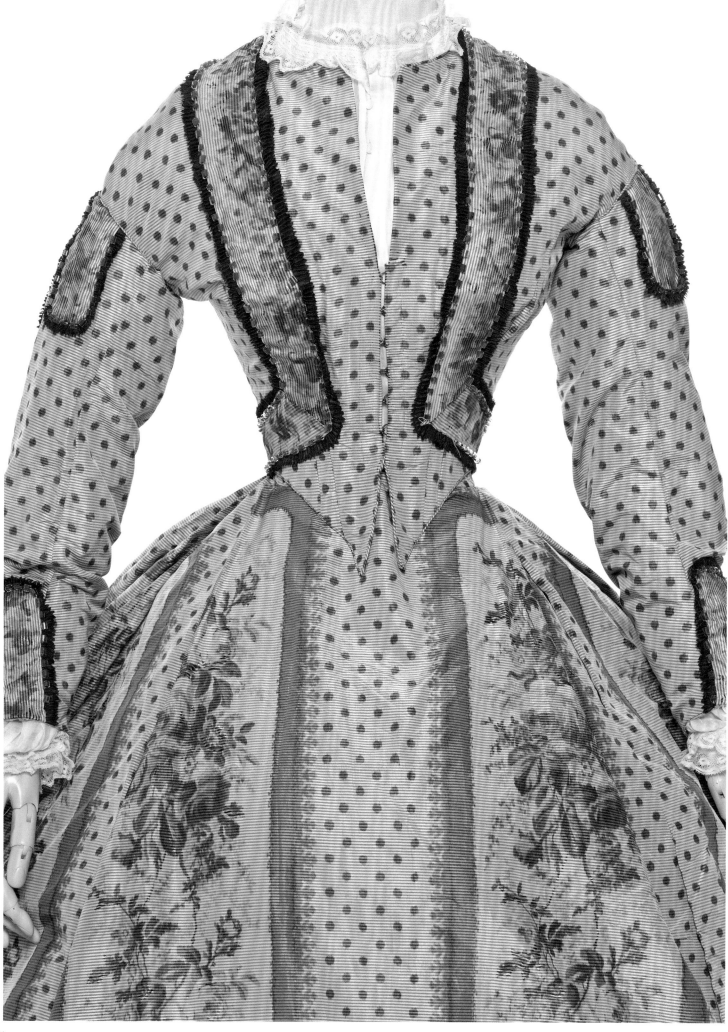

FOR DINNERS, PARTIES, OR CONCERTS

"I recommend to you, for these occasions, a cool taffeta gown. Select from the following novelties that I shall indicate: a taffeta with black netting strewn with Pompadour bouquets on a white background (a very pleasing arrangement)."

—*Magasin des Demoiselles*
LETTER 5, FEBRUARY 1861

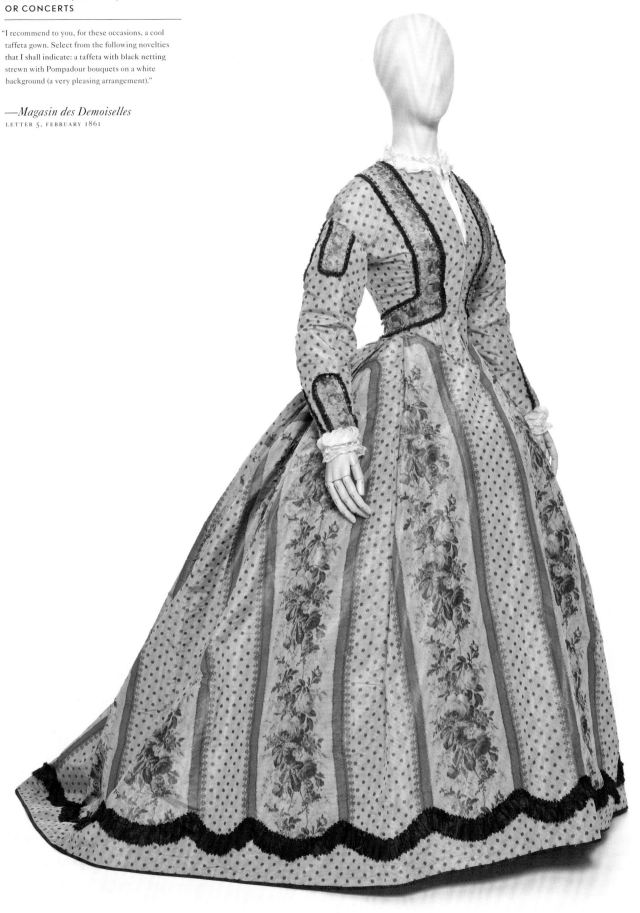

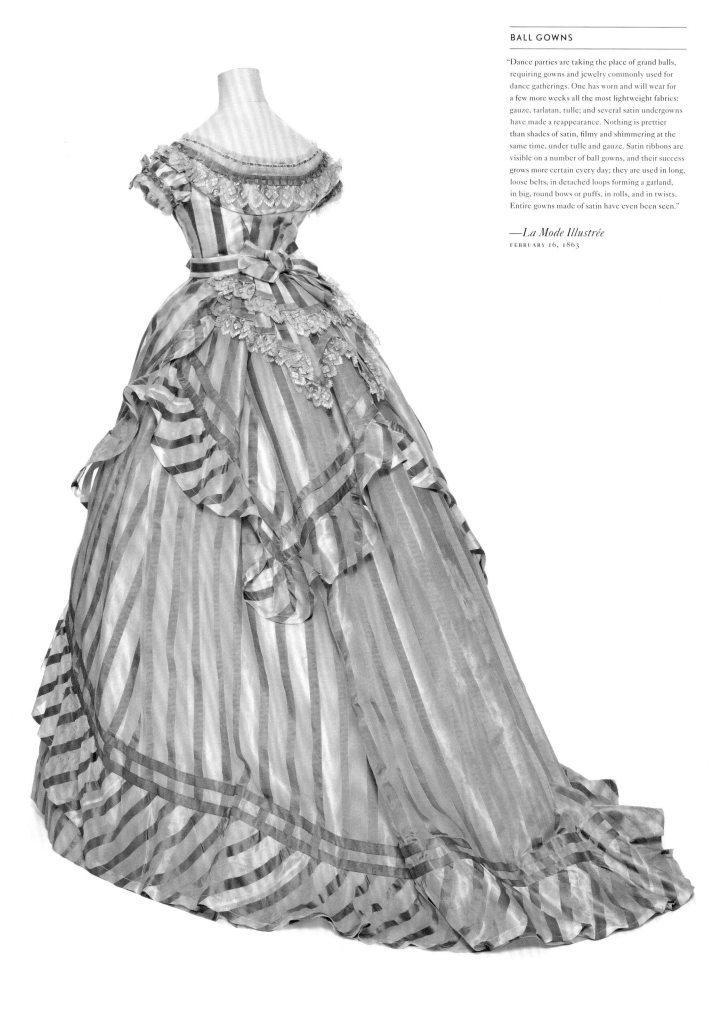

BALL GOWNS

"Dance parties are taking the place of grand balls, requiring gowns and jewelry commonly used for dance gatherings. One has worn and will wear for a few more weeks all the most lightweight fabrics: gauze, tarlatan, tulle; and several satin undergowns have made a reappearance. Nothing is prettier than shades of satin, filmy and shimmering at the same time, under tulle and gauze. Satin ribbons are visible on a number of ball gowns, and their success grows more certain every day; they are used in long, loose belts, in detached loops forming a garland, in big, round bows or puffs, in rolls, and in twists. Entire gowns made of satin have even been seen."

—*La Mode Illustrée*
FEBRUARY 16, 1863

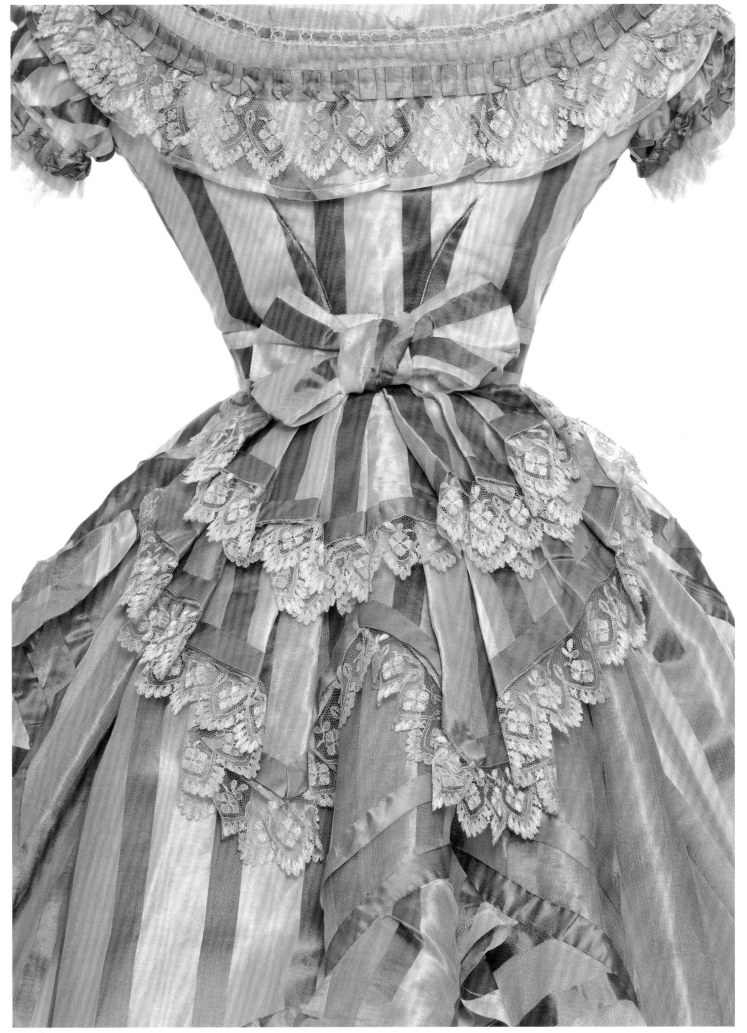

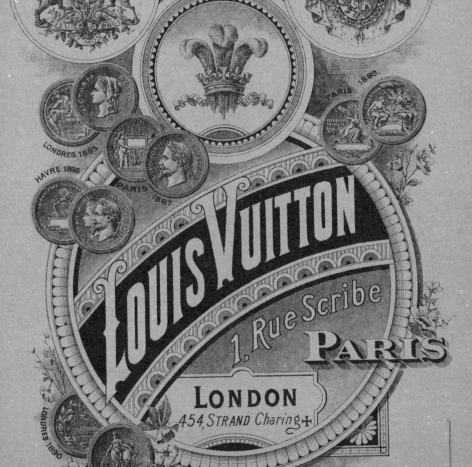

Louis Vuitton

1, Rue Scribe

PARIS

LONDON
454, Strand Charing+

LOUIS VUITTON

TERMS
NET CASH

INDEX

ALL PREVIOUS
LISTS ANNULLED

January 1892

PARIS — 1, Rue Scribe, 1 — PARIS

LOUIS VUITTON

Louis VUITTON

Being constantly on the look out for making new improvements to his trunks, to give his customers more and more satisfaction. begs them to excuse this catalogue being incomplete, as new models are always in preparation.

<div align="right">Louis VUITTON.</div>

WORKS :

<div align="center">

18, *Rue du Congrès*

ASNIÈRES-PARIS

</div>

LOUIS VUITTON

Louis VUITTON

Begs his customers to read his Catalogue with attention, and in case they should not find what they wish, to kindly note their requirements to him, and special plans et models shall be made for them free of charge.

<div align="right">

Louis VUITTON.

</div>

LONDON — 454, Strand (Charing +) — LONDON

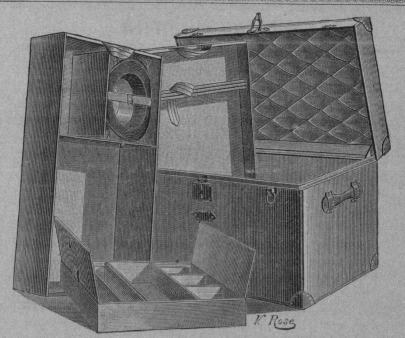

Our 35 ½ long by 21 deep, leather covered trunk, first serie £ 15.0.0

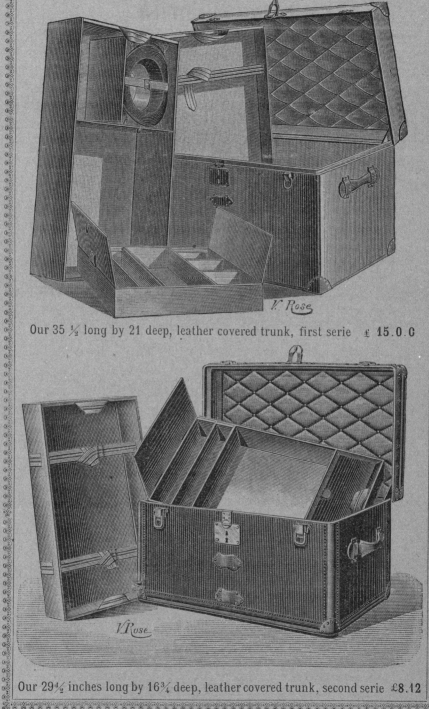

Our 29¼ inches long by 16¾ deep, leather covered trunk, second serie £8.12

LOUIS VUITTON

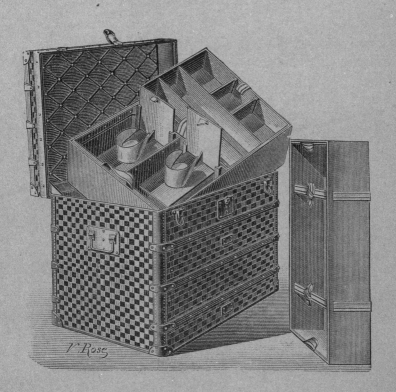

Our 29 1/2 × 19 × 22

3rd Quality with top tray divided

At...................... **4.0,0**

L. V'S DRAWER TRUNK

We consider all such trunks as unpracticable, in spite of the advantages they seem to possess, when looked at through a shop window. L. V. has, however, made a special model superior to those generally shewn.

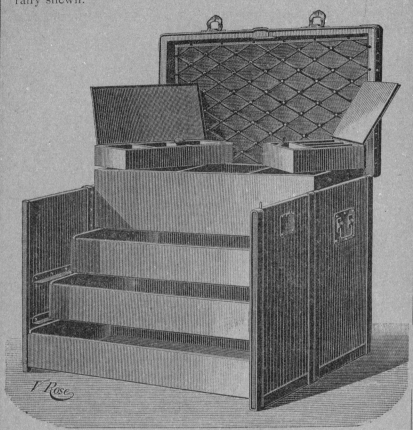

The model shewn measures

33 ½ inches long, 22 wide, 27 deep
made to order, outside all leather, inside lined leather & plush
value. £ 50

It can be made to order in any of our qualities from. £ 5.0.0 upwards

A fortnight's notice required

PARIS — 1, Rue Scribe, 1 — PARIS

LOUIS VUITTON

L· V'S EXPLORATOR'S
Camp bed trunk

unrivalled for comfort and wear

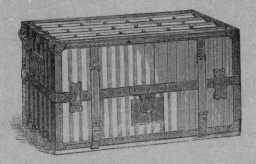

MADE FOR PRIVATE CAMPING

Gives a comfortable Bed, measuring 6 feet 6 inches long, 2 feet 7 inches wide, and when closed, makes a small Trunk, 32 inches long by 15 inches wide and 15 inches deep, containing the bedstead, hair mattress (2 1/2 inches thick), 2 woollen blankets and 4 sheets.

The great advantages of this Bed are derived from its being packed or unpacked in three minutes, whithout the aid of any tool, and from its having a large wide base, — given by the trunk, — which prevents any of the feet from sinking into soft or sandy soil.

Trunk & Bed..........................	£	6. 0.0
The trunk can contain 1 pure hair Mattress		
2 1/2 inches thick........................	»	2.16.0
2 woollen blankets at 12/..	»	1. 4.»
4 linen sheets at 10/.......................	»	2. »
Complete...........................	£	12. 0.0

PARIS — 1, Rue Scribe, 1 — PARIS

LOUIS VUITTON

L. V'S GLADSTONE BAGS

We keep in stock at our London branch the finest choice of British made bags, the lowest prices in London. They will not compare with those manufactured at our Paris works, made with our wrought steel frame and on best models with lock same length as bag.

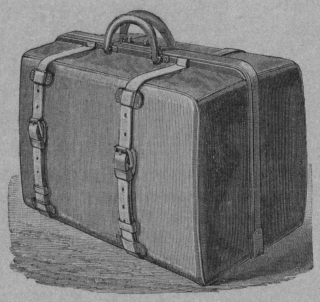

Inches	Varnished Cowhide cloth lining	Natural or brown Cowhide cloth lining	Black morrocco leather lining	Pigskin leather lining
20	72/-	88/-	136/-	152/-
22	80/-	96/-	148/-	168/-
24	88/-	104/-	160/-	184/-
26	96/-	112/-	180/-	200/-

PARIS — 1, Rue Scribe, 1 — PARIS

LOUIS VUITTON

L. V'S. "NEVER FULL" BAGS

Made of the finest cowhide or pigskin, lined with a special linen. Also kept in stock in London the finest British made bags of same style at lower prices than our own.

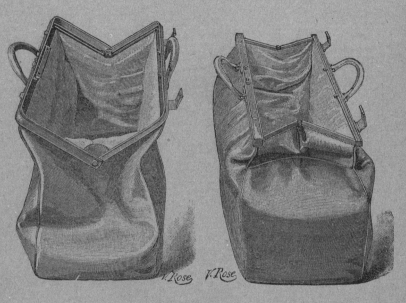

Inches	Varnished Cowhide		Natural Cowhide		Pigsktn	
13	40/-	double	44/-	double	64/-	double
14	44/-	hinge	48/-	hinge	72/-	hinge
16	52/-	frame	56/-	frame	80/-	frame
18	60/-		64/-		92/-	
20	72/-	82/-	76/-	86/-	104/-	114/-
22	88/-	98/-	92/-	102/-	112/-	122/-
24	96/-	106/-	104/-	114/-	120/-	130/-
62	104/-	114/-	112/-	122/-	128/-	138/-

LOUIS VUITTON

L.V'S LADIES' FITTED BAGS

These bags, made of the finest pigskin, or morrocco, always lined leather are made in many styles, with all requisites practically needed, so as to render them light and easy to carry.

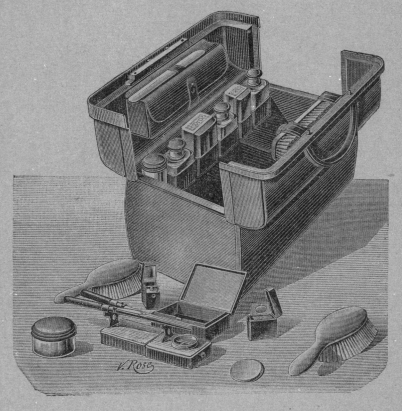

V. Rose

Inches	Morrocco		Pigskin	
	Plated tops Ebony brushes	Silver and ivosy	Plated tops Ebony biushes	Silver and ivory
	£ s.	£ s.	£ s.	£ s.
14	13 4	23 4	13 16	24 0
15	14 16	24 16	15 8	25 12
16	16 16	27 0	17 12	28 0

PARIS — 1, Rue Scribe, 1 — PARIS

LOUIS VUITTON

L. V'S LADIES' FITTED BAGS

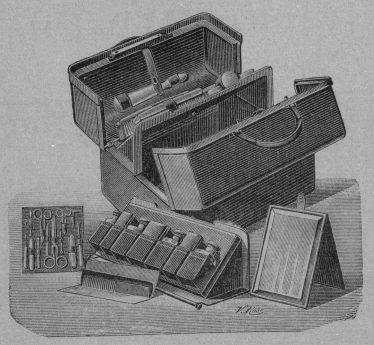

With all fittings in the top part, in vacant space that can not be otherwise utilized.

Each side can be removed by itself or both together

VERY COMPLETELY FITTED

Inches	MORROCCO		PIGSKIN	
	Plated tops Ebony brushes	Silver and Ivory	Plated tops Ebony brushes	Silver and Ivory
	£ s.	£ s.	£ s.	£ s.
15	17 0	25 4	18 0	26 0
16	18 8	27 4	19 8	28 0
17	20 0	29 0	21 0	30 0

LONDON — 454, Strand (Charing +) — LONDON

LOUIS VUITTON

L. V'S
LADIES' HAND BAG

Is the lightest bag ever made ; quite flat when empty, can carry any object.

It is the handiest shopping bag.

| Inches | Lined all leather | |
	Morrocco	Pigskin
	Shillings	Shillings
8	28/-	32/-
10	32/-	38/-
12	40/-	45/-
14	45/-	52/-

PARIS — 1, Rue Scribe, 1 — PARIS

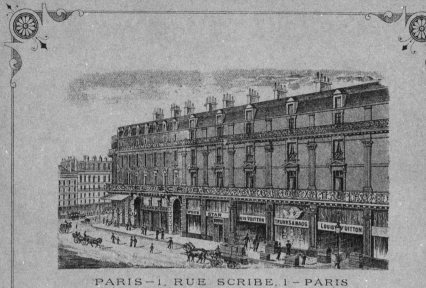

PARIS—1, RUE SCRIBE, 1—PARIS

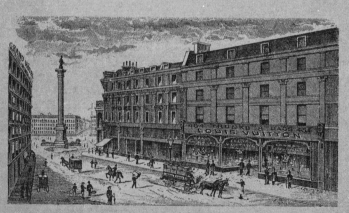

LONDON 454 STRAND (Trafalgar Sq)

This booklet is a selection of pages reproduced from Louis Vuitton's
first commercial catalog, published in January 1892, after the Louis Vuitton
shop in London moved to 454 Strand Street. Louis Vuitton Archives.

Marc Jacobs.

FROM A
TO B
AND BACK
AGAIN

5

PAMELA GOLBIN

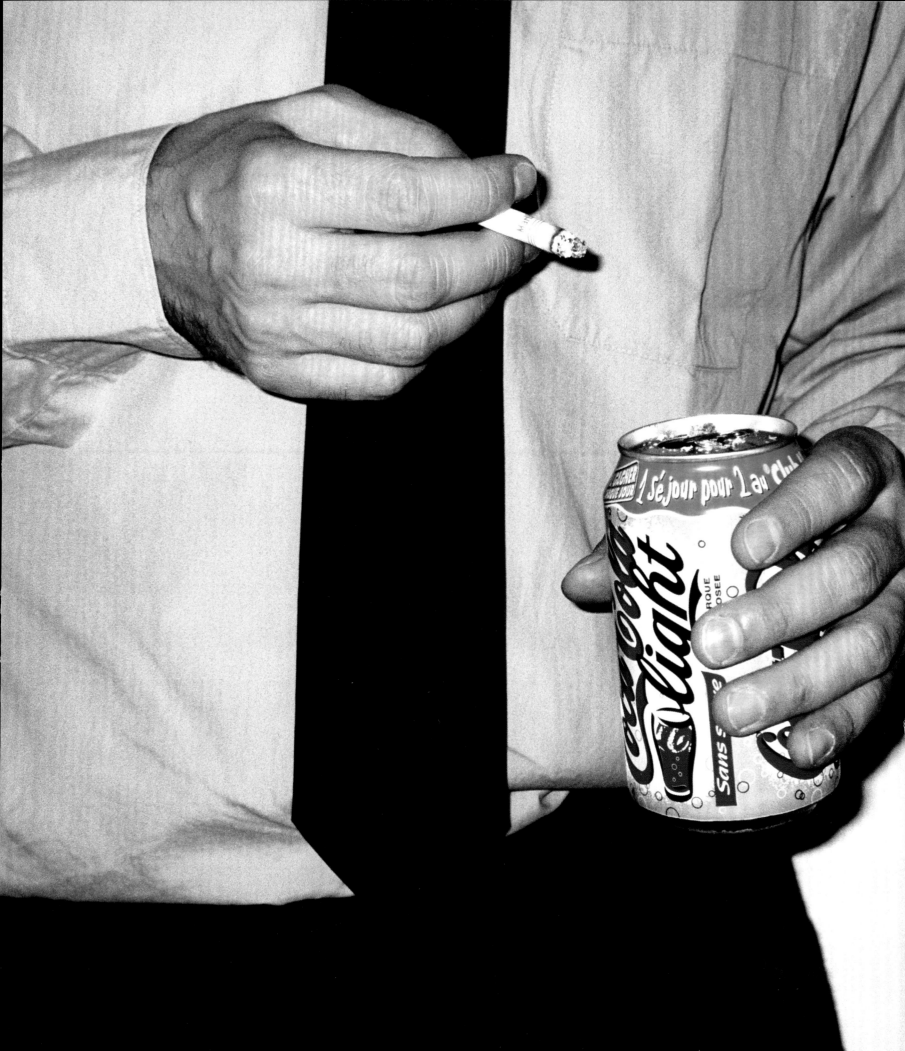

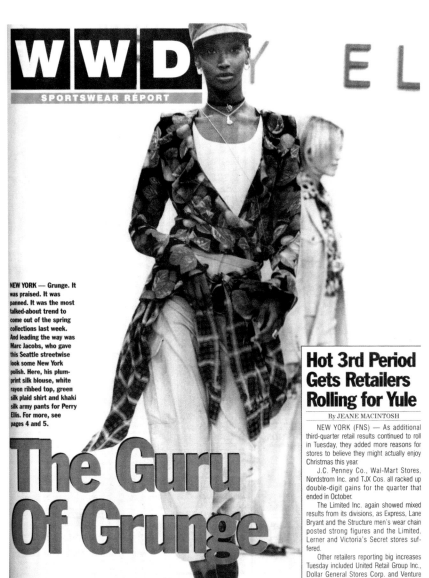

PAGE 107

Portrait of Marc Jacobs by Rankin, October 2011.

PREVIOUS SPREAD

Portrait of Marc Jacobs by Terry Richardson,
July 2001.

THIS PAGE

Cover of *Womens Wear Daily*, November 11, 1992.

FOLLOWING SPREAD

Kate Moss in a Louis Vuitton Jewelry 2001
advertisement photographed by Inez van
Lamsweerde and Vinoodh Matadin.

WWD

SPORTSWEAR REPORT

NEW YORK — Grunge. It was praised. It was panned. It was the most talked-about trend to come out of the spring collections last week. And leading the way was Marc Jacobs, who gave this Seattle streetwise look some New York polish. Here, his plum-print silk blouse, white rayon ribbed top, green silk plaid shirt and khaki silk army pants for Perry Ellis. For more, see pages 4 and 5.

The Guru Of Grunge

Hot 3rd Period Gets Retailers Rolling for Yule

By JEANE MACINTOSH

NEW YORK (FNS) — As additional third-quarter retail results continued to roll in Tuesday, they added more reasons for stores to believe they might actually enjoy Christmas this year.

J.C. Penney Co., Wal-Mart Stores, Nordstrom Inc. and TJX Cos. all racked up double-digit gains for the quarter that ended in October.

The Limited Inc. again showed mixed results from its divisions, as Express, Lane Bryant and the Structure men's wear chain posted strong figures and the Limited, Lerner and Victoria's Secret stores suffered.

Other retailers reporting big increases Tuesday included United Retail Group Inc., Dollar General Stores Corp. and Venture Inc.

F ashion underwent a tremendous transformation in the late twentieth century, and the American designer Marc Jacobs was an integral part of this change. In the 1980s and '90s, fashion—once the exclusive domain of a handful of international capitals—became a truly global industry, forcing the new generation of designers to evolve in order to meet the demands of the market. Creative talent was no longer the only criterion sought by the megabrands that held sway in this globalized world. Fashion designers were required to be even more efficient in terms of marketing and artistic direction while taking on the role of spokesperson of the brand. Marc Jacobs has proved to be the perfect man for this new paradigm.

Upon graduating in 1984 from Parsons School of Design in New York, Marc Jacobs was recognized by a trio of prizes: two Gold Thimble awards, from Perry Ellis and Chester Weinberg, and the Design Student of the Year Award. It was also at this time that Jacobs met Robert Duffy, who became his inseparable business partner. Hailed as one of the most promising talents of his generation, Jacobs gained experience through a variety of business ventures. He began by designing for the Sketchbook brand for one year, then launched his own label with Duffy's partnership.[1] Along the way, he suffered a series of setbacks, losing an entire collection to theft and another to a fire that gutted his studio in 1988 and going through four consecutive financial backers—as a result becoming known in the press as the "Comeback Kid."

"IT SEEMS AS BRILLIANT A MOVE AS CHANEL HIRING KARL LAGERFELD."[2]

On November 23, 1988, the press announced that Marc Jacobs—who had just turned twenty-five—had been named designer for Perry Ellis. Together with Ralph Lauren and Calvin Klein, Perry Ellis was considered one of the major names in the American ready-to-wear industry; Marc Jacobs's appointment as the head designer of a company with an annual sales volume of about $100 million propelled him into the major league of designers.[3] He was put in charge of women's fashions as well as given the responsibility for overseeing the design of licensed scarves, coats, glasses, shoes, and bags.

Unlike their Parisian counterparts, American fashion houses generally closed with the passing away of their founders.[4] However, upon the death of Perry Ellis in 1986, the new owners decided to promote the house—which was then in full growth—and called upon the creative talent and energy of Marc Jacobs. While most American designers dream of having their own label, Marc took on the challenge of designing under a name other than his own.

Jacobs set the tone from the start: "I hope to bring back the energy and sense of humor I used to admire so much. I want to make friendly, whimsical, and accessible clothes, and I hope to grow myself at the same time."[5] For four years at Perry Ellis, he was guided by the principle that "the aim of American sportswear … is to present separate pieces that can be put together in a different way, depending on the taste and the degree of sophistication of the wearer."[6]

However, with his second collection, Jacobs already had transcended the role of designer to adopt the perspective of an artistic director, advancing an overall and more coherent vision of the brand. He called upon the photographer Steven Meisel to work with him on his advertising campaigns, saying: "He has an amazing energy. He creates an exciting image, but the clothes don't get lost."[7] Together, they developed a concept in which youth and vitality were expressed by a single model: Linda Evangelista.

The image of the brand may have gained in clarity, but the collections did not meet with the expected success. As Robert Duffy was quoted in the press: "It's a challenge, all right."[8] Jacobs's turning point came when he decided to express himself freely, from his very personal point of view, as announced in the *New York Times*: "Marc Jacobs, who has had a hard time filling the shoes of the late Perry Ellis, has solved the problem by being himself."[9] Although his name did not appear on the Perry Ellis label, Marc both asserted his vision and distanced himself from the entire stylistic heritage left by Ellis. Having become an "uninhibited designer,"[10] Jacobs presented collections that were qualified by the press as being increasingly witty, amusing, and exuberant, his designs expressing a bold and dynamic vitality. At the presentation of his eighth and what was to be his last collection for Perry Ellis on November 2, 1992, Marc Jacobs was dubbed the

"Guru of Grunge" by the celebrated daily trade paper *Women's Wear Daily*: "Grunge. It was praised. It was panned. It was the most talked-about trend to come out of the spring collections last week. And leading the way was Marc Jacobs, who gave this Seattle streetwise look some New York polish."[11]

Coined by the Sub Pop record label to describe the punk-metal music of its groups based in Seattle, "grunge" quickly became a cultural phenomenon that was taken up by an entire generation. For Marc Jacobs, "grunge is a hippied, romantic version of punk."[12] He had his models wear "everything from matte jersey low-riding bell bottoms and shrunken car coats to romantic chiffon blouses and satin Birkenstocks… It's exaggerated proportions, like cartoon characters. A heavy foot with a light airy dress."[13] It was with this collection that Jacobs's signature style finally matured. The point was not to follow the establishment but to follow his instinct. Jacobs championed a trend that combined various influences, from the East Village to the French avant-garde that were upbeat and unexpected, but always cool. He did not define a template but instead expressed an attitude: a balanced offbeat mix, laced with funk, chic luxury, and a hint of trash.

With what became known as the "Grunge Collection," Jacobs marked the passage from one era to the next: "There is no wrong or right now."[14] It was no longer a matter of imposing the dictates of fashion but of freeing the consumer from them: "It's all about giving people choices. It's harder to sell that conceptually. It's hard to make people understand that, as opposed to saying, 'You should be wearing a skirt that ends here, with a shoe that looks like this.'"[15] Jacobs's idea was to deconstruct and demystify the fashion codes in order to apprehend them differently. A page had been turned. This was also the end of Marc's venture with Perry Ellis, for even as he earned critical acclaim, the collection proved to be a financial disaster. However, he had established his modus operandi once and for all: "In my heart, I always create grunge fashion." Jacobs, at barely thirty years old, and Duffy found themselves once again searching for new business backers. Ironically enough, it was the owners of Perry Ellis who were to finance Jacobs's new solo career.

"WE ARE GOING THROUGH A YOUTHQUAKE AS OVERWHELMING AS THE SHAKE-UP IN SOCIETY THAT CHANGED THE LANDSCAPE OF FASHION IN THE SWINGING 1960S, OR EVEN BACK IN THE ROARING '20S."[16]

At the beginning of the 1990s, a profound change in the fashion landscape was underway. Marc Jacobs belongs to the generation of American and European designers who broke off definitively from the fashion system that had long been dominated by the Parisian tradition of haute couture with its strict and outdated rules of decorum. Through their designs, they all defended a simple message, one in tune with the times: "aspirational

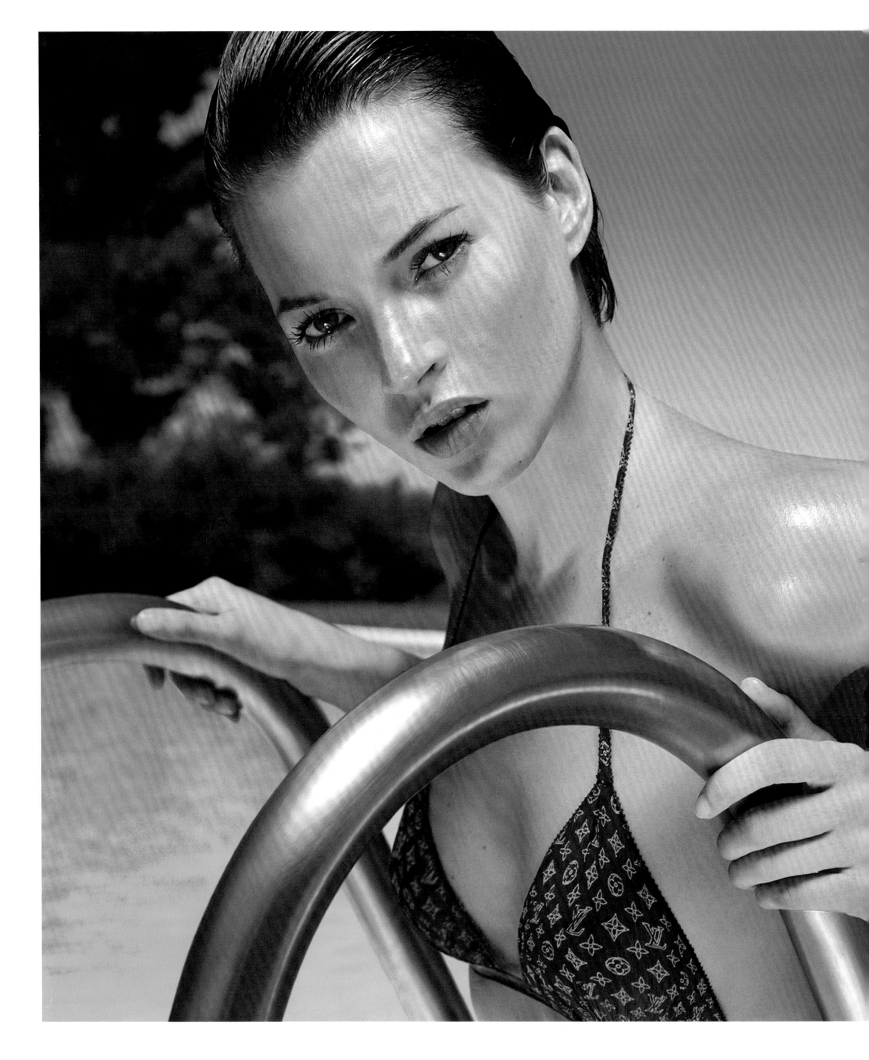

career clothes for women who want to take on the world."[17] The conspicuous consumption that marked the '80s was over. The grunge movement in America, like the Belgian School (as exemplified by Ann Demeulemeester, Dries Van Noten, and Martin Margiela) in Europe, protested against obsolete values and defined a new vocabulary of style. Overnight, minimalism became the height of fashion, spearheaded by the Austrian designer Helmut Lang. The Italian fashion industry positioned itself as the worthy successor of American sportswear, propelling the names of Dolce & Gabbana, Prada, and soon Gucci to the forefront.

Meanwhile, the First Gulf War came and went, leaving in its wake an aftertaste of global recession; nevertheless, as writer Michael Gross stated in unequivocal terms in *New York* magazine: "Fashion, having been overthrown, is being reborn amid the ruins."[18] By 1995, as noted in *Le Monde*: "Paris was once more the world showplace of fashion. The ready-to-wear shows in the capital inspired an unprecedented enthusiasm...."[19] Even the press noted that Paris was welcoming the arrival of international designers to take up the flag as mercenaries of French fashion houses: "This season marks a watershed moment in the globalization of fashion. For the first time, native French designers are in a minority at the ready-to-wear collections."[20] Seconded by Phoebe Philo, the British Stella McCartney joined Chloé; the Israeli Alber Elbaz took up the artistic direction of Guy Laroche; and the Belgian Martin Margiela championed his vision at the venerable house of Hermès. There was only one Frenchman in this manifestly international landscape: Nicolas Ghesquière, who took over the house of Balenciaga. But the all-out influx of Anglo-Saxon talent went to the French luxury group Louis Vuitton Möet Hennessy, which had been created by Bernard Arnault. Two explosive talents from the other side of the Channel, John Galliano and Alexander McQueen, found places respectively in the prestigious couture houses of Dior and Givenchy. And to revamp the great *maroquiniers*, three Americans were chosen by Arnault: Narciso Rodriguez for Loewe, Michael Kors for Céline, and Marc Jacobs for Louis Vuitton. The French press did not take long to draw its conclusions: "The young talents of New York's Seventh Avenue are there to counterbalance the excesses of the *enfants terribles* of London. Their mission is not to change the face of fashion, but to put design in the service of marketing, to dress the everyday in luxury attire, the chic without the shock. In a word: wearables."[21]

"IT IS GENIUS, HAVING THIS AVANT-GARDE, UNIQUE DESIGNER WORKING UNDER THE VUITTON TRADEMARK."[22]

On January 7, 1997, Marc Jacobs was named artistic director of the venerable 143-year-old Louis Vuitton company. His job was to introduce, for the first time in Vuitton's history, ready-to-wear collections for men and women, as well as a line of fashion accessories that included shoes and bags. The crown of the LVMH Group, Louis Vuitton was not the first house to diversify in ready-to-wear fashions or to call upon a foreign designer. The spectacular revival of the Florentine firm Gucci coincided with the arrival of the American Tom Ford at its head. As Jacobs explains: "Tom and I were good friends and saw each other socially.... And he is responsible for me getting the job at Louis Vuitton in 1997. The Chief Executive Officer Bernard Arnault was aware of Tom's success at Gucci. His thinking was, If one American could be so successful in Europe, why couldn't another? I was lucky enough to be chosen as that American."[23] Tom and Marc knew each other well, since Tom Ford had worked for Marc Jacobs when he was at Perry Ellis. But among all the American designers in Europe, Jacobs was the only one to have had the kind of experiences that proved to be a

conspicuous absence of the famous 'LV' logo ... and a minimalism that hesitates between not much and nothing at all, reinforced by the very-plain-dress and the discreetly quilted coat. Products on call, products for all."[26] On the other side of the Atlantic, the tone was more upbeat: "Jacobs, hip New York's fashion darling, presented minimalist clothes that are imminently salable and perfectly in tune with the new Vuitton image of understated luxury (good-bye, ubiquitous monogrammed pigskin; hello, subtly logo-embossed patent leather). The collection ... will no doubt be as coveted as the company's new accessories."[27] Unlike Marc's first collections for Perry Ellis, which had been criticized for being either "too Perry" or "not Perry enough," this time Marc was writing his own stylistic vocabulary on a clean canvas for a brand that had never had a fashion collection. "We couldn't make it look like old Vuitton, because there was no tradition, and if we put logos on it we'd be accused of looking like Gucci or Prada. So I started from zero, without putting any insignia on the outside of things—just in the linings, pieces in pale gray like the original Vuitton trunk and in fabric like bonded cotton that had both luxury and practicality."[28]

"TIMING IS EVERYTHING. THE RIGHT THING AT THE WRONG TIME IS THE WRONG THING."[29]

valuable asset in dealing with this new challenge. Through his own label, which he continued to design while working with Vuitton, Jacobs had cultivated a following among fashion editors and powerful buyers working for American department stores; they had supported him throughout his development. In addition, familiar with the intricate workings of the corporate world, Jacobs stepped onto the Parisian stage well-equipped with in-depth knowledge of the new fashion industry.

"AT FIRST, WE WERE DAMNED IF WE DID AND DAMNED IF WE DIDN'T... IT WAS A MINIMALIST START."[24]

For his first Louis Vuitton show on March 9, 1998, Marc presented a single bag with the LV monogram to accessorize an entire minimalist collection. In his incisive and humorous manner, Marc explained: "I made a conscious decision not to do what the fashion community expected. I mean, a lot of people came up to me after the show and said 'There were no bags on the runway!' Silly thing to say. We were supposed to be having a fashion show—it wasn't a luggage carousel!"[25] The French press commented ironically: "In keeping with the logic of the luxury LVMH group ... now here is the young American Marc Jacobs with the job of making clothes for a house that did not have any before. Conclusion: the

"In the very beginning, I used to define my role here as not to do away with the existing universe of Louis Vuitton but to create a parallel universe. And, in a way, I think those universes have gone further and further in different directions. You've got this ultra-classic conservative age-old world of Vuitton that exists alongside the very trendy up-to-the-moment fashion world. And I think the further apart those two things get the more they complement each other in a way. So you have Annie Leibowitz doing these ads with Gorbachev, Catherine Deneuve, and Agassi, showing this historical Vuitton attitude about travel and sophistication—this old world, in a new way. And then you have our Mert and Marcus side of it, which is glossy and glitzy and glamorous and about film stars and whatever. I think it's better the further apart the two become."[30] By creating these two parallel universes, Marc Jacobs has made a legitimate place for himself within the corporate entity that Vuitton has become without competing with the spirit of the house. As Yves Carcelle, CEO of Louis Vuitton, points out: "When he came to us, we were living according to long-term rhythms and very deeply rooted codes: a monogram canvas invented in 1896 and products dating from the end of the nineteenth century. He brought in a breath of fresh air. He integrated himself without losing himself. Today, we make up the oldest couple in the industry."[31]

Marc Jacobs has a precise and pertinent vision of the situation: "A great name. A famous, unique house that will exist after me. Vuitton is not a fashion company. We make 'fashionable' things, we introduced the idea of fashion, which changes according to the mood of the times, the icons of popular culture. But

the heart of the brand remains unchanged and unchangeable, which is just as well."[32] He very quickly recognized what was at stake and fit perfectly within the logic of the brand: "As Yves Carcelle often says, 'Louis Vuitton is a diamond with many facets that have to be handled differently.'"[33] Marc is very clear about his role at Vuitton: "My name is Marc Jacobs. My name is not Louis Vuitton, so I only play a contributor's role. That's it. I contribute. I don't control. I don't run the company. I don't always agree; in fact I very often disagree. I've come to accept that I can only do the best of my abilities, to show them products and then it's out of my hands."[34] Marc Jacobs masters the subtleties of management and design with great finesse. He chooses to work in a collective context, which he openly declares: "I am a 'designer' working in the midst of a team of designers. We make our proposals for ready-to-wear collections, accessories, and other LV products together. We present our ideas in the fashion show format, clothing and accessories together. We also give our opinion on the way things are presented at all levels, even advertising. But it is only an opinion, for within the LV structure, we do not have any possibility of controlling as far as merchandising, advertising, or the image. Design in fashion, as in every other realm, involves a series of choices. My creative process is born of constant communication within a team."[35] And so, quite naturally, Marc Jacobs called upon artistic collaborators like Stephen Sprouse, Takashi Murakami, and Richard Prince—associations between art and fashion that have become textbook examples for the industry.

The Vuitton style patiently elaborated by Marc Jacobs swings back and forth from season to season in order to better define the "LV woman" who is always on the go, always in tune with her times. Jacobs is comfortable navigating between the extremes—"Last season was painterly, and this season's sculptural"[36]—taking every liberty, without imposing any preconceived ideas: "Honestly, I do not have a specific plan. Everything here is linked to spontaneous wishes, and the public can feel this. I do not want to fall back on formulas."[37] Indeed, Jacobs continues to innovate "with impulses rather than numbers, because fashion is not a science."[38] He remains rooted in reality, intent on making his work accessible. "For some, life has no meaning without fashion, but for me, fashion has no meaning without life."[39]

What is the reason for the worldwide success of the Louis Vuitton label? From the CEO of LVMH Bernard Arnault's point of view: "If Vuitton is the foremost luxury trademark in the world—by far—it is because we have managed to combine a completely free creative process and a production structure behind it in which nothing is left to chance."[40] For fifteen years, Marc Jacobs has masterfully maintained a balance between his designs at Vuitton and those, more personal, that he creates under his own name. Jacobs works and commutes incessantly between Paris and New York, making the most of the two capitals of fashion. Has he defined a new breed of contemporary designer? "I'm not perfect, but I'm perfect in imperfection. Perfectly imperfect."[41] Or is it simply an obvious truth, which Marc sums up so perfectly: "We've been in and out of business, fired, everything. The thing is, I don't want to quit. I'm not a frustrated rock star. I don't want to be a fine artist or a writer. I just want to be a designer."[42]

OPPOSITE PAGE
Portrait of Marc Jacobs by François-Marie Banier, 1997

THIS PAGE
Marc Jacobs with Robert Duffy in 2007, preparing for the Spring–Summer 2008 runway show.

6

MARC JACOBS

AN AMERICAN IN PARIS

JO-ANN FURNISS

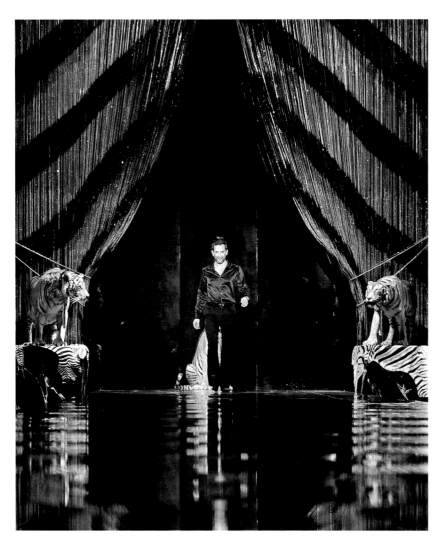

PREVIOUS PAGE
Portrait of Marc Jacobs by Terry Richardson, 2009.
THIS PAGE
Marc Jacobs at the end of the Spring–Summer 2011
runway show.

"I was in a clothing store," says Marc Jacobs. "I asked an assistant, 'Can I try a jelly jumper?' These great new sweaters [were] made from actual jelly…. Anyway, the man who was assisting in the store replied: 'We don't make jelly clothes for somebody of your stature, so no.' I was not allowed [to try on] jelly clothing. I was too short. That's just one dream that happened during the collection."

Three days after the Louis Vuitton Spring–Summer 2012 womenswear show, the dreams of Marc Jacobs will change but will still be tinged with self-doubt. Now the collection will no longer be complete; now the show will not have taken place. "It will take me at least a week to get over the nightmares," Jacobs says, sitting in his office in the Louis Vuitton headquarters in Paris. "The dreams about forgetting to book hair and makeup or how we forgot to book the models, or that a dress is not complete…I wake up and write all these notes of things for correction. It takes a while to let it go. It takes a week, a real week, to really move on to the next thing."

For now, in the idea of the future that a fashion designer like Marc Jacobs almost perpetually exists in—in fact, by its very nature, the fashion industry as a whole forever exists in a perpetual future—there will be a dream state of an unfinished past. That is, until he begins to sleep properly again. Yet in his awake, working life, Marc Jacobs does not like to think too much about what has gone but rather about what is to come. Ask when he began at Louis Vuitton and he will reply quite genuinely, "I can't remember."

"I have no idea of how old I was when I started here. My mind just doesn't remember dates," he says. "I cannot tell you what year I came here. I don't even remember what happened last season; how difficult certain things are around a show seems new for me each time. There are certain things I retain and certain things I forget. I have a built-in forgetter." In actual fact, Marc Jacobs was first employed as creative director of Louis Vuitton in 1997, aged thirty-four. The year 2012 sees the fifteenth anniversary of his role at the house.

Simultaneously, Jacobs is not futuristic. For example, he does not like the misuse of the word *modern* in fashion. This time last year, in October 2010, when discussing his Spring–Summer 2011 collection, he explained, "In the studio, we were saying to each other, 'We don't care if it is right or wrong, retro or modern. We just care that it is something…not just nice, smart clothes for women." At the end of the day, you have a dress hanging in a shop. If you like it and it looks good and it appeals to you, then it is fine. If it is made today, then it is contemporary. But there is nothing modern about an item of clothing, unless it can do something new, like wash your dishes or make your bed. There's nothing modern about two sleeves and a bodice. It is just a stupid conversation."

Although his compulsion to design is not governed by history, his encyclopedic knowledge of fashion history and technique and that of his atelier at Vuitton, like many of the great French houses, is reliant on the intricate history of craft passed down through generations, learned by and added to by a contemporary one. And it is craft that Jacobs has been obsessed with over this past year. Or, as he as he succinctly puts it: "Radically new does not last very long."

"Recently, I have been observing people taking on the 'style' of haute couture in prêt-à-porter—a surface look, but not the craft, not the 'high sewing,'" he explains. "I have a real respect for the craft of fashion, and that is what we have been concentrating on in our prêt-à-porter. What I really love to do is make things; it is just what I love to do. But there are actual specific rules for defining haute couture and being able to give something that term in this country. The French rules for couture are like the rules for the language. English dispenses with those rules and will take on board anything with a certain fluidity. I have heard that French *Vogue* is only allowed to use a certain number of English words per issue. The French are protective of their language and do not want it to be bastardized. We live in a world that keeps changing, but here you can't say *camera* or *computer*. I actually quite admire this. If you don't protect certain things, like an animal, they become extinct. If you have a respect for something or believe it is a thing of beauty, it should be preserved and it should last. These rules apply to a skill or a craft in France."

In many ways, this could be seen as the metaphor for Marc Jacobs being at the house of Louis Vuitton. He has brought the fluidity of the English language to a venerable French luggage brand and has changed the very vocabulary of it, in particular through the introduction of clothing. As the omniscient author of Vuitton, he has expanded its global vision and reach to a wider audience. At the same time, he is anxious to preserve the very things that drew him to head a French atelier in the first place: the dream of making things and, ultimately, craftsmanship.

"At the beginning, I was really confused and really…*scared*," explains the designer. "When I look back, it was exactly the same feelings I had when I was really young at Perry Ellis. It was the feeling that no matter what I did, half the people would be disappointed. Half the people expected there to be logos all over it, so if there were those, people would be satisfied and pleased, but if there weren't those, people would be disappointed because they didn't get what they wanted…this was kind of a no-win situation."

He continues: "Mr. Arnault wanted me to be here, and he took a chance. Maybe he was looking at the success of Tom Ford at Gucci. But whatever provoked him to start this endeavor with me—and I really just don't know—he gave me an opportunity to be here. I also knew I was damned if I did and damned if I didn't for a while. I knew the process would be about evolution. Whether people would like it or not was another thing, but it would evolve as long as I was given a chance. And luckily, I was."

Now, almost fifteen years later, Marc Jacobs can sit back and view his younger self from a position of confidence. Despite the nightmares, he now knows exactly what he is doing; he is the omniscient author of Vuitton, after all.

"When I first came here and looked at everything, I thought, *Well, it is not the most practical luggage, it is not the most lightweight—what is it that makes people buy it?*" he says of his initial defining of the brand. "I realized that it is [bought] because it is recognized. And it is the Monogram logo that gives that recognition. It is like Coca-Cola, Nike, Mickey Mouse, the American flag…. This is human nature, and people want to be the member of a club. You can be a card-carrying member of the Louis Vuitton club and have it recognized all over the world."

The Monogram has become something of a ready-made for Jacobs, and through it he has evolved a different conception of luxury for the brand while at the same time adhering to its heritage.

"I guess the Monogram always provided something to work with… or against," he explains. "But you don't want a jacket that looks like a trunk, and you don't want a skirt that looks like a trunk. So you need something as 'a thing.' It almost became—whether it was a plus or a minus, whether it was hidden or celebrated or collaborated on—a touchstone. It was what I thought of Vuitton."

He continues: "Through finding my way, building a team, and celebrating things I might have been afraid of at one point—such as the Monogram—instead of saying things like 'That is not what we should be about,' I embraced it. Maybe I was looking at the problem and not the solution at first, and then I decided to concentrate on the solution…."

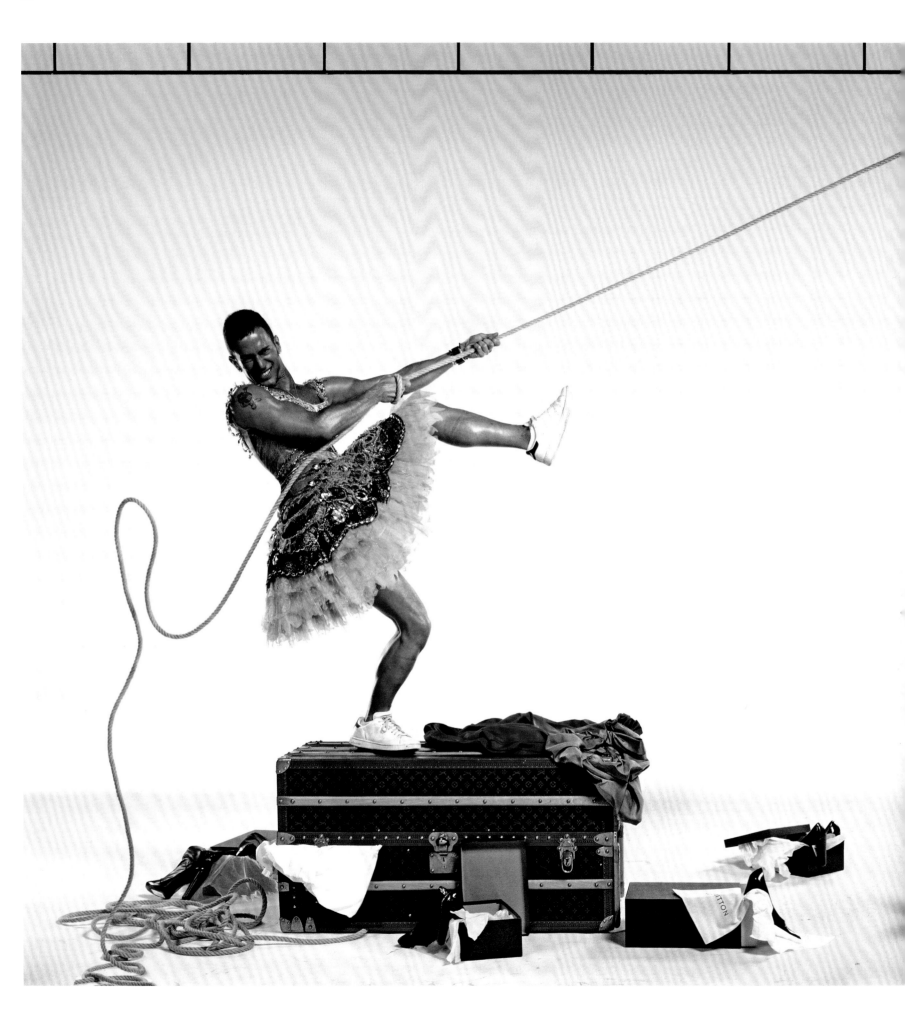

MARC JACOBS

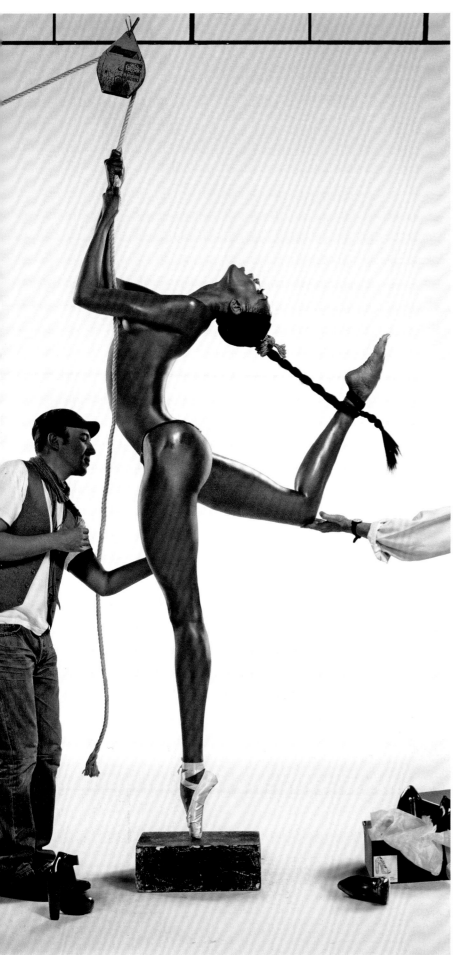

He pauses in his own train of thought before continuing on the train of thought he found for Vuitton. "I think this is a bastardization of something that Karl said—Lagerfeld, that is, not Marx or any other—I suppose I have twisted it into something I say a lot: I think you have to have a healthy respect and a healthy disrespect for an institution. You need to be respectful in order to preserve, but you also have to be somewhat disrespectful in order to evolve. When we did the Stephen Sprouse graffiti, it was a disrespectful act that looked like it was defacing something, but it was also calling attention in another way to something that may go unnoticed. I had all of those feelings about taking the venerable Monogram and sort of defacing it, but it also made it entirely visible for a younger group of people. It was disrespectful and respectful at the same time, and I think that is why it worked."

Quite understandably, his work on this first Sprouse collaboration is some that he says "I feel particularly proud of." It could also be read that in it, he found a solution to the problem or an answer to the question of what constitutes a luxury brand such as Louis Vuitton today. In many ways, for Marc Jacobs the subversion of the luxury brand became part of the luxury itself; the punk playfulness with the edifice of Vuitton became a dominant luxurious element.

The playfully smart, luxurious subversions of his collaborations with the artists Takashi Murakami and Richard Prince followed and are two of his other self-confessed highlights of his career so far at Vuitton.

"I loved working with Takashi Murakami and Richard Prince…but perhaps I am proudest of what we just did. I had said to a reviewer after the

show I thought the 'egg bag' was the most incredible thing we had done. She then said something like, 'After Prince and Murakami and Sprouse, that was quite a statement.'"

The egg bag in question comes in the form of a rounded 'Coquille d'Oeuf' Minaudière. This evening bag sums up the intricate crafting of the Spring–Summer 2012 collection overall for Jacobs. It was painstakingly constructed over three hundred hours, with 12,500 pieces of eggshell mosaicked to form its exterior Monogram pattern. It is a particularly rarefied technique and a craft that can only be executed expertly by a single person at this level.

"What I meant with that statement was that craft is what is most important to me right now," he explains. "It felt like the greatest thing we have done in terms of craftsmanship, and to me, it felt like the most important thing we have done at this moment right now. I felt it was the zenith of craft and of luxury. It wasn't diamonds or crocodile; it was taking an egg— and a hen's egg at that, not one from a rarefied bird—and painstakingly elevating something mundane to an absolute peak. And there is something very OCD about it, which I love. Neuroses can be a wonderful thing. Woody Allen turned it into a career. That obsessive, neurotic, compulsive behavior can really be a gift." He laughs before adding, "Have you seen that movie *Adaptation*? That maniacal pursuit of something, that obsession, I can identify with that."

Many designers working at the level of Marc Jacobs share some of that "maniacal pursuit" in their work. To do a job like this, at a certain level, you have to. Contrary to what might be widely believed, designers at grand houses do not secretly work with flowcharts, focus groups, and the like to come up with formulas for fashion. They work on the basis of instinct and compulsion and a finely tuned sense and belief that their ideas will eventually translate into commerce. The idea that what Marc Jacobs will anticipate and believe in will also be believed by and invested in by his audience for all intents and purposes is an act of faith.

"It is something that is very hard to explain to people," says the designer of his initial impetus for his process. "I often think, *Am I just not articulating this?* It is not like there is a choice of five different things and I pick one to focus on. It just is 'the thing.' It is the thing I am compelled to do. I am not sitting with a bunch of options. This is the commitment. I don't think people quite realize sometimes what it is like to be committed to something and how important it is. There is a certain process that has to happen for me to be secure enough and confident enough to be committed to a thought or an idea and be able to see it through. Once that commitment is made, there is no other choice. That is the point where everything falls into place. It is like a leap of faith, in a way. You have to take that leap, and then it becomes the map. If you are hesitant or confused, nobody knows how to follow."

In turn, this is also how Jacobs works with his team. "There is this delusion that a designer's or somebody's name that is on a label is this great,

powerful [Wizard of] Oz," he explains. "Everybody I know who is creative in some way influences me; I like the idea of creative exchange, but above all, this is true of the team." As the omniscient author of Vuitton, Marc Jacobs is far from hands-off, but he has the knowledge and the unerring skill in letting people that he has chosen to work for and with him excel at being themselves while still being firmly on message for his vision of the brand.

"When we first have our fabric meeting and I am listening to everyone in the team, sometimes I will think, *Hmm, no*, but if somebody is so committed to a thing, I will say 'Let's go for it' because it will evolve and I believe in them. But the foundation for that evolution will be the belief in something. It is having faith in other people and believing in what they do and why you chose to work with them in the first place as much as believing in what you think. It is that spark or catalyst."

At the same time, it is not merely a self-indulgent, solipsistic world of a designer and his atelier ensconced in an ivory tower at work at Vuitton. It has been Jacobs's skill in making a connection to his audience that has seen the might of the brand expand and given Vuitton a human connection for a whole different set of customers.

"I sometimes hear, 'Well, that was very courageous to do that.' But it has nothing to do with courage. I didn't do anything that was courageous," he says. "There are always two sides: you have to find that thing that pleases you, but it is not only for you. You hope that you will please others because without them, it is only masturbating. And it might work, but it is so much more fun to do it with a partner."

"I remember reading *The Moon and Sixpence* at one point, that whole argument about 'art for art's sake,'" he continues. "If it is only about creation, then the painting never had to be seen. Then literature never has to be read. Then music never has to be heard. Then clothes never have to be worn…. That is just not true, and anybody who says they are doing something only for their own sake, it's just not true. Or at least I don't think it is true…. On the other hand, I remember when I was in rehab and I was coming out of years of some drug stupor, and I would insist that I was only doing all of this to please others, that my self-worth was based only on pleasing other people. But the therapist would insist, 'You are doing this for yourself; you couldn't do what you do if this was just for other people.' It is true, you want other people to appreciate and recognize what you do, and maybe in your upbringing you need the approval of other people to feel whatever, but it is not only about one or the other; it is about both. You are compelled to do something because it is really what you do."

Today, Marc Jacobs is the happiest he has ever been doing what he really does at Louis Vuitton.

"I feel really good about this season," he says, a rare statement coming directly after a show. He continues, "It has taken so long to create this team to be really capable of doing what we did. It just felt really right and

really good. There was such a nice flow and feeling, and it does feel like we do manage to do the impossible somehow…. But everything is possible. It just takes everybody working toward the same goal. It was such a beautiful process, but the fear—the fear factor—seems to have gone. Of course, there were moments that were stressful, but I have such trust in the people I work with, and you know what's going to happen. That's a feeling that probably wasn't there two years ago; then I'd think we'd never get it done."

It is perhaps not surprising, then, that in this state of mind and with his anniversary approaching Jacobs felt ready to reassess the start of his career with Vuitton in the latest offering. But still, it was an unusual move for the designer who believes very much in the now to look back in such a way.

"I did look at my first collection for Vuitton a little bit in this one. It did feel kind of right to look at it again," he explains. "That idea of non-Monogram Monogram came from the non-Monogram trunk and an idea of luxury that was hidden. In that collection, we did these huge hems on the sweaters so there was as much of the sweater in the reserve hem as in the sweater you saw. [We showed] things had that weight—double-faced cashmere, lamb's wool in the hems of skirts. We only showed one bag, and it was white on white on Kirsten Owen. So this time I said we should only show white Monogram. Every time I saw a prototype in white, I just thought that it looked right. I kind of wanted to do the Monogram, but I also kind of wanted it to disappear. In the beginning, that led to us creating the Monogram Vernis, where you still see the bag. It created a strong surface, but the Monogram would be embossed and the shine would attract you. This time, it was about being able to see the Monogram through it."

There was also an undisguised and purposeful sense of joie de vivre in the collection, and in many ways, it was one of Jacobs's most distinct paeans to Paris and could be seen as both for and about Vuitton.

"I suppose I have that *Funny Face* attitude toward Paris," says the designer. "That 'I am back in Paris and there's the Eiffel Tower!' sort of thing. I feel like my life here is so unreal and so much about work [that] I don't see the politics, I don't see anything negative. Instead, I see the charming woman who works in the boulangerie who says 'Bonjour' when I walk the dogs. I tune out or I am not even aware of the negative. I like the wedding-cake aspect of it. Look across the street. If that's not a wedding cake, what is?" he says, waving over to the art nouveau concoction that is the La Samaritaine building directly opposite. "And that was just a department store," he adds.

"Is it the ultimate design experience being in Paris? Yes, it is," he confirms. "I have learned a lot about how I work technically by being here. I am not really a person who can achieve balance anyway, but somehow by going between New York and Paris there is a balance. Here it is slower and I feel calmer, but if I get too relaxed, I get bored, and if I get too stimulated

in New York, I get exhausted. Going and working in New York and Paris has created a strange sense of balance, both in how I work with the two teams and how the dialogue is between the collections."

He continues: "I actually get very emotional about being here. I love the love for fashion in France. A few years ago, I was in the airport and John Galliano was there, and the customs people recognized him. That was telling of how important fashion is here in Paris—a customs officer recognized him as a couturier. I can get in a cab here and a driver will start talking to me about the *defilé*—that would never happen in New York."

There are other reasons for his romantic view of Paris, as he explains: "I was always in love with that idea of a city of creative exchange. It was one of the reasons it felt very natural to do those collaborations with artists at Vuitton. There were various reasons for each one, but ultimately it was responding to something I felt and knew. I thought, *Just do it*. It felt like a way of perpetuating that beautiful twenties notion of the creative society in Paris, of Picasso doing a set and Chanel doing costumes. It was people who wanted to express their voice in different mediums and putting the voices together with others to create something else. It also seemed very French, somehow, that playfulness with Vuitton, that joy, that joie. It is such a beautiful word and has a lightness, a cheekiness."

In fact, *joie* became one of the defining words of the latest collection for Jacobs; the creative exchange this time focused on the supreme craftspeople he has access to through his French atelier. This idea of the romance of Parisian fashion became embodied in the clothing and accessories and personified by the women he can envisage wearing Vuitton.

"Again, it might be my fantasy of what this city looks like, this wedding cake or the idea of the Frenchwoman and her joyful flirtatiousness and playfulness," he says. "So whether she is playing at being a dominatrix or playing Jolie Madame or playing at being a coquette, it is a kind of pose. But there is nothing wrong with that. Everything is stylized here; the city is stylized, I like stylized. I like a bit of irony and perversity and wit. I think wit is one of the most admirable qualities in fashion."

At the same time, artifice does have its limits for the designer, and in Paris and its fashion Marc Jacobs has also found it to be a place with a soul. At a certain point during the interview, when talking about his travels between Europe and America, he asks: "Do you know the Gertrude Stein quote about L.A.? She said, 'There is no there there.' I can see that Gertrude Stein quote as quite a positive thing in that at times it can be nice to be somewhere that isn't! As fashion people, we like the idea of inventing an image or a façade, and L.A. is about actually inventing a city, so it can be appealing. But it also drives me mad after about four days…."

In contrast, for Marc Jacobs, as an American in Paris, there is definitely a there there.

THE LOUIS VUITTON DESIGN TEAM

AN ORAL HISTORY

INTERVIEWS BY MURRAY HEALY
EDITED BY PAMELA GOLBIN

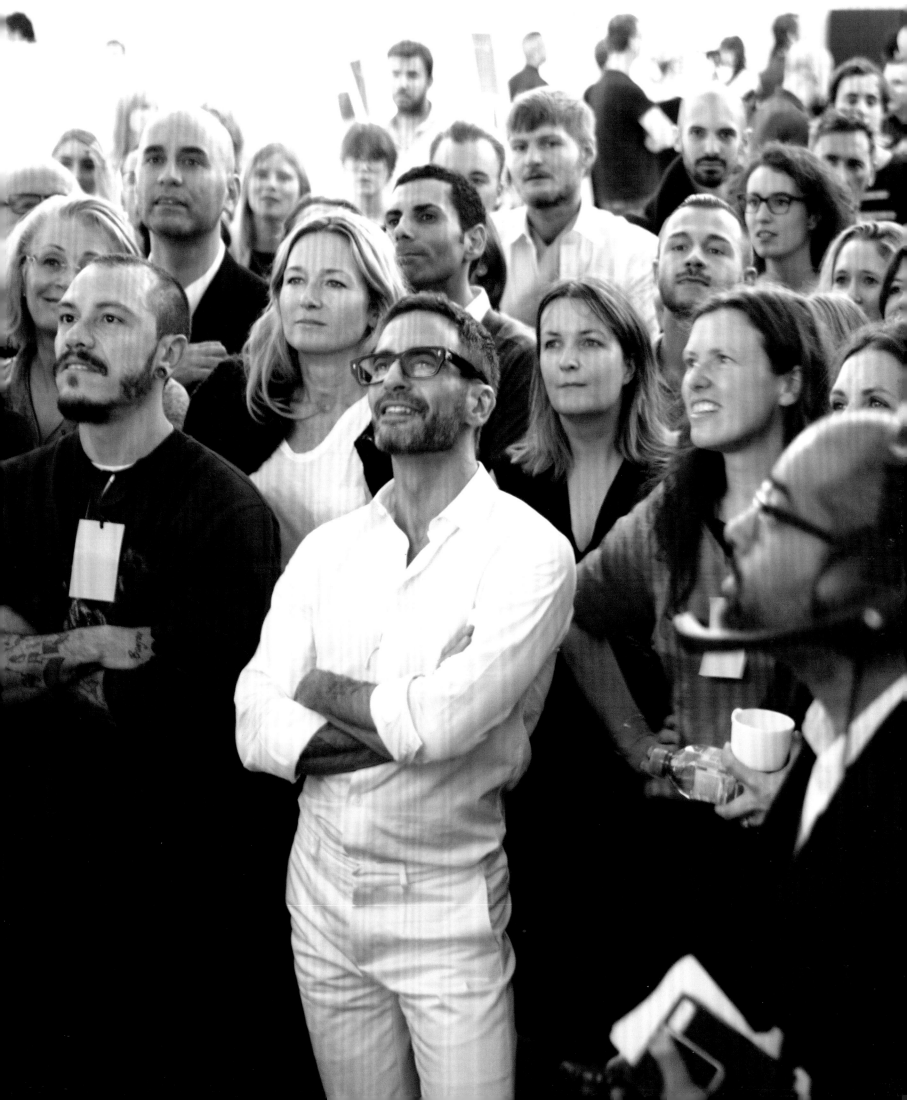

MARC JACOBS.
INTERVIEWED NOVEMBER 2011

JANE WHITFIELD
INTERVIEWED OCTOBER 2011

PETER COPPING.
INTERVIEWED DECEMBER 2002

CAMILLE MICELI
INTERVIEWED OCTOBER 2011

KATIE GRAND.
INTERVIEWED JANUARY 2010 AND OCTOBER 2011

FABRIZIO VITI
INTERVIEWED OCTOBER 2011

JULIE DE LIBRAN
INTERVIEWED OCTOBER 2011

FAYE McLEOD
INTERVIEWED OCTOBER 2011

EMMA WINTER
INTERVIEWED OCTOBER 2011

PREVIOUS SPREAD 127

Marc Jacobs and the Louis Vuitton design
team watching the Spring–Summer 2012
runway show from backstage, October 5, 2011.
Photo by Sølve Sundsbø.

IN THE BEGINNING…

Marc Jacobs: I probably took a lot of things very seriously in the beginning, but we all went from strength to strength by finding what it was that we could do and that we believed in.

Jane Whitfield: I met Marc Jacobs and Robert [Duffy] one Saturday morning in Milan [in 1997], and they said they were interested [in working with me], but they didn't mention anything about Louis Vuitton at all. It was about working with them on the Iceberg second line in Rimini, where a friend of mine worked, and I went along because I was really interested in meeting Marc. And then about two weeks later I got a letter from Louis Vuitton, an invite to come to Paris. By then there were a few mutterings on the grapevine that Marc was going to do it, but it wasn't sure or anything. So I turned up in Paris, and then he explained: "We're setting up a team to work in Paris for Louis Vuitton."

It was quite interesting from then on, because it's a huge corporate structure, you're not really sure what you're getting into. So Marc and Robert are basically, "Yes, we want her," and then you have to go through this whole kind of psychotherapy, meeting lots of different people. I went over there quite often, and there was one day I must have met about seven people from all over, from HR, up to the president, to Yves Carcelle. I guess at that point it was already decided, but you have to go through the whole rigmarole.

I'd been at Gianfranco Ferrè for two and a half years, and that after leaving college, so I was still quite junior really. It's really organic, what you end up falling into. It's more inclined toward what you like. It was never really "You're going to be…" The post was designer on womenswear. But designer ends up being a huge thing, because we always work together on everything, basically.

I moved from Milan and started in March '97…. It was really an interesting prospect, really amazing. And especially having someone like Marc at Louis Vuitton! The excitement of that was really there. But what we didn't imagine was the reality of what was not there *(laughs)*. We probably expected a lot more than what was there. Which was very little.

Peter Copping: I was brought in to be a senior designer in March '97. I met these kind of headhunter people first of all and they presented me to Marc and his business partner from New York, Robert Duffy. So I met with them a couple of times and we got on pretty well instantly. We had that common ground of the Iceberg thing. There was another thing that Marc said: "I took you on 'cause you were wearing Carhartt trousers and I like that." 'Cause he is swayed by the way people dress and how they look, and I think he quite liked it that I hadn't really made an effort when I went along to the interview, that I hadn't dressed up. Those details are

significant! You can judge a lot from the way someone presents themselves, as much as by looking through their dossier. It's those kind of things that are important for Marc—that they have old Carhartts on.

Vuitton was such a huge brand anyway and it seemed quite weird when you saw other companies like Gucci and Prada, all luggage companies that had started from the same roots as Vuitton, that Vuitton didn't have a ready-to-wear line. And the exciting thing was you knew that if they were going to start something up, it would be done properly. They're a company that has the budget to do it. That was interesting, I thought— you knew it was going to be a really good product.

Camille Miceli: I was working at Chanel before, and when I heard about the prospect of doing ready-to-wear for Vuitton I was very excited by the idea. So I spoke about it to Naomi Campbell—very glamorous! And to [my friend] Michel Botbol, who at the time was working at *Women's Wear Daily*. And they both went to Marc and said, "If you need a PR person, why not get Camille?" because at the time I was doing communication. So that's basically how it started. And then we met and we immediately fell in love.

To me it was super exciting that you had to build everything. To develop something that had never existed before. I was supposed to take care of communication. But there was nothing to communicate about, because there was nothing there yet.

You should have seen that place! Because when I did the first interview with the [Vuitton] executives, after the [initial] meeting with Marc, they were at La Défense. That is the most terrible place you could find.

Jane: Originally we were meant to be in the Grande Arche, which was one of the places that I'd met Marc in, and he was like, "There's no way on God's earth that we're going to work here." I mean it's an amazing building, but inside it's just… ugh. Awful.

Camille: So luckily they rented an *hôtel particulier* [a private townhouse with courtyard] in rue du Bac, which was super nice. But the neighbors were not the happiest of people because they were seeing all these lights always on. So they used to show their anger against us by putting vacuum cleaners and brooms outside on their balcony. Quite funny, I must say.

Jane: Yes. It was rue du Bac in a courtyard right next to the, the taxidermy place, Deyrolle? A *hôtel particulier*, beautiful. Within the courtyard there was another *hôtel particulier* in front of us, which was a residential house. We must have driven them crazy—well, we did, actually. When we moved in, there was basically nothing there. There was carpet. There were padded walls in an apricot colour. But no tables, no desks or anything.

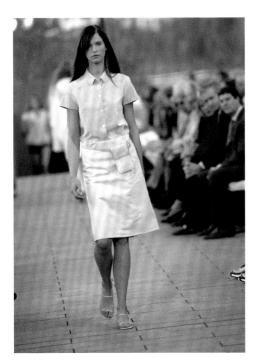 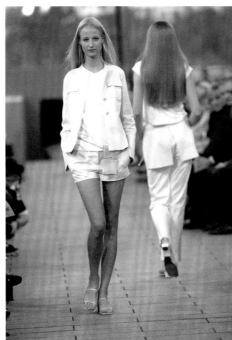 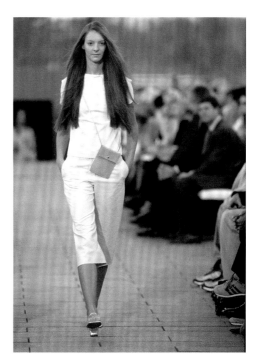

Runway show, Spring–Summer 1999, looks 11, 17 & 21.

FIRST COLLECTIONS

Marc: Before we ever showed? I don't remember too much. I remember we had some crazy late nights. None of us knew what we were doing. We were working on a presentation, basically. We were trying to figure out what it was that Vuitton should be in terms of ready-to-wear. That was before the first show.

Camille: Well, for that first year there was a kind of brainstorming between everyone to work out what Louis Vuitton [ready-to-wear] should be.

Jane: We sat on the floor for quite a long time in the end. I remember pictures of us sitting on the floor. I think that after a few weeks we actually got tables. We didn't have an atelier, so what we would do, like a lot of people, was to work with factories in Italy. So it started like that, basically. Collection Zero started like that.

Marc's vision for Louis Vuitton was really quite interesting. [Collection Zero] wasn't about doing a show, it was really about very wearable things. Very simple things. It was quite logoed. It was very minimal, simple, very much about the most beautiful coat, the most beautiful mackintosh, the most beautiful cashmere sweater, the most beautiful leather piece. It was very much about items. Not in the sense that you'd think of a collection for a show. And so that was how we started. And his [internal] presentation had been very much about the coolness of travel. It very much stemmed from there, and his love of really beautiful textiles and materials and things. Basically we had all of that, the ideas, but not necessarily the means to do it. I mean seriously, nothing! *(Laughs)* When I think about it, it's just so bizarre.

Peter: Er, I'm trying to think how it was back then. There weren't so many demands on us 'cause the first collection there wasn't even a show.

Jane: It was basically like having your own collection. You know? Like… it's your label. It was obviously not our label, it was Marc, it was Louis Vuitton, but when you set up your own label you basically have to do everything. Like go and find factories… I spent a lot of time looking around factories. And slowly, slowly we got people who could support that. Developmental people…. But in the very beginning it was very much like, Marc had a couple of factories in Italy, especially a cashmere factory that he always used. So we started knitwear there. And then we just started to try and find people to do it in the beginning. But that was before we had the atelier. It wasn't until we did the first show collection that we had the atelier. We were there for quite a long time doing Collection Zero, which was kind of just on paper, and then to actually do a collection. It was a year before we actually set up a proper show collection.

It was mostly from sketches, very simple. Then we slowly got someone to start doing patterns. We had someone there that was basically in our room, toile-ing [making up patterns]. It just grew slowly like that. Then we did the first collection, which was actual pieces. You know, garments and clothing, and things like that. And that was quite interesting because Marc started the Monogram glasses, he started with the bags. And he had this idea for this leather, which was quite unheard of at Louis Vuitton, if I may say: real leather which was patent to look like the glasses, with the Monogram embossed. I think that was the real turning point because it was very successful, and it came from him. Then I think they started to think, "OK, we can make money out of these people in some way." That was quite the turning point. Yves Carcelle was very excited about it, because it was their language. They didn't understand our language. At the time, there were only two collections a year, so it was six months— for them, that was really quick. In their language the turnaround for bags was two years or something, it was enormous. So they learned a lot, and so did we, I guess.

Marc: I had this idea that I wanted to do the Monogram but I wanted to make it invisible. So we did this Monogram *Vernis*—we came up with this idea of creating a surface that was very visible and striking through the colour and the fact that it was shiny and patent leather, but the Monogram had become just embossed, so it kind of disappeared. Again, it was about making something more visible but downplaying something of what it had always been before, or changing what it had always been.

Peter: At the beginning Marc was even more involved and I think it's because none of us really knew one another so he was probably less sure of giving someone else responsibility. We've won his confidence over the seasons.

Jane: Well, it was quite funny because Peter and I had to order the fabrics ourselves. We'd source the fabrics, we'd show them to Marc, we'd make a choice, we'd put the colours on. This was before we got a fabric person. And [Peter], for some reason, went toward the silks, because he's more silky, and I for some reason went toward the wools, because I'm more… woolly. *(Laughs)* You see? And what happened later is Peter went more toward the embroideries, because he's so into that, and I went more toward the knitwear. I mean, we both worked on the ready to wear. But those specialities were just what we went toward naturally, without Marc saying anything, really. Because that was what we liked doing, really, that was what it was.

Peter: So then the team fell into sort of natural roles, and I'd always worked much more on the research and style of things. Jane is a brilliant organiser so she worked very much on that side and then she took on the knitwear. That's how it developed. I'd say I fulfil the role a bit like Venetia Scott does for him at his line in New York—she starts the research at the beginning of the season, proposes direction and all of that. I kind of fill that role.

Camille: And then as we approached the staging of the [first] show a year later, there I was with the atelier. I was in the same room as the atelier *(laughs)* and I had only one person with me, and I had to do all the production of the show, everything! All the PR, everything, by myself, with one person.

At that time the Paris collections were before the New York collections, and we were showing on the first day. So I went to see Marc and I said, "Listen. As we show on the first day, we should maybe do an invitation and a press kit that people will carry around during the week of the collections, so that the Louis Vuitton name gets spread around." I was having more fun doing those things than doing the PR.

I think that the first show that Marc did [for Vuitton], which was March 1998, that collection was such an important one because he said, "OK, this is just to establish the base, and then we are going to evolve." Which was very clever of him. The edgy part [only] started when Louis Vuitton did the collaboration with the designers for the centennial of the Monogram. And then Marc really transformed that place. Not in terms of product but in terms of image, also. It's always been a debate, either for Marc, or for Peter and Jane, to find the right balance between something fashionable and something showy, something sexy. And I think that now, Marc has got the balance exactly right.

Peter: The second collection they decided to do a show, 'cause obviously they were interested in the show being the vehicle to promote the house, so that happened fairly quickly. There was no one to do fabrics—it was a really small atelier at that point, so I had to work on the fabric research a lot, ordering all the material at that point. So I was on the phone to Italy getting the fabrics in and making sure that was done. That didn't really leave that much time for designing.

Jane: We were still in this kind of two-up, two-down place, the *hôtel particulier*, and then to do the show, we needed an atelier. So we started with the *chef d'atelier*, for a trial, and then we basically built up the workshop. A few of them are still there, from the beginning. There's always people around who've come from really good houses, so they have that kind of expertise. But it's quite hard to get that kind of a modern touch as well, which Marc is kind of obsessed with. There's an entrenched way of doing things, and it's quite special. But to get also a kind of a modern [feel], so it doesn't look old, is quite a hard thing.

At some point we took up the carpet and put some decent flooring down, and then put the atelier in. Which drove the neighbours even more crazy, as you can imagine. We were in this beautiful *hôtel particulier* in the

Autumn–Winter 1999–2000 runway show, look 11.

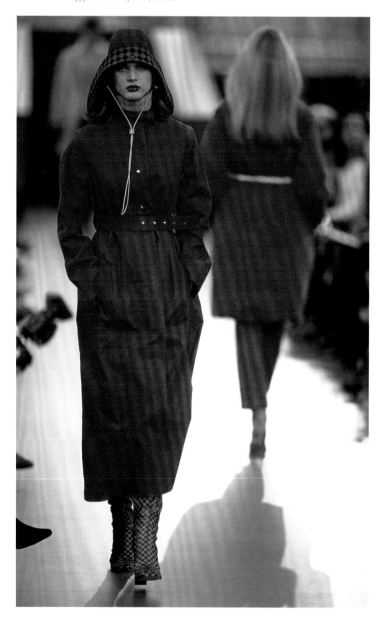

MARC JACOBS

Marc Jacobs surrounded by friends and collaborators, including Jane Whitfield, Camille Miceli, Peter Copping, Lee Radziwill, Robert Duffy, Katie Grand, and Pharrell Williams. Photo by William Klein, 2007.

Seventh, in the courtyards, and you look over and you can see an atelier making clothes all day and night! *(Laughs)*

Marc: At the time we were working with [stylist] Joe McKenna and the original team —it was just a few of us. And we took this grey [19th century Louis Vuitton] trunk as inspiration. There was one bag in the whole show—it was a white messenger bag that was very close to the messenger bag that both Joe and I carried, which was a black nylon messenger bag. So we made it in white lamb and it had a blind-embossed Monogram. With the clothes, the buttons had *Louis Vuitton* on underneath so they were not visible; the tapes on the inside of the raincoats had the Monogram but of course it was on the inside. I remember feeling that the luxury was all hidden. We did skirts that had huge resources, huge hems that were wrapped twice and these cashmere sweaters that were endlessly long but they were folded up twice and they had these bulky hems. So there was a lot of extra luxury but it wasn't what you saw. And I think, if I remember correctly, it was this pale grey, non-Monogrammed trunk that I decided at the time should be the start [the source of inspiration] of the Vuitton ready-to-wear.

Jane: Well, in the first show collection there was only one bag *(laughs)*.

Peter: And then Marc looked to the rest of his team for a lot more help. We just pursued it much more in the style of how I thought it should have been from the start—a little bit more frivolous, more Frenchy, less stark, less cold; the first collection was very minimalist, very severe in some ways. It *was* luxury in some ways—the fabrics: lovely cashmeres, beautiful silks; but outwardly it didn't read as a luxurious collection. I think it's that balance you have to find, a conspicuously luxurious collection that never becomes vulgar. There's a fine line between the two but I think it's something we tried to find.

Jane: For me, the [Autumn-Winter 1999] collection with the red mackintoshes and the red hats was a very full collection; I loved that collection. I think that was a very complete collection in lots of ways, with the little bags. There were a lot of clothes; it was very rich. I think that was quite a turning point for me, that one. And then there's the Sprouse. That was a turning point, massively, for everyone, because of the use of an artist. And then it grew from there, with Murakami. You know, the whole thing. But the Sprouse collection was really "Ah, that's clever," you know?

TEAM

Marc: When I arrived I interviewed people: I met Peter Copping, Jane Whitfield, Camille Miceli, Victoria—we were a small team. It was Robert and I who interviewed everyone and we didn't even have an office at that time. We were out at La Défense and we were interviewing people from hotel rooms.

Jane: We didn't have job titles for years. I hate job titles! They really get in the way. We never had them, until the structure got a lot bigger, and it had to have that, because of the corporate situation, and people had to know who to go to for what. [But before that] it was very free. I mean obviously Camille had her job title, because she was doing what she was doing, at the time. But we were just designers for a long time. Marc's very good at

putting people together, he does have a good sense of that. I mean, he must do, because the team stayed together for years, basically from the beginning.

Peter: That's one thing that Marc's really good about. Whenever he speaks about the collection publicly he's always saying, "*We* thought we'd do this or that…" So he's always acknowledged us all and said it's very much teamwork.

Camille: What was very unusual was to have a designer who gives you a lot of freedom, who gives you so much space to do things. That's very rare. And I must say that Marc is exceptional at that. Because he has the ability of getting the best out of people. You know? Me and Peter and Jane…I mean, we were spending our lives together. During the time of the show, for a month, we didn't have any other life than Louis Vuitton. So we were spending morning, lunch, afternoon, dinner, night, all the time, weekends. You'd better get on well together! Because otherwise you don't do it. And there is a kind of freedom also in the relationship with people, you know? You don't have to fear [judgment]. You are free to express yourself, then either Marc likes it or he doesn't. But he lets you [express it]. After one or two seasons he came to me and he asked me to design. He was not doing jewelry in the collection then, so he asked me for a pair of earrings. So that's how the second stage of my work there started, the costume jewelry at Vuitton.

Katie Grand: I think Mert [Alas] and Marcus [Piggott] brought me in. I knew Marc socially because I gatecrashed his dinner once! It became a ritual that we would never be invited but we would always go anyway. And Marc would always be very happy to see us—presumably it's good to see fresh faces when you've been locked in the studio for weeks. So I started working on the campaigns and that was before Marc was really involved with them [professionally]. And then I started working on the men's shows with Keith [Warren]. Then I was asked to do the women's shows and I couldn't because I was with Prada at the time. And then when I stopped working with Prada I started working with Vuitton.

Fabrizio Viti: I think it was around seven years ago that Vuitton called me to work with them. I can't remember exactly what my job title is— I'd have to look at my business card! (*laughs*) But anyway, I am in charge of the shoes for men and women, and I am involved in both the commercial collections and the shows… And the best part is working with Marc, as I'm sure you know. We are more or less the same generation— he's just a few years older than me. It's the first time I've worked with someone who has the same rationale. Marc is very, very funny—*Hello Dolly*, Barbie, and the *Eyes of Laura Mars*—I have got on very well with him since the beginning. We have more or less the same references and I like what he likes. It makes it easier if you know what I mean.

So in a way it is very easy to work with Marc. On the other hand, it's very hard and complicated because Marc is obsessed with detail. I think he is the only person I work with who has a global view of the collection. As the designer you work with prêt-à-porter shoes, bags, and so on. Shoes are not his main thing, but he is so obsessed with detail that he knows everything about them. He knows everything, he checks everything, he is aware of everything. He knows every single colour and every single material from every single tannery in the world. If you ask him "What's that?" he'll say what it is right away. And he's always right! He has this strange kind of memory. He knows every colour by heart—every code of

every colour. So in a way it's like working with someone from the development department! *(Laughs)*

Julie de Libran: It's all about working as a team, giving each other ideas, and constructing them little by little.

Faye McLeod: When I started I was just [doing] the windows. My whole thing is windows, more about the branding of a company and giving it a personality, that's always what I've done.

Somebody called and said, "Marc would like to see you." And he said, "So, do you want to do the show with me?" I was like, "No, I've never done this before." And he just said, "We'll teach you. Treat it like a window." Marc has an ability to inspire trust. I refer to him as the Wizard of Oz. He's like the mad scientist in his laboratory, because he brings all these different people together, and he mixes all the potions up and the people up, and it ignites. But his feet are on the ground, he's planted in the ground. When you work there you feel like you're part of a real team.

Marc: I don't believe anybody does anything on their own, in terms of designers. I love that quote about the whole equaling the sum of its parts…

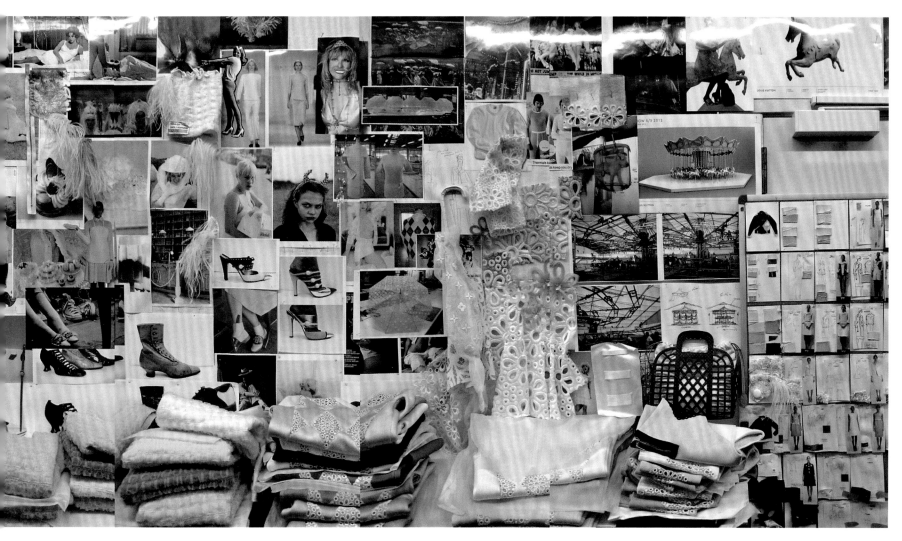

Inspiration wall for the Spring–Summer 2012 collection.

THE SECOND FLOOR

Peter: The Vuitton building is this huge building in the centre of Paris. Whenever anyone comes in they're really wowed by the foyer, which has padded leather walls, dark wood, and big sofas. But then you get up to our department and there's cardboard boxes lying everywhere, vintage clothes hanging around—it's a real mess up there. And they've really left us apart. There's been a little bit of control but never really that much; we've always been very free. And it really is a very corporate atmosphere. You take the lift up to our floor in the morning and it's quite funny, you're with men in suits or French ladies with their coiffed hair, perfectly turned out, and they give you a bit of a funny look 'cause you're there scuffing around in jeans and trainers and what have you. But they know that we're capable of making a really luxurious desirable product.

Jane: And we didn't really want to move to the Belle Jardinière [building], because we were quite happy, even though the space we were in then was very dysfunctional, it wasn't really a design studio. But eventually you give in to that, and we moved there. And it was fine in the end. We got to design the space, after a few years, and it grew. We had our own kind of enclave on the second floor, which was very separate.

I think it's very much to do with their badge system. No one's allowed on the second floor unless they have a badge. I think that the rest of the

company created that myth as well. We've always been quite open, to a certain extent, but we are "the designers." I mean, Marc is not a scary person, but to the outside he is, weirdly. He's very strong, he's a very strong personality. He's not scary, but I think that he scares people, to a certain extent. So there's this whole kind of design set, with him at the head, so maybe that all was created in some way.

Emma Winter: I was on the fifth floor, so three floors above. It was like chalk and cheese. One was the business side and the other was creative.

Peter: There's so much clutter around, there's no space to breathe. It's kind of open plan, there's a lack of space. We're going to be getting new offices in the building which will be architecturally designed and a bit more fancy. But I know what's going to happen. It's just going to be a lot more space to fill with junk, basically. It's still going to be open plan which I think works well. 'Cause you walk past someone's desk and you see something that they're doing and you can say, "Oh what's that" or "You shouldn't have done that" —things can happen quite spontaneously that way. It's a good way to have a good overview.

Katie: In the actual design studio there's tons of stuff just lying around, which is quite inspiring. But then you'll say, "Can we look at some

CREATIVE PROCESS

ribbons?" And literally drawer after drawer of beautiful ribbons will come out. And then you can guarantee you'll have the colour card in front of you, and they won't have the particular colour that you like, or that's right to go with the clothes that season.

Emma: I guess there had never been anyone who had been on the business side who had then gone into the creative nucleus. So that was when I traded my Dell for an Apple Mac and cell figures for colour cards. That's how I see it, really, it was just so black-and-white and changed from one day to the next. So now I'm Studio Director for Leather Goods. So this involves the sharing of ideas and directions for each season, plus basically whatever bag Marc works on for whatever reason then I'm with him.

It's never just about whether you've come from the right place. It's often about what feels to be the right idea. And Marc just said that he was excited about working with me and that was it. Then he went in and introduced me to the whole team, which was good because I could have been seen as just some stranger coming in from the upstairs offices.

Marc: I work with the team. I've always liked to start things off with a dialogue or a discussion. I'm really bad with a blank piece of paper. I'm not someone who can say this line should be x, y or z. You know, if you put a line in front of me I can say whether it should be curvy or less yellow, less blue or whatever. So the way we start off at Vuitton is by everybody bringing something forward.

Peter: We would all sit down and discuss things together. And that process started with me and Jane. And then when Marc's back from New York it continues with him.

Jane: It's never really been a formal working system. Marc had to spend a lot of time on his collection. In the beginning he used to work very, very closely with us. We would present things to him, do research… We would spend a lot of time together, deciding on colours, on fabrics, the whole thing. And then over time, as he got to kind of trust us and as we got to know each other's language, we would present him with ideas, and sometimes whole parts of collections and all the fabrics, and he would come in and OK this, and want to do this, add this, and change this… The whole thing for him was very much the team—you know, that we were working together on it. It developed more like that, really.

THIS SPREAD
Stills from Loïc Prigent's documentary
Marc Jacobs & Louis Vuitton, 2007.

Peter: Quite often what it could be is, I say to Marc, "I really think jackets should look like this this season," and you find some imagery somewhere or a jacket at a flea market and you present him with that. And you give the direction and then he'll be the one who sits down and does the sketching, because that's a part of the process he really likes doing. Or other times Jane will sketch or I will sketch—we're all pretty open in that way. I don't think any of us have egos—and certainly not Marc—that he sits there thinking, "I've got to have designed it"—he's quite happy for things to have come from anywhere, and it's the final result that we're interested in—getting together a really good, powerful show that promotes a strong statement. He doesn't really edit it—he picks up on what we've done and working all together takes it on and pushes it further, questions things and really pushes it along. It is very much a team effort.

Jane: It's very much how the show works as well. If he was working on his show he would come when the shows changed to the Paris stretch at the end; he would come in three weeks before our show, and at that point there's a lot already done. And then he would drive it massively toward the end, and twist it and turn it and make it into whatever you see.

There's a lot of work that goes before that, to support that. And that's really important whether Marc comes back and hates it and changes everything or comes back and adds to it. Whatever happens, a lot of work is the basis of it. But then, always, he would come, and obviously he's very tired from his show. So he would slowly get into it, and we'd start presenting stuff, and working on stuff and it just kind of escalates to the end, basically. The difficult thing, everywhere, is to get on that loop and find it. The secret is to try and find what is the roll. And once you're onto that, you just start churning out and churning out and it just becomes easier, once you're finding that click, really. In three weeks! *(Laughs)*

You have to have something to know that it isn't that. If you're sitting in a white room, you don't know what it is. Whatever it is, it's part of the process, whether it's eliminated, added onto—exactly that.

And also the magnitude, and the size of it, and what he can do there, the possibilities, are really enormous, and that's taken time to develop and to be appreciated.

Peter: And there are deadlines to meet—you can't just sit back and wait for him. He needs decisions made by us.

We remain calm in the face of really quite extreme situations. It's quite crazy how it is, 'cause sometimes there's a real intensity when Marc

Still from Loïc Prigent's documentary
Marc Jacobs & Louis Vuitton, 2007.

comes back from New York. He's done his show and we've proposed all our things and got some things working. And quite often what Marc will bring in is a different element to play off against what we've done. That always works really well for us 'cause we need something to jar it a little so it doesn't look too perfected. And that's a really intense period, normally two weeks before the show, working really late. And sometimes at that point we'll have all the fabrics and know the direction but we don't have any finished clothes. And it's a huge amount to get together!

You know, people who work in French ateliers have an excellent level of craftsmanship. They know what a good product is so it's never really a battle getting that done. When you suggest things that are tricky or take a lot of time they relish that, in fact. The more complicated it is, the more they like it. I oversee the ateliers as well and when you give them a sketch, you go and see it on the stand and they mock it up in calico first and then they cut in the proper fabric and that's when you fit it on a model. You always know it's going to be a good show when the [seamstresses] are going, "Oh we really like it!" They do know when something's good. They're next door to our studio. There's two ateliers, each with about fifteen people, and then it gets increased quite greatly during show time depending how far behind we are. And that's another thing, I think there is that panic before the show, but [at Vuitton] we have the luxury of money—"Oh shit, we

need ten extra sewers"—and you can just get them in. We work with a double-face factory, a fabric where the outside and the inside are the same, the way it's made up is a special process, it can't really be done in our ateliers: you cut it open with a knife and turn the seams in on themselves and then you close them by hand.

Katie: The first thing I did for Vuitton was [the ad campaign with] Eva Herzigova in the Alps. The Hitchcock collection. It was about 2002, a winter collection. I was doing the ads then. Then, the Vienna collection [Autumn-Winter 2003], which was quite heavy and dark and had lots of embroidery and super, super couture-y. That was probably the first season I'd worked on, so you're less emotionally attached to everyone. You're a lot more ruthless than someone who knows how much work went into it all. That's one of the reasons designers work with stylists—they like someone who's not as emotionally involved with the process and come in with a fresh eye.

Marc: For some years I worked with Mert and Marcus and we did some really great [advertising campaigns]. I would say the one during which I started going on the shoots was probably Eva [Herzigova] with the Murakami, and then of course the Richard Prince [shoot] was really close to me, so we had the cars and the supermodels. Richard had lent the car that he had designed for the shoot. So I guess

there were several years when I was going on the campaigns with Mert and Marcus and I was collaborating with them quite closely. During one of the meetings with Antoine Arnault, he asked me who we were going to use for the advertising, and I suggested Jennifer Lopez, and I think that was the first time that we did a celebrity, and then it was Uma Thurman. And then we did Madonna, but that was after Mert and Marcus—we were working with Steven [Meisel] by then. And I've been working with Steven for the past few years since the Madonna campaign. That was a very funny story. Antoine was across the street from where we are right now, and he came in and asked who we were going to use this time. And I really had no idea, but I had just been at the Madonna concert the night before here in Paris, so I suggested her, and he said, "Do you think she'd do it?" So I sent her an e-mail that minute, and five minutes later I had an e-mail back saying, "I'd love to do it—have Antoine call Guy [Oseary] and work it out." We were both in shock! I mean I was so surprised to get a response from her so quickly the day after her show. So there were a few years starting with the Eva campaign with Mert and Marcus and choosing different celebrities, and these last few years working with Steven and Ronnie Cooke, and again I feel like everything is a collaboration. I work here at Vuitton with Isabelle and Antoine, Steven and Ronnie, Guido [Palau] and Pat [McGrath], the editor on the shoot—we all contribute.

Katie: Maybe now that the new team is in place things are a bit more formal. And now Faye [McLeod]'s involved. Marc has become a lot more involved with the stores and the presentation, and how merchandise goes in. It's become much more proactive as a whole structure.

Julie: Well for this spring collection [2012], we start with our fabrics. Marc is here in July, so we work with him on inspiration, general things that inspire us—images, colours, materials—and then we put together a fabric selection that we choose together. We then create our colour cards from lots of different sources of things that influence us. So we work on all of that together in July and pretty much order all of our fabrics in July because, of course, in August most of the fabric mills are closed. That's really our start, the inspiration; and things come from him, things come from us, from the team. One thing often leads to another, and once everyone has come back at the end of August, we start from the inspirations we worked on in July with Marc. We start designing and putting together some prototypes and toiles, some muslins and some samples of some of the fabrics that work together, and some embellishments.

Katie: Well we've got a new thing now in that the whole team goes over to New York [before Marc's show]. That didn't use to happen, but it does now and I think it's really useful because it means that he is more involved.

Julie: I try now to go and see Marc in New York when he's working on his own show: I'll have a meeting with him over the course of two days. During those two days we work on the bags, the materials, the shapes, the details and then of course the ready-to-wear and the silhouettes for the show that we want to take forward.

Katie: There are usually around two or three initial meetings. Early on [for Spring-Summer 2012] I said softness and romance; you tend to react against what you've just done. In the initial meetings we talked about white, softness, trying to find codes that were as straightforward as the mask in the winter show. You sit there talking about what it could be. At this point we're talking in very loose terms. Then I sent him a text it must

have been in the third week of August just saying "Broderie Anglaise" and then we all met in New York and started playing around with some fabrics, some white fabrics.

Julie: Well the textiles are mostly created by us. It's really about looking into different fabrics and saying, "We like that, we don't like that." [This season] we looked into a lot of white fabrics, a lot of things that were very light and transparent or materials that had cellophane to keep it airy but with a modern feel.

Katie: I suppose because I'm there solidly for two and a half weeks now, sitting next to Marc the whole time, it's not putting tops with skirts any more. It's more about silhouettes and fabrics.

Julie: Each fabric, before we even design something, is completely controlled—it goes through all the quality-control tests to ensure that it doesn't tear easily, that the seams work properly—every fabric is tested in the wash to make sure that the colours stay in—all the things you can imagine! Sometimes it's a bit frustrating because we might want something more delicate or something that gives a more modern twist, but it doesn't pass the quality test, so we can't even use it. It's quite a challenge….

Katie: There was a print that was developed this season that everyone was really attached to but Marc never really felt for. It got nearer to the show and he was still trying to keep it in, but we just had to edit it out—it wasn't working, it wasn't as strong as the massive Broderie Anglaise. He'll quite often text me at midnight or two in the morning about the new season, saying "I'm still worried about the plastic." And I'd text back something like, "Should it be metal?" and he'd text back, "No, it shouldn't be metal but maybe we'll put studs on it." So he's very 24-hours-a-day on it. It's his thing!

Obviously, there's a big process that happens in a phenomenally short space of time that goes from Marc's sketch to the first toile. [Julie] will work with the atelier and then Adrian Appiolaza will as well. He's phenomenal at pattern cutting, so when they do a fitting he'll see if something's dropping wrong or the dart's in the wrong place. I mean we can all see that stuff, but he's particularly technical. I know that the dresses this season looked extraordinarily simple, but actually it's very, very difficult to get that amount of ease in a waist. It looked like a straight dress, but it wasn't. It was cut up the centre and swung out from the middle to give just the right amount of ease. So it looked kind of like a Thirties or Sixties silhouette, quite narrow across the chest and quite straight. But to do that kind of shape still make it sexy was really difficult—much harder than a corset and a circle skirt. Because this is still the Vuitton woman and she wants to feel kind of sexy and have a bust and some kind of definition on the waist. It's hard.

Julie: Things are very worked and detailed at Louis Vuitton—they are things that are really beautiful and interesting because of the savoir-faire of our ateliers. So much is hand-stitched, so detailed, and everything in the inside is as beautiful as it is on the outside.

Marc: I'm very detail-oriented. I mean I like to see the size of the stitches, how many stitches per inch, how thick the thread is, and all this kind of stuff. I get into all that, the linings and so on. I used to say how when a woman takes off her jacket in a restaurant and puts it on the back of a chair you should be able to look into the back of the jacket and it should be as beautiful on the back of the chair as when she's wearing it.

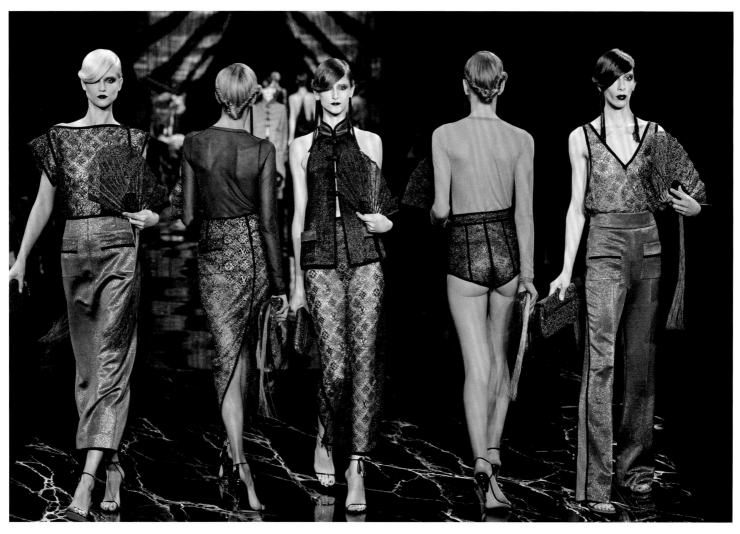

Spring–Summer 2011 runway show,
looks 10, 8, 11, 9, and 12.

And I think when you open a handbag, the idea of a rich color inside or a pocket with a particular label inside—all these things are as important, even if they're not the first thing you see.

Julie: The design team has a lot of rules and a *cahier des charges*. When we design a collection we have a budget to respect, we have a collection plan to respect, timings to follow—we're definitely in a large organisation. It's great because we have the space to be creative and to experiment, and we have the possibility to try different things and we have that luxury, but we are definitely within a larger structure. We have to get results, and if we don't have those results then it becomes a problem. So I can assure you it's not like the design team can just get on and design what they like! No, no, it's not at all like that.

Faye: Usually the ideas for the staging come at the end. First it's like "OK! The clothing!" and then later you work out what you want the performance to be.

Well, you're called the crazy Brit! You can get away with it! Marc breaks rules, and he's got his whole studio breaking rules as well, but using the savoir-faire. They're all the best at what they do, in all of their ateliers in Paris. They're just brilliant. So it's kind of just getting that mentality and making it rebellious, I guess. Being led by a rebel. I think it works.

Marc: I'm not actually very rigid about the structure of how it comes together. And I think that what I've learned, or rather what I feel most comfortable with, is not feeling very comfortable with the process itself, or at least not to be too rigid in the process. I need to look at things almost daily and think about them daily. I have a sort of system whereby I make odd little doodles on Post-its at home when I can't sleep at night, and it just kind of evolves and one thing leads to another. It is a real process from the previous collection to the next. I think it's helpful to define what design means, and for me design is just a series of creative choices. It doesn't mean they're good or bad, right or wrong, they're just a series of choices. So I think designing a shoe or a bag or a dress or a hat is kind of the same process. Maybe there's a functional aspect to it, maybe there's a practical aspect—I certainly think there's a decorative aspect to it, so you deal in different degrees with each of those things and you make choices.

I don't actually know the definition of couture, and I don't know what's required to call oneself a couturier. It really makes no difference to me. We all just want to make beautiful things, and I think that although what Vuitton made was beautiful trunks and traveling pieces, what went into those things was skill and luxury and a kind of craft, and if we can do that in a fashion handbag or in a shoe or a dress, then we're right in line with what Vuitton should be.

Marc: I think it [the collection] does start with the bag. It's certainly the first thing that I think about, but again, whether it's literally the first thing that we do…I know I've said it before, but the bags are the star of the ad campaign. Even if we've had Madonna in the ad campaign or Jennifer Lopez in the ad campaign or three supermodels or three unknown models, it's like the bags are the star at Louis Vuitton. It is the heritage of the house. So I don't know that I'm unique in thinking this but—first of all, I feel it is my job—I think we put as much design work and effort and certainly as much time into the bags and into the materials and into the finishes and even just into the joy of the concepts.

Emma: Obviously this was an amazing experience. It's the heart of the business, it's the image of the business—leather goods are the core of the company. Working on the fashion leather goods was amazing training and experience, getting to understand the global workings of the top-ranking French luxury-goods company in the whole of the world. It was very good to see how that works, how you grow businesses, how you start up even the segmented businesses within leather goods. How do you convey the message of Marc throughout the store network—how is that creativity communicated? I'm not just talking about an advert at the end of the line. It's about how to release things, how things are evolving creatively and implementing that within the business. If the bags are getting more sophisticated, how do you speak about that? How do you treat the bags? So there's lots going on there.

Emma: I think that nearly every single season since Marc's been here he has reworked the *Speedy* in some way. For Marc the *Speedy* is the iconic bag of Louis Vuitton, and every season, however the mood is, it's been about reworking that.

I should say that it is such an immense pleasure to work with him on the bags at Louis Vuitton. He's just so passionate about it. There are so many designers that prioritise the ready-to-wear, and the accessories can be a struggle, but for him it's just such a natural process. Every season we really strive to do something better than the season before, and to be with someone who's just so dedicated and comes each season—naturally we have to inspire, but it's about him then coming in and taking hold of that and giving a direction from what we offer. That's so exciting. He's so hands-on. It's almost like surgery sometimes the way he cuts and pastes, taking something from one bag and putting it on another, adding a metallic piece there and cutting a piece of leather from here. It's a very exciting process.

I guess the process for bags is a longer process than the ready-to-wear just in terms of the ordering of materials from a purely logistical point of view. Generally we have very exclusive materials. If we have a leather we'll have it in our own colours—it won't be from stock or anything like that. And in order to have that you need more time. At the start of each season, all the designers will come up with ideas, and the process is very much about the sharing of these ideas, and then Marc will edit these down bit by bit until it comes to what we're actually going to have in the show.

We launch maquettes at various points in the weeks before the show. We're evolving forms, we're evolving shapes up to around two months before the show.

When the final materials arrive, we launch something we call the "duplications," and that's when Marc really chooses which bags he wants in which colours.

Marc: I do feel that you could probably take the bags from any collection and it would somehow give you the entire spirit. You could probably pick out a *Speedy* or a *Locket* or one of the iconic Vuitton shapes from each collection and say that this gives an impression of what the show was about.

Fabrizio: I work a lot with Julie on the collection. We were both at the Istituto Marangoni [fashion school in Milan]. We talk, and after 20 years it's super easy, I think. We have reached a point where we understand what we like very quickly.

So it's kind of funny. I start with the studio, with Julie and so on, then Marc comes in—usually back from doing his latest show in New York—and then I show him some stuff I've been thinking about for after the show. Sometimes he'll call me and give me some indications. It depends. The first step is always to talk about the boards and the samples. Sometimes they are really disgusting and we look at each other and say "Urgh!" *(Laughs)*. But a charming quality of Marc is that if he

Spring–Summer 2008 runway show, look 42.

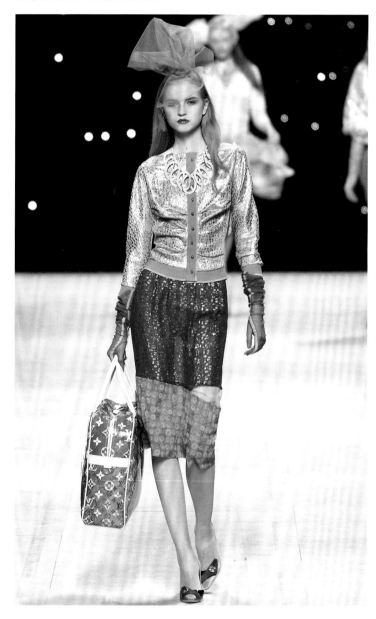

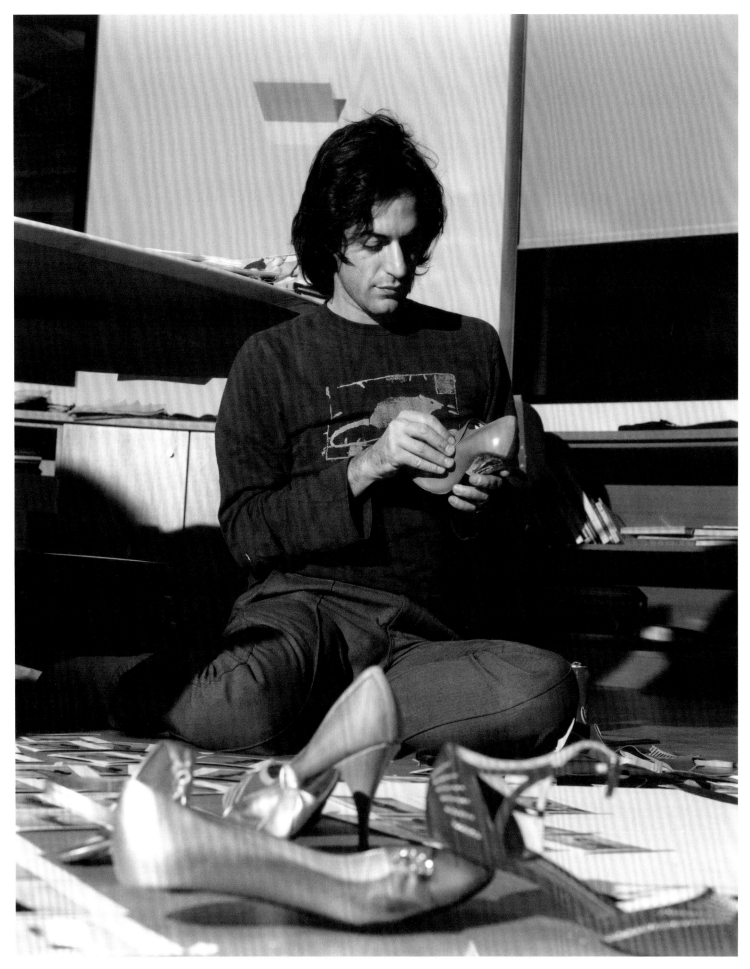

Marc Jacobs at the Louis Vuitton studio, 2001.

sees something he really doesn't like, he always says that it is good to have seen it, because we know that we don't like it. So it's the sort of process in which you don't have to reach your goal immediately. Sometimes it's a process of destroying in order to rebuild again. Marc is not judgmental at all. He's very open to suggestions. And he's very open to mistakes. Sometimes there are some obvious mistakes, but he has the magic to turn it into something right. Sometimes we even start from the wrong place, but we know that it will end up going somewhere. And then, you know, he gives me indications and I understand what he likes. Then I go off to factories and put shapes and ideas together. I come back, and from that moment we really start to work. I should say that he is very dedicated; he works on details—down to the millimeter on the heels, the lining inside, and so on.

We often say that it's like *Mission Impossible*. At some points I think we have the pleasure of being in a difficult situation—maybe we enjoy the idea of being in danger! *(Laughs)* It's kind of pleasing. We see if we can do it. The rubber boot [Autumn-Winter 2011] was done in nine days—usually it takes like two months.

With Marc we really play with our hands. It's very handmade. We mock up nearly everything—don't ask me how! We take something from here, we cut a shape from there—it's almost like applied art or bricolage at this stage. I have kept some of them, as they were so fantastic—I couldn't believe that they had been done in this way. We play with what we have, and we try to imagine what we don't have. If we need a small detail such as a buckle and we need ten of them, we just make a photocopy. There are no computers involved at this stage, no technology, just scissors and glue and so on. It's very much about pushing yourself to see what you can do at that specific moment, about getting your brain working and trying to do something with it. Marc likes to see the mock-ups. Sketches at that moment aren't very useful—we have the models there. Then we take these mock-ups to the factory. Sometimes they're like, "Erm, okay…"*(Laughs)*

Katie: When we did the Richard Prince shoes, not only was the material for the actual shoe ordered superlate, but then every shoe had a different embroidery on it. The bow had to come from a different country. And then what made it even more difficult for everyone is we designed the left and the right shoe to be different from one another because we liked the idea that when you looked at them they weren't identical, they were slightly off. Not only was it a design for however many shoes, but every shoe was different. I hate to think how the boxing up went that season.

Fabrizio: Do you remember the Richard Prince show? Well we spent a night cutting and embroidering—we did those beautiful embroideries at Lesage, and then Marc destroyed them. Again, it was necessary to destroy in order to rebuild. When we finished it was like three in the morning, four days before the show. Marc turned to me and said, "Now we've made the right shoe, but the left shoe should be different." *(Laughs)* I was, like, "Er, what?" So we had to work on the embroidery for the left shoe. The factory didn't understand what I meant.

Katie: And all this stuff happens in two weeks. The clog thing was amazing. The metal component came from somewhere and had to be shipped somewhere else to be sprayed, and they had to be shipped to the factory… Ridiculous things like the Mongolian lamb [skin] that we could get at that particular time was only available in these colours, so someone sat there with a Pantone pen colouring in [leather] to put in the clogs. And then the

elastic, which attached the metal component with the Mongolian lamb through it, that came from Japan because it was a special hiking elastic. Which had been specifically embroidered so it wasn't just pink hiking elastic, it had a metallic thread running through it… the layers of people and expertise that are involved in every single tiny part of the product. The brilliant thing is that this all starts with six people around a table in a design studio generally at two in the morning putting a bit of Mongolian lamb next to a bit of metal next to a wooden sole next to a bit of pony skin and a photo being taken of it…. "Oh that looks quite nice, maybe that'll work as the shoe." It starts off in this very light, casual but very inspired manner, usually with some kind of show tune playing in the background. This season, when we were doing the shoes they had on Barbra Streisand doing [the soundtrack for] *On a Clear Day.* There was Marc sitting there with Mongolian lamb as a moustache and us lot piecing bits together. Stapling them to a colour card going, "Ooh, that looks nice!"

The funny thing is the whole thing happens in an eight-day period. Obviously there's all the groundwork that happens before that. You can't just sit there on a Sunday night and go, "Oh, shall we do clogs this season?" There's a bit of a process before then. But within that eight-day period you finish designing the shoes probably at about four in the morning. And literally seven days later the whole shoe order will arrive at midnight, and that's when you're doing the fittings. Obviously it's very exciting when you're working for a company where it does happen. I've never had to be in the factory when they're doing the shoes. I dread to think…. It's certainly very nice not to see that! Marc is so fastidious about how things are finished.

Fabrizio: There are many different components in the shoes, such as buckles, small details, bows. Every component has to be developed, and in different colours. I still remember the night—it was about four days before the show—and we still had to do the colour combinations. *(Laughs)* I think it was the night that Katie and I started singing "These are a few of my favourite things…" We made up our own lyrics—"A big buck-le, with the ye-llow…." I think we had reached a point somewhere between excitement and desperation! It's a very thin line, and I'm not sure how we got done what we did, because this time the shoes were the most complicated ever. And they really were done in four days.

The way in which Marc works is also very simple. It's not pretentious. [For the Africa collection] nobody took a trip to Africa or to explore the culture of the Masai. We were in Paris, mostly talking about Josephine Baker and the idea of the exotic. It was fun.

Katie: Emma has to work on the bags in a much more organised way than the clothing or the shoes can be done.

Jane: With clothing there were no rules. But the rules are very rigid for the bags.

Katie: Probably between 60 and 80 percent of the bags in the show have some kind of Monogram on them. And there's a whole bag department that works on new leathers and new embossings and new embroideries and new print techniques. And then you'll have your fantasy of "OK, I love the Monogram in Lurex." And then it'll have to go through this whole process of can you do it, does it stand up to any amount of wear and tear? Can you really read the Monogram? Does it look like a real Monogram or does it look fake? The amount of work in development they do on those bags is amazing.

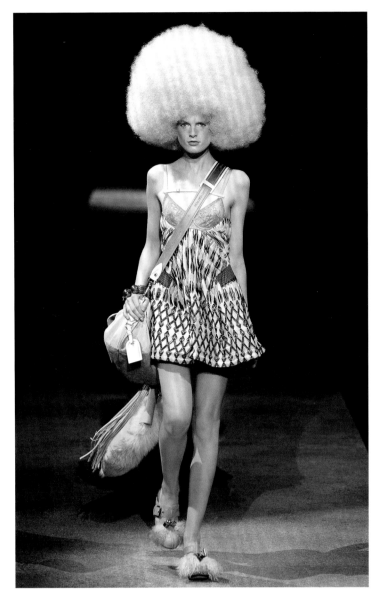
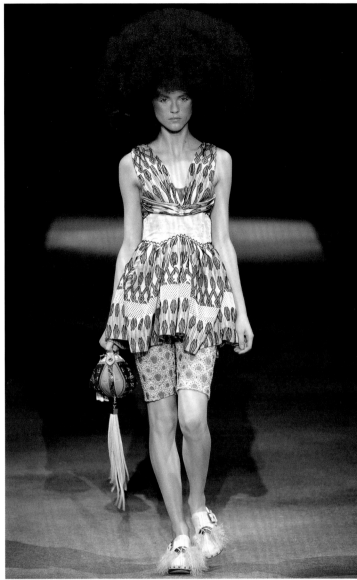

Spring–Summer 2010 runway show, looks 16 & 15.

Fabrizio: One of the things that I love about Vuitton is that it has no complex, we are what we are. We know that we can build a dream and develop products that are very exclusive and very beautiful. At the same time we're doing things that everyone can like, and we're fine with that. So we're trying to get the best kind of quality we can across all of our products. The most simple ballerina shoe and the most complicated shoe are done by the same team. The concept is to bring some quality and some touch in whatever field we are working in. I think it is fine for a designer to be able to work in the same frame of mind on different products, because that's how the world is. The difference is that with the show Marc has to please a woman in a place that is between her heart and the sky, like a fantasy in a different reality, but in the main collection we are more bounded by reality! *(Laughs)*

Katie: There are several different accessories departments, but all the show bags come under Marc's remit and about 96 percent of the looks that go out in the show will have a bag with them. So on average you'll probably show 50 bags every six months. It's a hell of a lot of work.

Emma: I think that's the thing about Marc—he's always challenging new ways of construction or materials. But it's never just for the sake of doing something new, it's because there's a real reason for it at that particular time. I think that part of what we do in terms of bags is very much about doing what's right for the season, but it's also about pushing new levels of savoir-faire. For example, for the [Spring-Summer 2012] show we did the bag with the eggshell [lacquer], which was actually an expertise that had its heyday in the 1920s. So it was about re-exploring that technique and working with an expert in Paris on producing this bag with all those hours of craftsmanship going into it.

Fabrizio: But then, of course, we always take ideas from the show and use them in the main collection too. Like the big bow from the Fifties collection [Autumn-Winter 2010], the one with Laetitia Casta and so on, you know, it became iconic, and now in every main collection we have a least one piece with that bow because it's so strong. So the show can certainly have an influence on the main collection when it is the right thing. On the other hand, Marc is someone who is super open to everything, so things can come out of the main collection too. We might use a detail or

a material or something like that. For example, this season there were the pumps and what we call *il crine di cavallo* which means "horsehair [in Italian]." Normally this is the most expensive kind—more expensive than crocodile—and we use it for the most formal shoes for men. You wouldn't normally think of taking something like that from a very formal shoe for men and transforming it into a basic pump. So there is an influence in both directions because we are working together across all categories.

Emma: There is a connection between sophistication and expertise; though even if it might look like a simple bag, the material might be sophisticated. For example, with the basket bag this season, it looks very simple, but actually it wasn't simple because it was two layers bonded together—a technique that was embossed and cut out and perforated at the same time. Before that we'd only done perforations, so we were challenging the production team to do [multiple techniques] at the same time. So there's always some way in which we are pushing new and innovative ways of working, but it's always for a specific reason and because it feels right. Marc often poses the question, "Does it feel real, is it real?" He wants to know if it feels right. It's about not being forced but about being considered.

Fabrizio: The words they use at the factory are "We'll try!" Even with Marc with the rubber boots [Autumn-Winter 2011], they thought it was such a fantastic idea that they were willing to give it a try. It's very rare. I don't think there was anything for the show that they couldn't do. No, they don't say no. We sit down and we work out how we can achieve what we need. I think that's the magic of being here. Normally things work. If it works, it works, if it doesn't, we try something else. The relationship is fantastic. They love Marc and of course Marc is always very happy to see them when they come on the night of the show. They are very proud of their work, as we are. Even though we know the processes that have gone into it, we are often still amazed by what they accomplish. When you're proud of what you do, in a way it doesn't matter if people like it or not...but of course it's better when people like it! *(Laughs)* It's like the clog with the moustache—it was such a fun and creative project that it was very good for us. When Marc is pleased, we are pleased, and it is our job to try to achieve what he wants to achieve.

THIS PAGE, LEFT TO RIGHT
Backstage at the Spring-Summer 2012 runway show.
Photo by Sølve Sundsbø.

Spring-Summer 2012 runway show, look 27 with model
holding the eggshell minaudière.

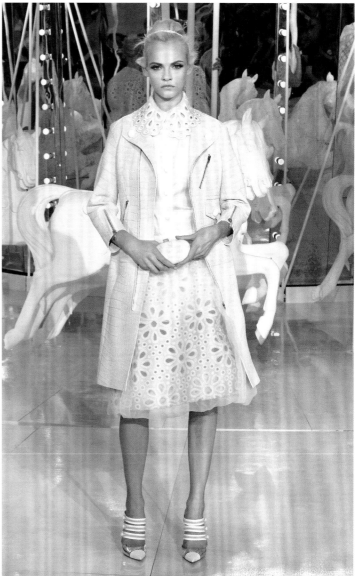

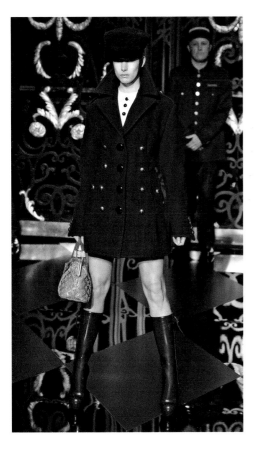 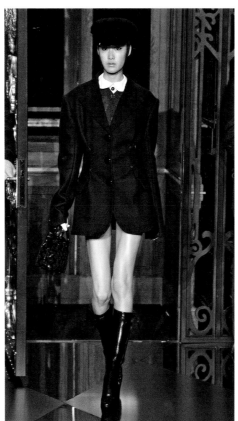 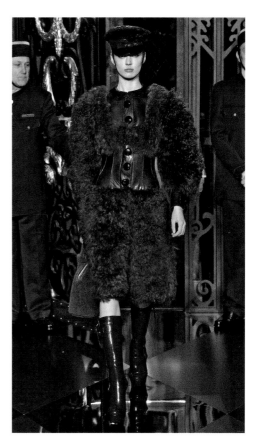

Runway show, Autumn–Winter 2011–2012, looks 9, 10 & 27.

SHOW

Julie: What's interesting with Marc is that more and more he likes to put on a show. We have to start on the venue ahead of time because it's a huge construction.

Camille: At first when Marc arrived, he was only doing some very, very simple staging for his shows. So he was not understanding, really, the point of having a concept around for his shows. And you know, after working with Karl [Lagerfeld] for several years, where he was passionate about the cause and he wanted to deliver a global message, I thought we should have something like that for Louis Vuitton. So step by step we evolved to do something more and more grand, and more and more fun.

Jane: That's when he started [the Stephen Sprouse show Spring-Summer 2001], and we were all like, "Oh no, that's really naff!" *(Laughs)*. Before that it was like, I don't know, 40 models going backward and forward really quickly, that was a kind of coolness. But that, that's when the whole staging started, and it just went crazy from there. And that's what people came to expect, the whole show, down to the last bit. Which, you know, now, the last one [Spring-Summer 2012], it's enormous, the whole production of it.

Faye: It's got bigger! We've pushed it. So Ansel Thompson and I work on all the designs in-house. We'll say, "What's your vision, Marc?" and push it, and then we do full-scale, detailed renderings of it, and then we give it to the [production] company, and we work with them on it, and say, "Oh, we want more of this, and more of that." We've just upped the ante and the craftsmanship.

The first show I ever did with Marc was the one with the tiger theme [Spring-Summer 2011], and that was kind of a small taster of what we could do. I mean, it was really straightforward. It was a catwalk, and it was pretty simple in its aesthetic; the clothes were the thing that were the "wow." And then when we got to the elevator [Autumn-Winter 2011], we'd kind of pushed it that far that it was becoming a performance, which I think is super clever. Marc is pretty genius like that, he pushes you to your ultimate limit, like "Can we do it? Can we do it better?" You can always do better, it's always possible.

Fabrizio: I think Marc can be a bit like a movie director—the projection that he has on every single detail, into a room, and across a set. He turns

it into a major show and all the details work together. Also, it's done in a very short period of time, and he has the ability to really set up a show. Apart from the shoes and the bags and the clothes and everything else. I think he could probably direct a movie or a musical! He's got that kind of vision—it's a global vision, and it's kind of amazing. For the 13 or 14 minutes of our show, you can set up something with such a high standard that just wouldn't be thinkable in another context.

Faye: His shows aren't just shows anymore, his shows are pieces of theatre, moments in time that you'll always remember.

For the carousel [Spring-Summer 2012] it turned out that we already had the full idea of what we wanted in our heads. But it wasn't until the week before that we were like, "This is perfect." Because the collection comes out, and then you work out that you want all the girls sitting, and that you want the finale first, and that you want the horses not to come up so high…. We had to build the carousel in a film studio in this really strange part of Paris that the taxi drivers wouldn't really go to. You were in the middle of nowhere. And then, of course, the carousel wasn't big enough for us; we wanted it bigger. We wanted the carousel sunk into the floor so that it was like a jewellery box, and for it to move really elegantly and slowly. Then there was the matter of the girls on the horses. Because the horses actually moved up and down, your timing had to be right for the girls to get off at the lowest point. And then we had to build the step, and then we had to measure the shoe, the heel. There were all these different things that went into it. And then, what pace do you do it at? Is it too fast? So there was so much that went into it, with all the carousel horses.

Fabrizio: We're not allowed to make mistakes! Marc is obsessed with that—we're not allowed to make any mistakes and that's why everything always has to be perfect. By the way, I have maybe nine or ten people with me backstage to do the shoes. I have people from the factory, people from the marketing team and so on, so everyone is there. It all happens very quickly, in just a moment, and it is a moment that will never be repeated, so it has to be perfect. You have to do it or you will miss it forever. There is no re-run, no second chance, so we have to be focused on making it the absolute best that we can in that specific moment, which is also the magic of doing what we do.

Katie: It is definitely like they've got an army of magic elves and stuff just gets done. What the bag and shoe factories manage to achieve so last-minute is phenomenal. You start working early in the season on an idea for a shoe or bag, you can guarantee you won't really know what looks perfect or what the right thing to do is till about two weeks before the show. And what we manage to turn around—especially in shoes—is phenomenal. People never believe me how quickly they manage to do all the shoes for the show.

Fabrizio: Having worked with other companies, I don't think anyone goes into quite as much detail as Marc; even though they were equally well done, nobody quite has that same vision with detail. Those ten or so minutes can produce something that you will never forget. It means you can bring something new or take it to another level—a level of fun, beauty, or whatever. The show is entertainment—in and of itself it can be very superficial—and maybe there's nothing wrong with that.

Faye: But that's the thing, it's being able to take that real thing and put it in the window. A lot of other brands would just replicate it, but we're so close to it at Vuitton, because we do the show and the windows and

everything creative that comes from it, you can re-use different things. It's not about just throwing money at it, it's about keeping it in-house, in everything we try to do. When it comes to working with Marc, he keeps his teams really close.

Katie: Louis Vuitton's a major luxury-goods house, so everything does have to be to this level of perfection. Just talking about it, it blows my mind how they actually do this stuff.

Faye: I have a core team in Paris, who are half-British, half-French. So all the creative comes from Paris. I believe in a small qualitative team, so I've got really great talent, and we all really push each other a lot toward excellence. Then I have visual directors for every zone in the world. There's no other brand in the world that produces everything in-house.

Model opening the Spring–Summer 2001 runway show carrying Graffiti Monogram canvas luggage.

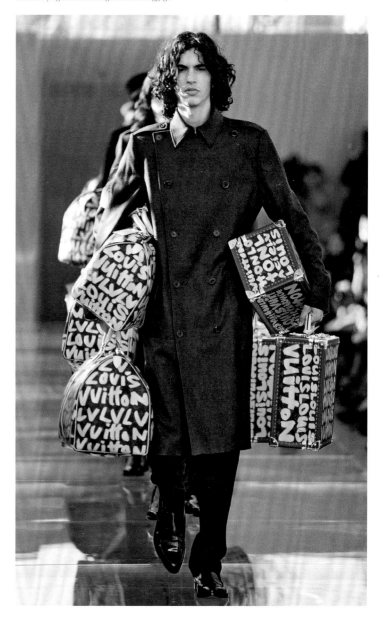

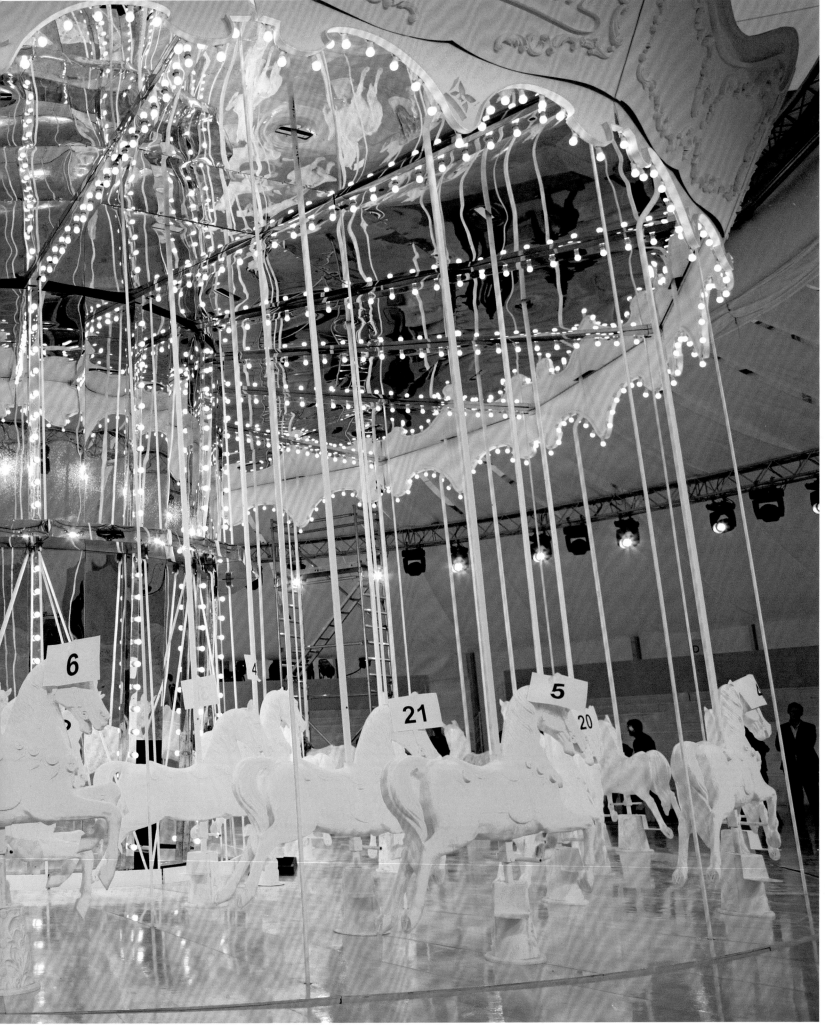

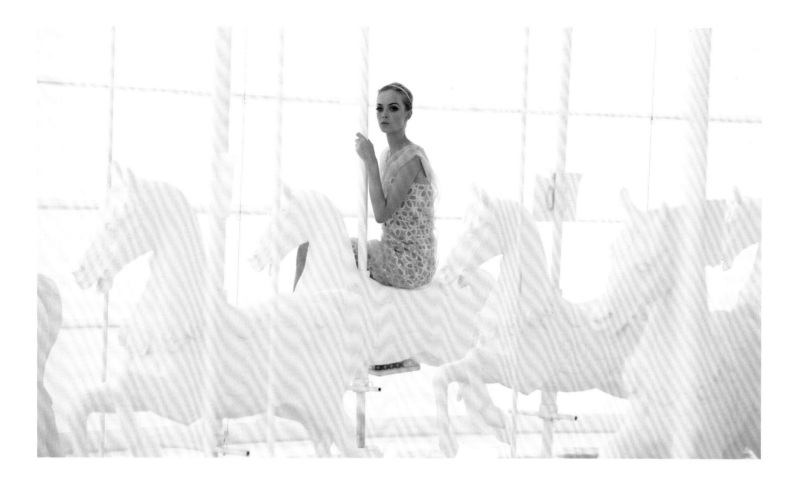

THE LOUIS VUITTON WOMAN

Marc: When we're dressing girls for the show, when we're styling the show and putting it all together, I feel like what makes it look like a Vuitton woman on the runway—and I think well, if she's holding a bag, then she looks like a Vuitton woman, so no matter what the skirt length is, whether it's a tight skirt or a full skirt, whether it's a big jacket, a small jacket, or short or long, I feel like if she's carrying a bag then she's the Vuitton woman. The Vuitton woman doesn't put her belongings in her pockets—that's just not the way that it is. (_Laughs_)

Camille: I don't know if anyone was thinking about the "Louis Vuitton Woman" when we were doing the collections. I think that now Marc is thinking about that woman. But at the time, no. At the time, it was more about feelings, about what you felt was right, more about fashion. That's why everything was changing each season.

Jane: It's always been quite a vague thing. What I always found quite interesting was the fact that Marc, as an American, was designing for a Frenchwoman, and we were English. So there's a funny combination. We would always try to look at the ideals of a Frenchwoman, but with a very American sportswear kind of take on that. As a muse we looked at, you know, Françoise Hardy, Jane Birkin, those kinds of women that we looked at, which fits very well into Marc at the time. She was always kind of cool, in Marc's downtown American way, but with a real French attitude, and a French finish. I guess that's the best that I can say, really.

It was always, "How do we make this French, in our eyes?" Plus, we had French artistry and their know-how. And that was one of the main reasons that Marc really wanted an atelier, obviously, to get that kind of mastery of the materials and the construction and everything, which you can only find here. That French touch.

Peter: Well it is a difficult one, being a man designing womenswear. But this is a comment I often make: I know that if I was a lady, I would wear that. And Marc always laughs and says, "You always say 'lady.'" But the Louis Vuitton customer _is_ a lady. The stuff that we did I liked because I believe women wanted to wear it. I don't think we looked at things from that clichéd male perspective, you know, of really tight skirts, sexy type of thing…. We tried to think what a woman would really like, what she'd feel good in.

Julie: In terms of who is this Louis Vuitton woman, I think you need to assure the clientele, the woman that comes to the shop, that she will find something that works for her and that she can come back the next season and find the beautiful coat she bought the season before, and can have the new version of it. I think working on the silhouettes creates a consistency for the Louis Vuitton woman that is recognisable. You can recognise a brand from the silhouette, and it can be because of an amazing material or fabric that you reuse in different ways, so you recognise that it's a Louis Vuitton piece.

Emma: The thing that Marc always says is that a Vuitton woman is not a Vuitton woman unless she's got a bag in her hand.

Katie: Well, she's kind of foxy and French and she wears high shoes.

MARC JACOBS

PARIS

Faye: I always used to think, "I'd love to work for Marc." I think that what he's built is just incredible. I know I sound really geeky, but you just have this kind of admiration for someone like that, who's maintained a normal life and has had ups and downs but is just visionary in what he does. I mean, the Marc Jacobs brand is genius, in the way that it goes to different levels, from luxury to accessibility. It's just fun.

Fabrizio: He understands everything and is very open to different approaches.

Katie: Marc likes problem solving. He likes his job and he likes the directors to be happy. He likes the product going into stores and he likes people buying it and wearing it.

Camille: You know, can I be super honest? I think the collections he is doing now are really, really, really fantastic. The last two have been amazing. You feel that he's liberating himself. And there's something else he did right at the start, which I thought was very clever. When he started at Louis Vuitton he said, "I want to separate the teams. Marc Jacobs is one team, Louis Vuitton is another" And think about it, are there many designers who have succeeded in two places? No! So that was very clever of him.

Marc: I find it so beautiful working here in Paris and in France with people who take so much pride in their craft. I couldn't in my wildest dreams have imagined this when I was young. I came to Paris when I was a teenager, and I loved it so much I cried when I left because I felt like I should have been born here and not in New York. I felt it was a terrible mistake that I was born in New York, although I do love New York. But I love Paris so much and could never have imagined that I would someday have a job here, let alone for the biggest luxury brand in the world. So it was a dream come true.

PREVIOUS SPREAD
Spring-Summer 2012 runway show set.

THIS SPREAD, LEFT TO RIGHT
Model on set of the Spring-Summer 2012 runway show.

Behind the scenes of the Spring-Summer 2012 runway show.
All photos by Sølve Sundsbø.

THREE
COLLABORATIONS

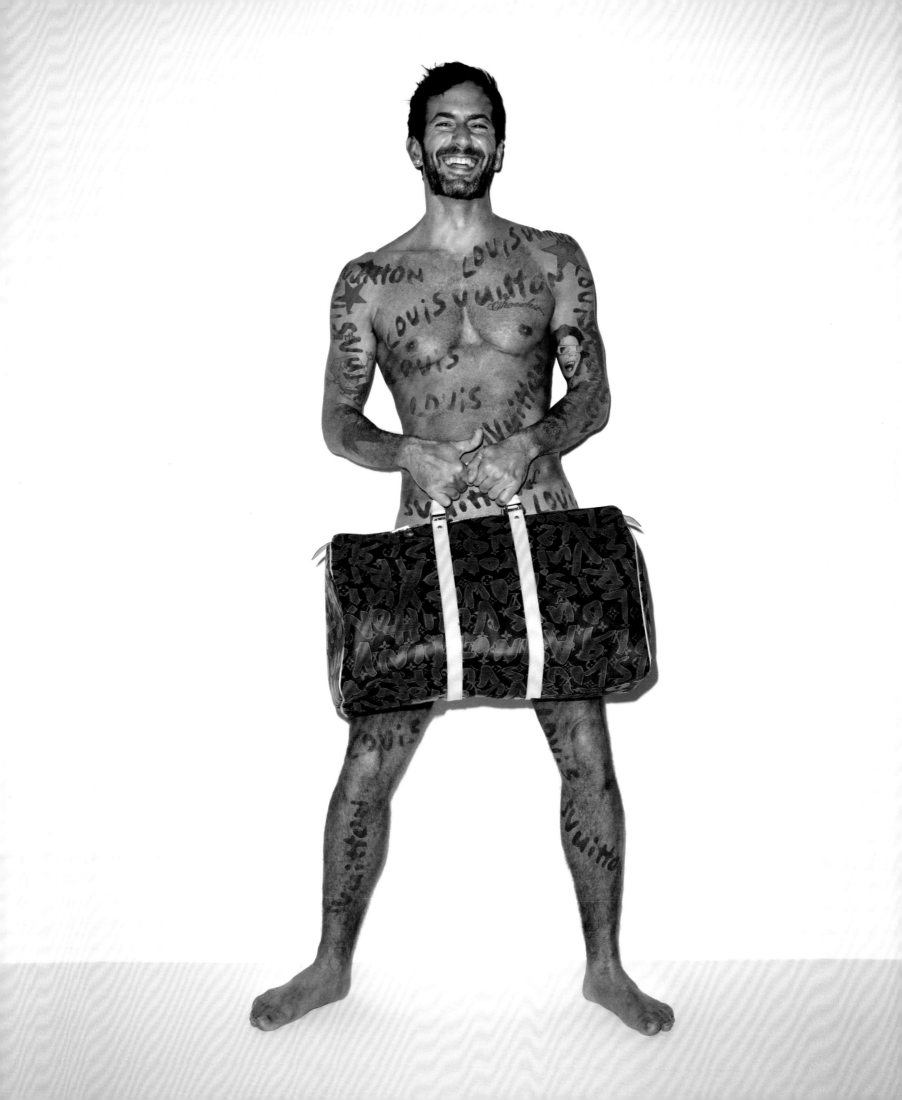

IN HIS OWN WORDS: MARC JACOBS ON THE COLLABORATIONS

INTERVIEWS BY MURRAY HEALY

THE STEPHEN SPROUSE COLLABORATION (SPRING-SUMMER 2001)

Marc: Through a mutual friend I got in touch with him about doing this thing for Vuitton. We specifically wanted to use Stephen's hand; it felt very right at the time. I was looking for an apartment in Paris, and I'd been shown this apartment by this real estate person, which was at the time being rented by Charlotte Gainsbourg. And she was there breastfeeding her child or something. And over in the corner of the bedroom there was a Louis Vuitton trunk. And it was painted over with black paint, or looked like it had been—apparently it's something Serge had had done. So I had this image of this defaced Vuitton trunk. Then I had this thing about Stephen and his graffiti in my head… I guess all those things together just prompted me to ask him if he would do something with graffiti with Vuitton and he said yeah, he'd love to. And when we talked about it, he got very excited and wanted to do as much as he could. I said, well why don't you come join the studio for a while? The Stephen I'd known before I didn't feel would ever have been comfortable working with other people in a group and whatever. But he was very, very open and really great with everybody and everybody loved being around him, and he seemed happy to be in Paris. We had some really good times, like going to the children's fair in the Tuileries, and the House of Horrors. He was anxious to see the Courrèges shop in Paris and we went there and he bought us each a cigarette lighter… We did silly, silly things. Again, this was the opposite of what I would have expected Stephen to be like. Although I would have expected him to be that kind and that nice. He'd get back to his hotel and think about things and come in the next morning all charged up with ideas about the lines on the TV screen and all this kind of stuff—all very typical Stephen. He was always full of energy and ideas.

PREVIOUS SPREAD
Marc Jacobs with a *Keepall* 50 Graffiti Monogram
canvas in fuchsia, created as an homage to Stephen
Sprouse for the Spring–Summer 2009 collection.
Photo by Terry Richardson.

THIS PAGE
Stephen Sprouse with a model wearing a roses-and-
camouflage printed fabric from the Spring–Summer
2001 collection.

I can't remember at what point during the process these ideas came, but we thought it'd be great if Stephen's graffiti was engineered to fit onto these classic Vuitton shapes: the *Speedy*, the *Keepall*, this and that. And they were to include the name of thing: so, "*LV Speedy*"… Then there was a whole other group of fluorescent patent bags with silver linings and metallic bags that we did for that collection. Then he developed some prints: photographic roses; a camouflage kind of print out of roses, so it was a kind of camo rose—guns and roses, like funny. We'd get excited about an idea, and he'd come in and work with Gracie. In the studio, Gracie was working with the computer and Stephen had very limited knowledge of how to use Photoshop and that kind of thing. So Stephen and Gracie spent a lot of time together working on things. When we started doing the gloves, we asked Stephen to graffiti over [them]. And then there were shoes: we asked him to scribble a tip and a heel in black on a pair of white pumps to make it look like someone had tried to make a pair of spectators out of them; or a ballerina with a hand-drawn stripe and bow or something, this DIY thing.

I'm not really rebellious, but it was kind of a clever solution to doing what we were told by a certain old guard at Louis Vuitton we couldn't do: "You don't deface the Monogram; you don't change the Monogram." There was a certain respect and a disrespect [in scribbling on the Monogram]. Again if anything we only amplified the attention to the Monogram by writing on top of it. It's like Duchamp's moustache on the *Mona Lisa*. And I made all those references at the time. Also [there was] the idea of collaborating. Some people said to me it's amazing ego-wise that I could work with Stephen and whatever. I was like, "What's the difference?"

I didn't make as much of it as others did. I was so thrilled to get the opportunity to work with someone I respect and like and admire. I don't think there was any kind of hierarchy or ego thing in the studio.

It was everywhere. And even now to this day some of those bad souvenir places right by our office in Paris have these little nylon bags that are so clearly taken from that Sprouse graffiti. They say things like "Paris France" written in a style that's obviously imitating Stephen's in the way we presented it.

I don't think there was much enthusiasm for the handbags from the powers that be until after the press had responded to them so favorably. People saw them on the runway and the press were like, oh my God—there was this huge graffiti-bag mania, whatever. And then I think everyone at Vuitton was like, we gotta get on this, it's huge. Since then it has changed. Now when I preview bags to people within the company, they're looking for that thing that the press will respond to. They understand that bags that we make and show on the runway can have that effect. So they want to be aware and geared up for it so they're not in that situation [we were in] with the graffiti where it was like, "Oh well, we'll think about producing it a couple of weeks after the show when we've seen the reaction"—and then we can't get it to the store within the season.

Well, that [Sprouse project] had a reason. It wasn't like a formula for me, like, "every season we're gonna collaborate with a different artist or designer." I think that's how some people expected it to go, but it was never my intention.

THE TAKASHI MURAKAMI
COLLABORATION (2002–03)

Marc: With the sesquicentennial of Louis Vuitton coming next year, I had the idea of asking a twenty-first-century artist to turn the various Monogram designs into comic characters.[1] I saw his work. And I was so blown away. I was so moved by the power and the strength and the contemporary…cartoon vision…. We started out with a mutual admiration; me for what he does and he for what our company is…. So, we approached the idea of the "icons of Takashi" and the "icons of Louis Vuitton" being the Monogram, and we worked on creating a brand new canvas; and many characters, iconic images for Louis Vuitton that had the spirit and the presence of Takashi and this history of Vuitton.[2]

I don't think Takashi knew how we were going to apply his art—even we didn't! But after I saw his work at the Cartier Foundation exhibition, I knew I wanted to do something with him. I've always been attracted to Pop Art, for want of a better description, and it grabbed me. I took a chance asking him. The next thing I knew, he was flying to Paris.[3] When I met Takashi for the first time, he came to the Vuitton offices in Paris and filmed everything, even my dog! At one point, he said: "Warhol used the popular icons that everybody knew. I want to create the icon myself. By creating a figure, by painting and repeating it, it will become an icon."[4]

My brief was very open.[5] I don't know how exciting a parade of luxury luggage would be twice a year. Fashion is special. You can't underestimate its effect. I understand that accessories are more lucrative than ready-to-wear, but I don't think about that when I'm designing a collection.[6] [For this collection] there were many inspirations for the clothes. But we wanted a very 2-D, doll-like woman: cheeky, sexy, flirty.[7]

What makes the Monogram so popular is that you recognize it right away. By buying the bag you become a member of the club…. But then you have to know how to maintain your status in the club. So this becomes a race to know who will be the first to dig up the very latest wallet in an ultra-limited edition. It all reminds me of when I was a kid and went to Studio 54. First, they let you in, then they let you in for free, then you got to go to the VIP room. It's the cult of the Very Very Very Important people.[8] In fact, I think that we are going further than the mere reinterpretation of a French symbol by a Japanese artist. These new models are fresh and modern and have nothing to do with Eastern or Western cultures. It's about something much more universal.[9] What it showed the art world and the fashion world was that now we, together, could create the landscape of this actual world that we live in. So it was a very successful collaboration on many levels.[10]

Takashi Murakami: Marc's assistant just sent me an e-mail asking if I would be interested in collaborating.[11] When Marc asked if I would be interested in working with Vuitton, the offer was quite abstract but very creative.[12] It was a real challenge. Louis Vuitton is a unique brand of fashion…. This Western icon brand was willing to take a risk and if I lived up to the expectations, I could escape Andy Warhol's phantom of supposedly not being able to bridge high art with the commercial. Louis Vuitton's long and fantastic history is going forward into the future![13]

For Louis Vuitton, I had to open up my mind to Marc Jacobs to give him my vision of commercial art.[14] When I do commercial work, clients often try to push me into a frame and thrash out a specific image. However, he [Marc] was somehow different.[15]

Our contract is really interesting. When it will be opened two hundred years later, people will understand what is art. It is really a beautiful contract. I believe it isn't my work. No, no. It is collaboration. It is not about the multicolor Monogram. It is a concept. If we could open [it] here people [would be] very impressed. The concept is very beautiful.[16]

I thought it [the fashion show] was like animation! These girls in these high-heeled shoes…. I was worried they wouldn't be able to walk in them. I've been to fashion shows before, but I've never been as observant. It was a refreshing experience. I didn't know that fashion shows were so cartoon-like.[17]

I began looking for a substitute for Japonisme. So at first, I did exhaustive research into patterns from Southeast Asian countries such as Cambodia, Thailand, Indonesia, and Myanmar, trying to retrace the origin of Japonisme…. I sent the patterns to Marc… he gave me the message: "Please make it more Takashi-like!"[18] Marc proposed the idea of "morphing" as a key word again, which he had originally suggested during our first meeting…. I was wandering in the forest of perplexity after getting his message. I struggled along until I stumbled across the idea that the new Japonisme must be related to the idea of the superflat…. In contrast with the Western classical technique of representation using one-point perspective, the concept of the superflat is based on [a] multiplicity of points.[19]

I am not familiar with fashion. The fashion industry moves fast and seems highly speculative.[20] In Japan, there are twenty million people who own a Toyota. But there are also twenty million people who own a Vuitton product.[21]

You know, Marc is like a prophet—he always predicts the right thing.[22]

Magazine excerpts on the Murakami collaboration compiled and edited by Pamela Golbin.

THE RICHARD PRINCE
COLLABORATION (2007–08)

Marc: Well, I never think of myself as an art collector. I do buy art and I do actually collect art, uh… but I don't term myself a collector. I don't look at what I do as an investment…. So a little over five years ago, I bought my first piece of art, which was a painting by Karen Kilimnik. And then I got the bug where I was like, ooh, I love waking up and seeing this painting in my house. So then it became another thing and another thing and another thing…. I became aware of Richard's work. I'd been aware of it before, but I became interested and more curious. So I bought my first Richard Prince. And since then I've bought several. And I met Richard—as you know, Richard, like me, is a big fan of certain rock groups like Sonic Youth, etc. There are similarities between Richard and I, or tastes I guess, and so I started buying his work. And I thought about [collaborating] back in February or March [2007]…. I had this idea that years after collaborating with Takashi [Murakami], and Mr. Arnault is always saying to me, When will you collaborate with another artist? and I answer him, When it feels right I'll ask somebody. And I asked Richard 'cause I thought, hmm, I had some ideas about what I'd do if Richard would do it. Even though it was vague, I thought he might be really great and it would be the perfect thing for him if he were willing. And I approached him and he said yes. So we started doing it that way.

He was gearing up for a retrospective, which opened [in 2007] at the Guggenheim. And I went through Richard's work and picked out different bodies of work and talked to him about what I loved so much about those and how I felt he could apply that to something for Vuitton. So I kind of did it by saying I want these to be hybrids of what Vuitton is and what you are, or what these bodies of works of yours are. And so there was the jokes—they were a hybrid of the nurse paintings and the jokes; and then there were cheque paintings. We did some other things, but we couldn't find a way of applying them. I've got all the canvases here. [There are many canvases stacked up in the corner of the office.] That was what was so great about working with Richard—we supplied him with all these silk screens and he just came up with all these different. So unlike Takashi, this is how we worked: I did the idea, and he did the painting. And then he sent all these paintings.

A lot of what happened with Richard which was so great was that things were off register: there were mistakes, there were flaws in the printing, and he works a lot without cleaning the screens. So paints would get mixed; or when taking the screen off the canvas you'd get like distortions and stuff like that. Or holes or spots or whatever. And Richard wanted to maintain them. And you know, in a big surface on a flat canvas that's one thing, but when you start laying out a pattern for a bag, you're like, "Oh this would have it, this wouldn't have it, how does this wrap round…?" So we really had to work. Plus with Takashi—I'm just pointing this [out] because the two things were so totally different—he worked by computer, so every piece of art that Takashi gave us was very easy to decipher into silk screens because you could break it down exactly into the thirty-three Pantone colors that the silk screens had to match. But with this, new colors were created and re-created by layering one pigment over another over another. So when you're silk-screening creating this textile, it was very hard. I mean every one of these things took like two, two and a half weeks to get the balance of the screens right, to reflect closely enough those canvases. And then to lay it out and decide where the flaws should be so they didn't look fake but like each bag had been painted as if it were

a canvas, to maintain that integrity and credibility. So it was a challenge for us. But we did it. We worked on it all summer up until… (*exhausted laugh*) until last night!

When we did the fabrics months ago, back in June, July, we chose the color palette for our fabrics and the textures based on certain nurse paintings: we had lined our favorite nurse paintings up and pulled colors from those. And we talked about other things…. At the first lunch where I had proposed this idea to him, Richard had come up with this thought that… he had come across all these romance novels, *Tokyo After Dark*, *Paris After Dark*, which is what the tent became [decorated with]. He had come up with all these paperbacks and I loved them so much, I loved the whole thing. So I had this "Louis Vuitton After Dark" thing in my head and I spoke to Peter [Copping] and Jane [Whitfield] and everyone on the team here and I said, you know what, let's do a nighttime show. Let's make it so different from spring, which was so about this beautiful day and romance and stuff; let's do something darker, with evening fabrics. And then we did these motorcycle belts that said "Louis Vuitton After Dark" that all the guys wore who were seating, which was another of Richard's ideas.

I always think Richard represents in the contemporary art world what so many great hip-hop artists do. And so much of music is about sampling, appropriation, remixing, remastering—recropping. Some of Richard's greatest photographic works are taken from images that we all know. They're clichés, in a way. The idea of the Marlboro Man, which is such a strong image, and then recropping it and then presenting it. That's an approach I understand very well. My big love is fashion and I look at iconic clothes from different designers from different periods, and I try to think of how I can kind of take it, change it, and redo it. So I have this feeling for what he does.

During that meeting when we were laying out the jokes, something came up during the working session where Richard said, "Warhol always said change three things." So you can take something but you change three things. I can't remember the context—it had something to do with what we were laying out—but that stuck in my head and I thought, well, that's a good rule of thumb.

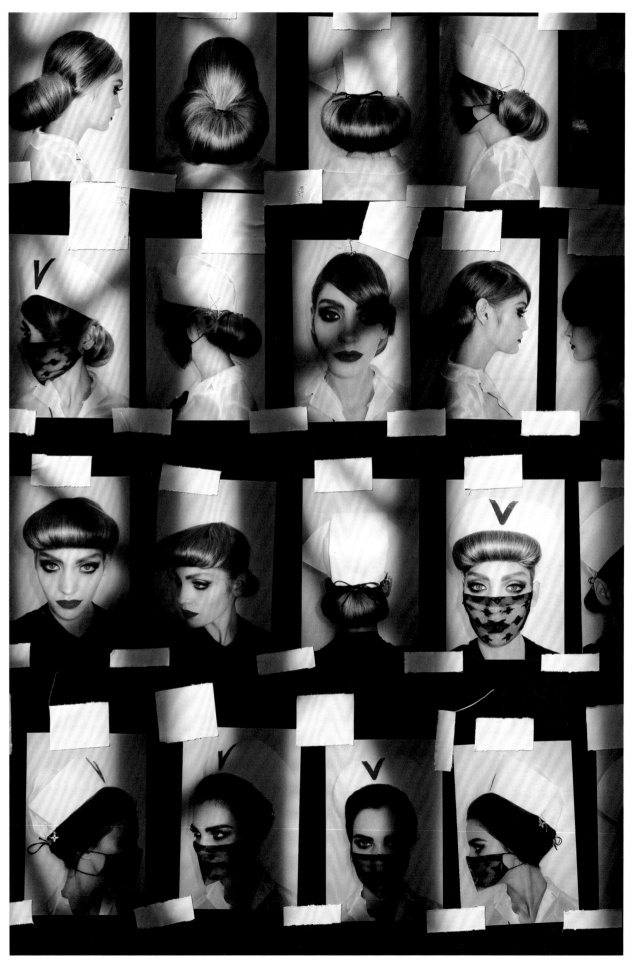

Polaroid sequence for the Spring–Summer 2008 runway
show, depicting Nurses inspired by Richard Prince.

MARC JACOBS

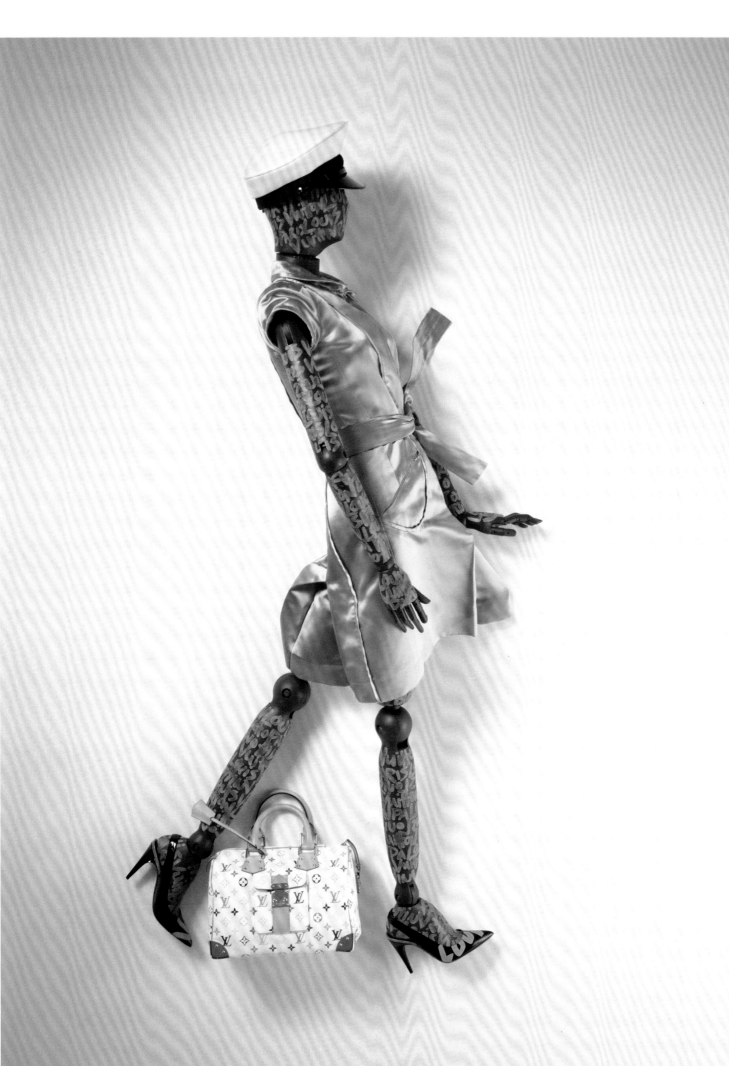

SPROUSE, MURAKAMI, PRINCE IN CONTEXT

ÉRIC PUJALET-PLAÀ

Stephen Sprouse (American, 1953–2004), Takashi Murakami (Japanese, b. 1962), and Richard Prince (American, b. 1949) were all invited to collaborate with Louis Vuitton by Artistic Director, Marc Jacobs.

The graphic patterns born of these collaborations—launched in 2001, 2003, and 2008, respectively—were used for leather fashion accessories and presented at prêt-à-porter shows and distributed, more or less, as seasonal limited editions.

Whatever the implementation of the patterns might be, one must keep in mind their original purpose: these graphic designs adorned the coated canvas used to cover trunks. This makes it easier to understand the significance of the task that Marc Jacobs, as Artistic Director, entrusted to Sprouse, Murakami, and Prince in asking them to reinvent the essential element of the maison's identity, the iconic trademarked design: the Monogram Canvas.

The distinctive feature of this ornamental task sets these artists apart from the other figures who have worked with Louis Vuitton since Marc Jacobs started in 1997—Julie Verhoeven, Pharrell Williams, Rei Kawakubo, Sofia Coppola, and Kanye West, among others—and whose collaborations did not affect or appropriate this century-old symbol of identity. Nor were their contributions so conspicuously visible on the contemporary stages of representation: fashion shows, window displays, advertising campaigns, exhibitions, videos, and the publications of the house of Louis Vuitton.

Cap from the Spring-Summer 2001 collection; "Hairdresser" dress from the Spring-Summer 2003 collection; *Speedy* bag in Multicolor Monogram canvas created by Takashi Murakami from the Spring-Summer 2003 collection; black fluo-printed leather pumps from the 2009 capsule tribute collection to Stephen Sprouse. Styled by Katie Grand for the opening of the New Bond Street store, London, 2010.

This major communications aspect aside, Stephen Sprouse, Takashi Murakami, and Richard Prince implemented their ideas at the level of the printed surface. The designers all used their own vocabulary, referring also to their own personal aesthetics inspired by urban graffiti, *manga* comics, or popular American culture. However different their designs may seem from one another, they all resulted from the use of industrial processes based on silk-screen printing, a technique of production or reproduction that each of the three designers had already used. "Silk screen is a printing process that uses polyester mesh frames. Using a stencil technique, the design to be printed is reproduced on the frame and then applied to the surface to be decorated. The ink is spread using a scraping tool that squeezes it through the weave of the frame. In this way the ink is applied to the surfaces to be printed. This procedure is repeated for each color…. The difficulty in silk-screen printing involves the fineness of the design to be reproduced (precision of the motif) and the number of colors (or number of frames)."[1]

Together, the creations that resulted from these successive collaborations comprise a sort of catalog of the visual options and conceptual stakes involved in industrial silk-screen printing.

The diversity of the three approaches made it necessary for Louis Vuitton to look for ingenious industrial solutions so as, on the one hand, to respect the aesthetic orientations of each artist and, on the other hand, to meet the imperatives of the house in terms of quality by creating materials that were as beautiful as they were durable. As it is, the Monogram Canvas, which was used most often as a surface for the new designs, is by its very nature quite difficult to print with silk-screen techniques (it is usually printed in heliogravure, one of the oldes types of photographic reproduction). Unlike paper and cloth, it does not absorb the ink, and so requires a constant monitoring of density, sequence, and drying times. This initial difficulty is compounded by the uniqueness of the successive projects such that each presented a new technical challenge.

Sprouse's Graffiti Monogram (Spring-Summer 2001) required printing which was aligned to the pattern of each hand-bag model (the cut of which is always centered on the underlying design of the Monogram Canvas). This printing method—called *impression à disposition*—preserves the appearance of the graffiti executed on all the sides of a finished article (for example, the design is interrupted by the holes for the straps but covers the hinges). The design of the Graffiti Monogram canvases and the Leather Graffiti Monogram is, therefore, not a pattern in the strict sense, but a series of custom-made compositions presenting particularities of rhythm and inscription specific to the bag style on which they are used (in some cases, the style names like *Keepall*, *Boîte chapeaux*, and *Speedy* are spelled out). All of these patterns are printed *à la lyonnaise*, that is, with a frame that slides continuously over a table.

Murakami's contribution for the Spring-Summer collection of 2003 called for a great number of different colors (six for the Cherry Blossom Monogram Canvas, thirty-three for the Multicolor Monogram Canvas, and, last but not least, no less than sixty-two colors in ninety-three separate screens for the Eye Love Monogram Canvas, of which nearly sixty colors were for the eye designs, and seven colors per eye alone!).

Rich colors also characterize the subjects dear to Murakami, like the LVHands, Panda, Onionhead, and FlowerHatMan, produced in fourteen colors in Spring-Summer 2003, or in twenty-eight colors in the case of Panda, which was destined for small leather goods marketed in Japan in 2004. The technical difficulties peaked in the Cherry Monogram Canvas of 2005 which was executed in some fifteen colors, with a fineness of line and graded details made possible only by the invention of a silk-screen technique that had never been used for textile before and that Louis Vuitton had borrowed from a graphic transfer process for porcelain. This meant that the Cherry Monogram Canvas—although it has repeating patterns—could not be printed in a continuous manner *à la lyonnaise*, but instead was executed with panels measuring less than one square meter.

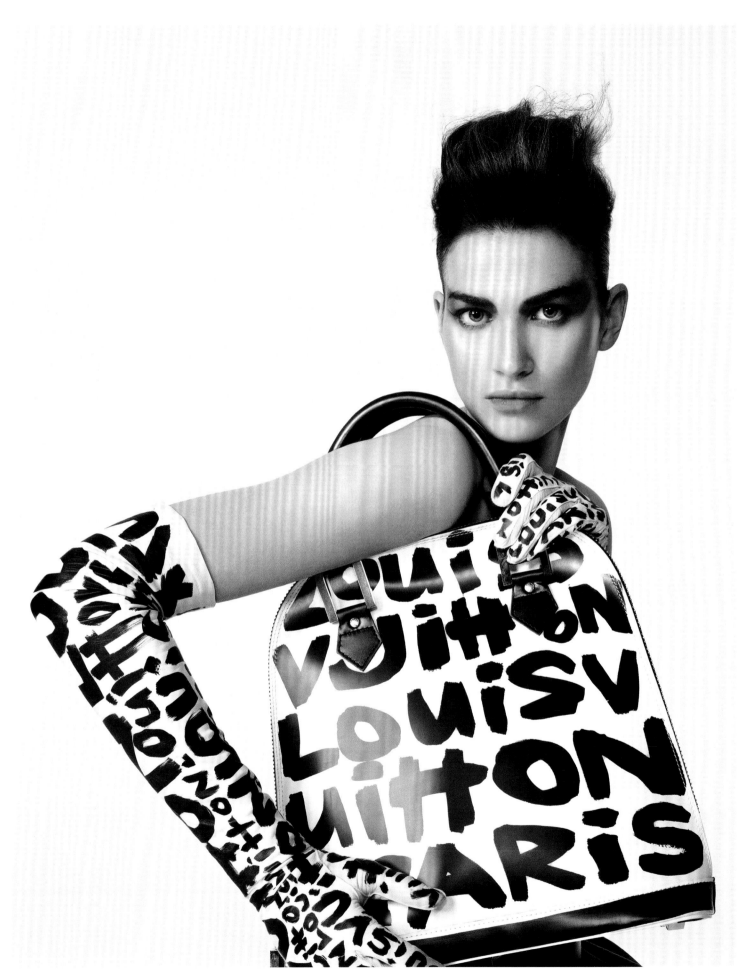

Graffiti Alma bag with prototype for matching gloves,
from the Spring–Summer 2001 Collection .

MARC JACOBS

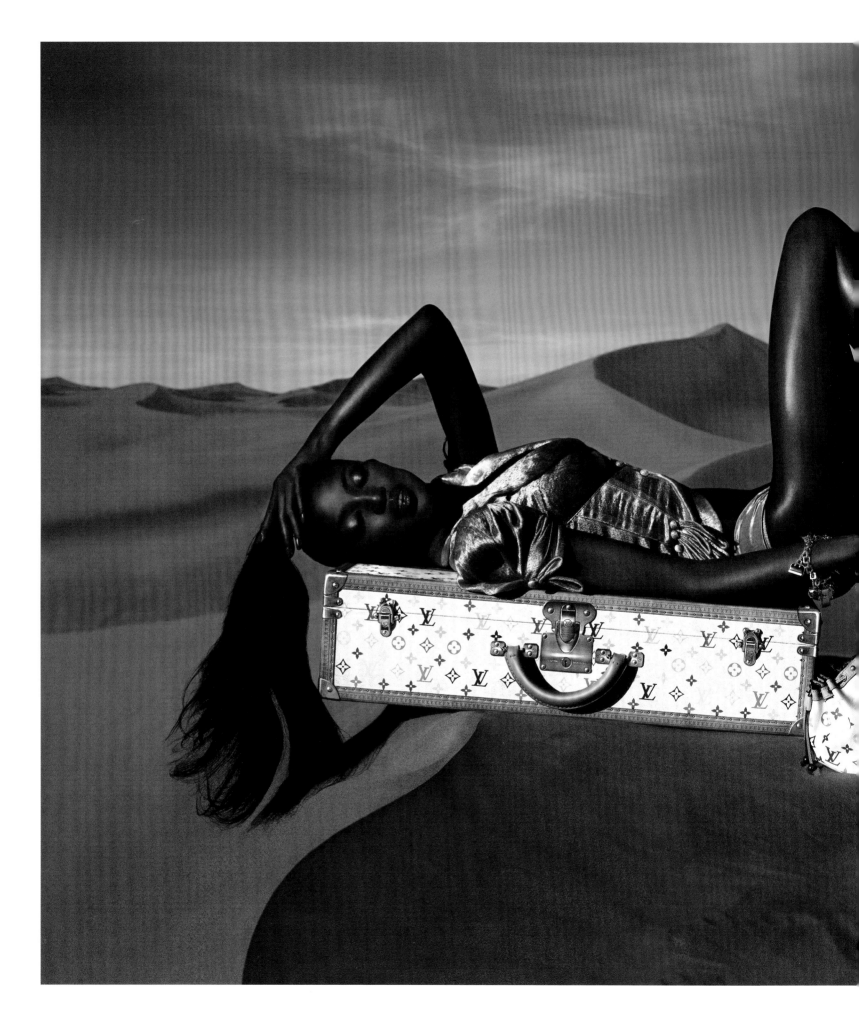

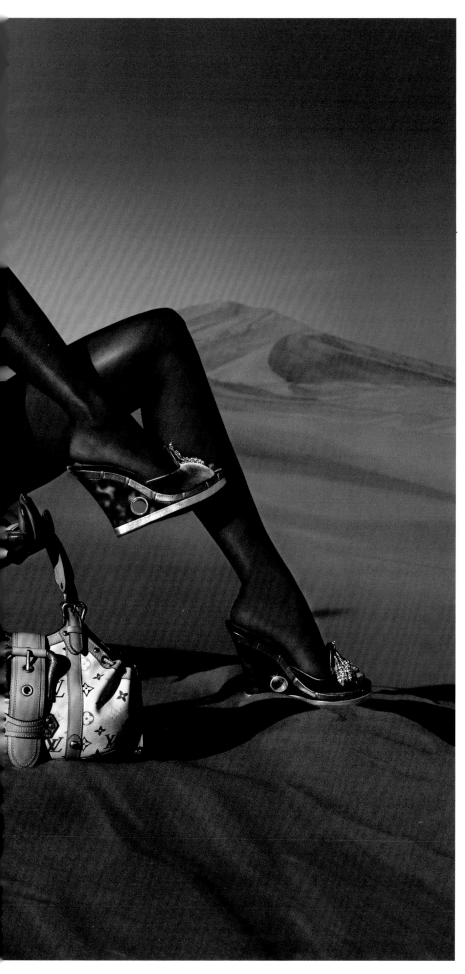

Advertisement by Mert Alas & Marcus Piggott for Spring-Summer 2004 depicting Naomi Campbell reclining on the *Alzer* suitcase and holding the large *Theda* bag in Multicolor Monogram white canvas created by Takashi Murakami.

As opposed to Takashi Murakami's designs, those of Richard Prince for ss 2008 surrendered the principle of excellence to the reproduction of silk-screen projects characterized by interesting "flaws." What needed to be industrially reproduced this time were "accidental" drippings, ink deposits, and register shifts as if they were original. Starting with a work of art on paper realized by Richard Prince with the help of industrial silk-screen frames "improperly" used, the print prototypes of Pulp Monogram, for example, were made by creating a patchwork of defective transparencies obtained by the random manipulation of frames in the studio (excess solvents, obstructions, shifting, etc.). The transparencies put end to end then permitted the final silk-screen frames to be developed, making it possible to reproduce every detail of the cumulative flaws indefinitely.

"Worked over" in this way, the Monogram Canvas decoration appears fragmentary, blurred, discontinuous, and irregular, while still remaining legible. The accumulation of variations, however, is such that it is no longer a repeating pattern: the decoration of the Pulp Monogram Canvas unfolds in a single seamless composition as large as the frames themselves. During this process, the prototype studio participated in the composition—or even the invention of the decoration—but did not master its creation, since they were implementing a process of imitation.

Beyond the interest in techniques and methods involved, these collaborations stand out because of their individual approach to interpreting the Monogram on a specific graphic level. This level can be likened to a layer in the strata of the colors of the decoration.

Sprouse's intervention was essentially directed at the surface. It superimposed his monochromatic graffiti over the design of the Monogram Canvas, making it a background pattern put in cartouches. This principle of decorative composition was often used on fabrics in the nineteenth century. The application of graffiti on all sides of the bags evokes another traditional decorative expression: the personalized marks painted by hand on all sides of the finished bags, as it is still practiced in the Louis Vuitton stores.

Murakami finely interwove his own motifs with the original pattern. He submitted designs with a complex polychromy stamped on the surface (like the Cherry Blossom Monogram Canvas and subjects like LV Hands). He explored the relative and very precise positions of the traditional design with the alternating monograms and rosettes (as in the Eye Love Monogram or the little unexpected cherries), and slid a background design underneath the typical Monogram Canvas (Monogramouflage Canvas). By the play of tones (warm or cold, saturated, light, pure, or mixed, etc.), he suggests, especially in the Multicolor Monogram Canvas, multiple planes of value floating against a black or white background.

Richard Prince's vision combined all these possible layers into a single material rich in transparency and densely linked (especially in the case of Pulp Monogram) to the interlocking of graphics printed as solid elements, outlines, or as knock-out text (with the traditional Monogram Canvas showing through).

These approaches, using preferred graphic layers, also reveal different signatures.

Sprouse's gesture is superficial, but it jumbles up all the reading directions while combining them with one another; from top to bottom,

left to right and right to left, reversed, in the direction of the Monogram, or inversely, surrounding each of his designs with the dynamics of his signature. It is an insolent gesture, though it is still organized absolutely around the LV Monogram centered on each piece of luggage according to the tradition of the *malletier* Louis Vuitton.

Murakami's digital writing appears in the coloring, precise line, and perfect juxtaposition of the fields of color. This assisted writing also determines the conception of the designs, which are full of color, flowers, and humor, and are always adapted to the very precise intervals calculated according to the weave of the Monogram Canvas (eight-centimeter intervals). The rhythms are defined by the appearance of colors (Multicolor Monogram Canvas, twenty-four-centimeter intervals), by the punctuation of details, such as the "jellyfish eyes" (Eye Love Monogram Canvas), or by the fitting together of large compositions (Cherry Blossom Monogram Canvas, forty-eight-centimeter intervals). This pattern size has a consequence: since the cut of a bag is always centered on the underlying Monogram Canvas, bags made from this embellished material that contain numerous seams may present variations in the placement of the colors, eyes, flowers, etc. from one bag to the next. The perfection of the finished products is enlivened with delicious details, as this unerring digital writing results in unexpected individual variations.

Richard Prince's designs again multiply the levels of interpretation, both in the literal sense (one puzzles over the meaning of the silk-screen jokes on the Jokes Monogram Canvas) and in the figurative sense (the Pulp Monogram Canvas presents a stratigraphy of lettering appearing in fragments and gaps according to the size of the solid areas of color). In the Bonbon Monogram Leather, the ink deposits are more or less irregular coatings blurred and repeated, and they present themselves simultaneously to the eye so as to offer vibrant visual shifts. In the case of the Watercolor Monogram Canvas, the slight shift of the multicolor decoration, relative to the reference mark of the underlying Monogram Canvas, goes so far as to call the hierarchy of the decoration into question.

All of the creations of Richard Prince for SS 2008 grew out of a large spectrum of implications on the artist's part in terms of artistic and industrial collaboration. His work resulted either in very concrete pictorial projections (Bonbon Leather and Pulp Monogram Canvas), in the inscription of texts or vignettes (Jokes Monogram Canvas and Cartoons Monogram Leather), or identifying punctuation (*Speedy* appliquéd label of gold metal on pink ostrich skin bag, application of pink plastic studs on the Firebird bags). In the last analysis, however, the artist's intervention could inspire only the names of the bags (*Beforedark* and *Afterdark*, a nod to Prince's *After Dark* collection). The list of these various contributions is an inventory of the forms of authorial appropriation.

From 2001 to 2008, the succession of these collaborations between Marc Jacobs and Stephen Sprouse, Takashi Murakami, and Richard Prince gravitated around the possibilities of silk-screen printing. This technique summarizes an artistic heritage and permits a re-reading or a rewriting of the Monogram Canvas. These collaborations, therefore, expressed in a contemporary language the values represented by this material. And these values are none other than those of the Louis Vuitton *malle*, illustrated today by fashionable bags with graphic impact, industrial concept, aesthetic dimension, and a romantic dynamism.

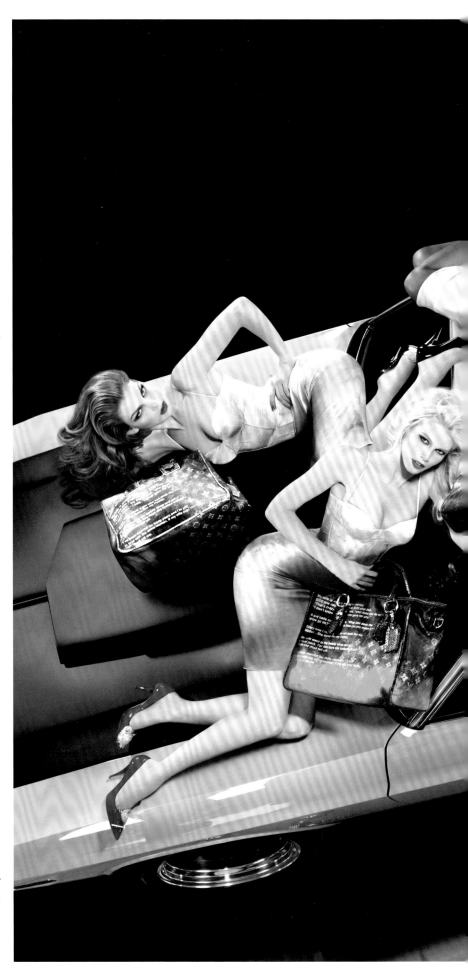

Advertisement photograph by Mert Alas & Marcus Piggott for Spring-Summer 2008, depicting Angela Lindvall, Claudia Schiffer, Naomi Campbell, Natalia Vodianova, Eva Herzigova, and Stephanie Seymour with bags from the Monogram Jokes line: *Mancrazy*, *Graduate*, *Heartbreak*, and *Duderanch*.

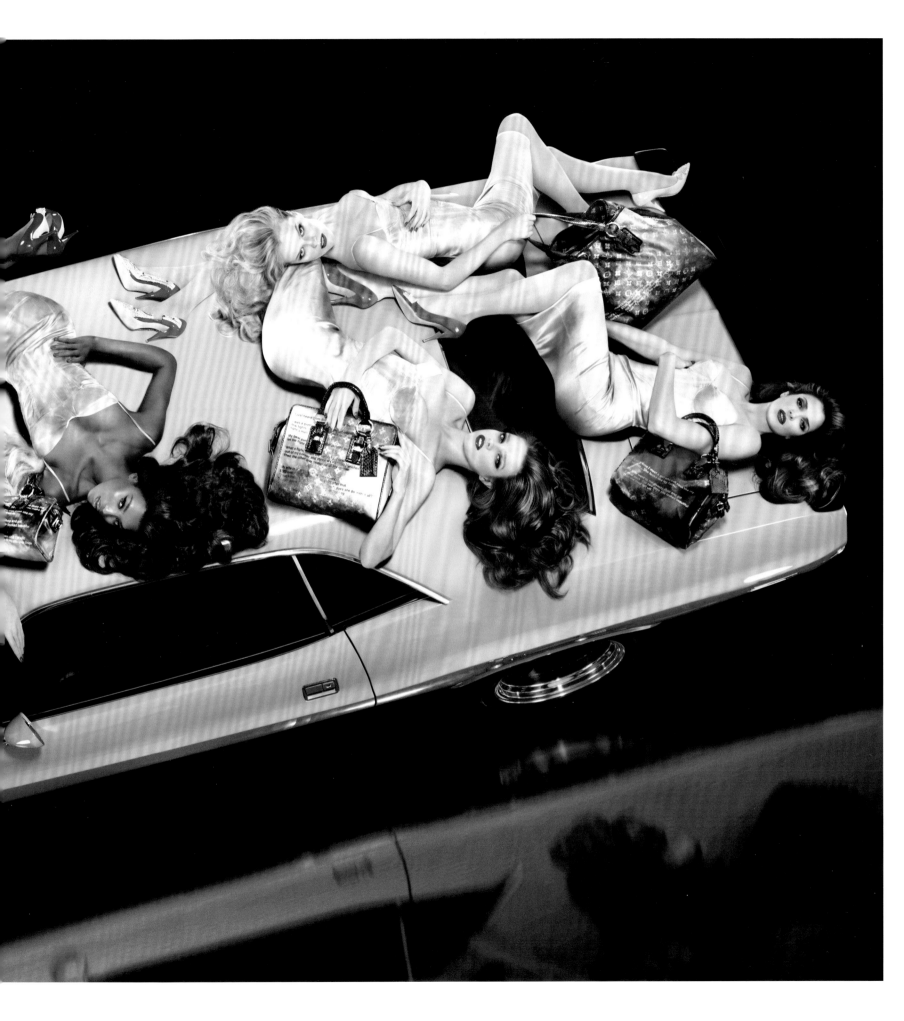

STEPHEN SPROUSE

SPRING-SUMMER COLLECTION 2001

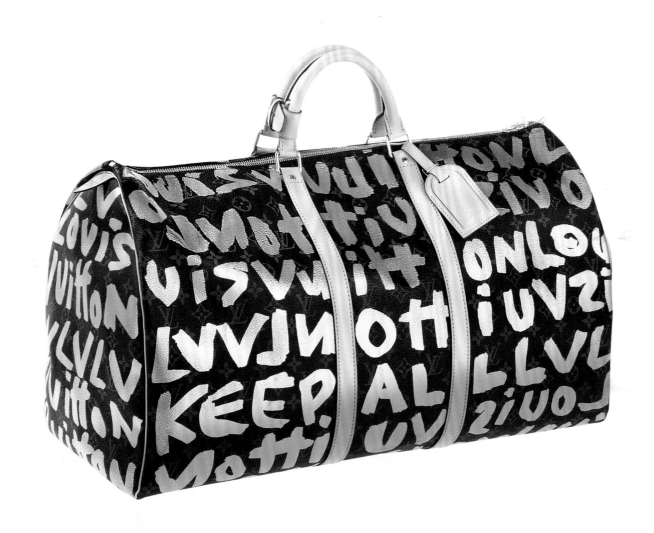

OPPOSITE PAGE

Keepall 50 Graffiti Monogram canvas in silver.

THIS PAGE

Horizontal Alma in Graffiti Monogram leather with palladium metal details.

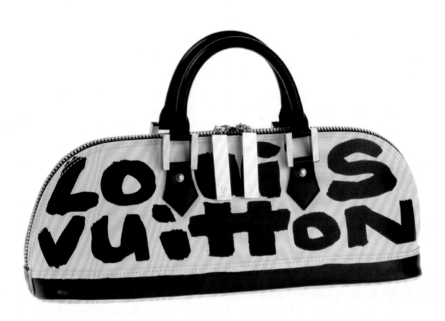

GRAFFITI MONOGRAM CANVAS AND LEATHER MONOGRAM GRAFFITI

PRESENTATION The Graffiti Canvas was presented at the beginning of the runway show in the form of seventeen bag prototypes. The styles were *Boîte chapeaux* (Hat Box), *Alzer* (traditional hard body suitcase), *Boîte flacons* (Vanity case), *Speedy* and *Keepall*, with peach, silver, and khaki graffiti (looks A, B, C, and D); looks 12 and 15 showed the *Pochette* wallet and *Pochette Accessoires*.

Leather Monogram Graffiti was presented as accessories for looks 21, 30, 43, 63, and 64, in beige or black *Alma* Graffiti bags. Look 12 presented prototypes of matching black-and-white kid gloves.

MODELS *Boîte chapeaux*, *Speedy*, and *Keepall* bags, as well as the *Pochette* line of accessories were produced in canvas, and leather was used for three variations of the *Alma* bag. They were marketed for only one season.

COLORS The canvas was available with the graffiti printed in one of three colors: silver, peach, or khaki; leather came in black or beige designs.

TECHNIQUE Silk screen on grained Monogram Canvas or ungrained white calfskin

DECORATION Each style was available with the bag's model name included in the graphic lettering composition—for example *Boîte chapeaux*, *Speedy* etc.—except for the *Pochette* wallet and the *Alma* bags.

ADVERTISING The *Keepall* bag in silver canvas and the black-on-white leather mini horizontal *Alma* bag appear in the advertising photographs of Patrick Demarchelier.

NOTE These creations were followed by other leather-goods collections inspired by unfinished projects of Stephen Sprouse using Leopard Monogram (Autumn-Winter 2006), then Leather Leopard Nocturne Monogram (Spring-Summer 2009). An homage was paid to the creator in 2009 with the new edition of a variant of Graffiti Monogram Canvas, the creation of Roses Monogram Canvas, and the patent-leather Roses Monogram, which was inspired by a fabric pattern featured in the Spring-Summer collection of 2001.

TAKASHI MURAKAMI

SPRING-SUMMER COLLECTION 2003

The collaboration with Takashi Murakami led to the creation of three canvases: Multicolor Monogram Canvas, Eye Love Monogram Canvas, and Cherry Blossom Monogram Canvas.

The designs appear in Takashi Murakami's animated short *Superflat Monogram*, presented in Louis Vuitton stores starting on March 1, 2003.

These creations were represented in the advertising photographs of Mert Alas and Marcus Piggott, and the Multicolor Monogram canvas continued to be featured in advertising campaigns through Spring-Summer 2006.

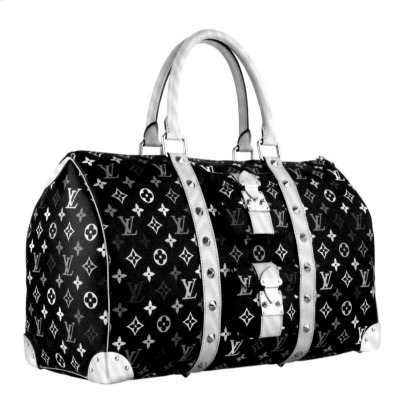

MULTICOLOR MONOGRAM CANVAS

PRESENTATION During the show, this pattern appeared as accessories to looks 1, 6, 9, 10, and 11, as *Mini HL*, *Alma*, *Speedy*, and *Keepall* bags. The miniature version of the canvas pattern appeared on the *International* Wallet with look 2. The multicolored canvas with black background appeared as a prototype with look 13. It appeared again at the Spring-Summer 2006 show with a white background. Its design also inspired mink accessories for Autumn-Winter 2006-2007.
MODELS Five models were marketed in the first season: *Keepall*, *Mini HL*, *Pochette Accessoires*, *Alma*, and *Speedy*. This canvas was used for other creations in the following seasons.
COLORS A single pattern consisting of thirty-three colors against a single background color, either black or white: thirty-two colors plus black on a white background or thirty-two colors plus white against a black background
TECHNIQUE Silk screen on grained white- or black-coated canvas
DECORATION Repeating pattern with 24-centimeter intervals and 12 centimeters for the miniature version

EYE LOVE MONOGRAM CANVAS

PRESENTATION This canvas is a variation of the Multicolor Monogram, in which the rosettes are replaced by polychrome "jellyfish eyes." At the show it appeared with looks 3, 4, 5, and 8, as *Eye Miss You*, *Eye Love You*, *Eye Need You*, and *Eye Dare You* bags.
MODELS Four models were marketed in limited editions: *Eye Miss You* (1,500 units), *Eye Love You* (1,500 units), *Eye Need You* (1,000 units), and *Eye Dare You* (200 units).
COLORS A pattern consisting of sixty-two colors on a white background
TECHNIQUE Silk screen on grained white-coated canvas
DECORATION Repeating pattern in an interval of 24-cm (equal to the distance between two identical eyes)

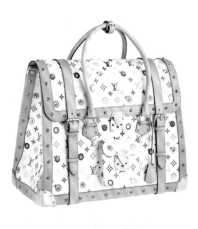

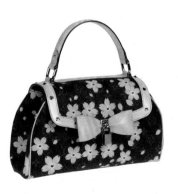

CHERRY BLOSSOM MONOGRAM CANVAS

PRESENTATION At the show, looks 40 and 41 were accessorized with bags made of this canvas: *Retro Bag* with a beige background, and the *Papillon* handbag with a brown background.
MODELS Seven models were marketed for a single season: *Papillon*, *Retro Bag*, *Pochette*, *International* Wallet, *Flat* coin purse, Key Pouch, and *Address* Bracelet. The following season, a satin version of Cherry Blossom Monogram was released.
COLORS Three colorways, consisting of flowers screened in six colors, either pink flowers against a brown or pink Monogram Canvas background, or red flowers on a flesh-colored background.
TECHNIQUE Silk screen on grained brown-, pink- or flesh-colored Monogram Canvas
DECORATION Repeating pattern (with an interval of 48 x by 52 centimeters)

SPRING-SUMMER 2005

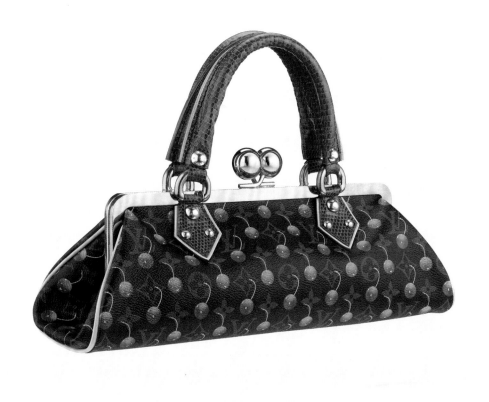

CHERRY MONOGRAM CANVAS

PRESENTATION At the show, looks 5, 6, 7, and 36 were accessorized with *Fermoir* and *Neo Deauville* bags.

MODELS There are four versions of this pattern featuring cherries screened over the Monogram Canvas with varied intervals:
(1) Scattered "little surprised and smiling cherries" used for the large *Fermoir Bag, Speedy, Bucket,* and for small leather goods, as well as the small trunk-like jewelry boxes produced in limited edition for the Cherry Charm jewelry creations
(2) Scattered "pair of surprised and smiling cherries," used for the Neo Deauville, medium Fermoir, Keepall, and Sac Plat bags
(3) Scattered "pairs of cherries head to tail," used for the mini Fermoir bags
(4) The "single pair of smiling cherries with leaf" had just a single motif per bag, which appeared on *Pochette Accessoires, Pochette,* and wallets
COLORS A single colorway, consisting of fifteen colors of solid and gradient variations against a Monogram Canvas ground
TECHNIQUE Silk screen on panels (65 x 92 centimeters) of grained Monogram Canvas
DECORATION Repeating patterns of "little surprised and smiling cherries" (4-cm intervals), "pairs of surprised and smiling cherries" (less than 8-cm intervals), and "pairs of head-to-tail cherries" (more than 8-cm intervals) on Monogram Canvas; placed pattern of "single pair of smiling cherries with leaf" with no repeat
ADVERTISING The *Fermoir* and *Speedy* bags appear in the advertising photographs of Mert Alas and Marcus Piggott.

These canvases were followed by other creations of Takashi Murakami. In 2008, the Monogramouflage Canvas and Denim Monogramouflage were launched, and in 2010, the Cosmic Blossom collection was launched. They were not presented at shows.

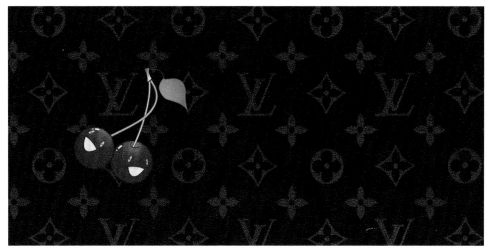

OPPOSITE PAGE, CLOCKWISE FROM TOP
Keepall 45 in black Multicolor Monogram canvas.
Eye Dare You in Eye Love Monogram canvas.
Retro Bag in Cherry Blossom Monogram canvas.

THIS PAGE, TOP TO BOTTOM

Large *Fermoir* bag in Cherry Monogram canvas and red lizard skin.

Cherry Monogram canvas detail, "single pair of smiling cherries with leaf."

RICHARD PRINCE

SPRING-SUMMER COLLECTION 2008

The 2008 collaboration with Richard Prince was named the *After Dark* collection. "The huge tent in which the Louis Vuitton show took place was decorated with enlargements of vintage covers of the [paperback] series that the artist collects. Their strangely similar titles—*Paris After Dark, London After Dark, New York After Dark, Hong Kong After Dark*—evoked the atmosphere of the collection." (Press release, Spring-Summer 2008)

The handbags of the *After Dark* collection use four entirely new patterns: Jokes Monogram Canvas, Pulp Monogram Canvas, Watercolor Monogram Canvas, and Bonbon Leather Monogram.

The collection also included handbags created using familiar materials. For example, the *Firebird* bag in Cartoons Monogram, (dyed, shaved, and incised calfskin) embroidered with humorous vignettes borrowed from popular publications; or also in Motard Monogram (topstitched suede and satin) appliquéd with pink plastic studs that evoked the thick impasto paint Richard Prince used to transform photographs. There was also the *Speedy Frame* (pink ostrich skin with a gold metal logo), and the *Afterdark* and *Beforedark* purses of Motard Monogram Leather.

These creations, which were marketed in a single season, appear—with some exceptions—in the advertising photographs of Mert Alas and Marcus Piggott.

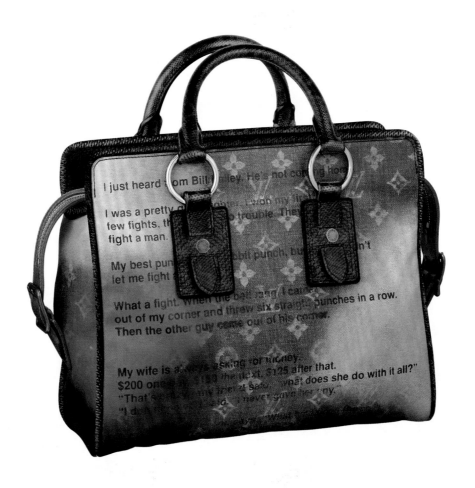

JOKES MONOGRAM CANVAS (AFTER DARK COLLECTION)

PRESENTATION At the show, looks 1 to 12 were accessorized with bags made of this canvas and were carried by a group of nurses with caps, in reference to Prince's *Nurse* series, bearing the letters L-O-U-I-S-V-U-I-T-T-O-N.

MODELS There are four versions of this canvas:
(1) Canvas with partially legible jokes and "My wife is always asking for money. $200 one day, $150 the next, $125 after that. 'That's crazy,' my friend says. 'What does she do with it all?' 'I don't know,' I said, 'I never gave her any.'" Used for the *Graduate* bag
(2) Canvas with partially legible jokes and "Every time I meet a girl…" "My wife went to the beauty shop…" and "I've been married for thirty years and I'm still in love with the same woman. If my wife ever finds out, she'll kill me." For the *Heartbreak* bag
(3) Canvas with the joke "My wife is always asking for money…" for the *Duderanch* bag
(4) Canvas with the jokes "Every time I meet a girl who can cook like my mother, she looks like my father" and "My wife went to the beauty shop and got a mud pack. For two days she looked beautiful. Then the mud fell off" for the *Mancrazy* handbag.
COLORS Four colorways of red, bordeaux, blue, and green
TECHNIQUE AND DECORATION Silk screen *à disposition*, which preserved the alignment of the underlying monogram pattern to the overlay of spray-paint effect and lettering, on Vieille Malle Monogram Canvas, printed in four colors

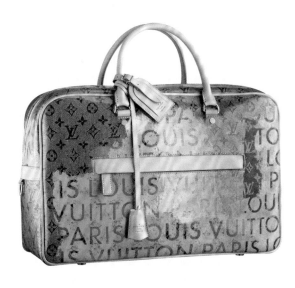

PULP MONOGRAM CANVAS (AFTER DARK COLLECTION)

PRESENTATION AND MODELS At the show, looks 18, 24, 34, 42, and 54 were accessorized with prototypes of handbags made with this canvas.
MODELS *Weekender* bag in two formats
COLORS Two colorways, with red or yellow as the main color on blue denim
TECHNIQUE AND DECORATION Silk screen *à disposition* of the Monogram pattern produced at normal and double scale, overprinted with "Louis Vuitton Paris" lettering either as solid or knock-out printed on damask denim canvas

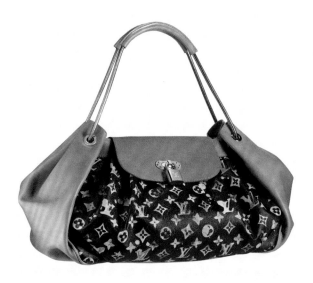

WATERCOLOR MONOGRAM CANVAS (AFTER DARK COLLECTION)

PRESENTATION At the show, looks 17, 25, 33, 35, 36, 38, 40, 41, and 64 were accessorized with prototypes of the bags made with this canvas. It was also presented at the Louis Vuitton store on Sloane Street, in London, in the form of fifty *Jamais* bags (white background and ostrich leather) produced in a limited edition and signed by Richard Prince on the occasion of his exhibition Continuation at the Serpentine Gallery, in London, from June 26 through September 7, 2008.
MODELS Three models: *Speedy Frame*, *Papillon Frame*, and *Jamais* (calfskin or ostrich)
COLORS One colorway, consisting of seventeen colors on a white background or on Monogram Canvas
TECHNIQUE AND DECORATION Silk screen on plain, white-coated canvas or on grained Monogram Canvas (with shifting)

LEATHER BONBON MONOGRAM (AFTER DARK COLLECTION)

PRESENTATION At the show, looks 22, 30, 31, 43, 47, and 63 were accessorized with prototypes of handbags in Bonbon Leather Monogram
MODEL *Pochette*
COLORS Pink and green colorways, consisting of four colors printed on a plain white calfskin background
TECHNIQUE AND DECORATION Silk screen of a pattern without seams, composed of random repetitions of the double-scaled Monogram, printed as solid and as outline on white patent-leather calfskin

LEFT PAGE
Graduate Jokes Monogram canvas in burgundy.

THIS PAGE FROM TOP
Large *Weekender* Pulp Monogram canvas in yellow.
Jamais bag Watercolor Monogram canvas in black.
Pochette bag Bonbon Monogram leather in pink.

MARC JACOBS

THE
COLLECTIONS

EDITED BY

MARC JACOBS & KATIE GRAND

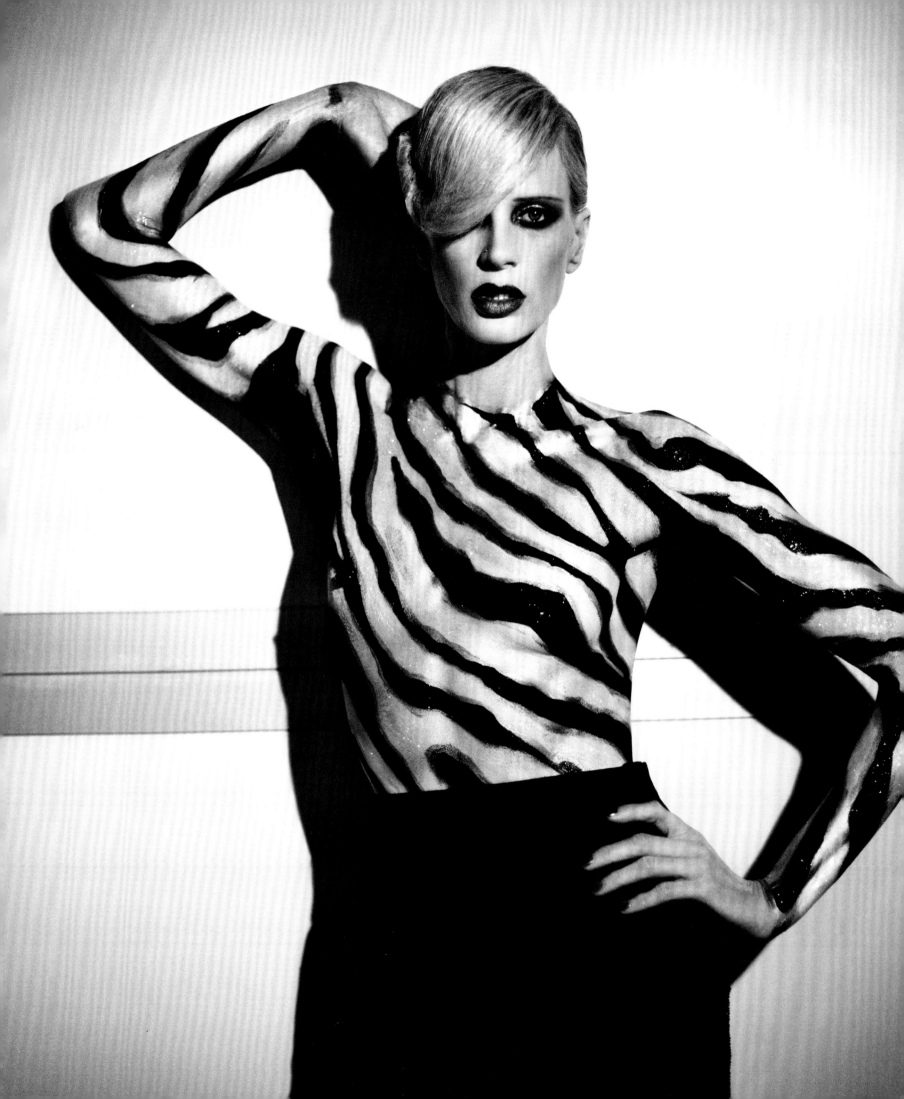

PREVIOUS PAGE
Backstage photograph from the Spring–Summer 2011
runway show by Boo George.

LOUIS VUITTON

PRIE

...

...

D'ASSISTER A LA PRESENTATION DE LA COLLECTION PRET-A-PORTER
AUTOMNE-HIVER 1998
LE LUNDI 9 MARS 1998 A 14H30

LA GRANDE HALLE DE LA VILLETTE
211, AVENUE JEAN JAURES
75019 PARIS

CE CARTON ET UNE PIECE D'IDENTITE SERONT DEMANDES A L'ENTREE

AUTUMN–WINTER

1998–1999

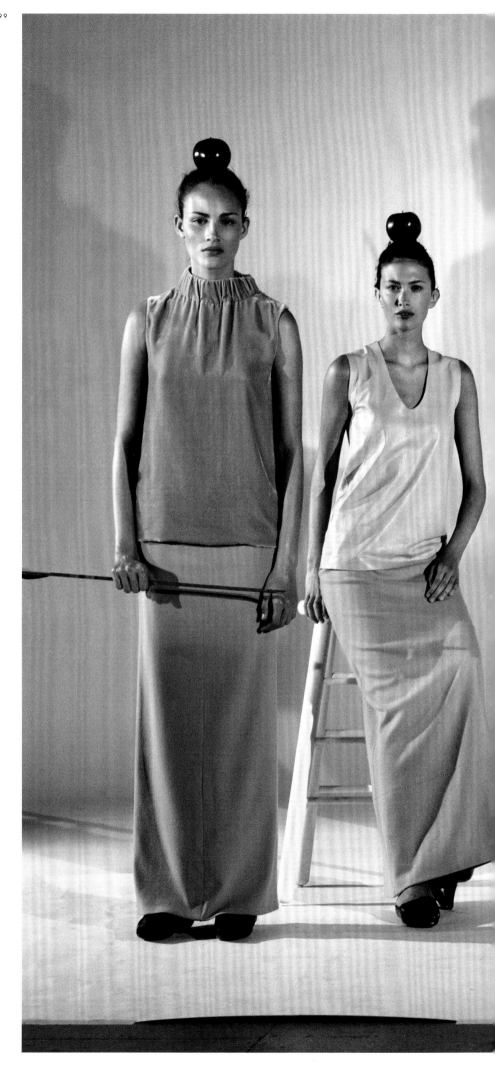

MARC JACOBS

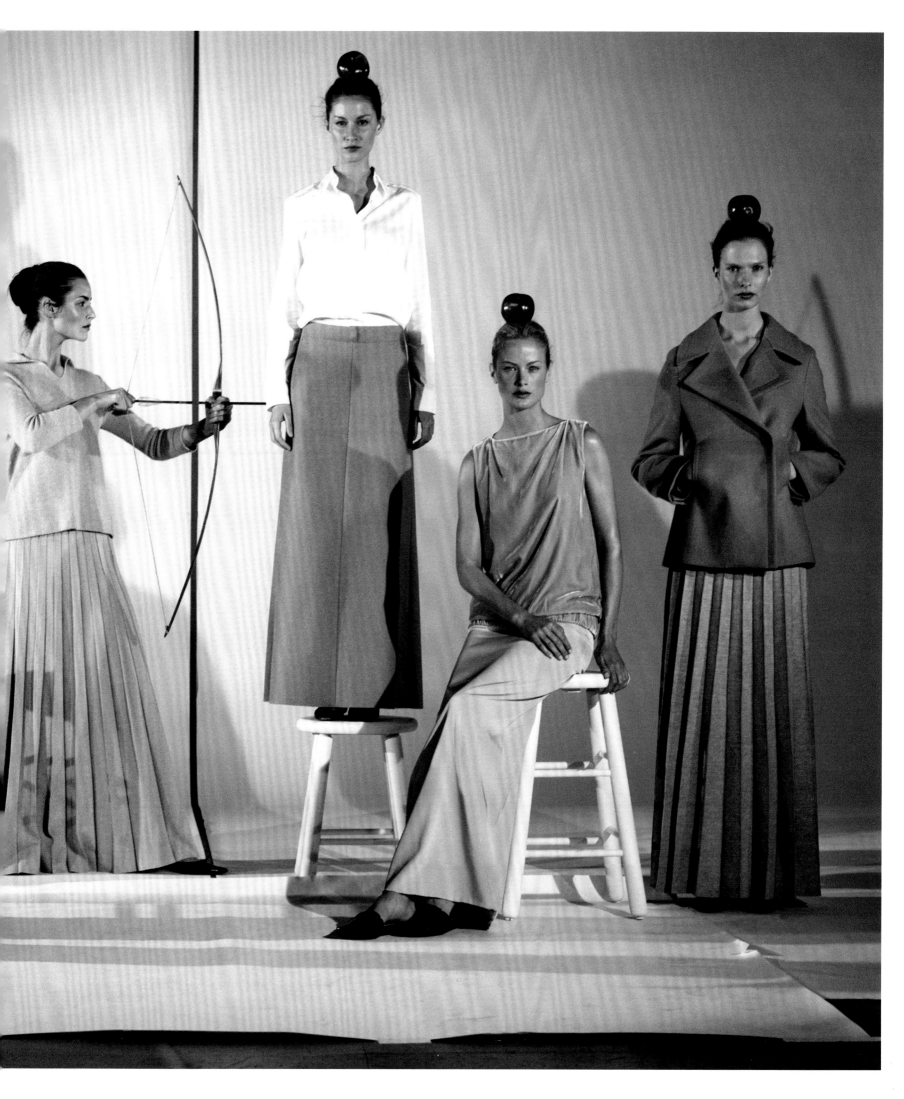

SPRING–SUMMER

1999

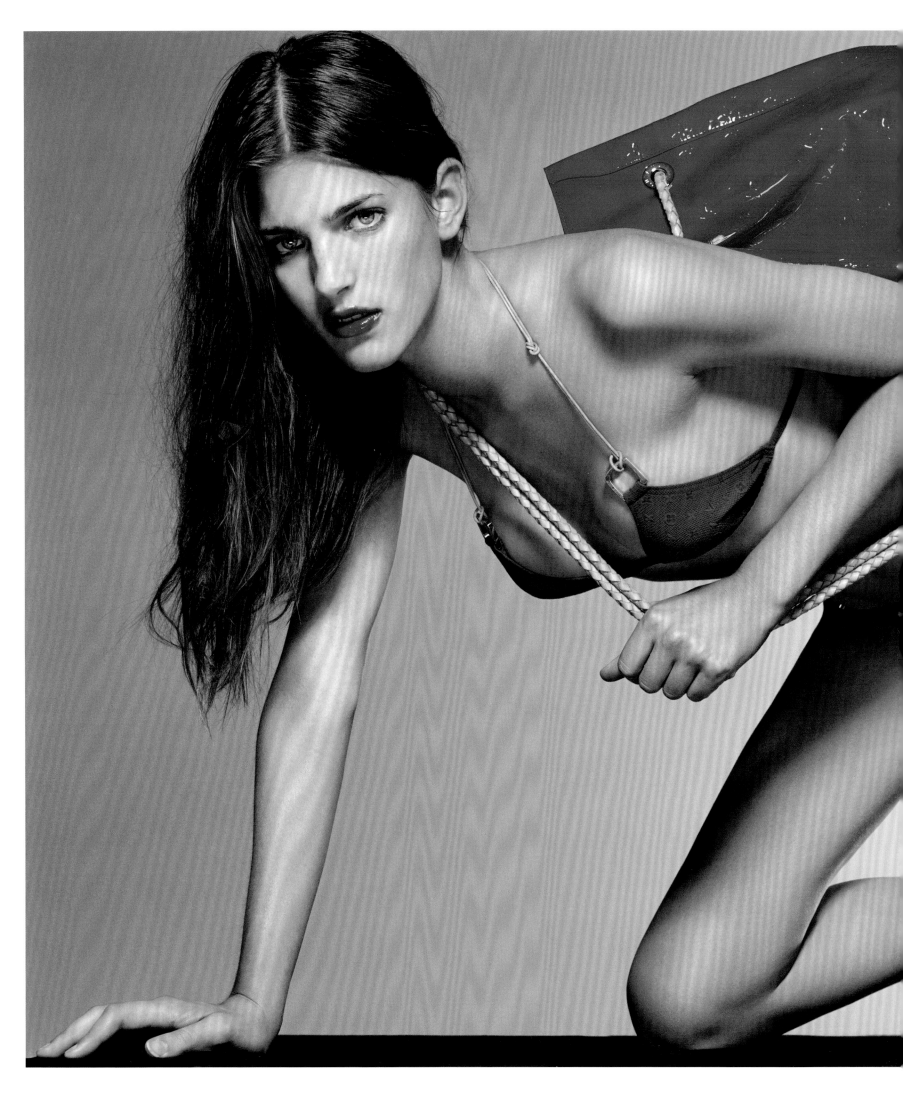

AUTUMN–WINTER

1999–2000

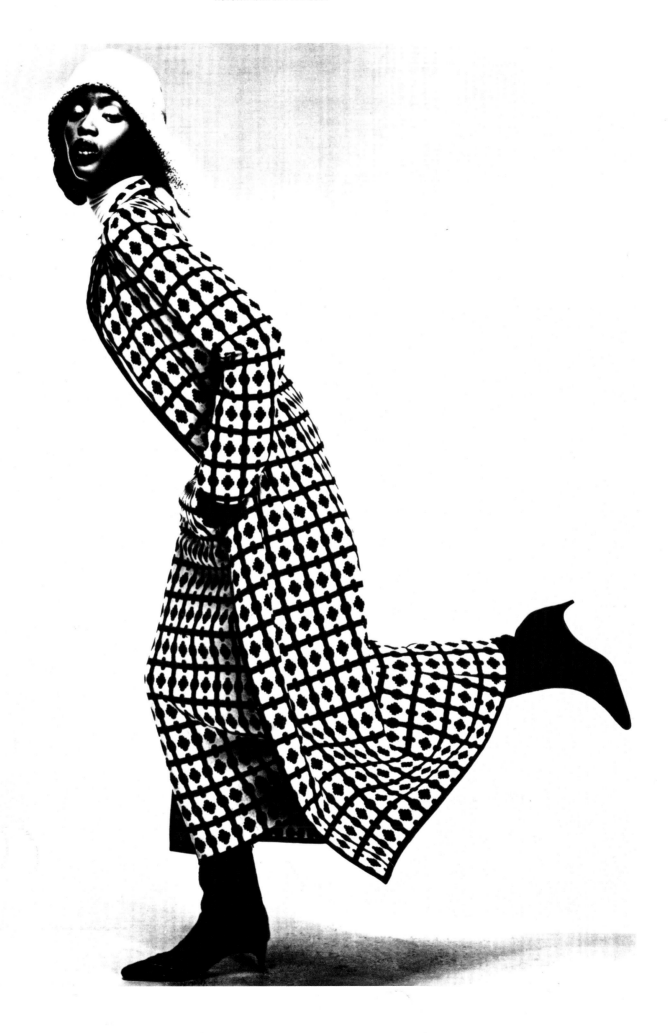

MARC JACOBS

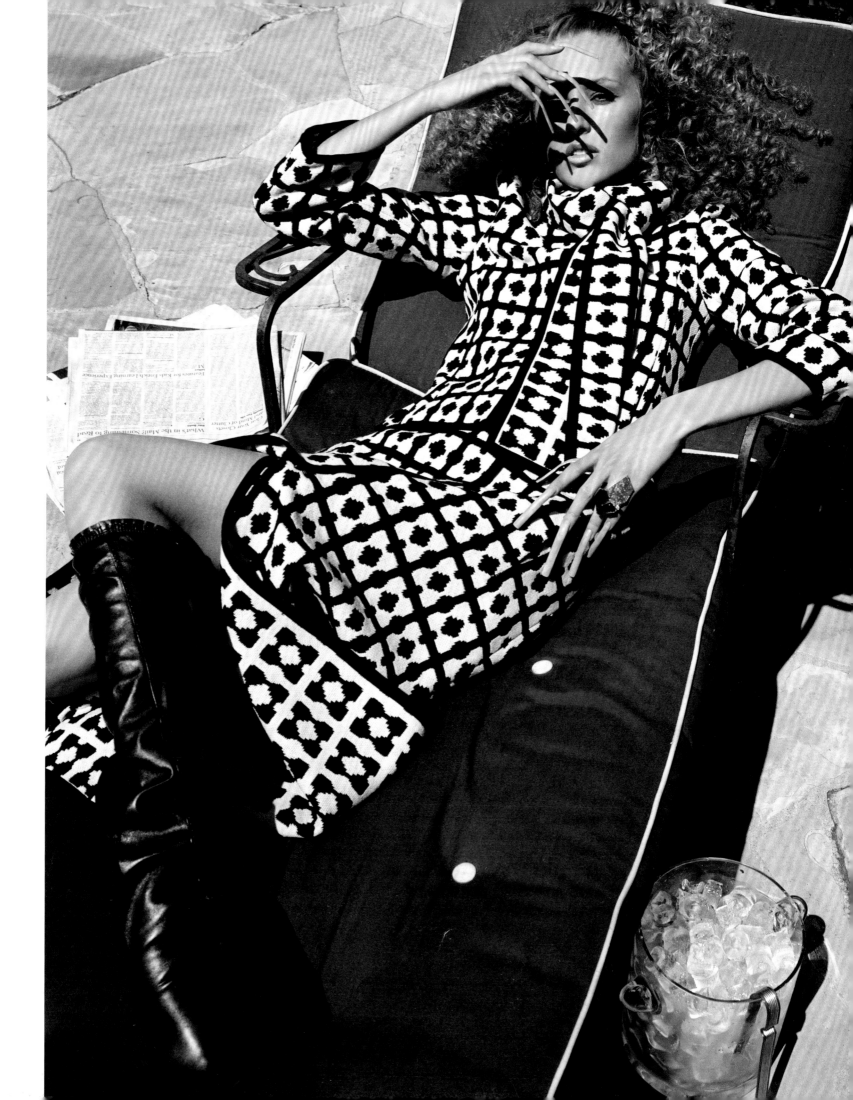

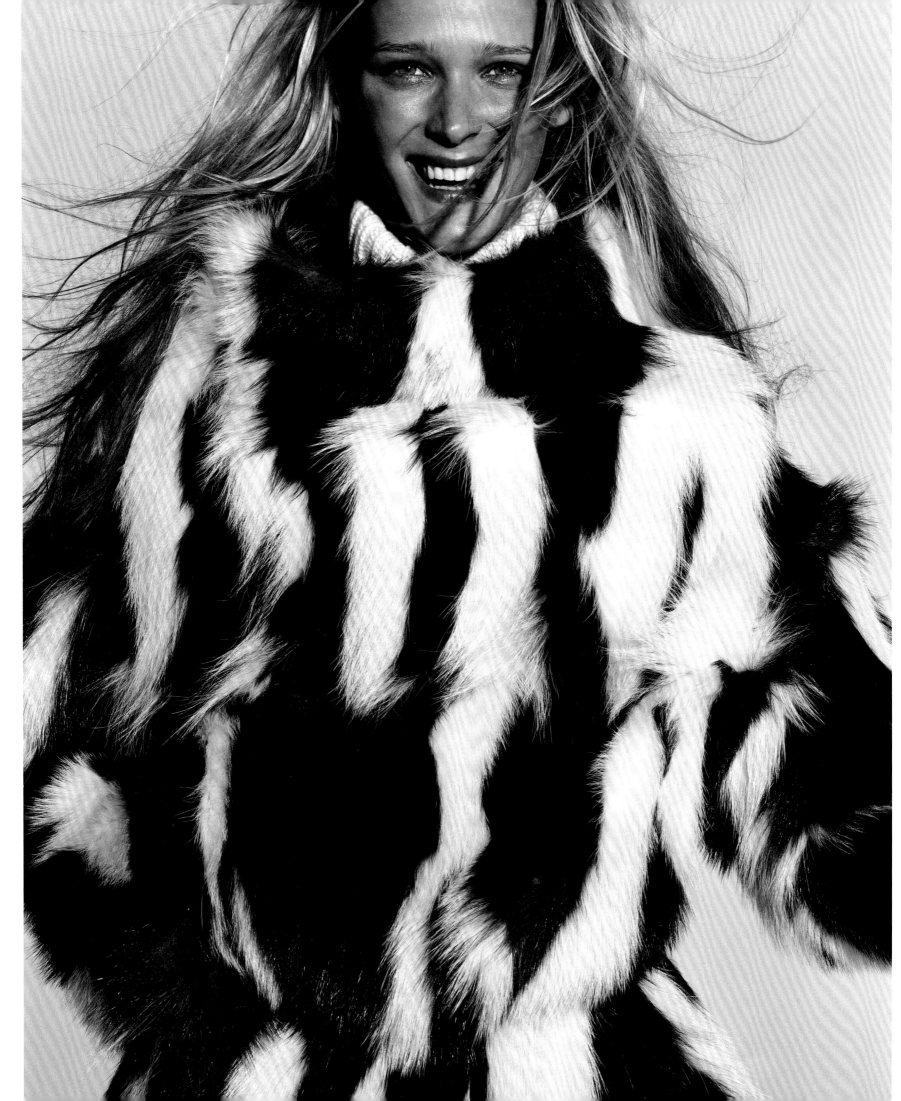

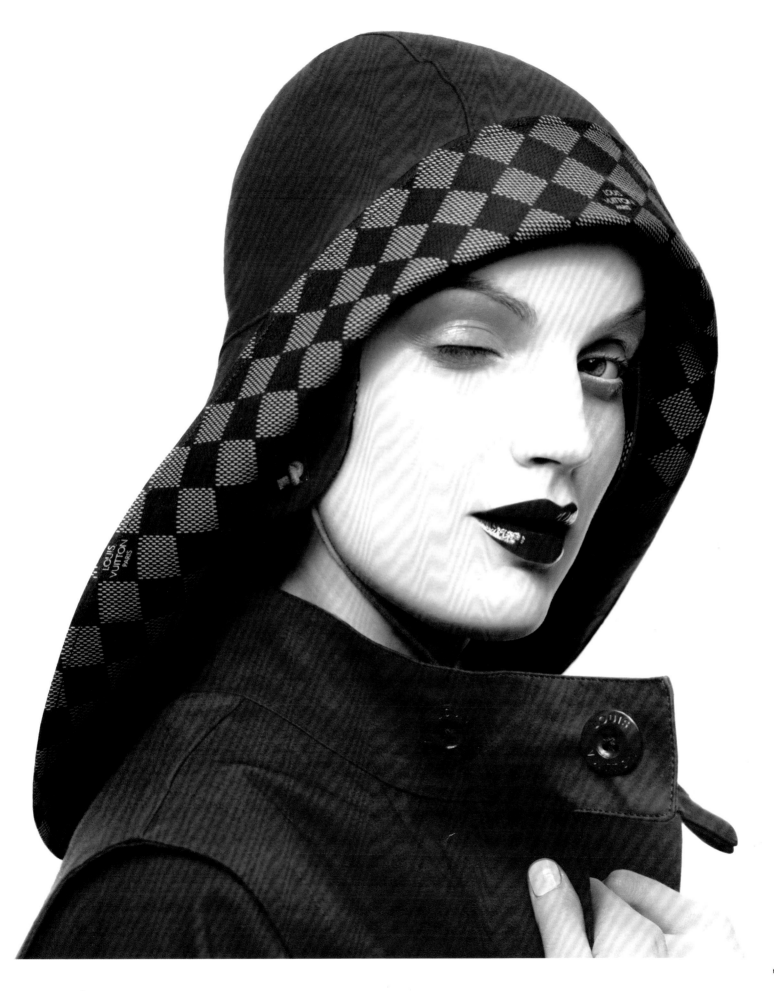

MARC JACOBS

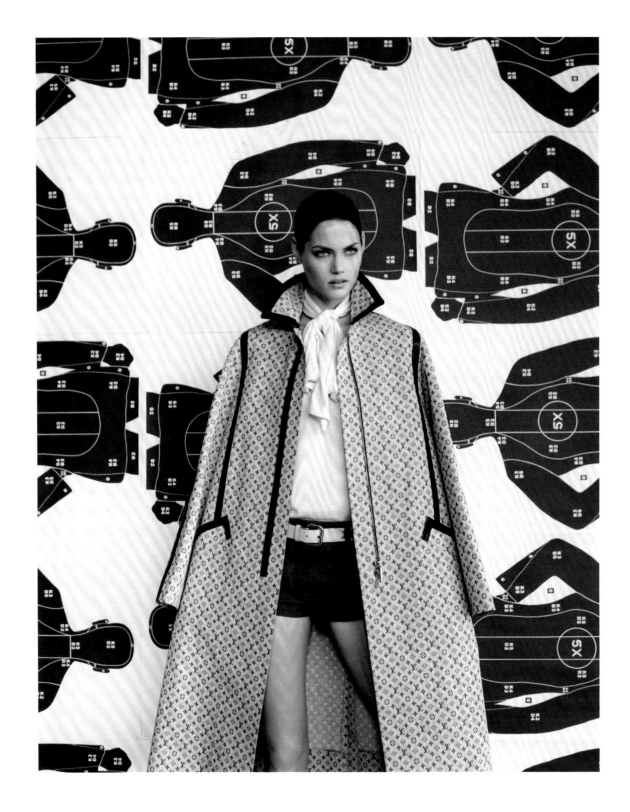

SPRING–SUMMER

2000

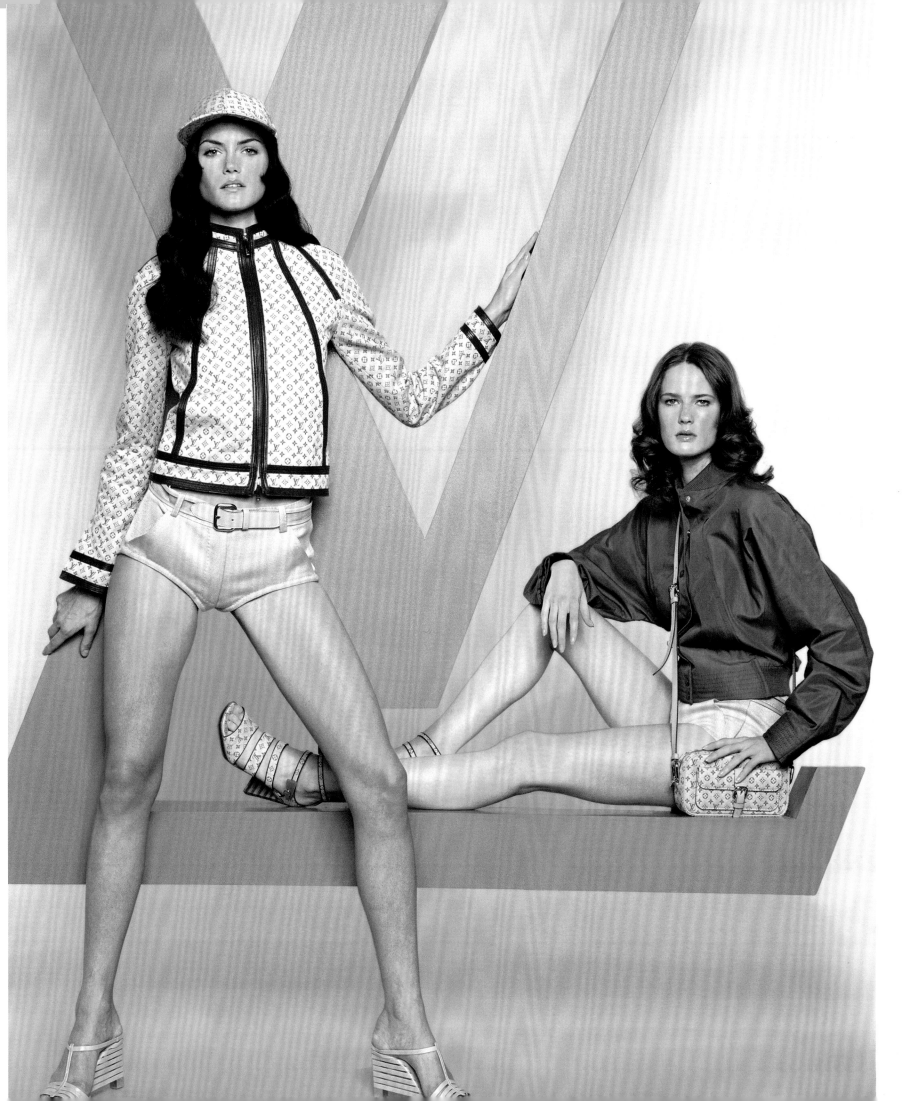

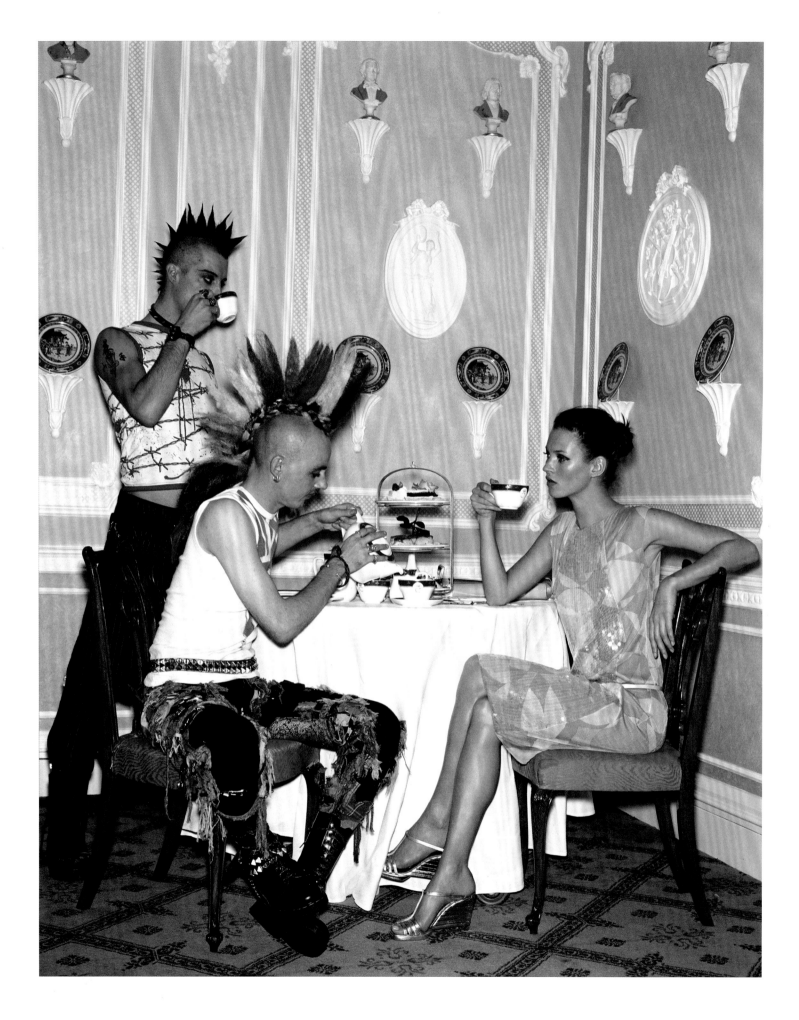

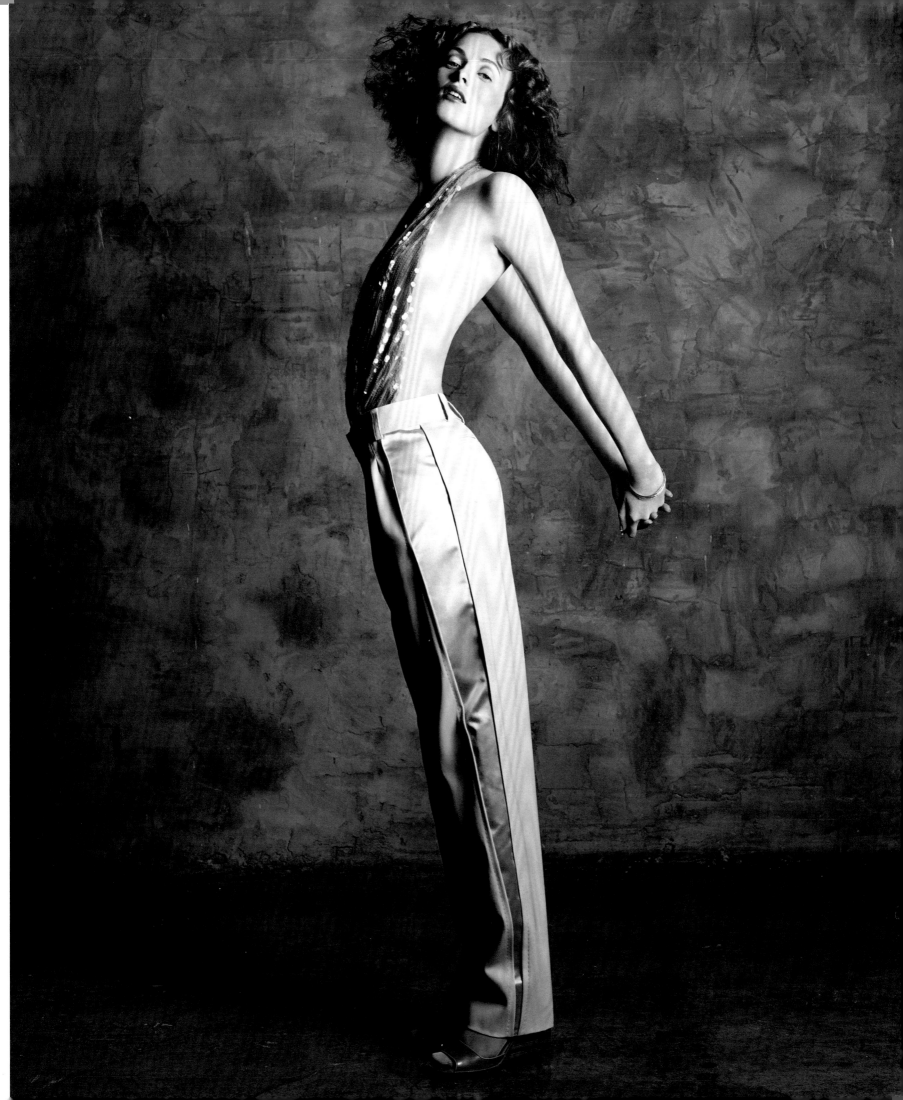

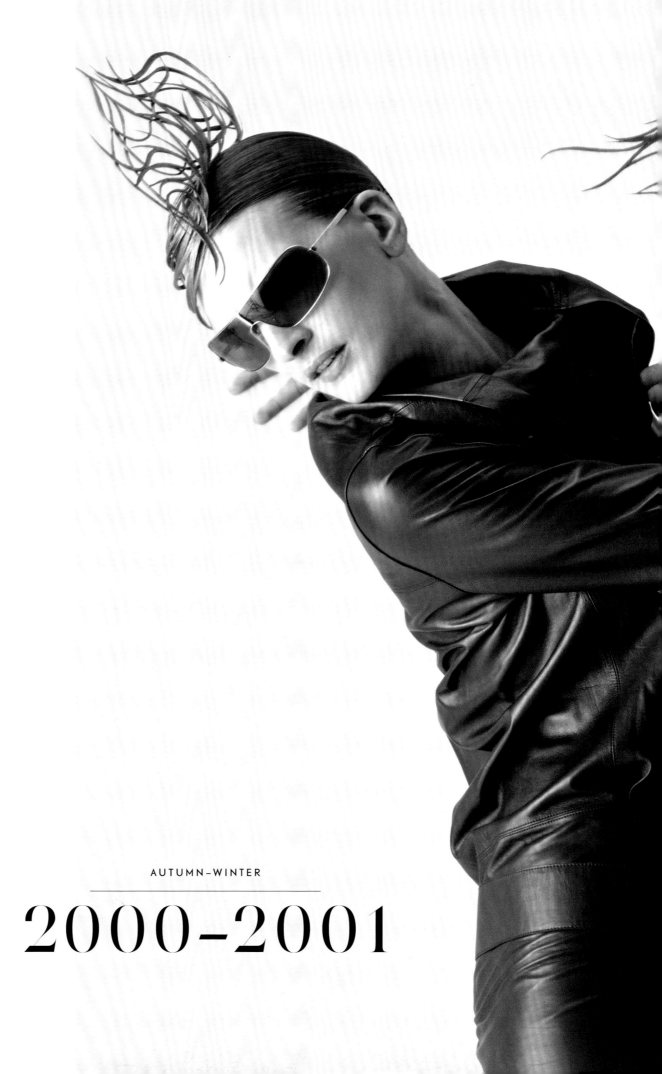

AUTUMN–WINTER

2000–2001

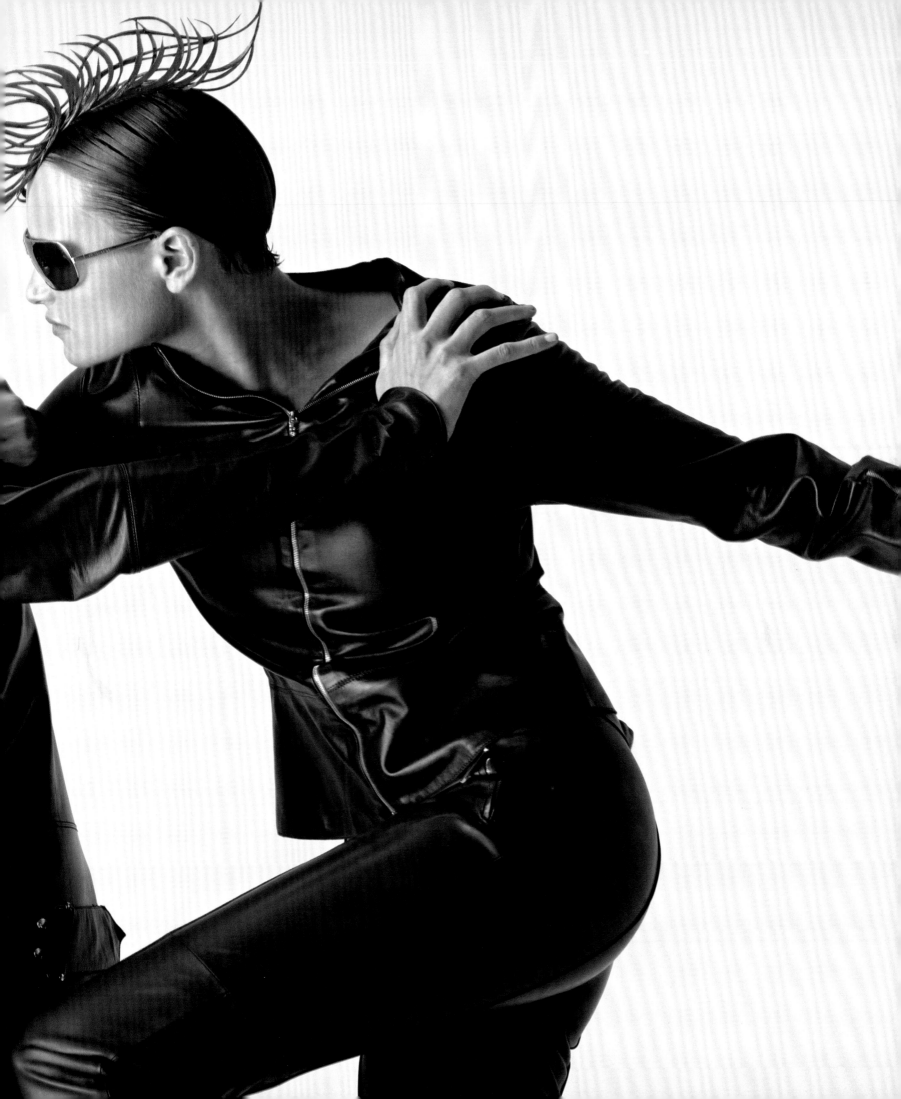

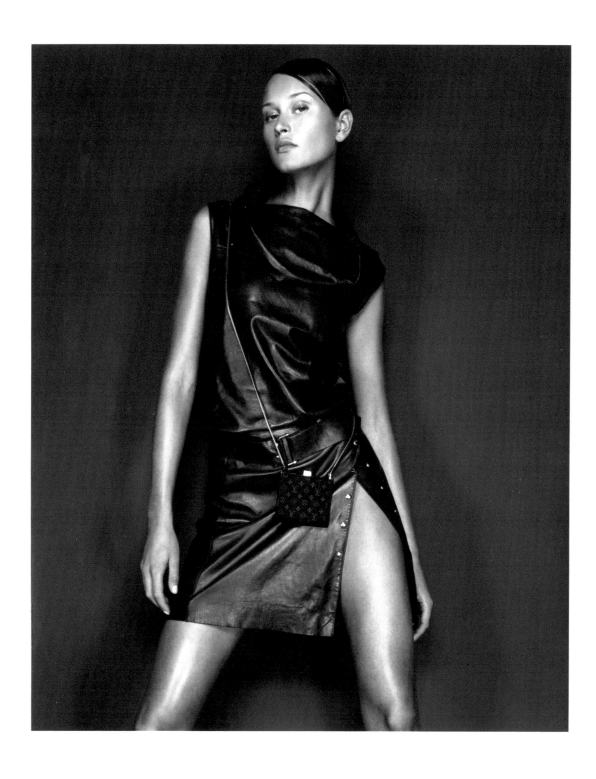

MARC JACOBS

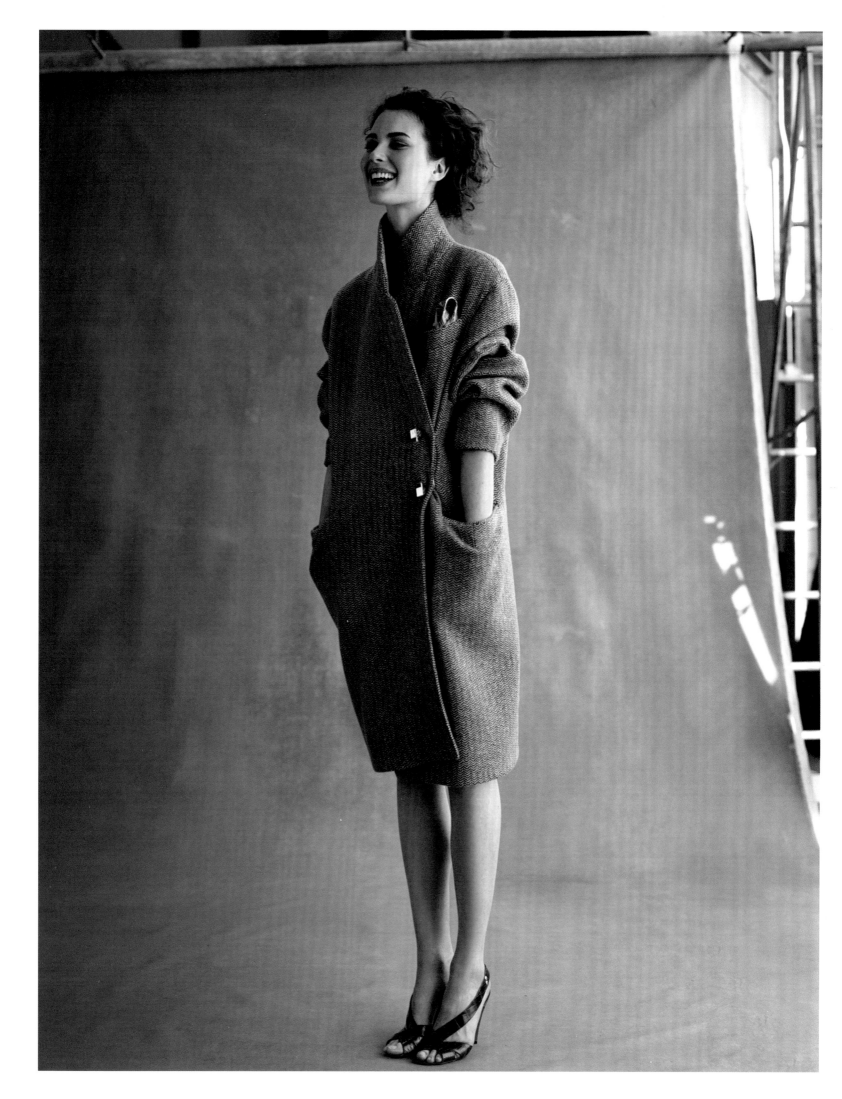

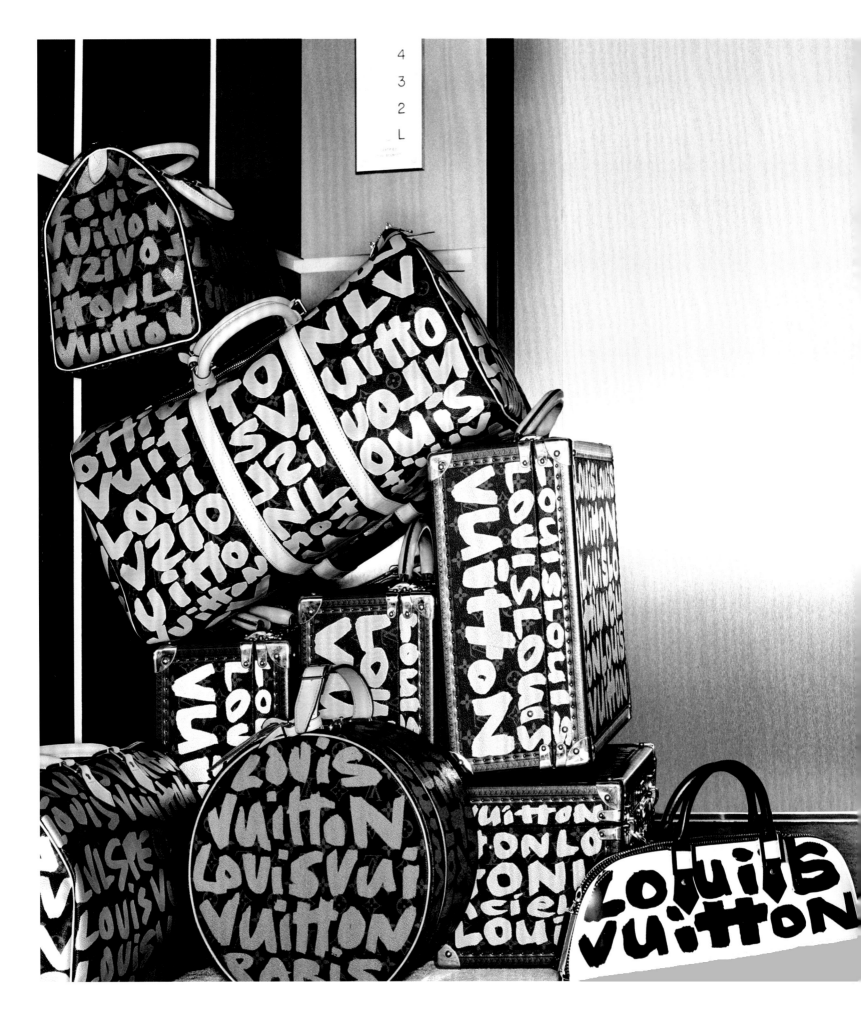

SPRING–SUMMER

2001

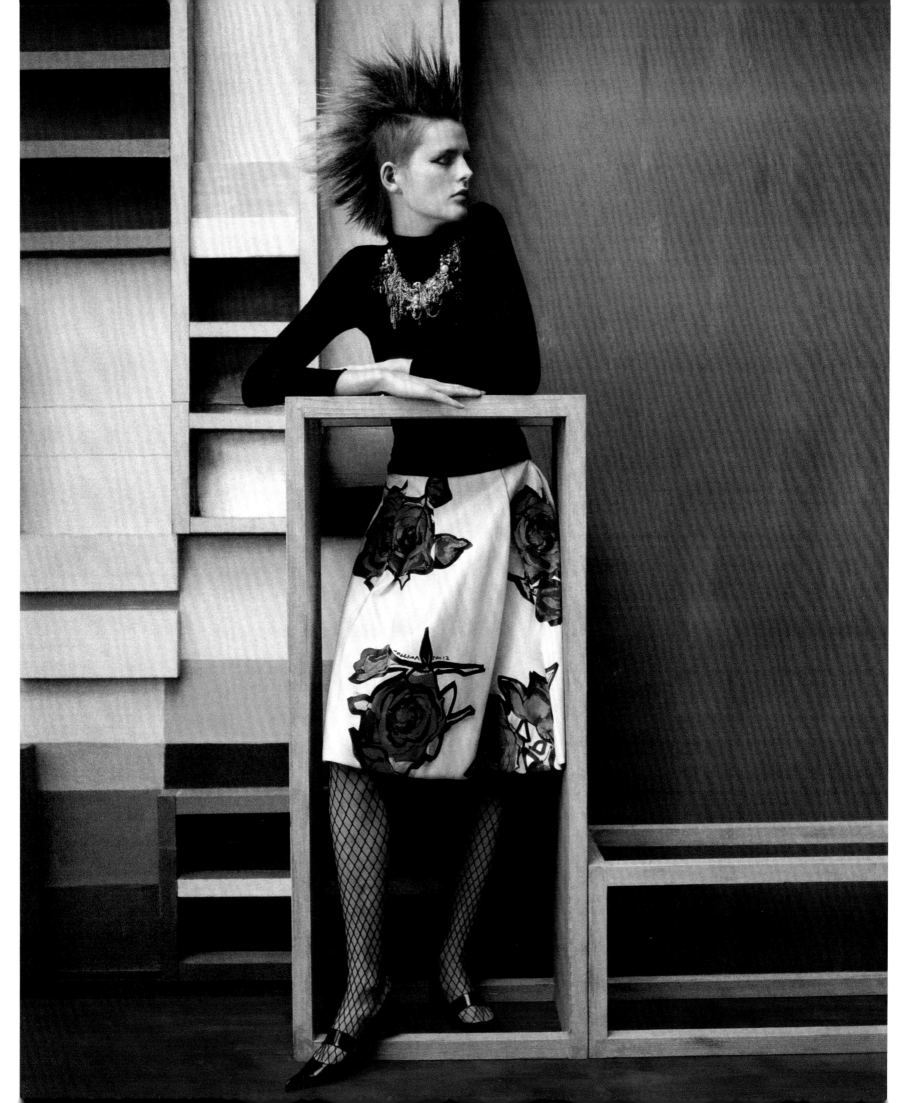

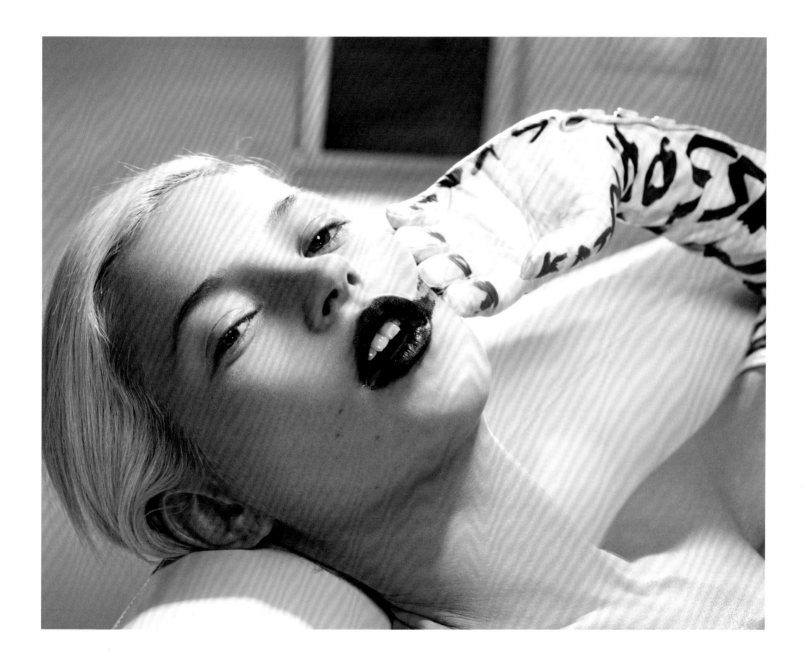

MARC JACOBS

AUTUMN–WINTER

2001–2002

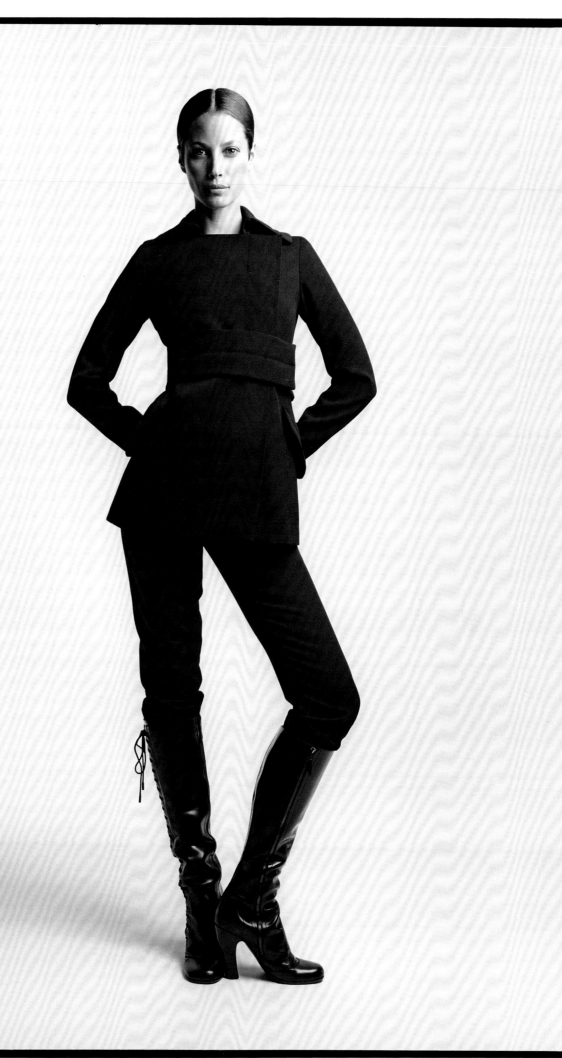

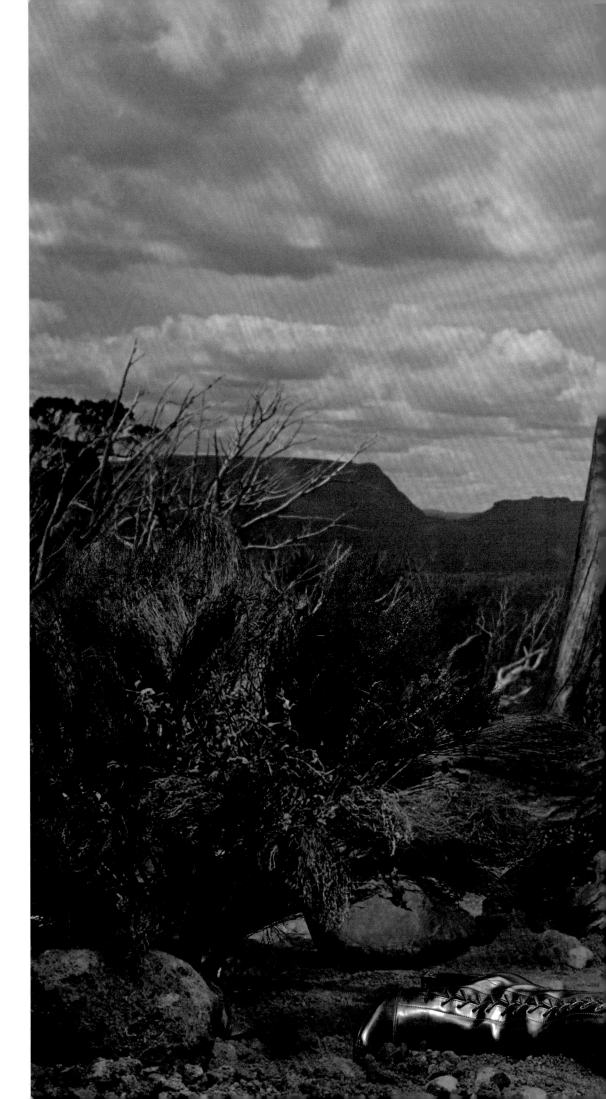

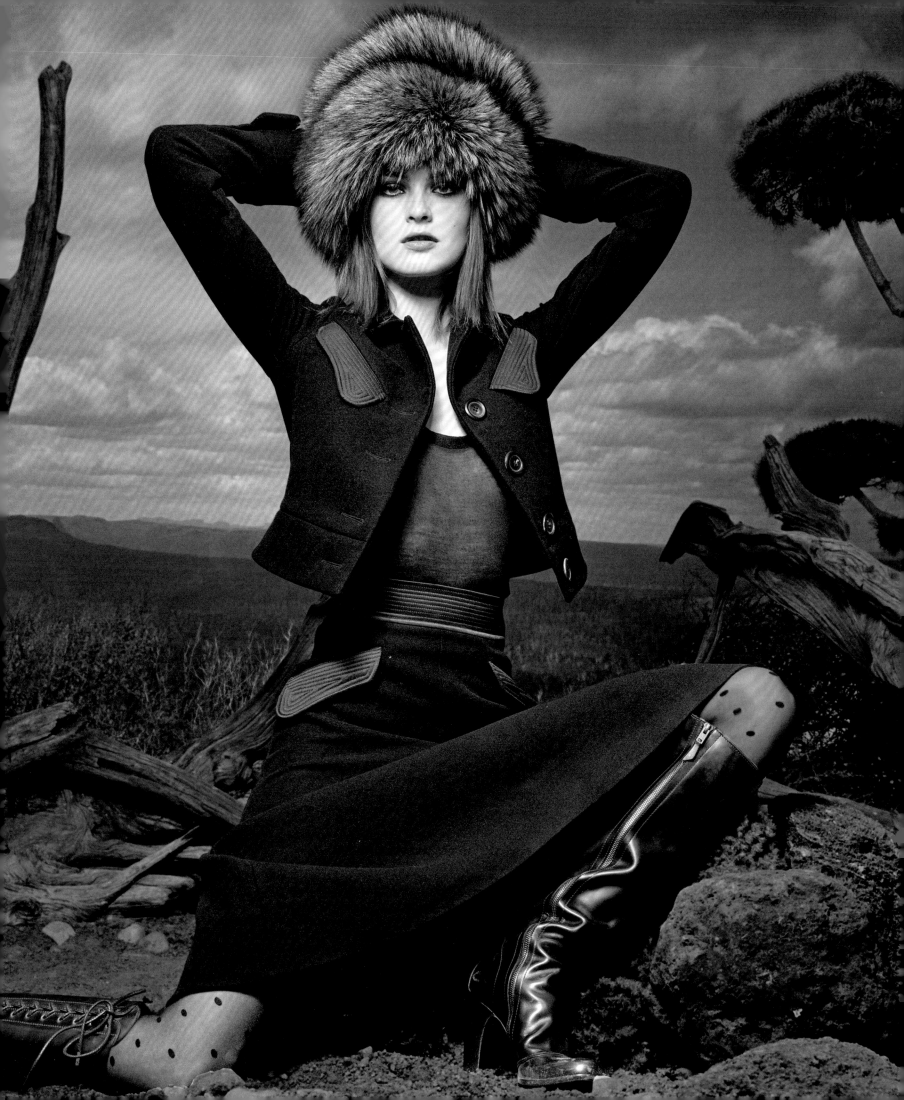

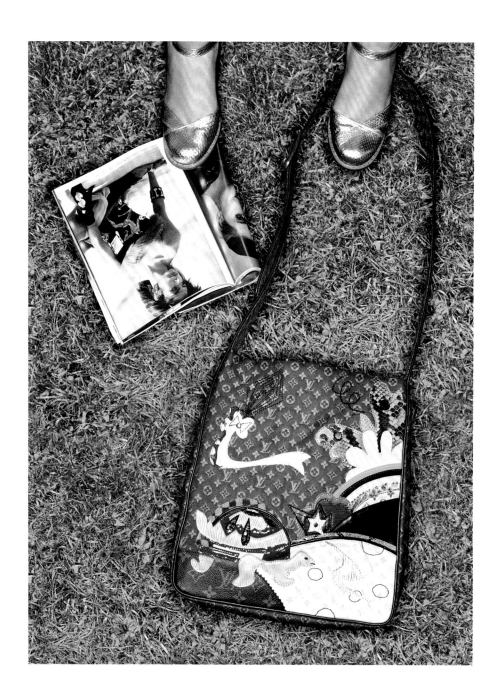

SPRING–SUMMER

2002

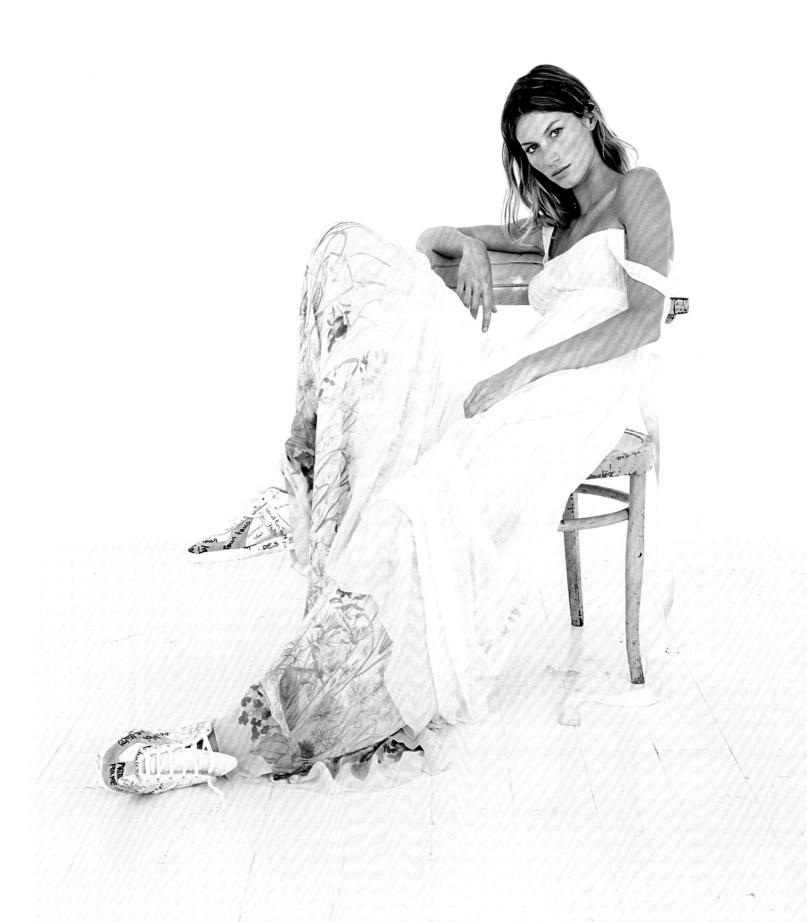

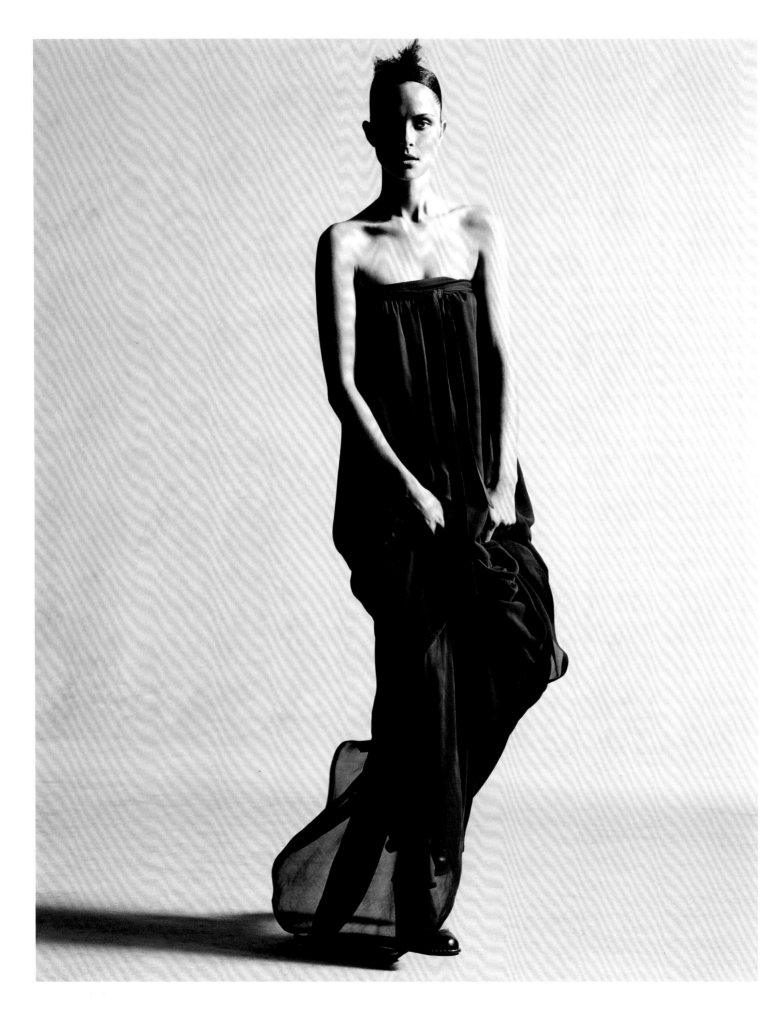

MARC JACOBS

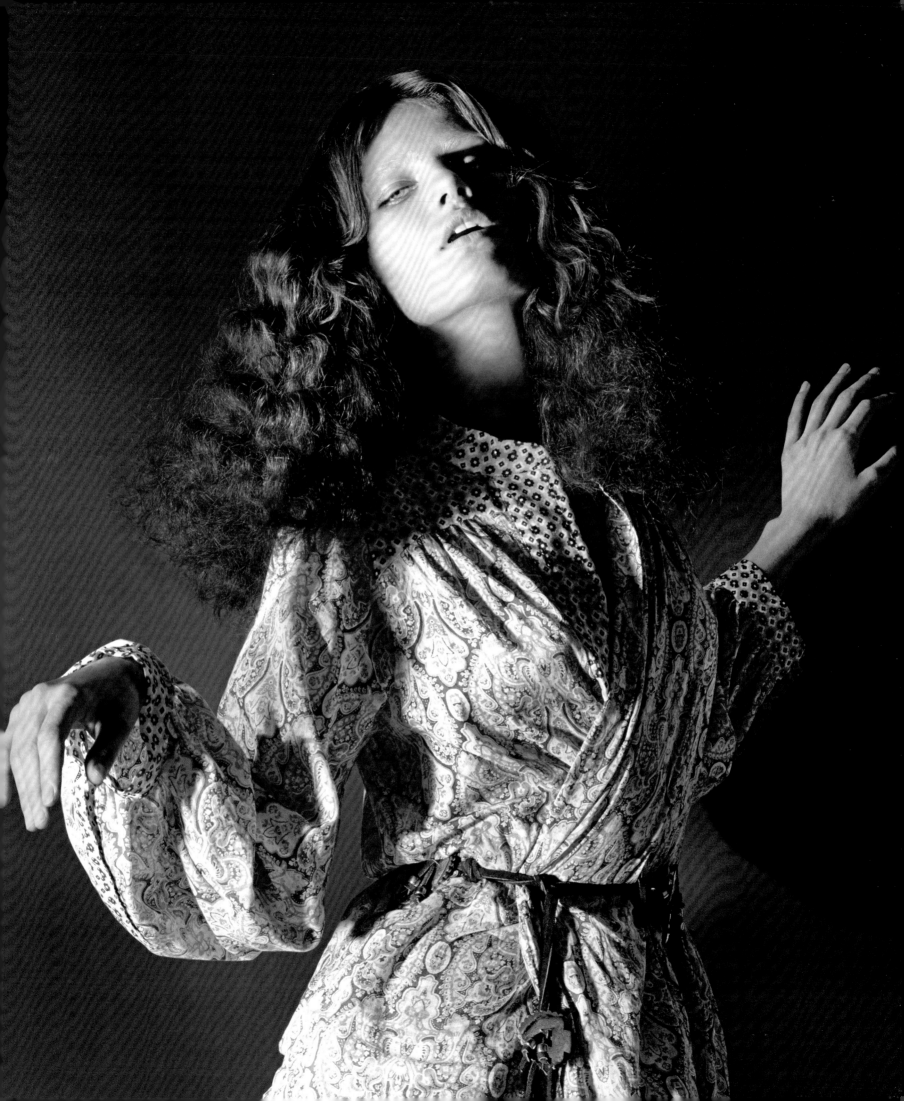

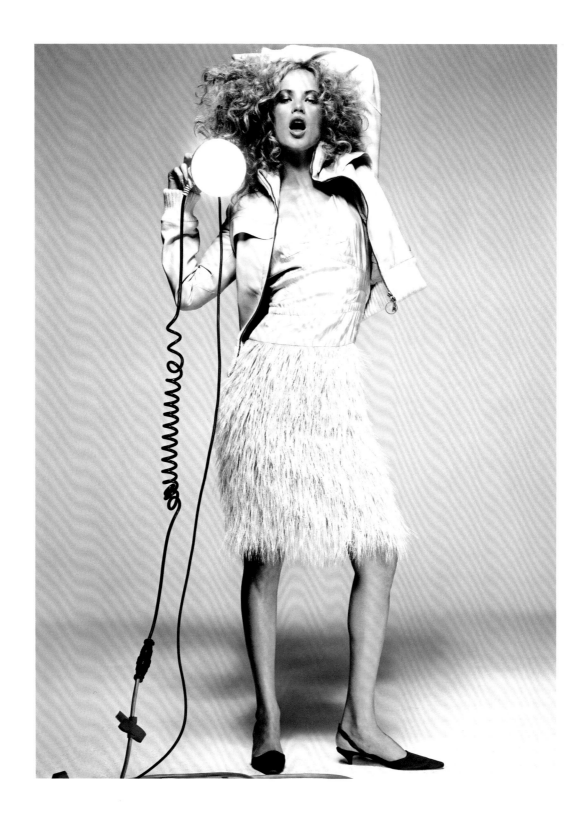

AUTUMN—WINTER

2002–2003

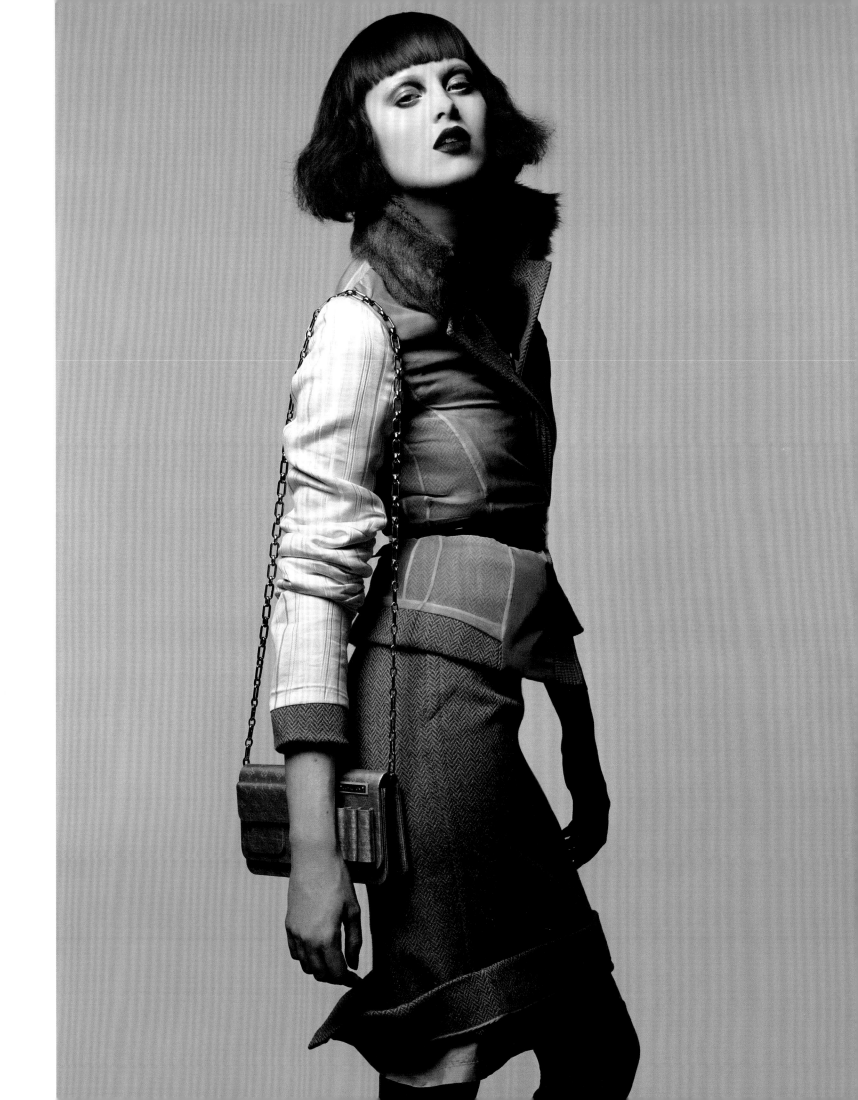

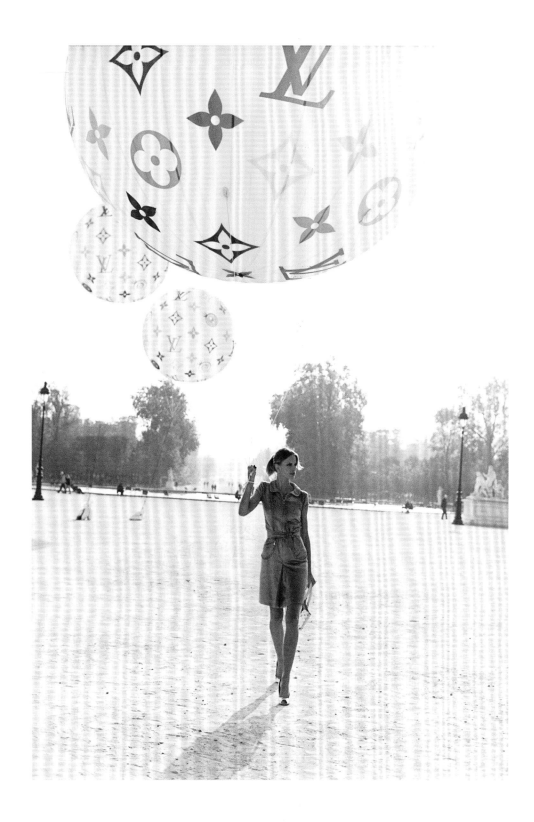

SPRING–SUMMER

2003

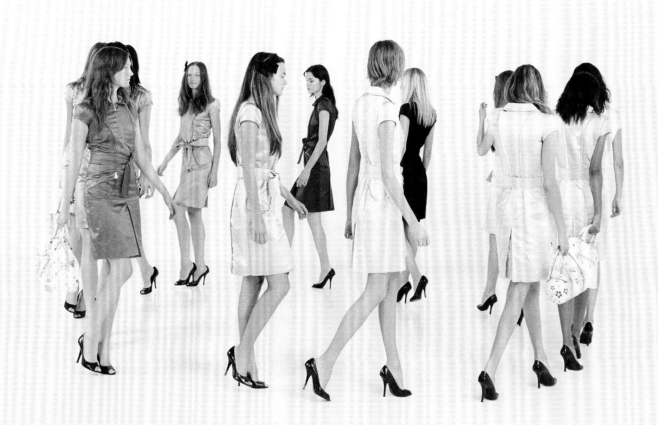

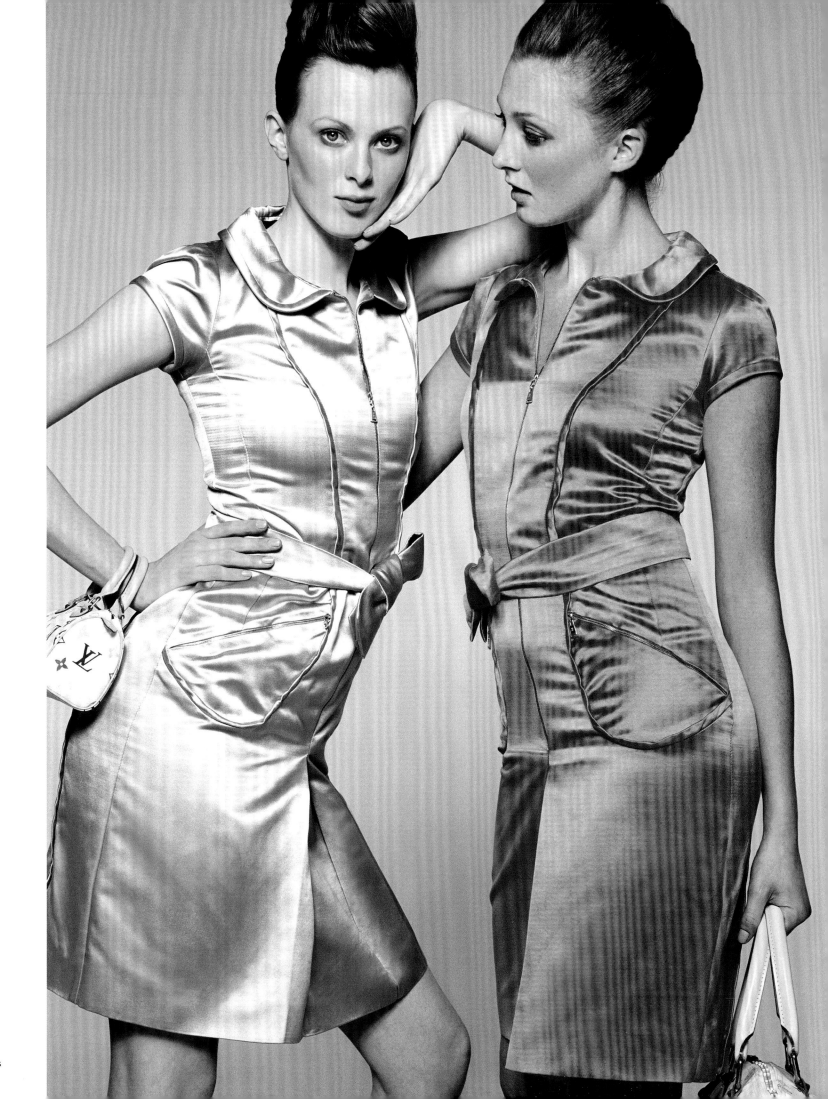

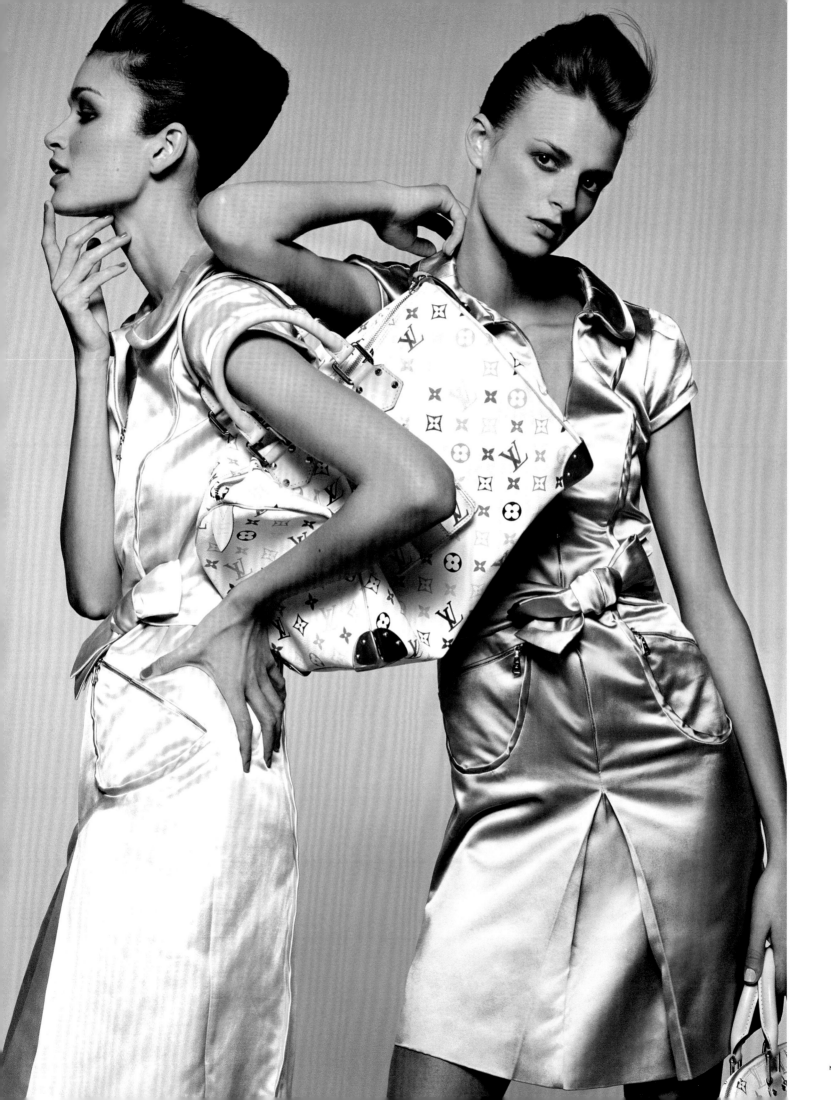

AUTUMN–WINTER

2003–2004

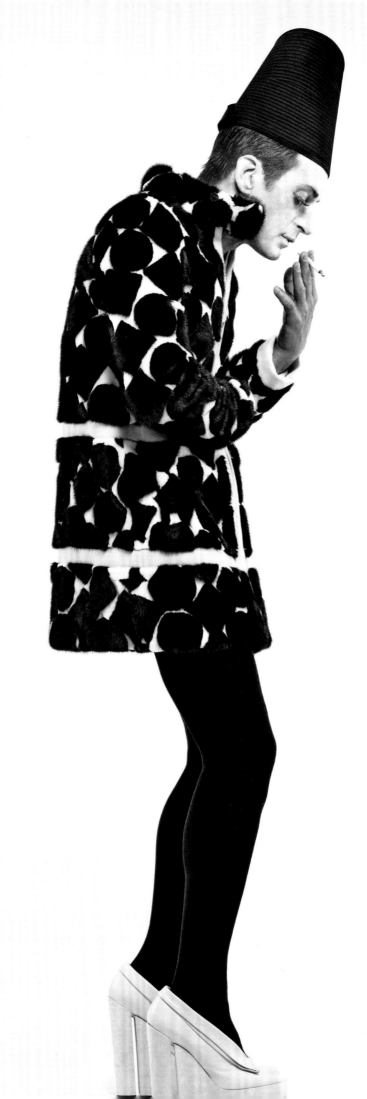

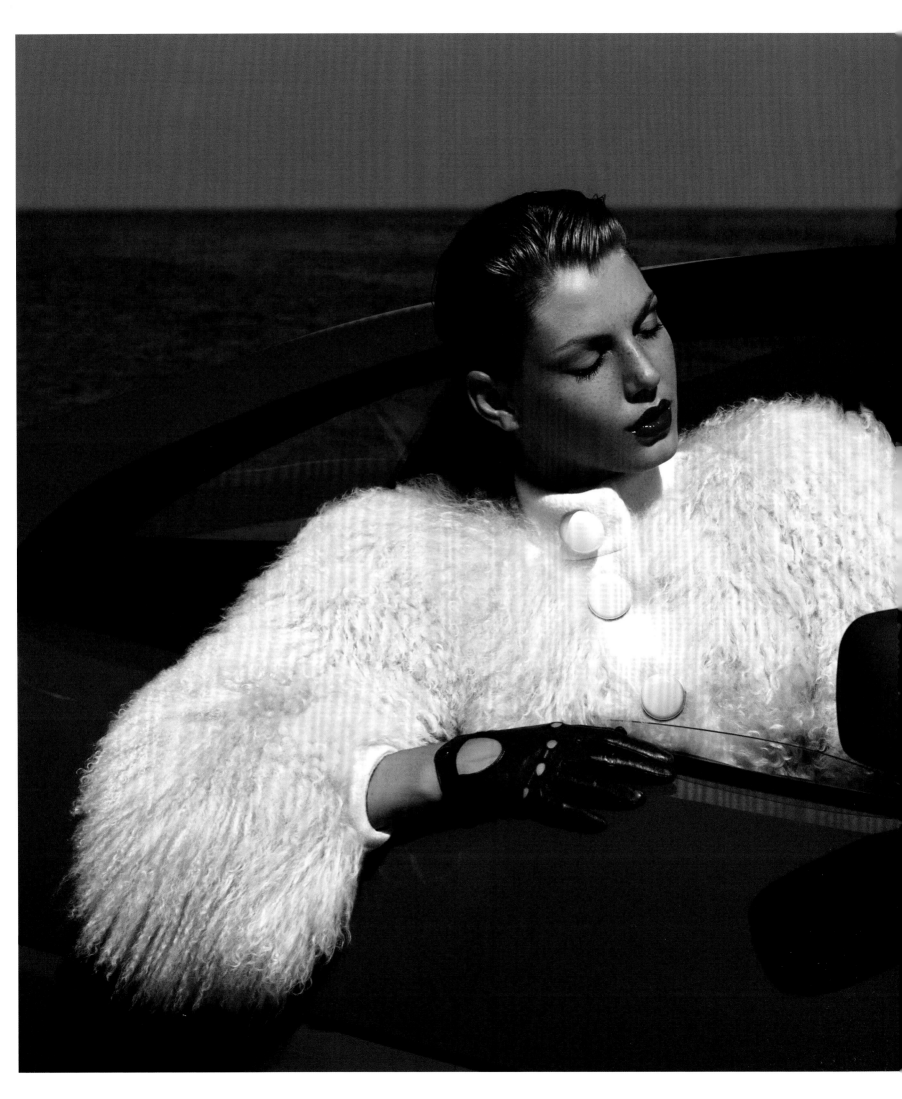

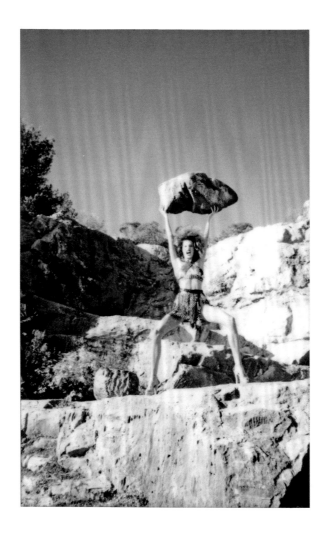

SPRING–SUMMER

2004

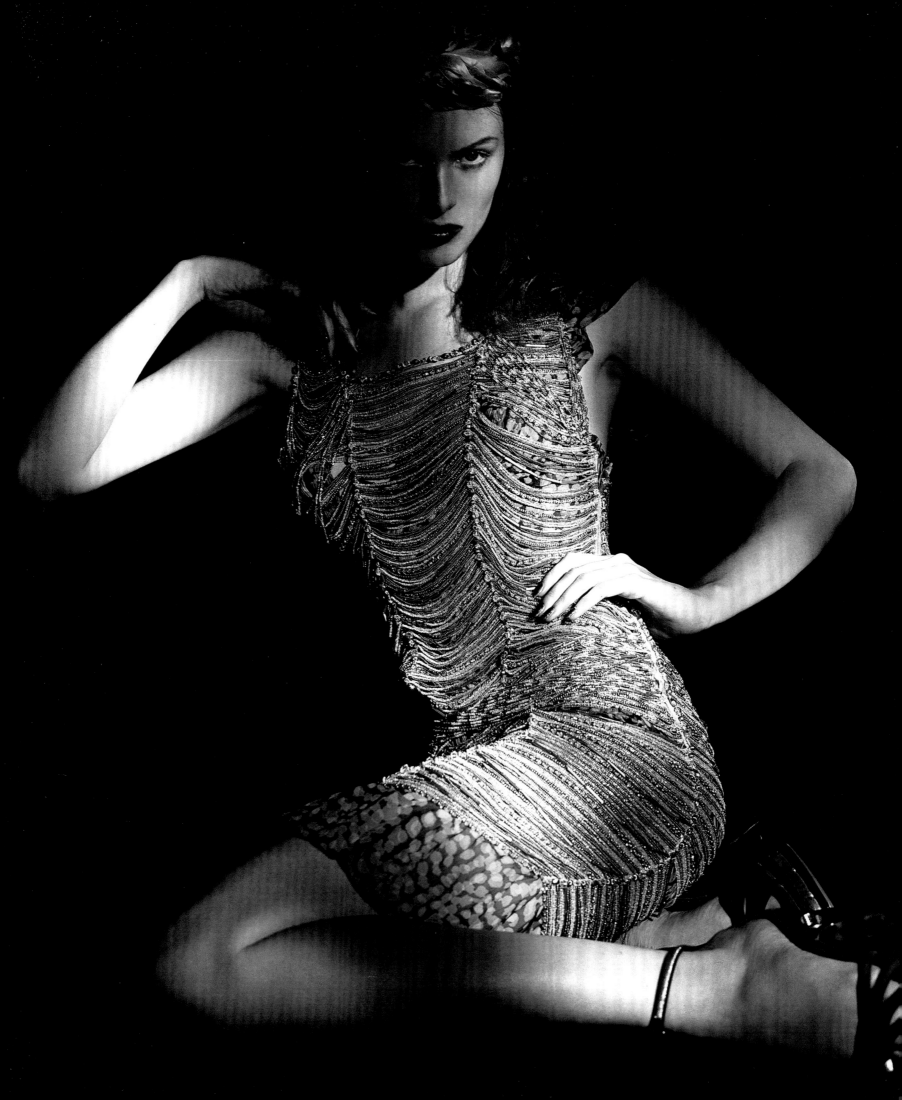

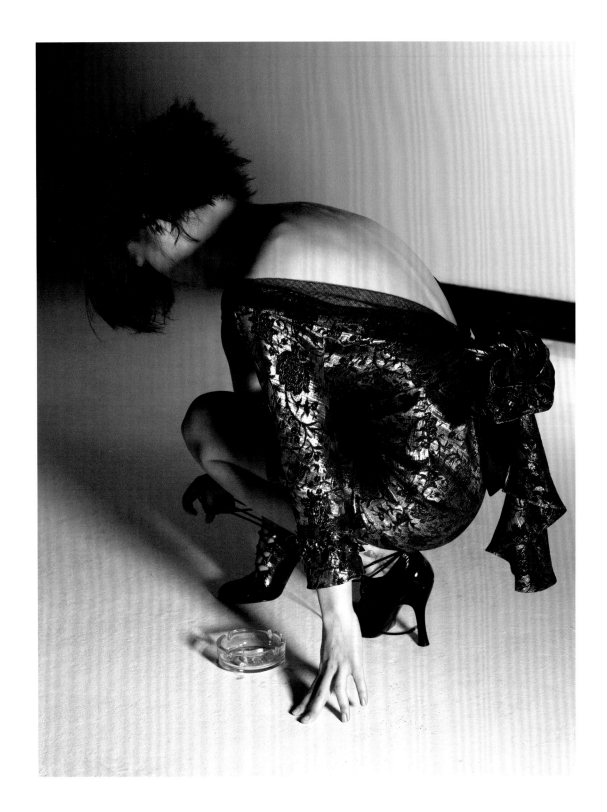

AUTUMN–WINTER

2004–2005

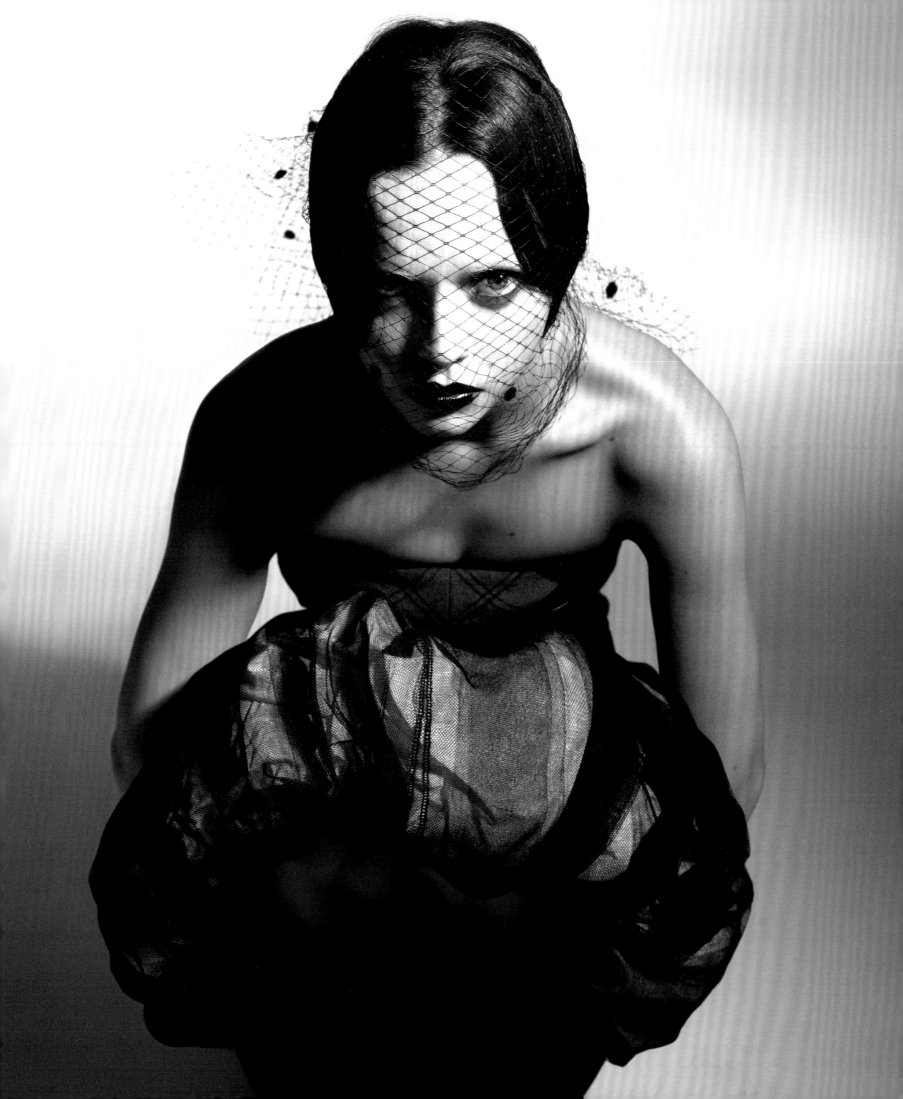

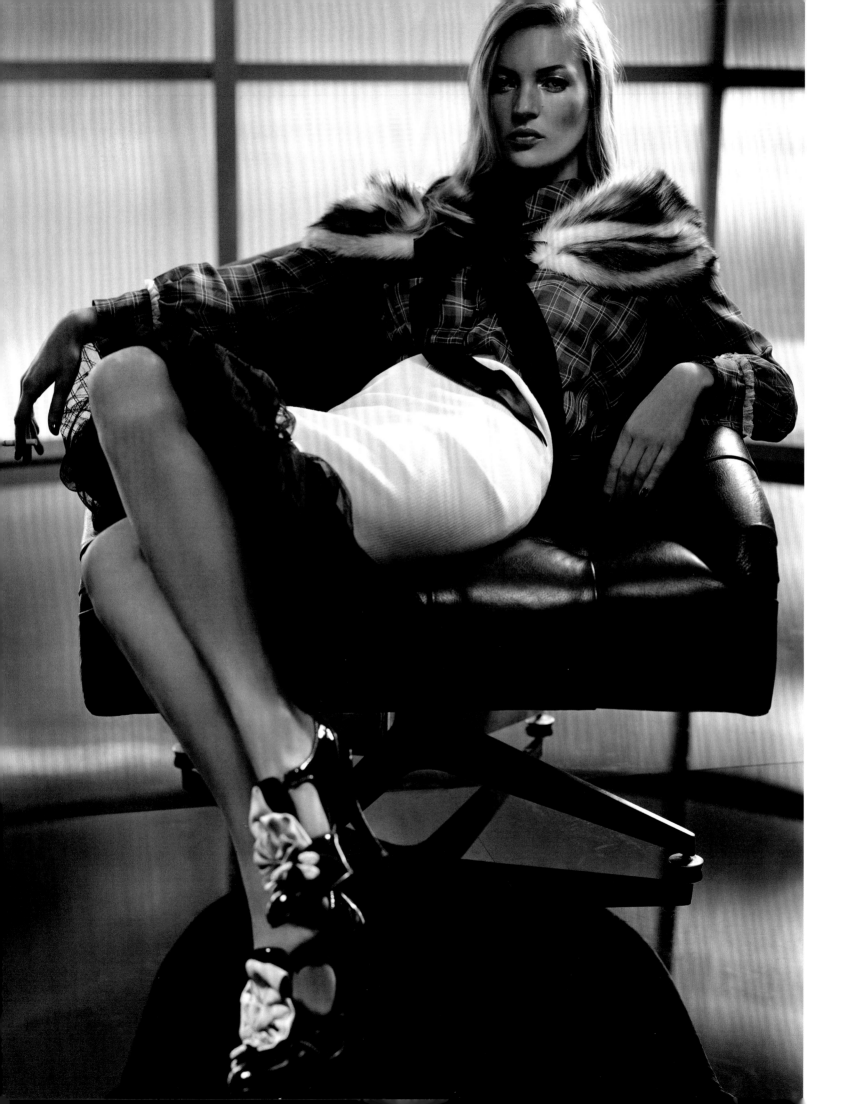

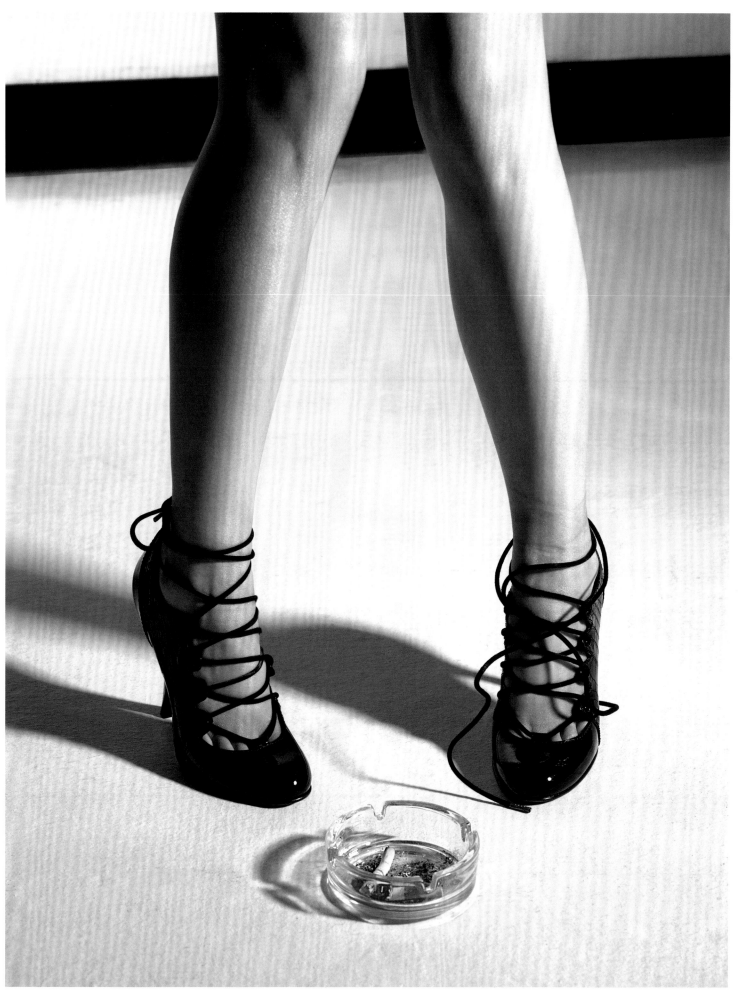

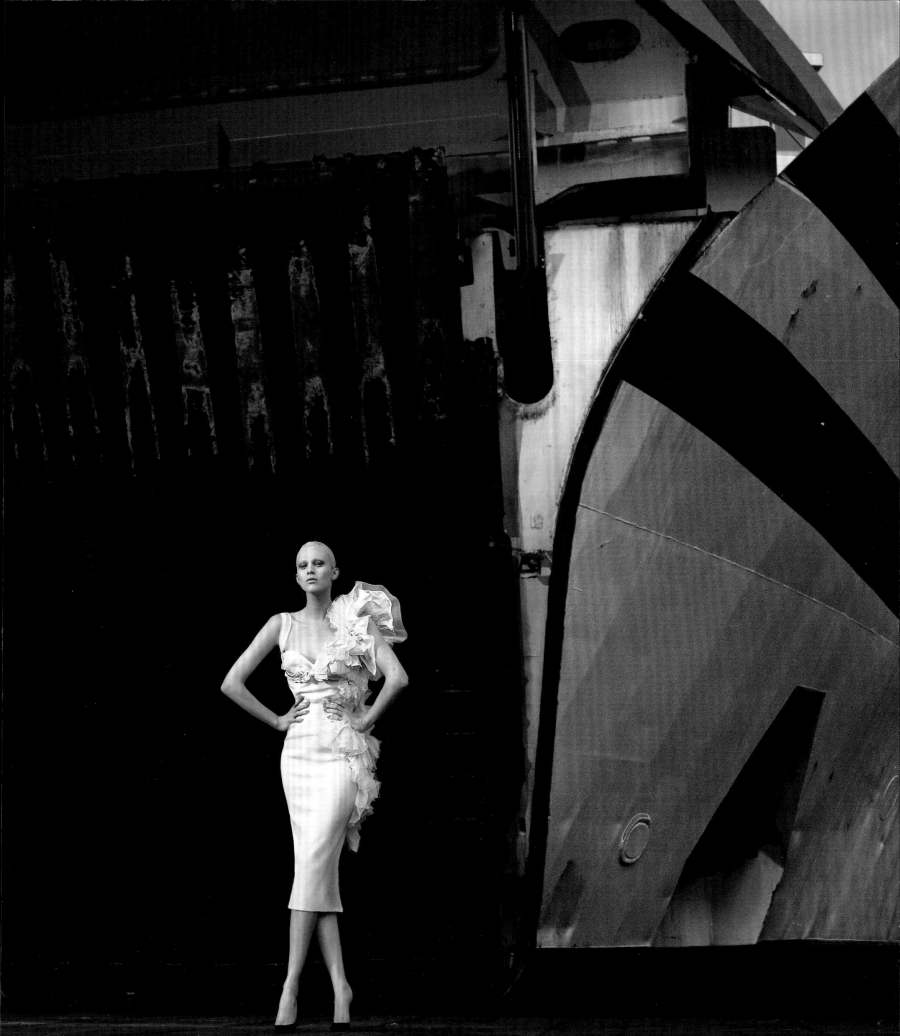

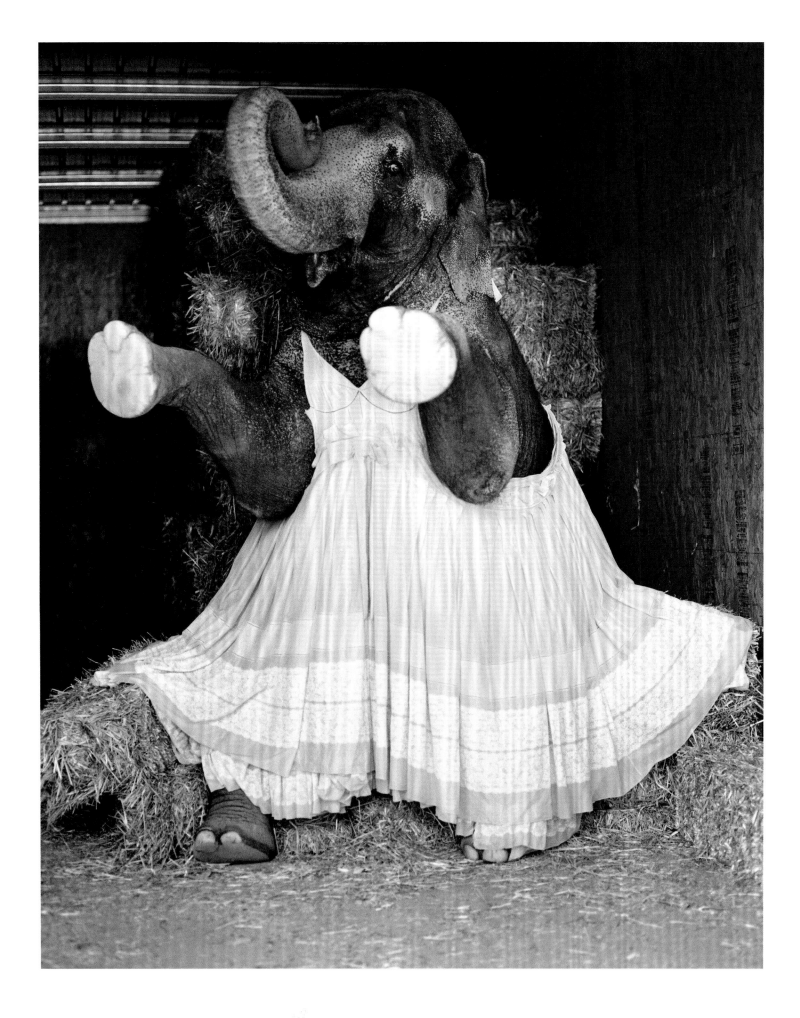

MARC JACOBS

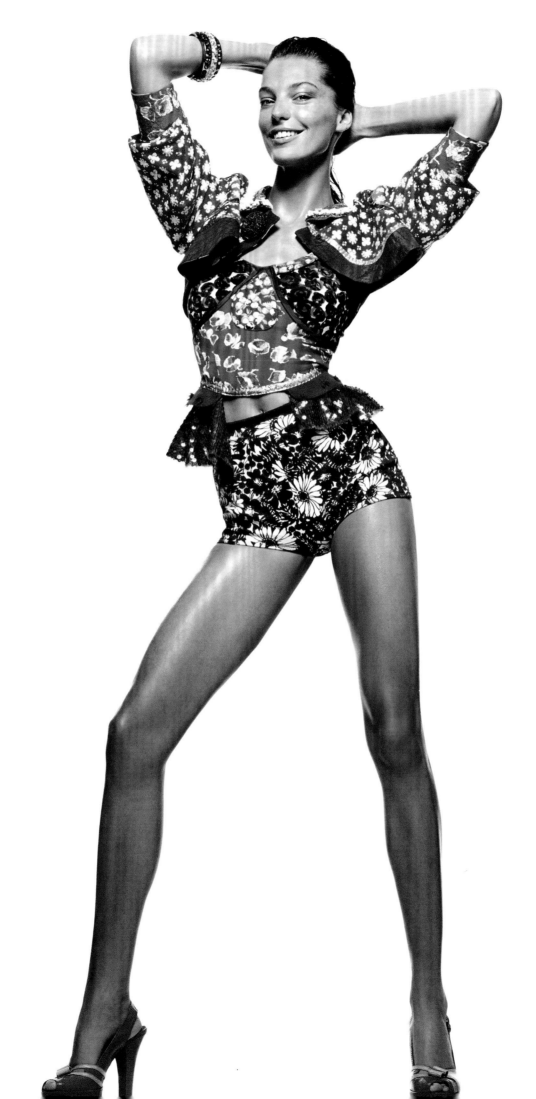

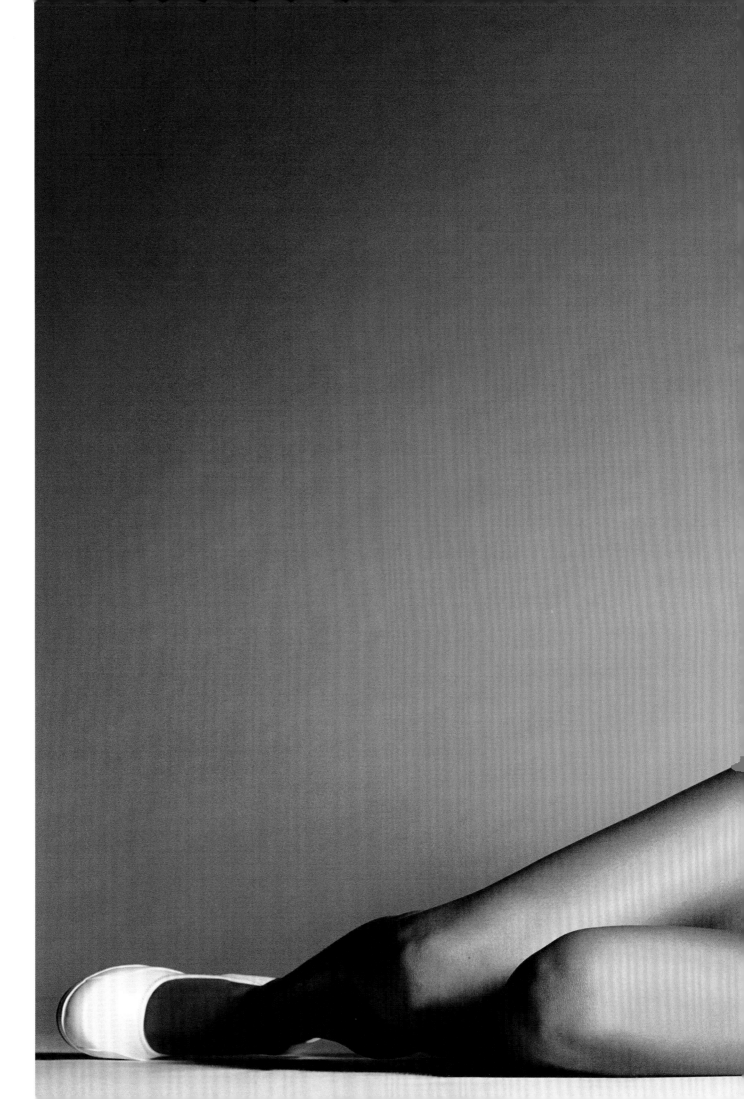

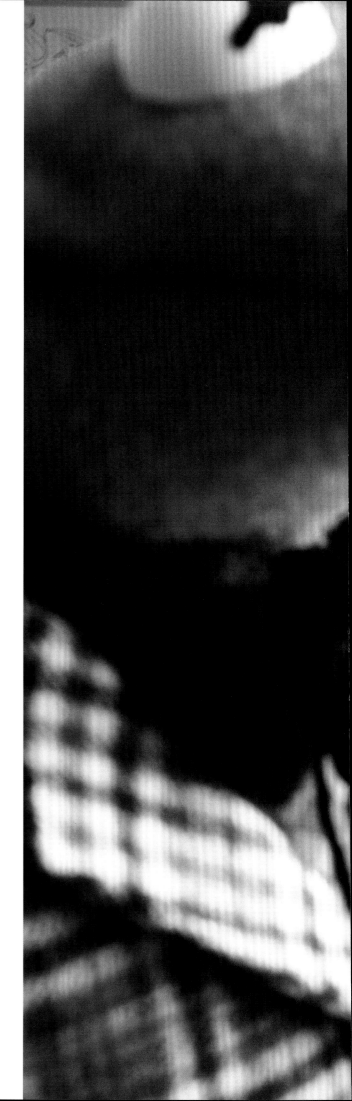

2005–2006

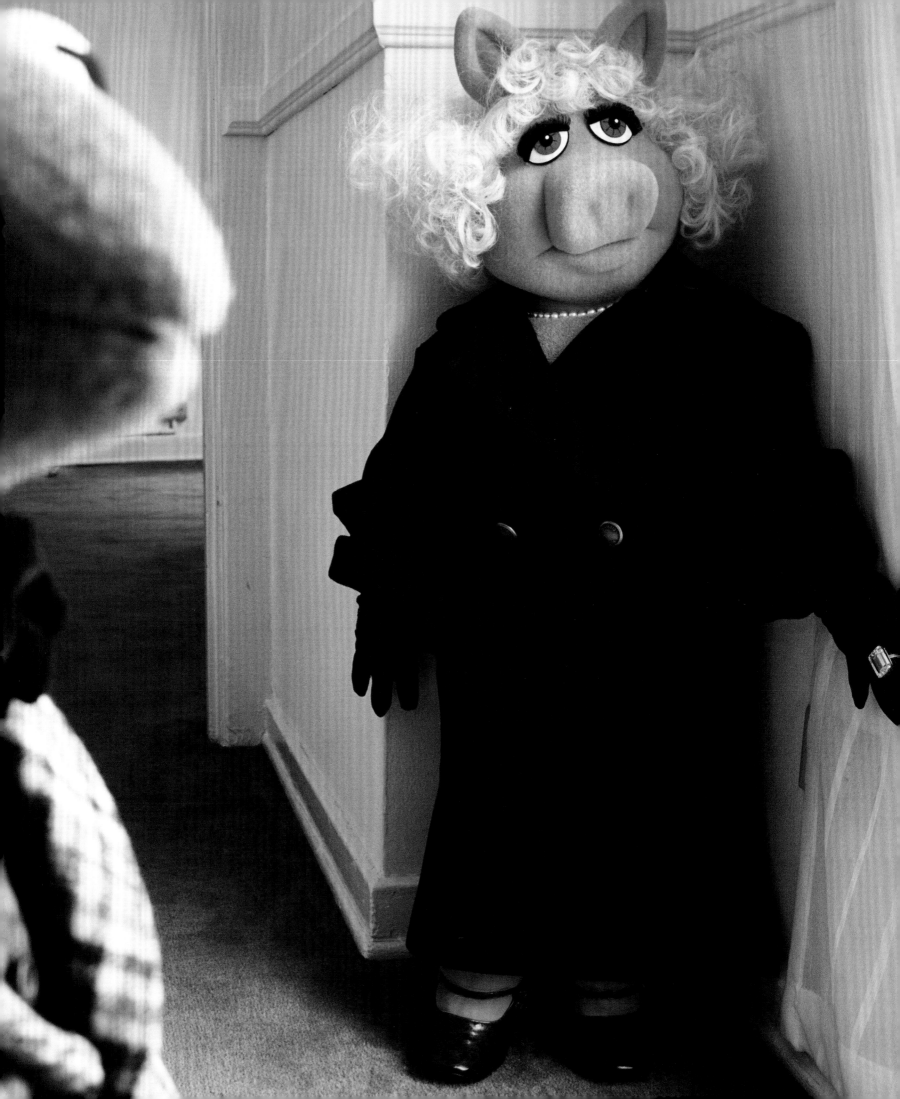

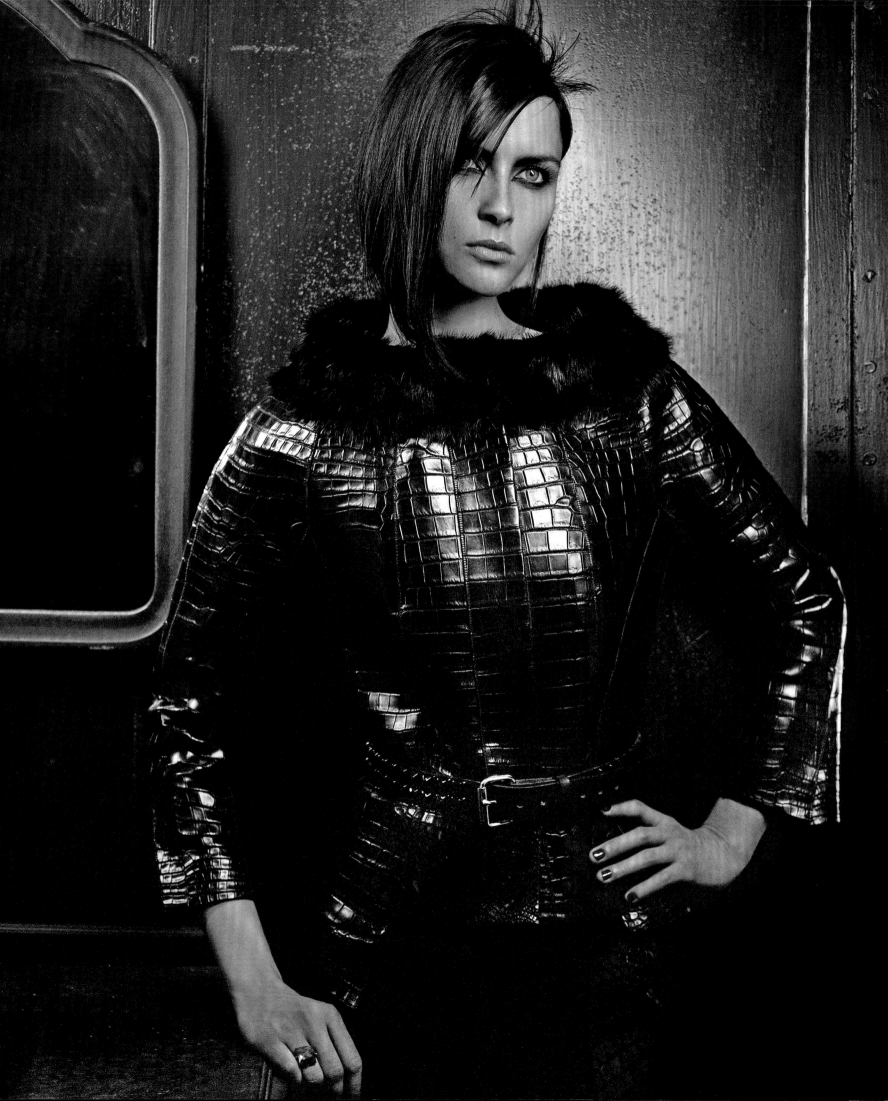

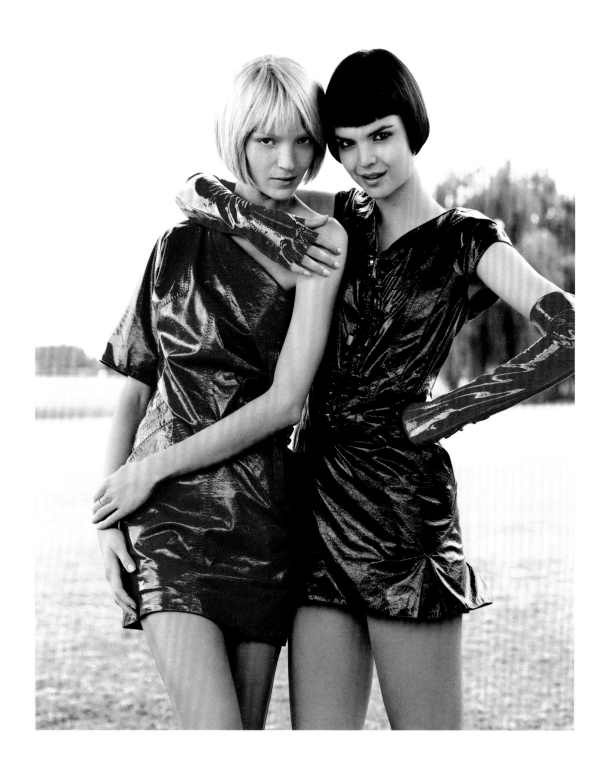

SPRING-SUMMER

2006

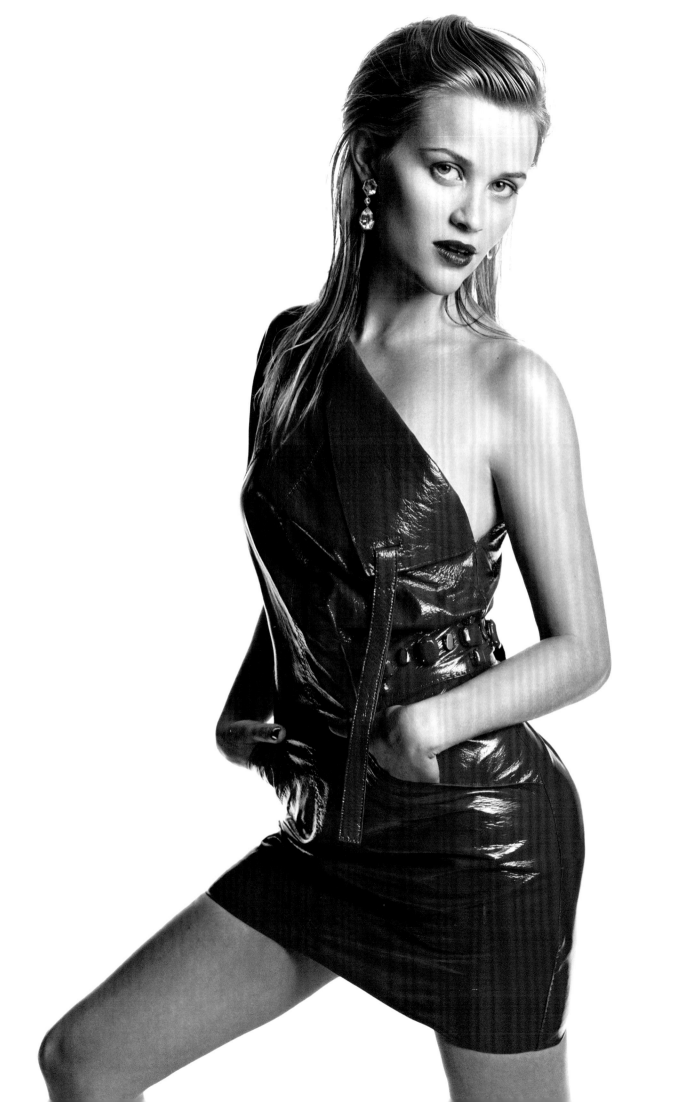

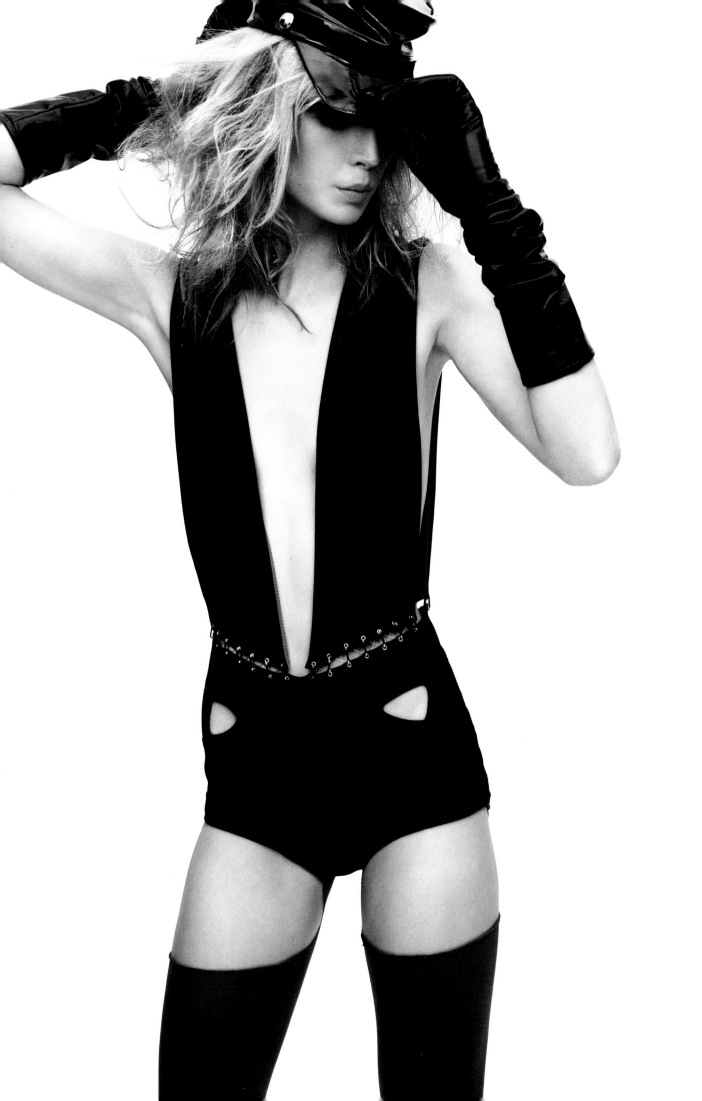

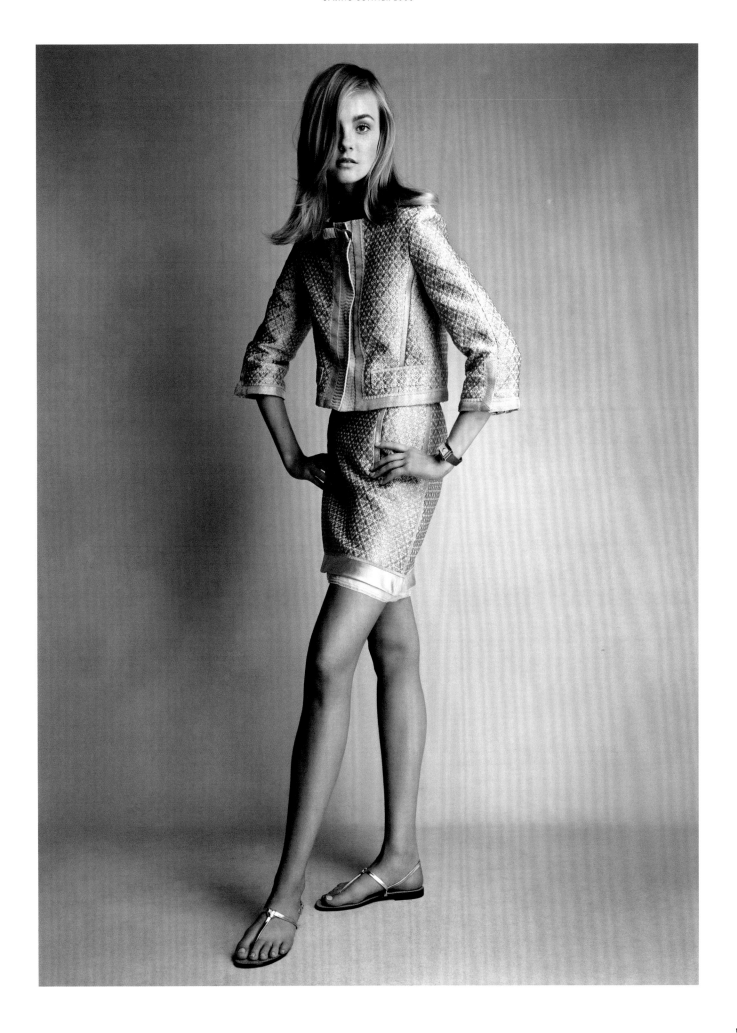

MARC JACOBS

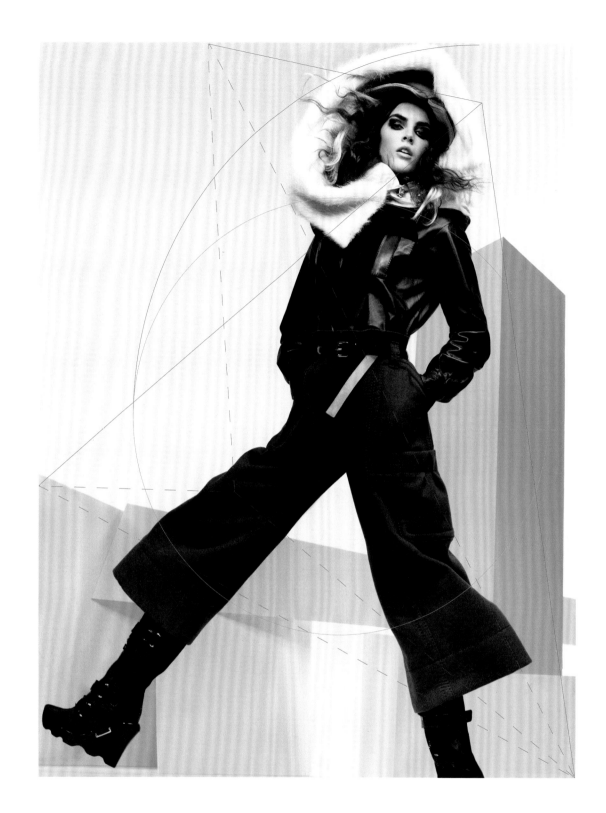

AUTUMN–WINTER

2006–2007

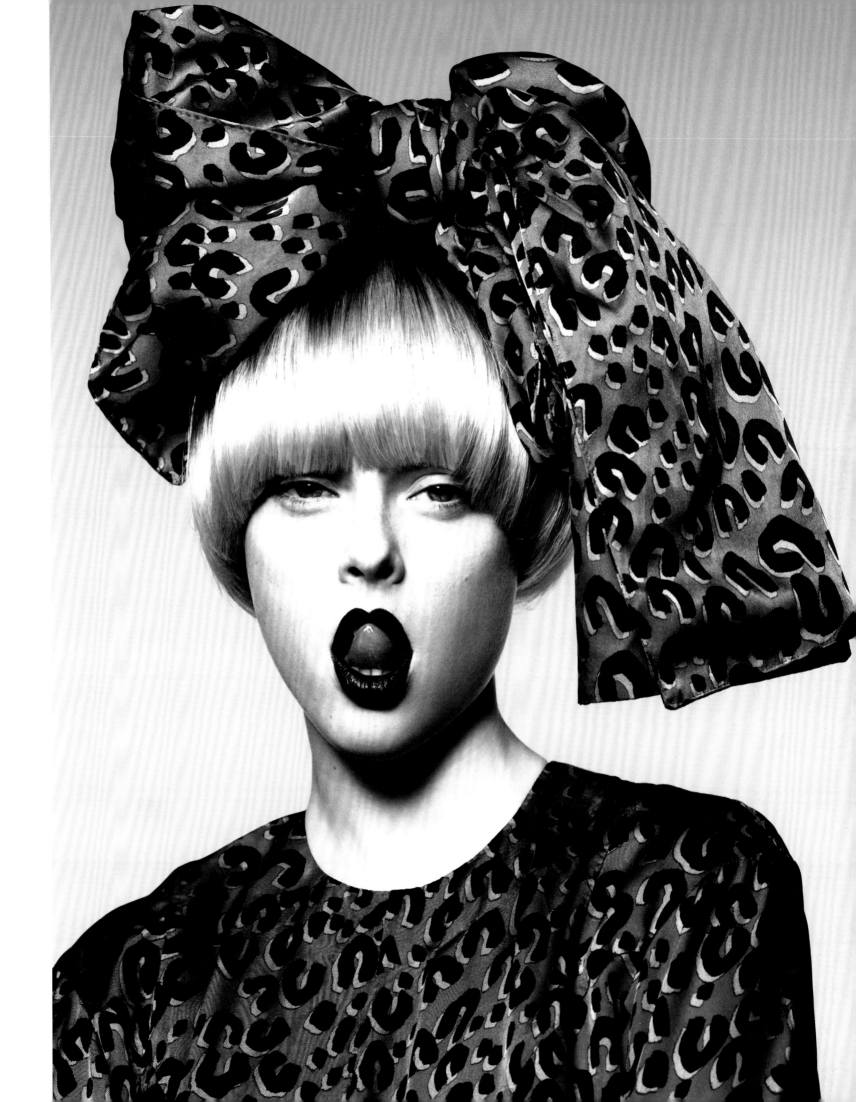

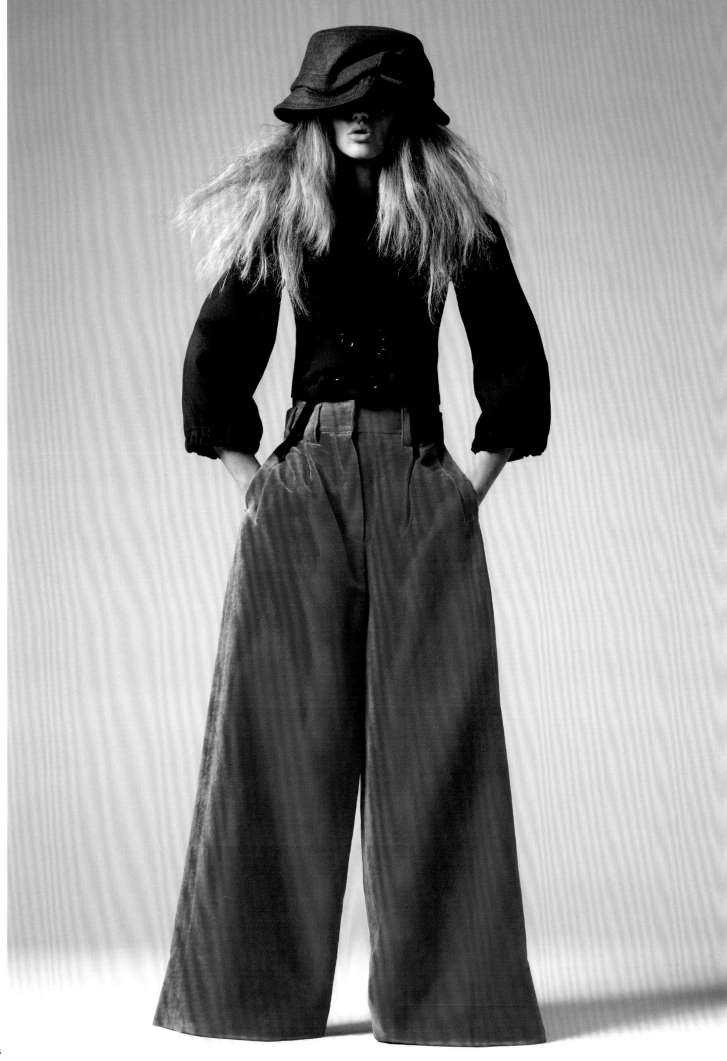

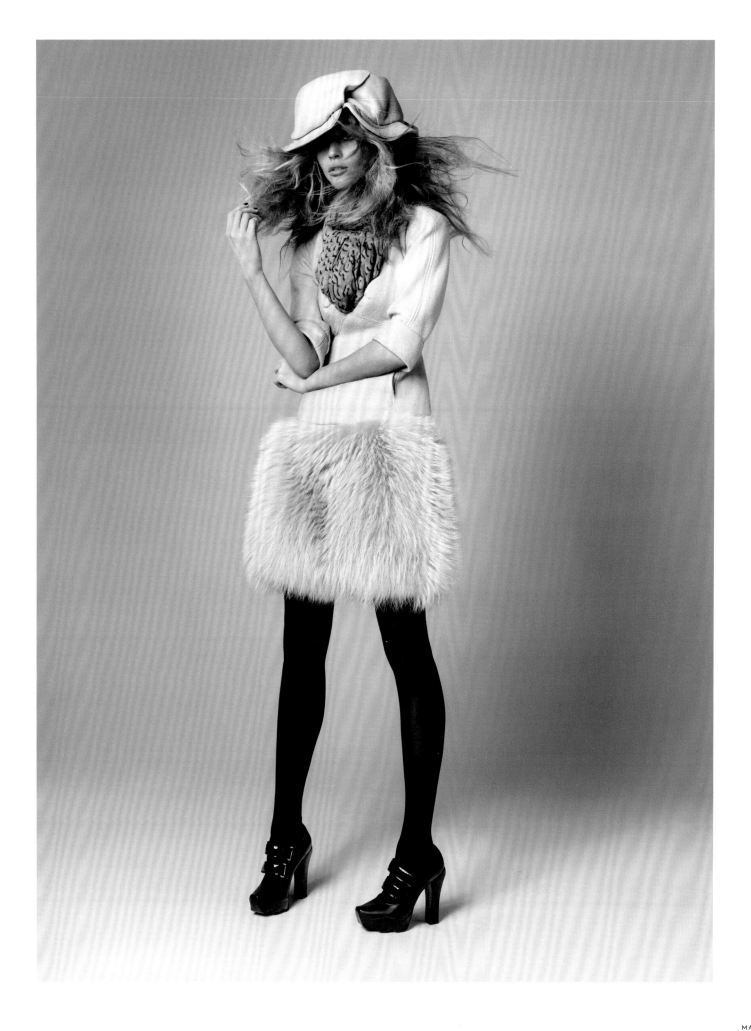

MARC JACOBS

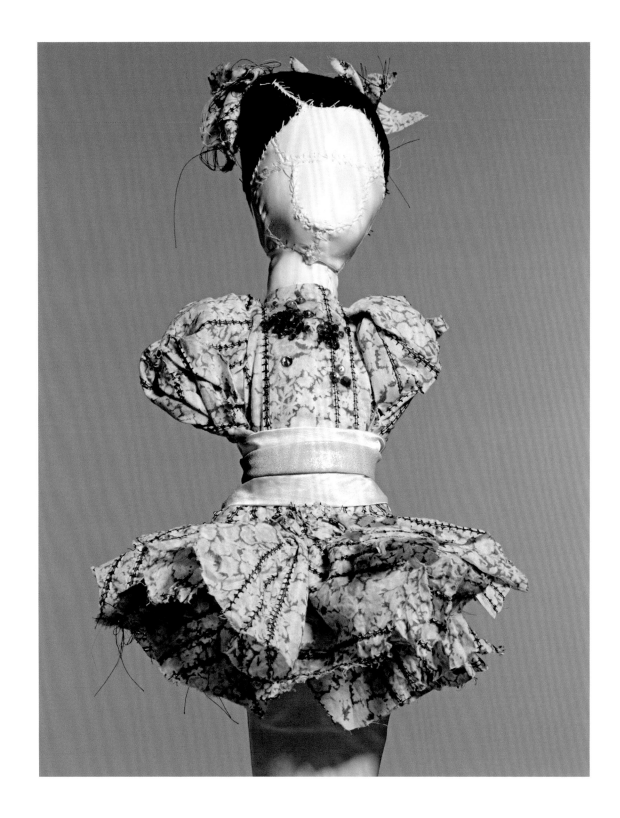

SPRING–SUMMER

2007

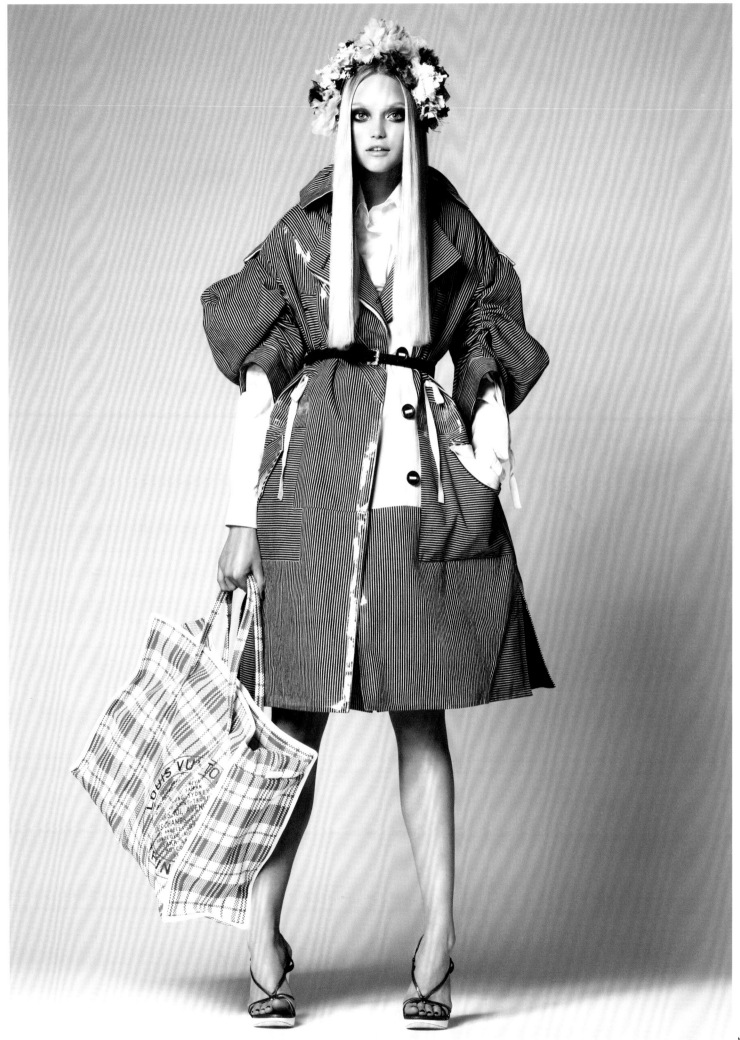

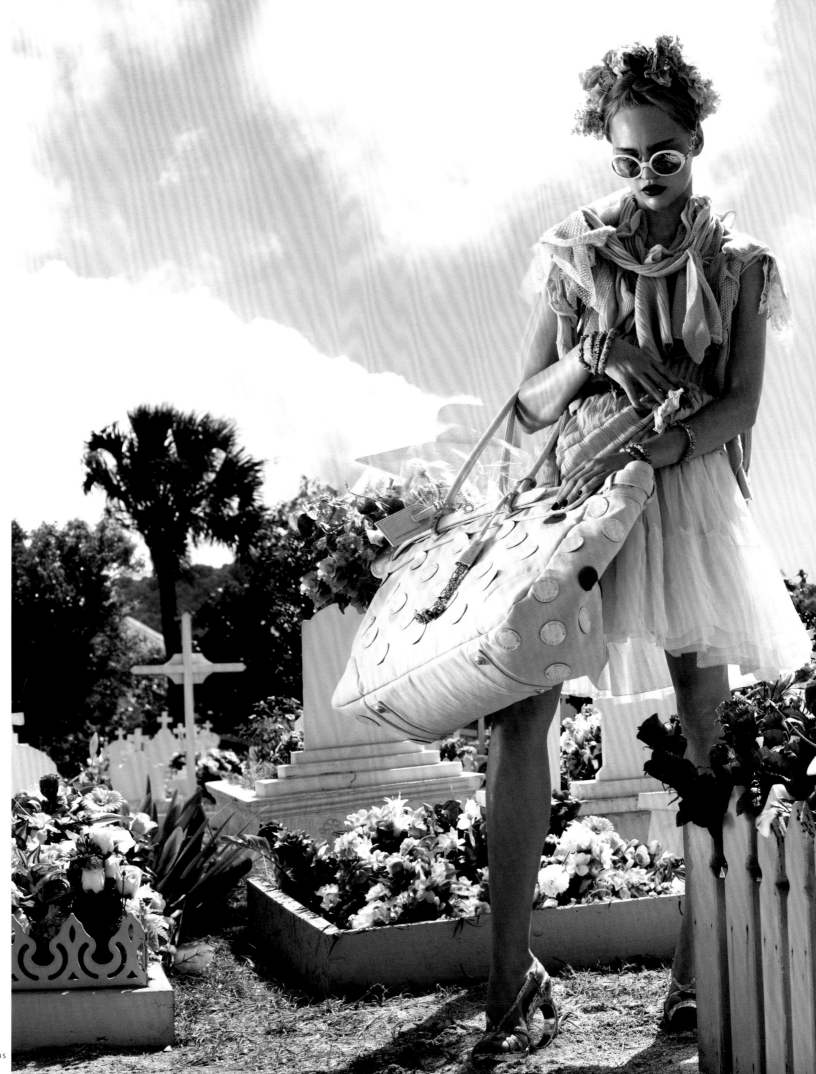

MARC JACOBS

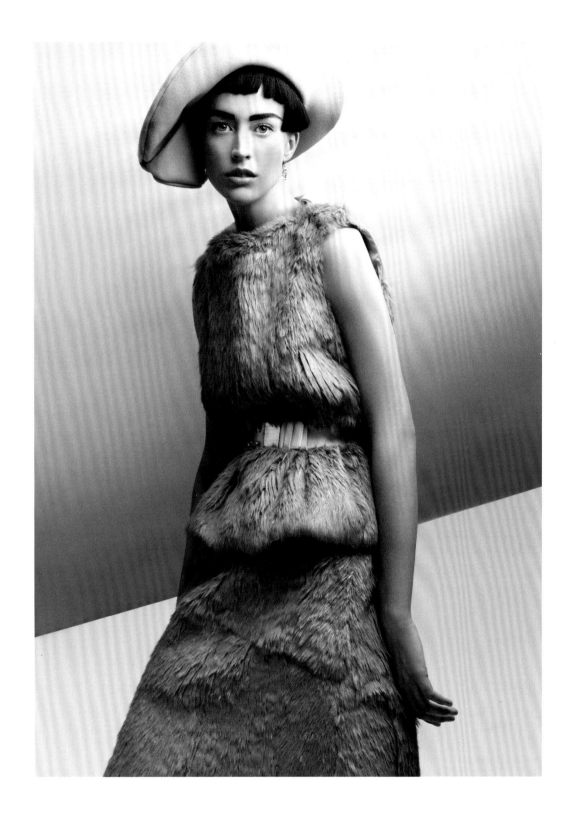

AUTUMN—WINTER

2007–2008

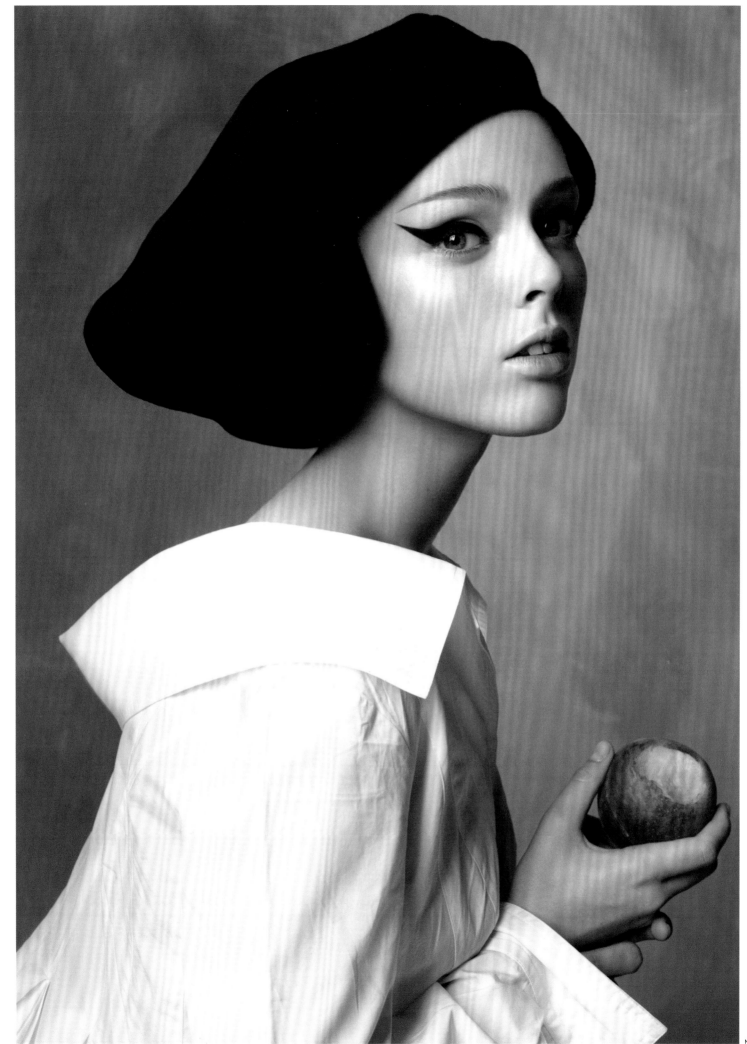

MARC JACOBS

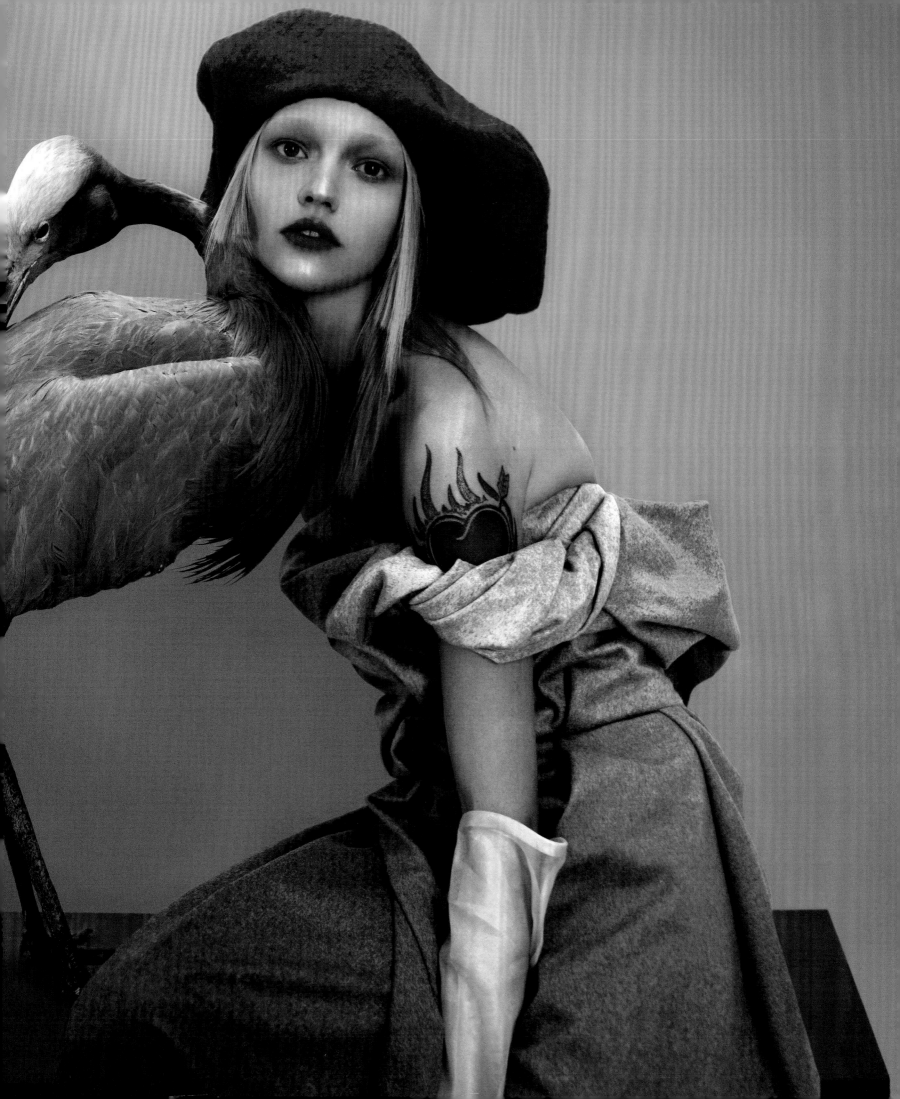

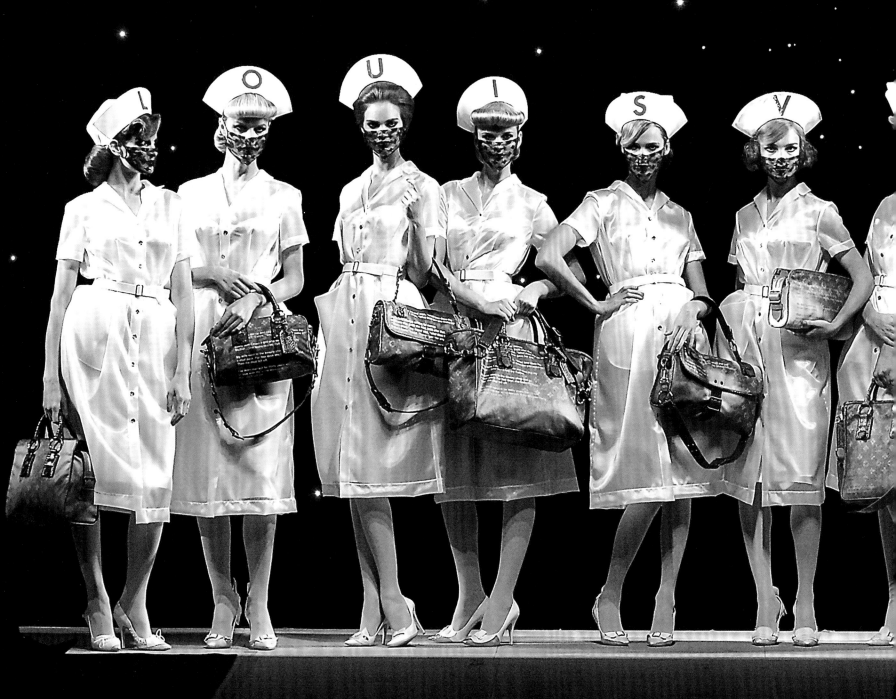

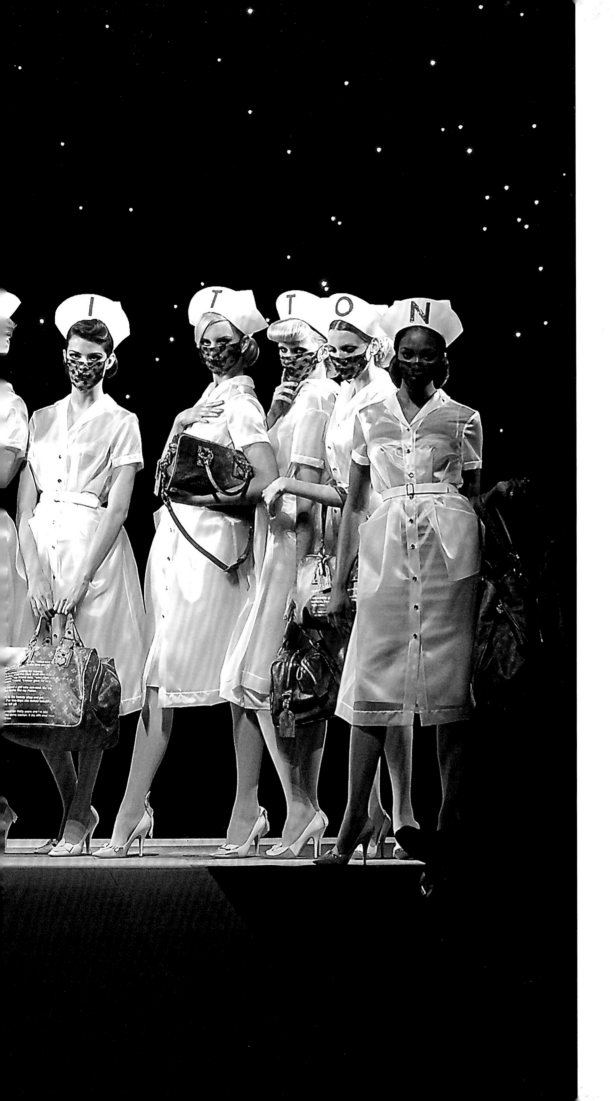

SPRING–SUMMER

2008

MARC JACOBS

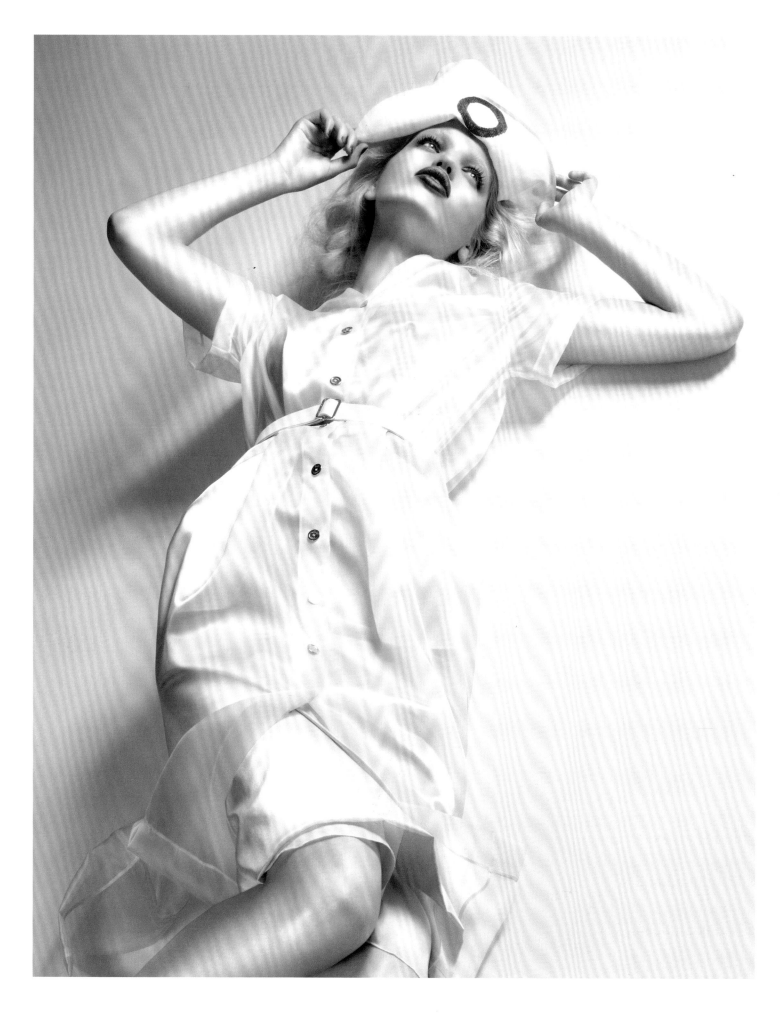

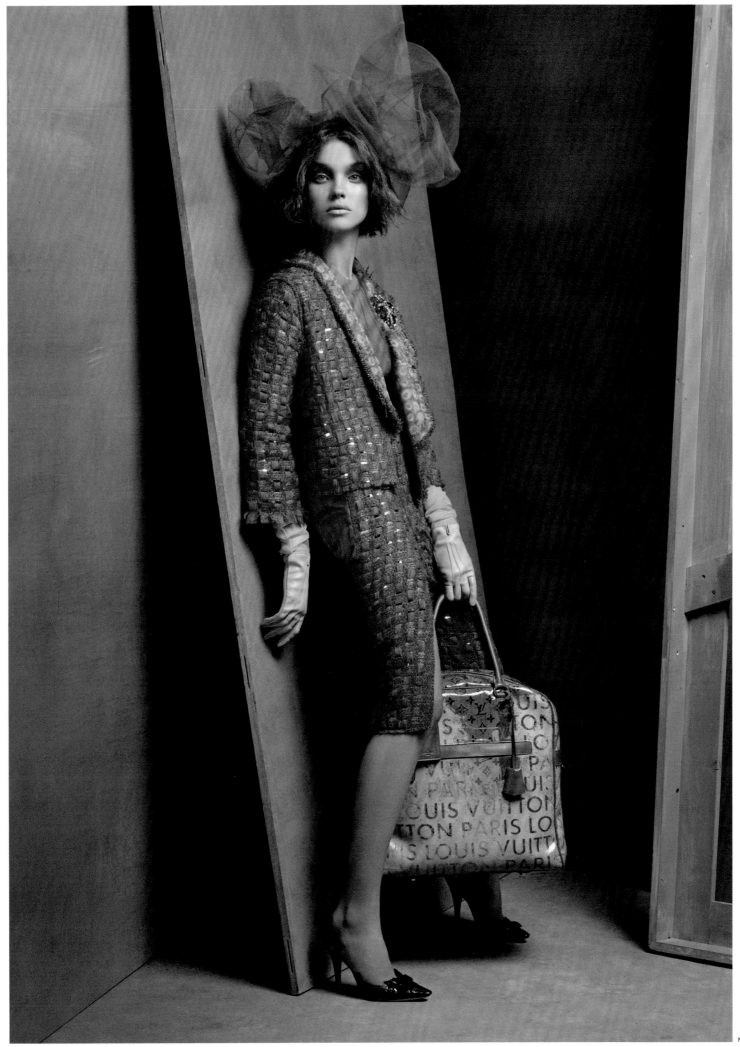

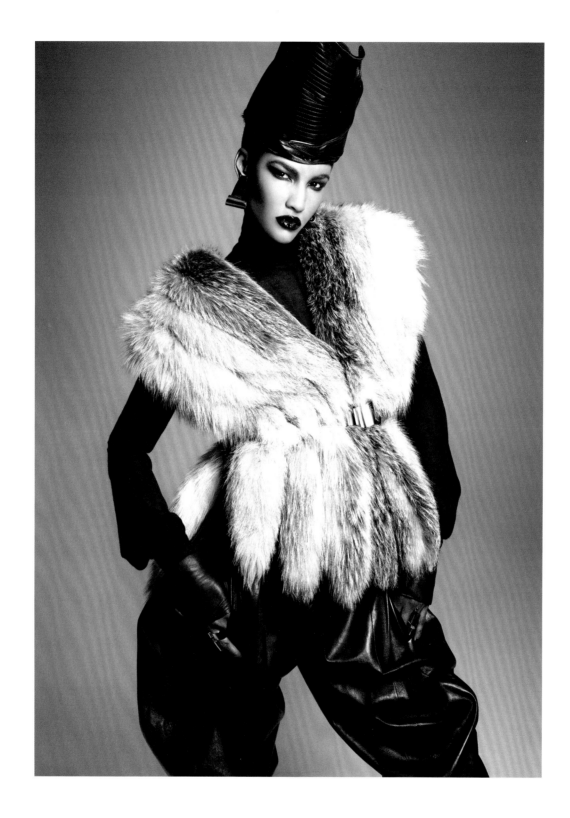

AUTUMN–WINTER

2008–2009

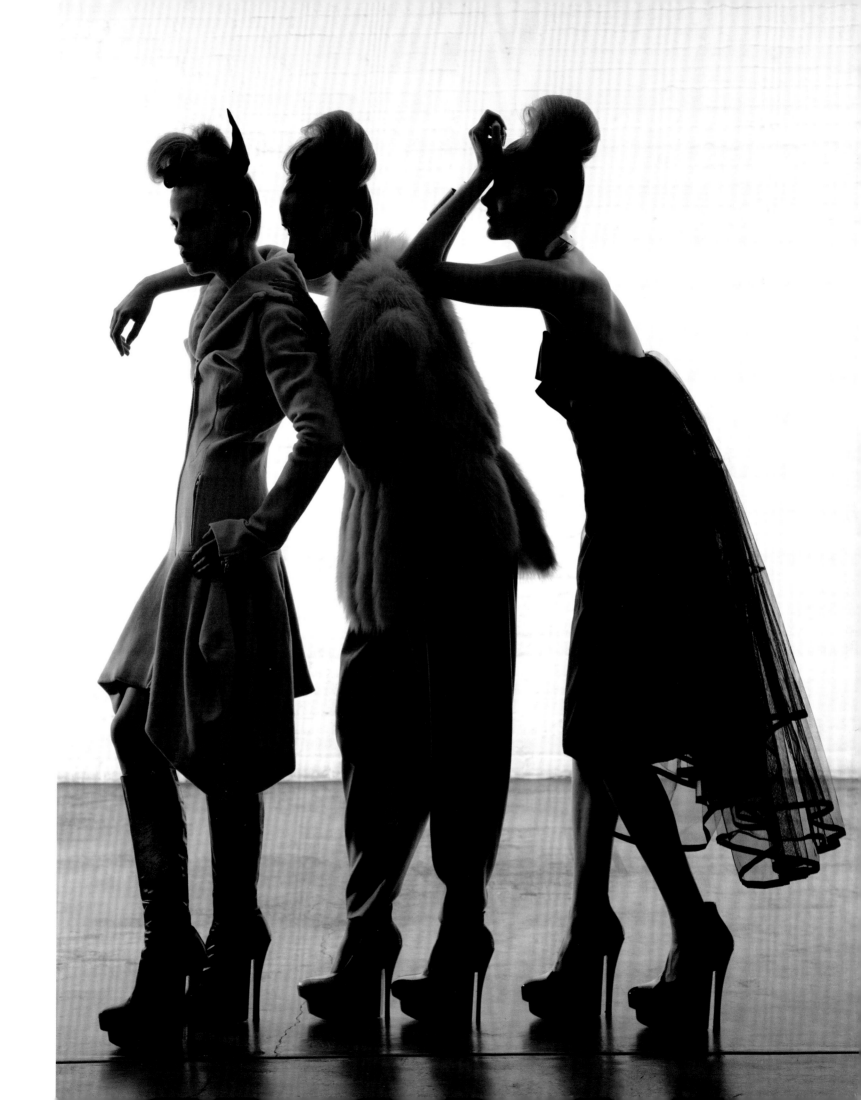

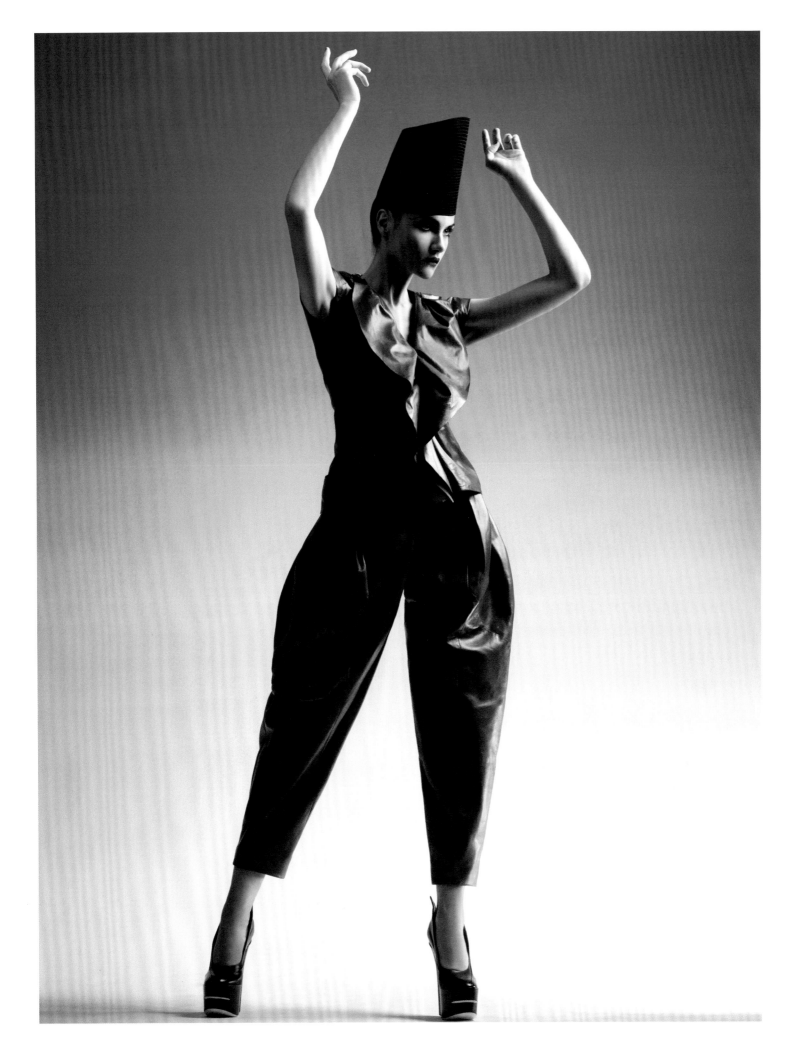

MARC JACOBS

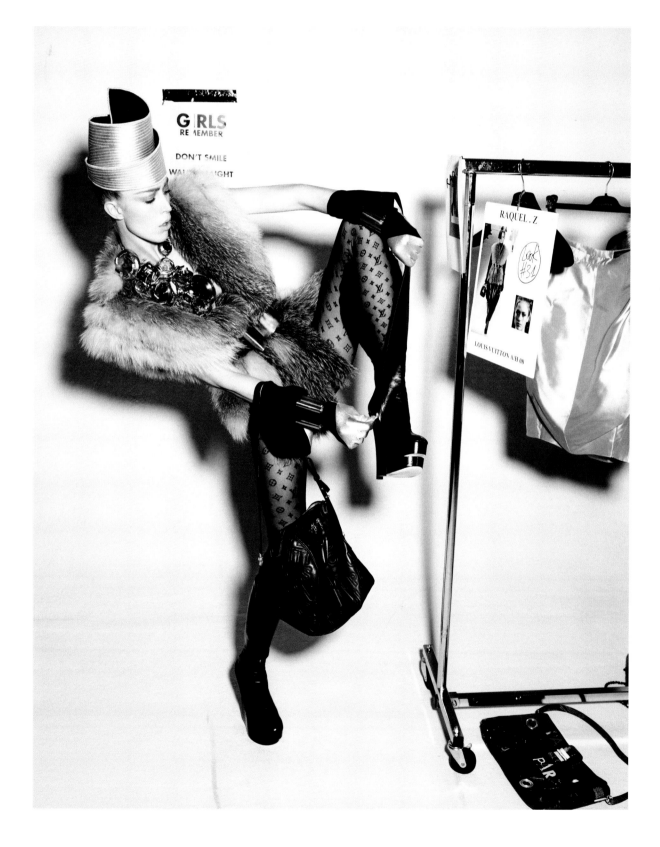

MARC JACOBS

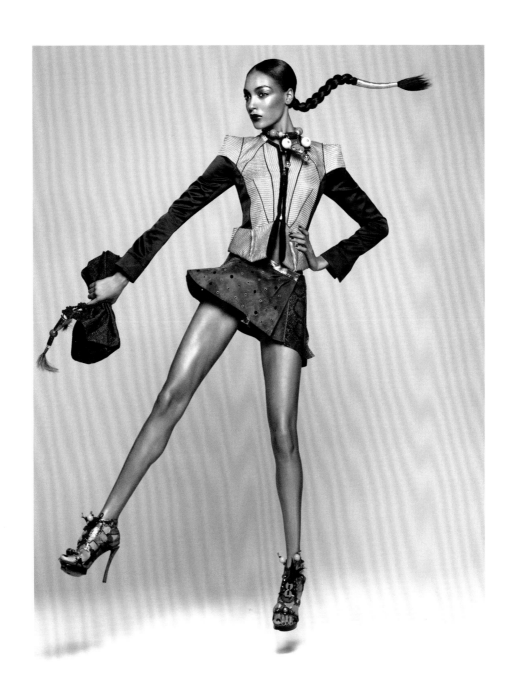

SPRING–SUMMER

2009

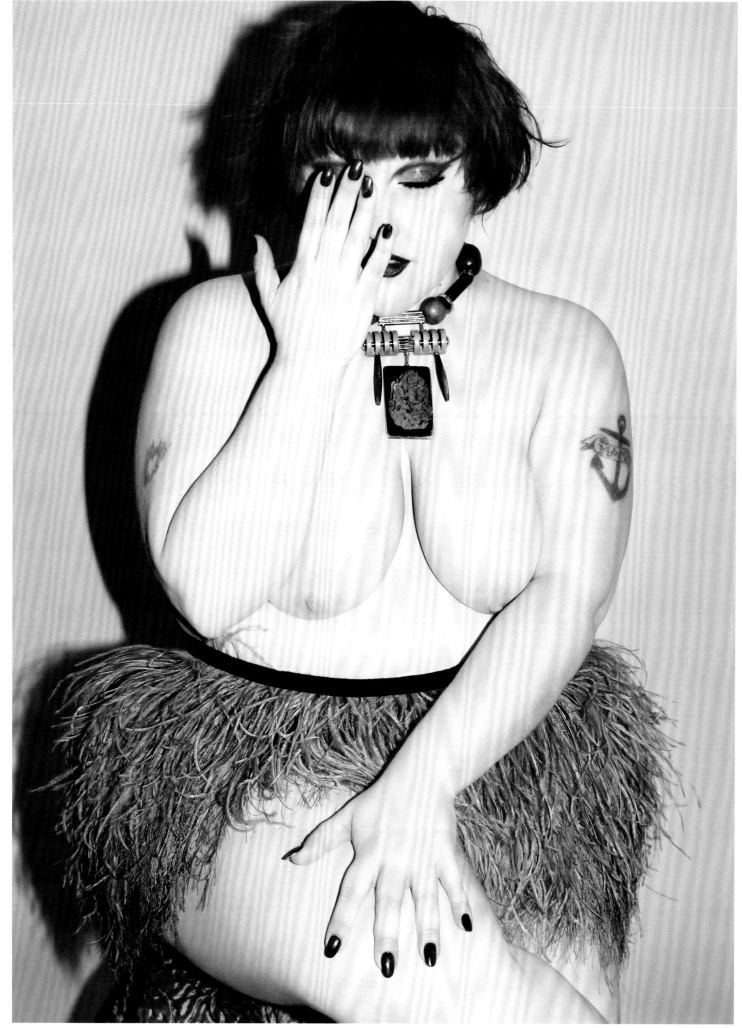

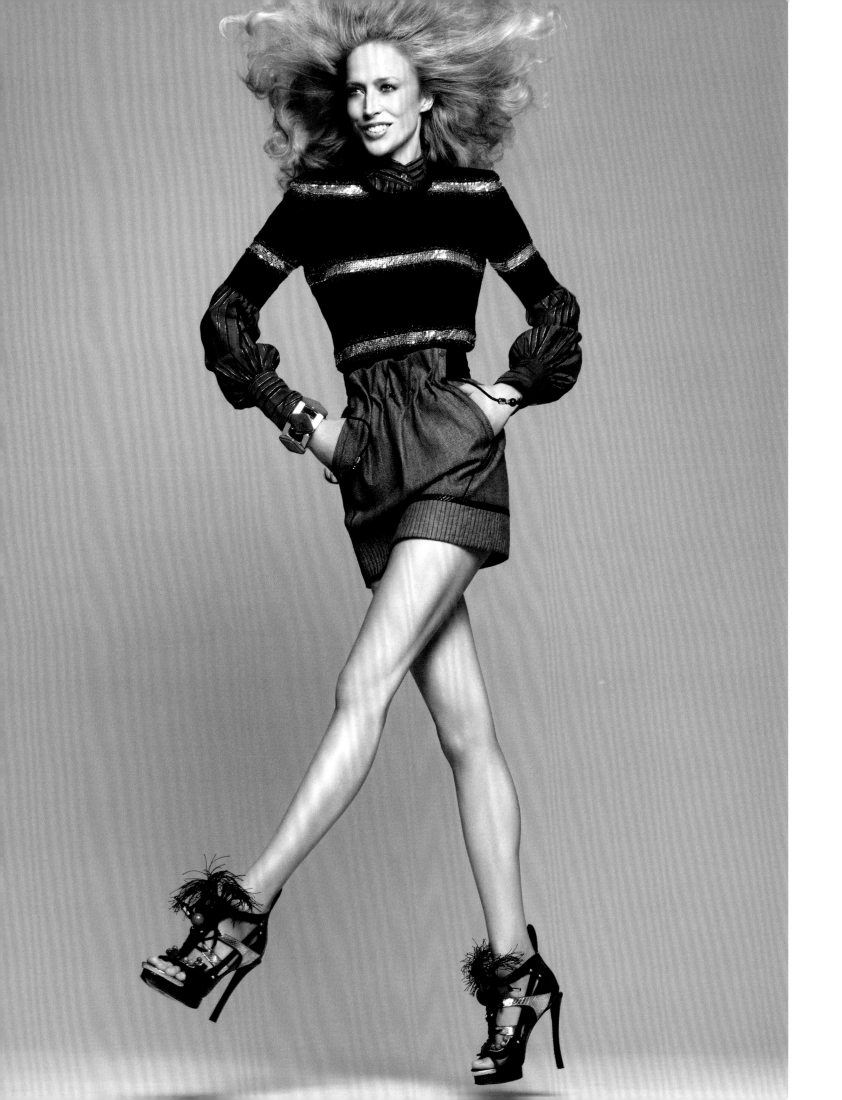

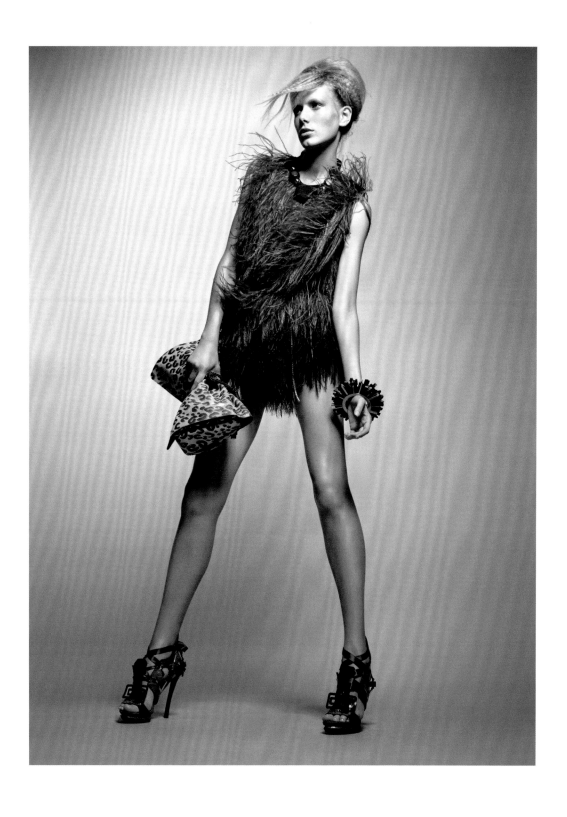

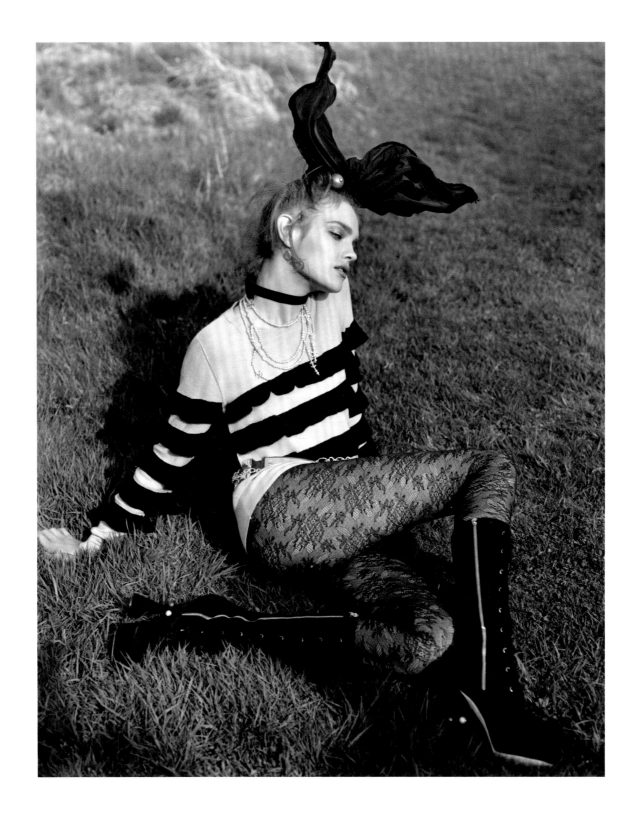

AUTUMN-WINTER

2009–2010

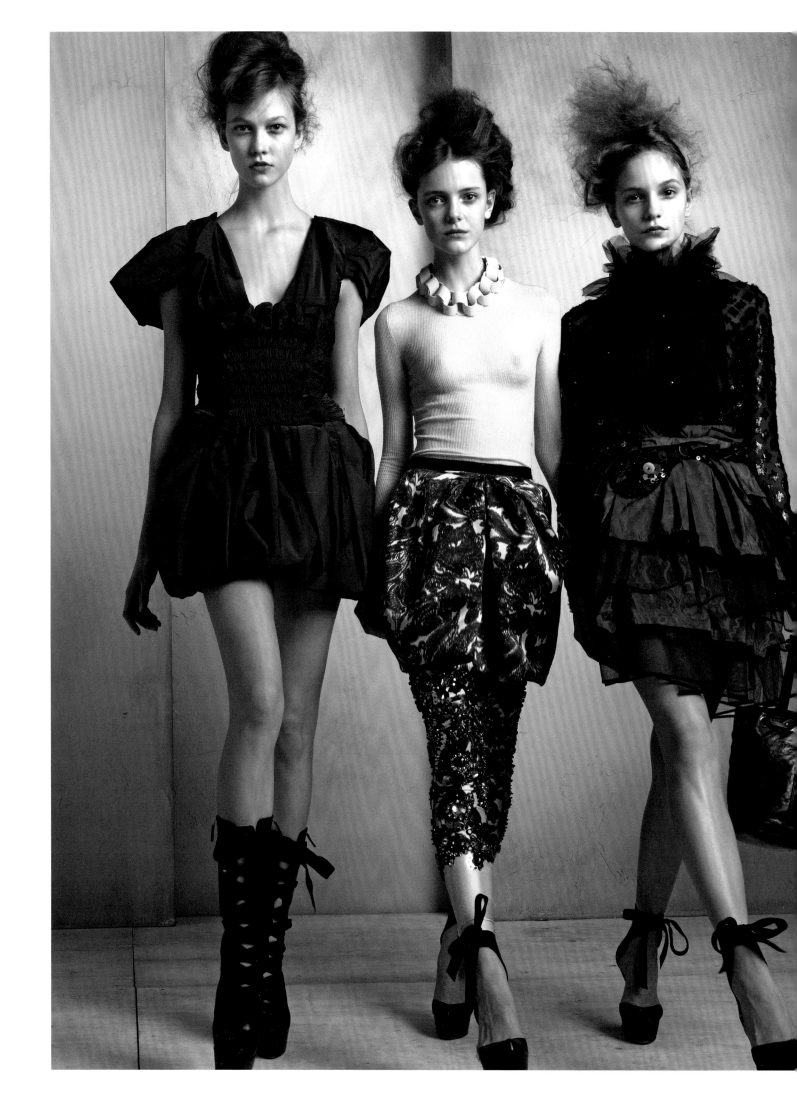

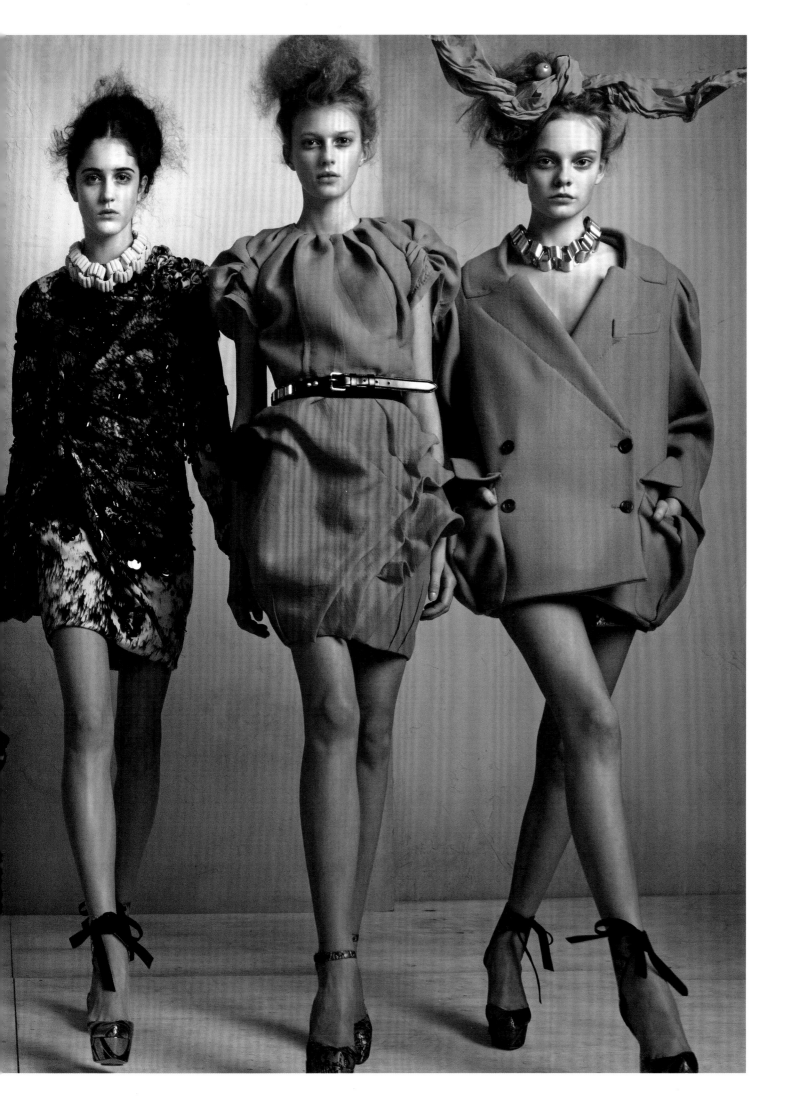

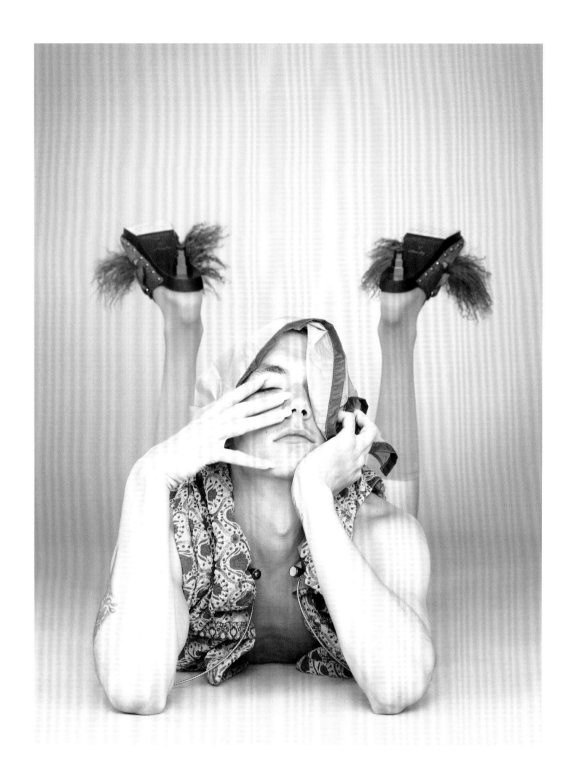

SPRING–SUMMER

2010

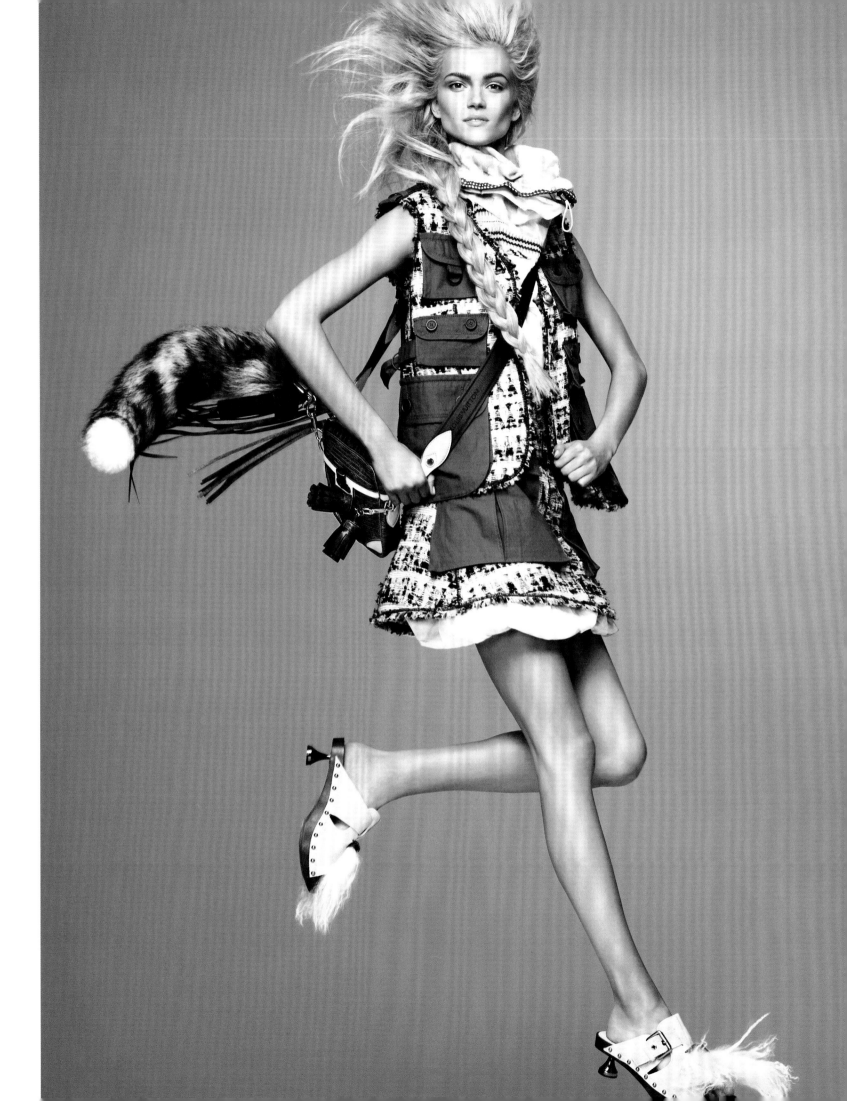

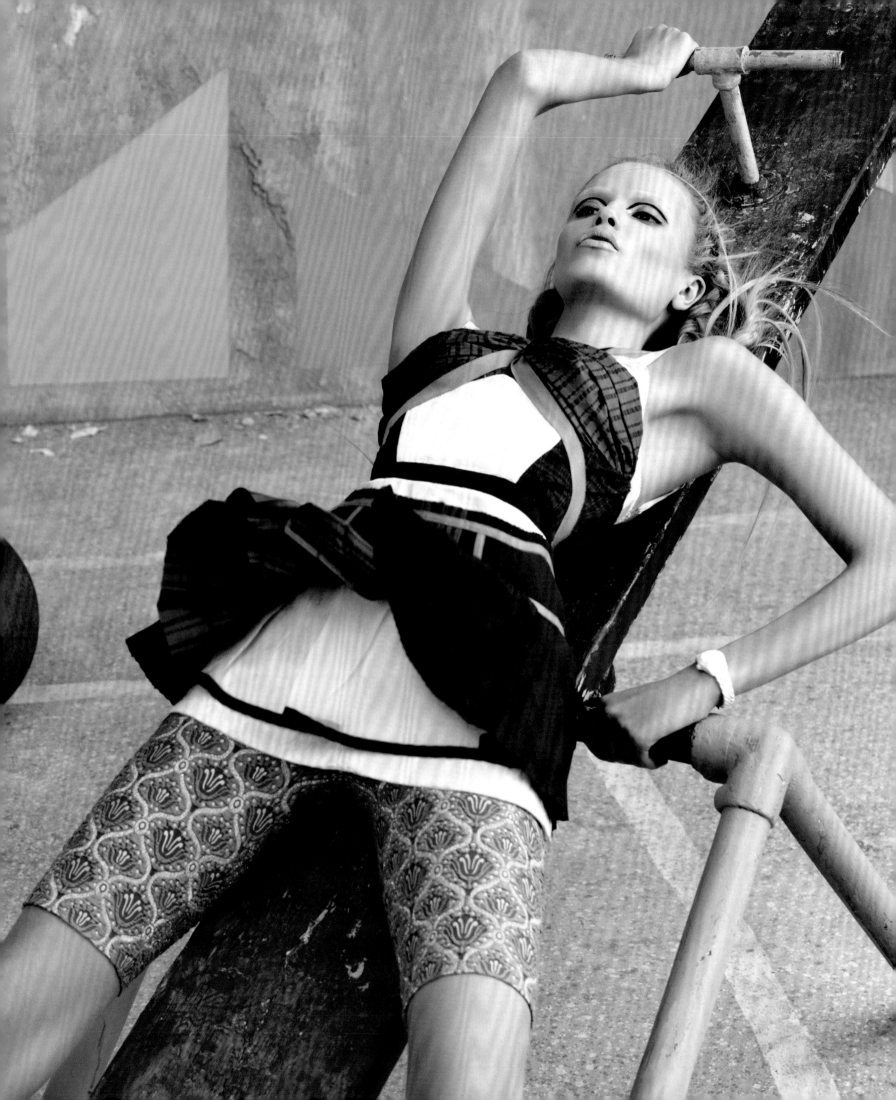

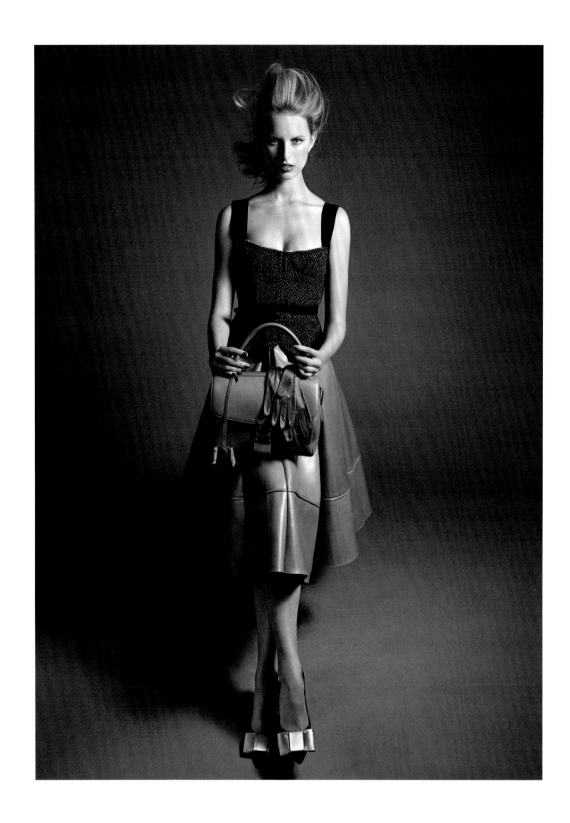

AUTUMN–WINTER

2010–2011

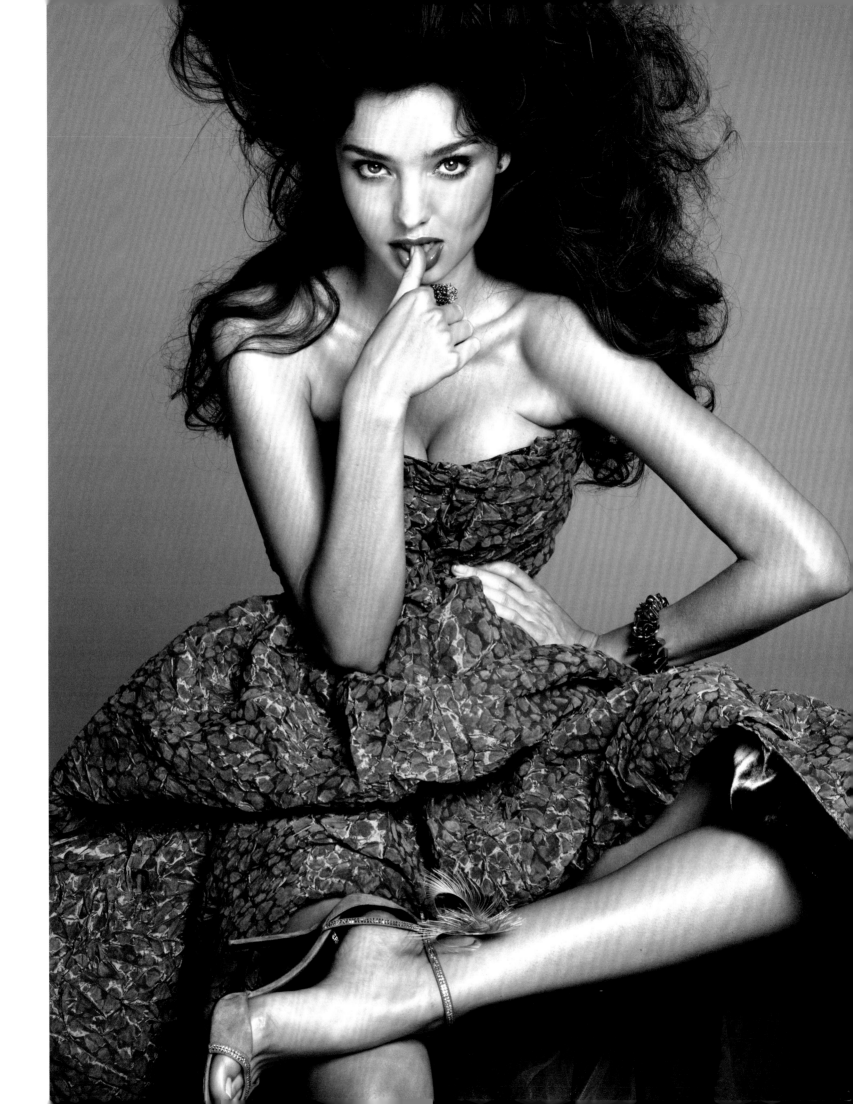

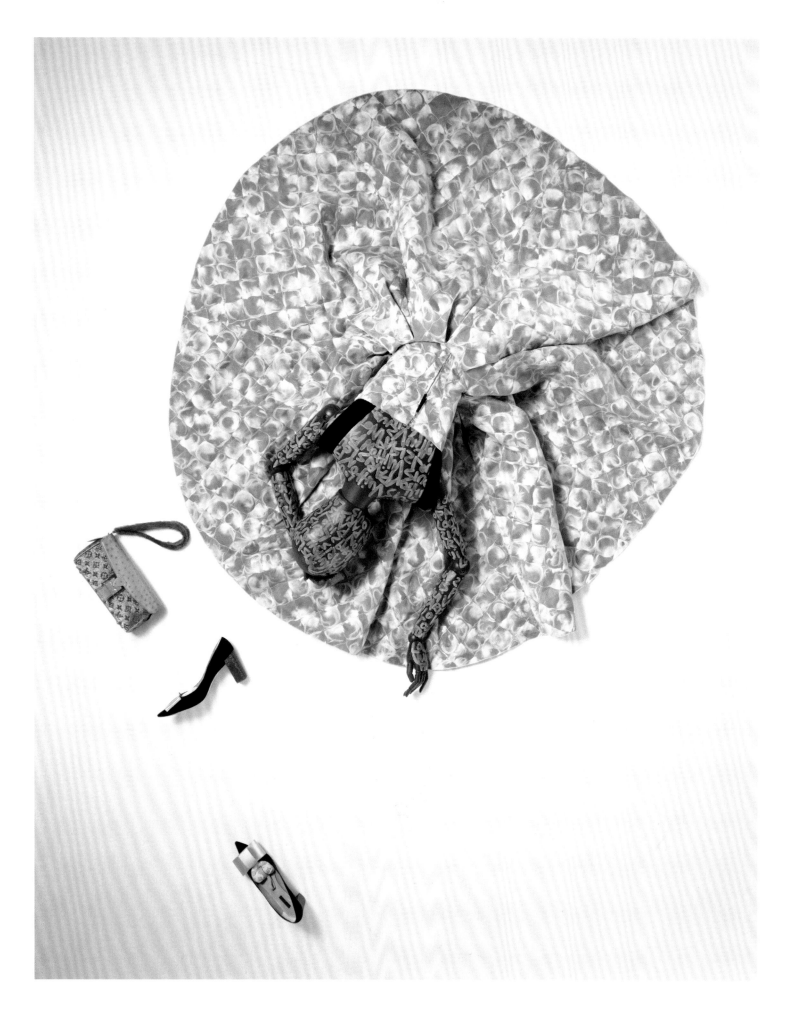

MARC JACOBS

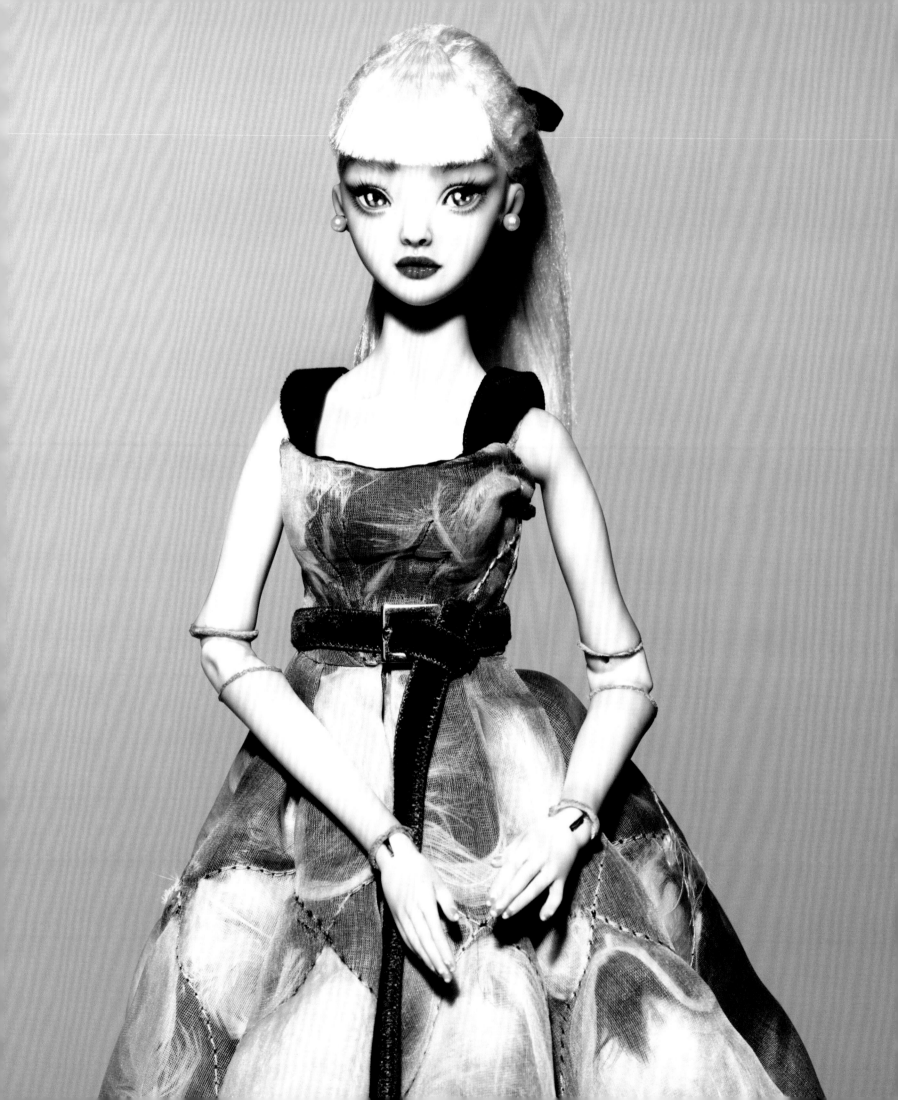

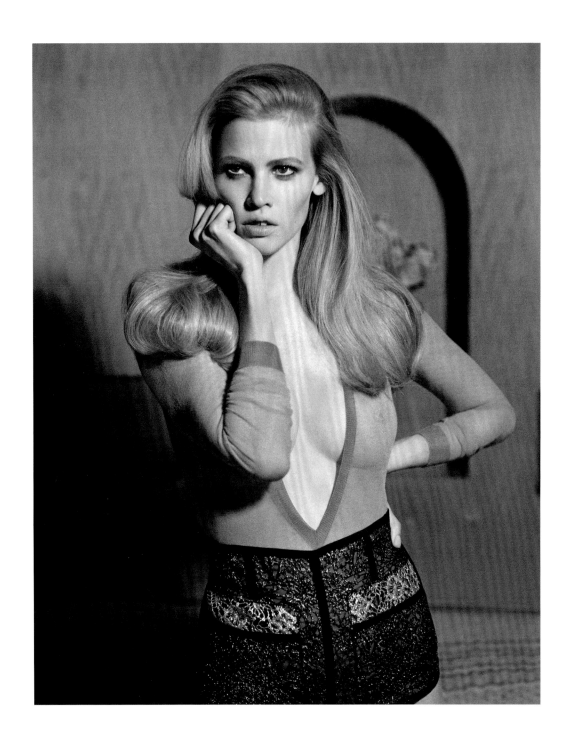

SPRING–SUMMER

2011

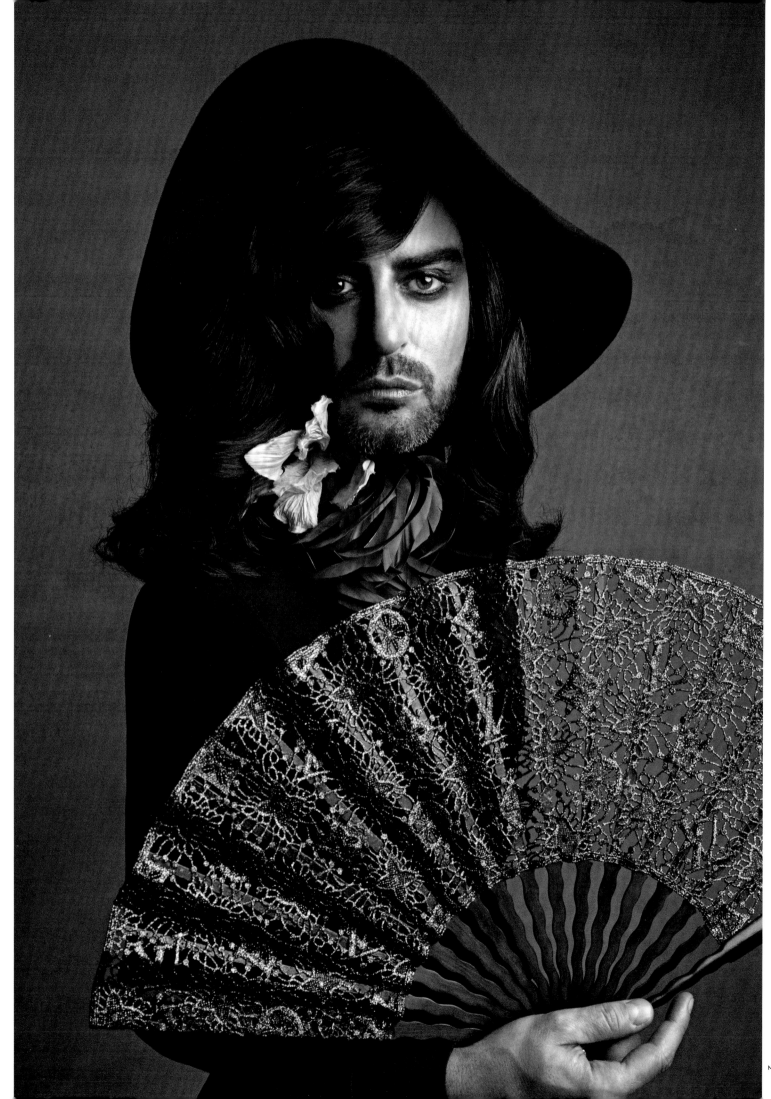

MARC JACOBS

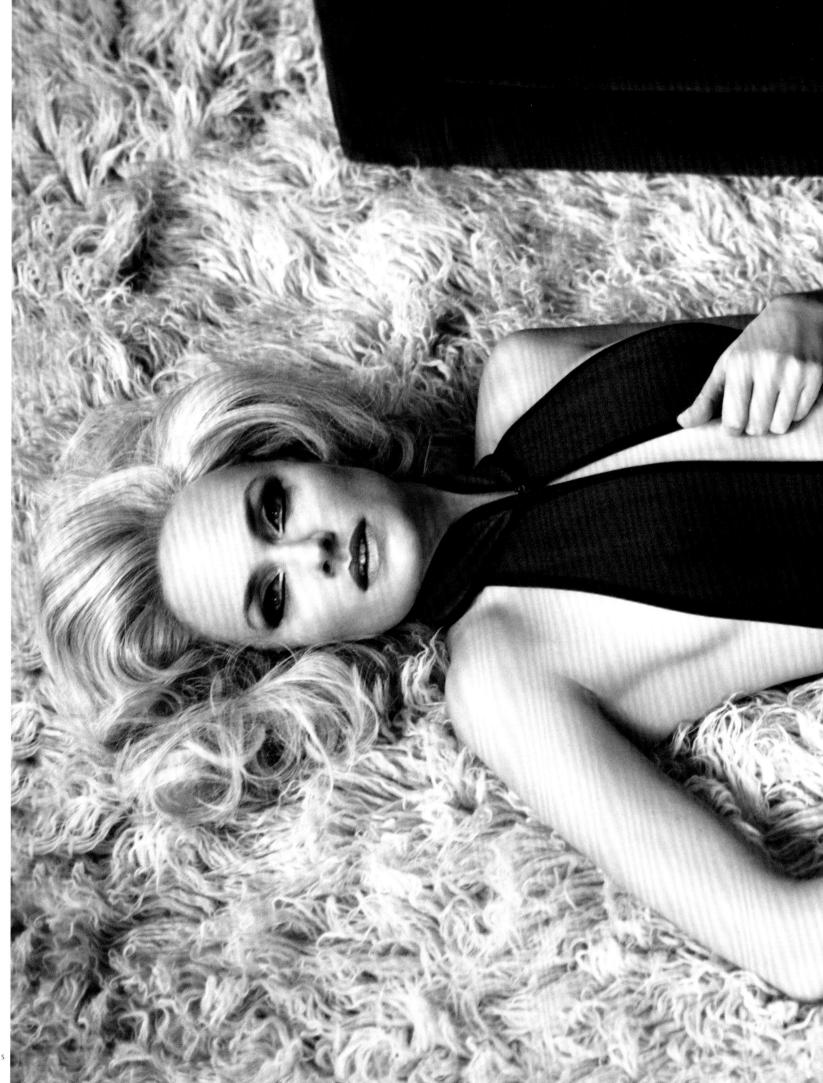

MARC JACOBS

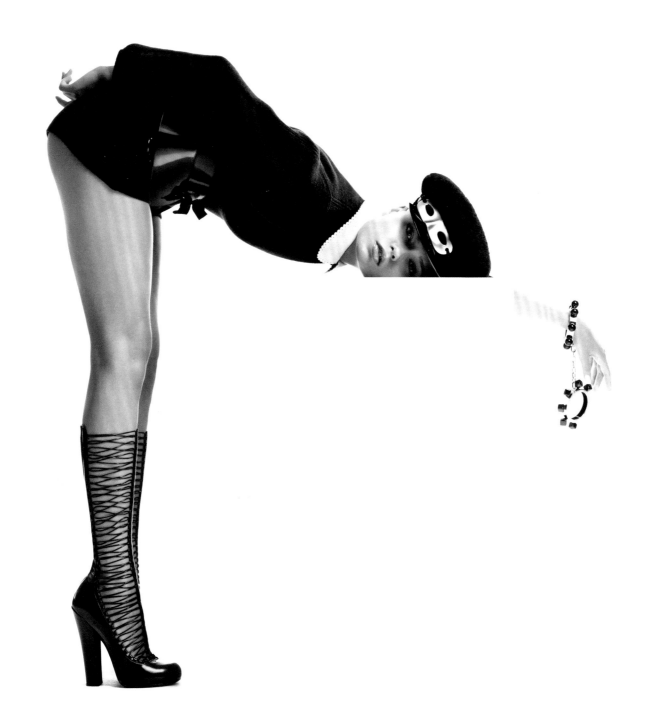

AUTUMN–WINTER

2011–2012

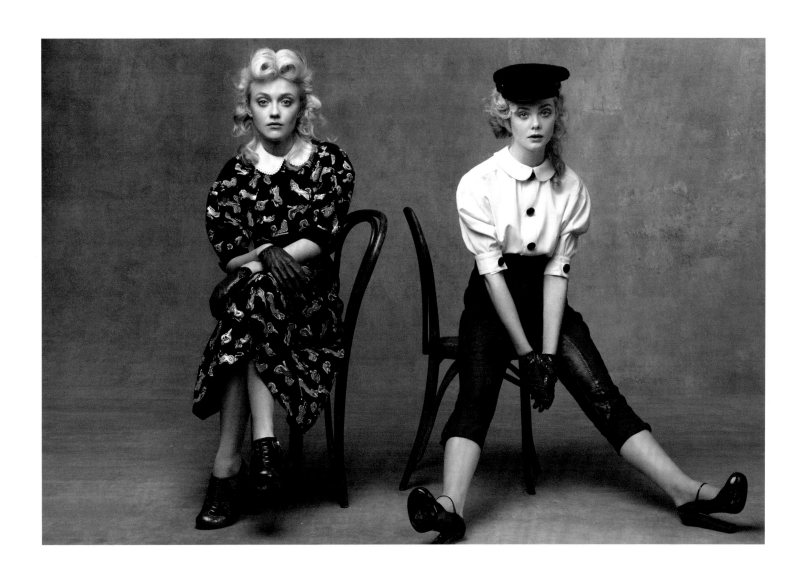

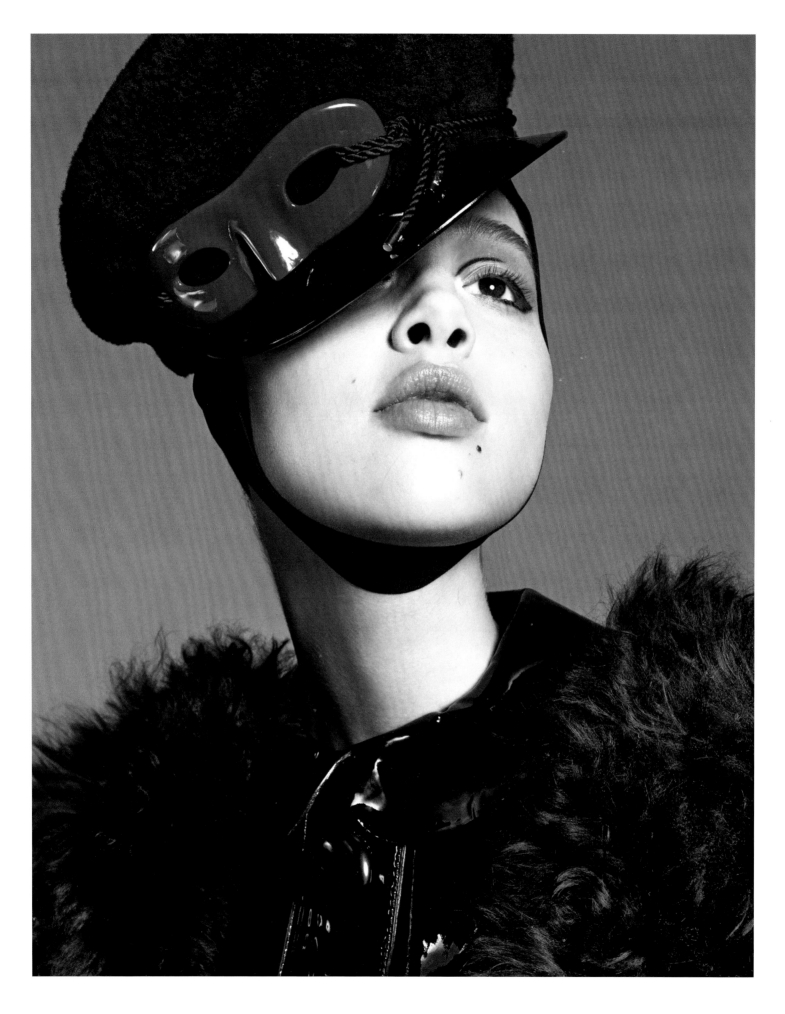

MARC JACOBS

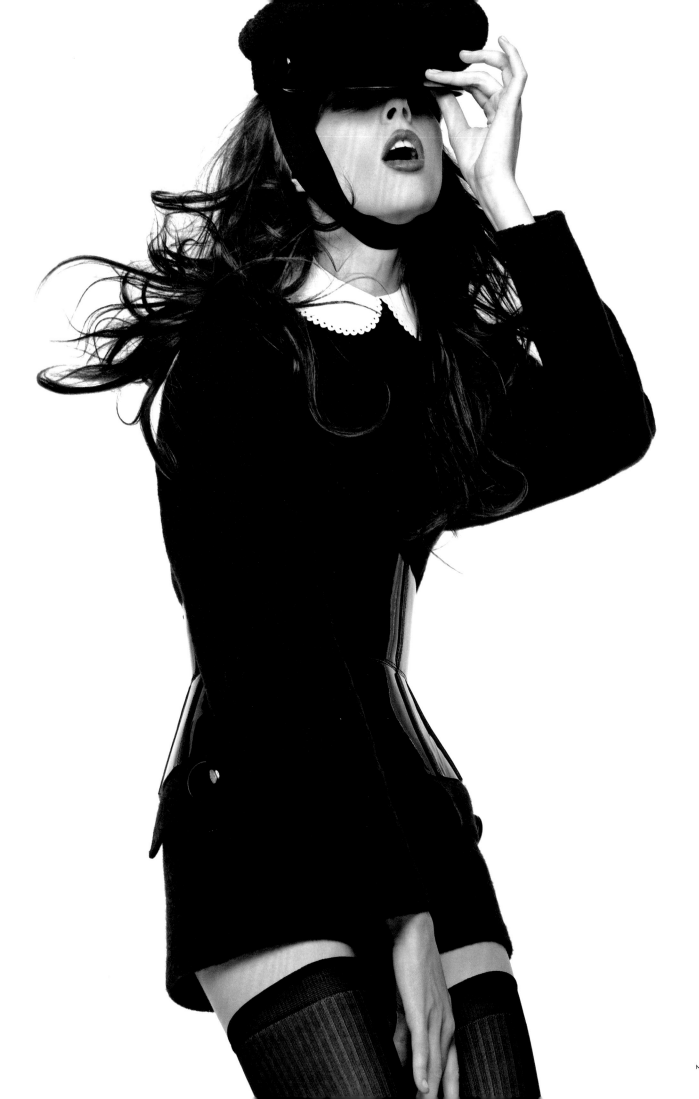

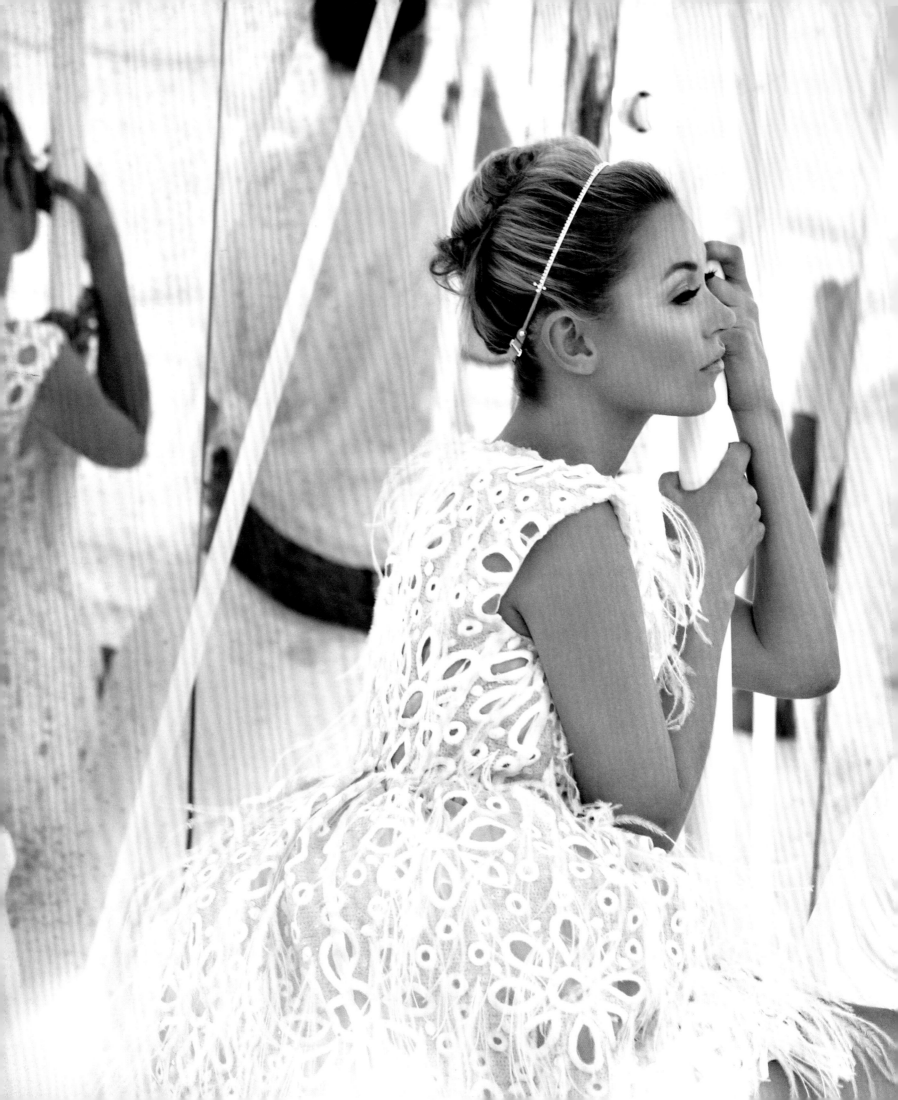

SPRING—SUMMER

2012

MARC JACOBS

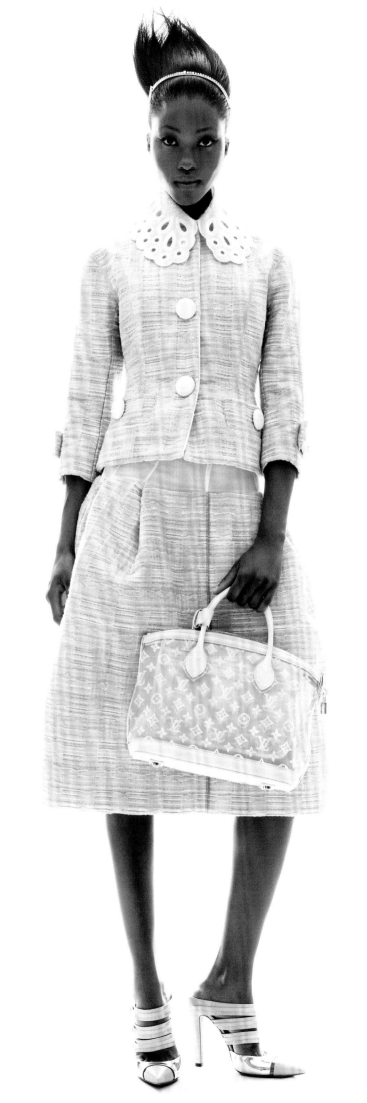

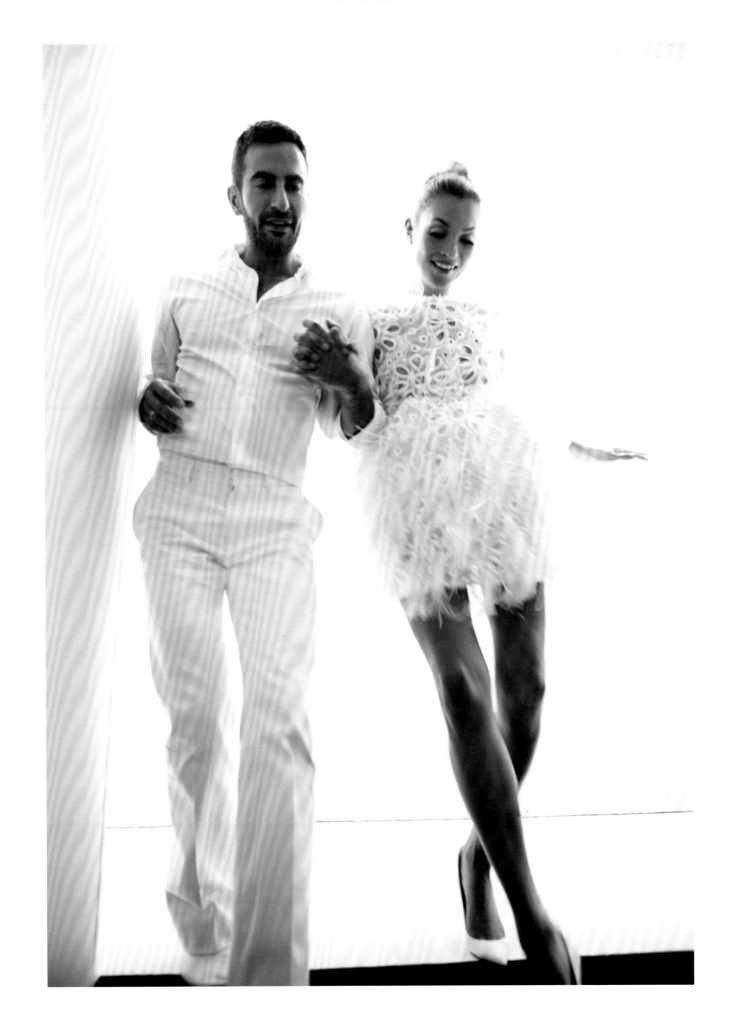

MARC JACOBS

THE ADVERTISING

MARC JACOBS
ARTISTIC DIRECTOR
2000–2012

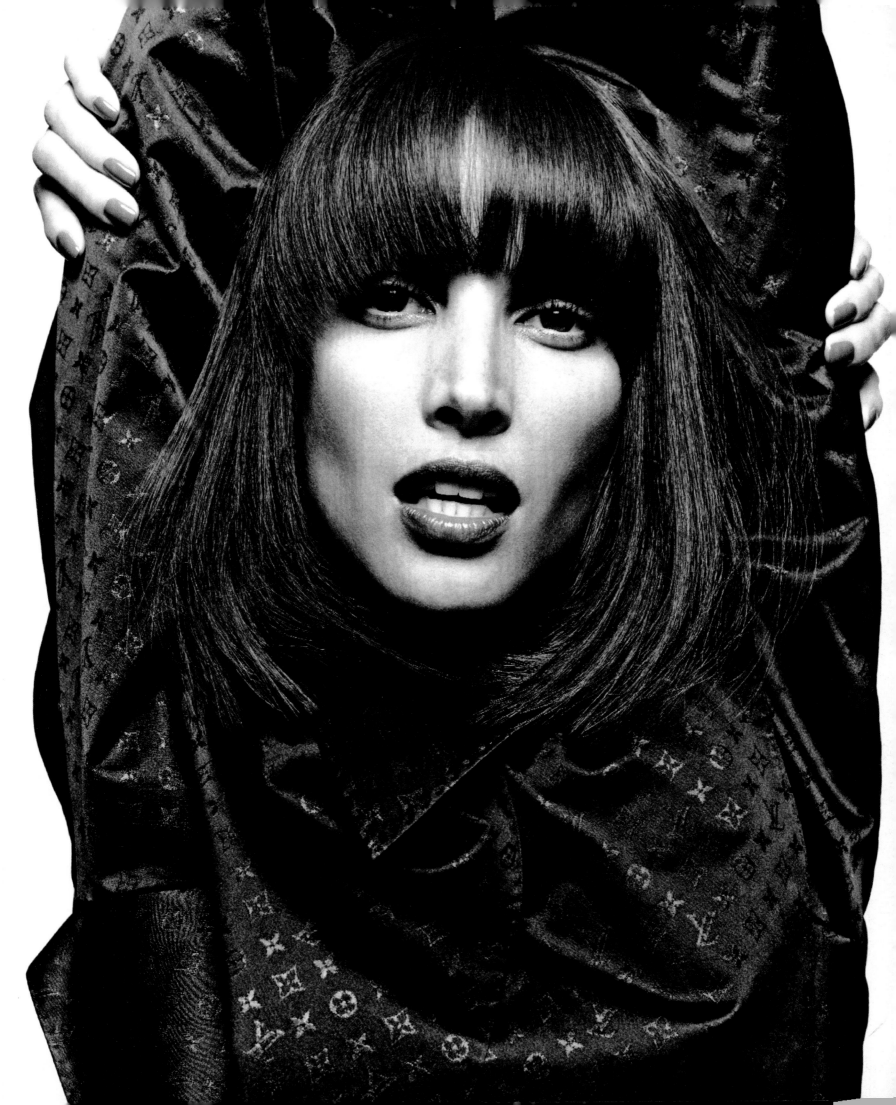

AUTUMN-WINTER 2000–2001

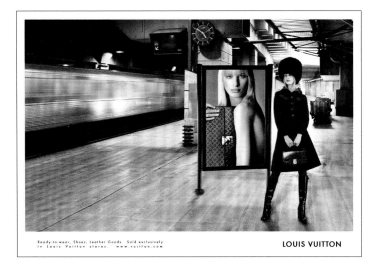

15 PUBLISHED ADS

PHOTOGRAPHERS
Inez Van Lamsweerde and Vinoodh Matadin
STYLIST
Brana Wolf
MODELS
Colette Pechekhonova, Anouck Lepère, Kate Moss, Stéphanie Seymour, Christy Turlington, and Beat Bolliger
MAKEUP
Eugène Souleiman
HAIR
Dick Page

*The first Louis Vuitton women's ready-to-wear advertising campaign under the artistic direction of Marc Jacobs.
All campaigns presented are under the artistic direction of Marc Jacobs unless otherwise noted.*

SPRING-SUMMER 2001

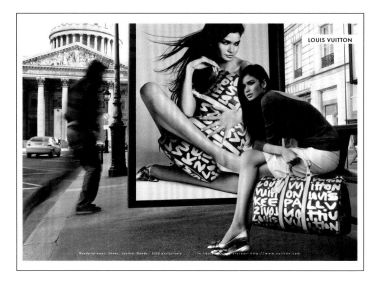

6 PUBLISHED ADS

PHOTOGRAPHER
Patrick Demarchelier
STYLIST
Carlyne Cerf
MODELS
Mini Anden, Karolina Kurkova, Amy Lemons, Ana Claudia Michels, Caroline Ribeiro
MAKEUP
Deedee Dorzee
HAIR
Didier Malige

* Artistic Direction: Maurice Betite, Agence EuroRSCG

AUTUMN-WINTER 2001–2002

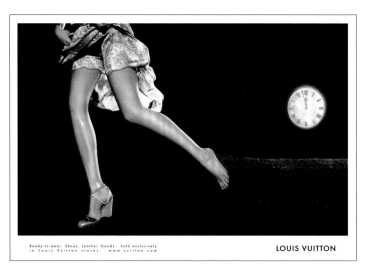

8 PUBLISHED ADS

PHOTOGRAPHER
Patrick Demarchelier
STYLIST
Carlyne Cerf
MODELS
Karolina Kurkova, Colette Pechekhonova
MAKEUP
Mark Carrasquillo
HAIR
Didier Malige

* Artistic Direction: Maurice Betite, Agence EuroRSCG

SPRING-SUMMER 2002

5 PUBLISHED ADS

PHOTOGRAPHERS
Mert Alas & Marcus Piggott
STYLIST
Joe McKenna
MODELS
Ann-Catherine Lacroix, Tasha Tilberg
MAKEUP
Charlotte Tilbury
HAIR
Luigi Murenu

AUTUMN-WINTER 2002–2003

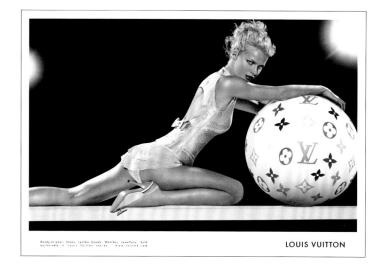

8 PUBLISHED ADS

PHOTOGRAPHERS
Mert Alas & Marcus Piggott
STYLIST
Katie Grand
MODEL
Eva Herzigova
MAKEUP
Charlotte Tilbury
HAIR
Guido

SPRING-SUMMER 2003

10 PUBLISHED ADS

PHOTOGRAPHERS
Mert Alas & Marcus Piggott
STYLIST
Katie Grand
MODEL
Eva Herzigova
MAKEUP
Charlotte Tilbury
HAIR
Guido

AUTUMN-WINTER 2003–2004

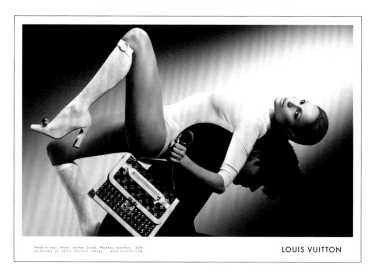

8 PUBLISHED ADS

PHOTOGRAPHERS
Mert Alas & Marcus Piggott
STYLIST
Katie Grand
MODELS
Jennifer Lopez; Lucas Babin and Andres Velencoso Segura
MAKEUP
Scott Barnes
HAIR
Oribe Canales

SPRING-SUMMER 2004

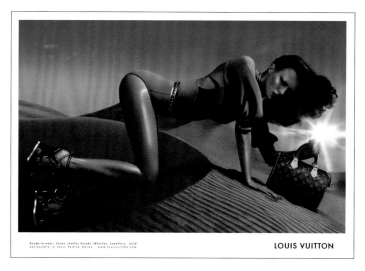

11 PUBLISHED ADS

PHOTOGRAPHERS
Mert Alas & Marcus Piggott
STYLIST
Katie Grand
MODELS
Naomi Campbell, Karen Elson, Liya Kebede, Angela Lindvall, Kate Moss, Amber Valetta
MAKEUP
Charlotte Tilbury
HAIR
Guido

AUTUMN-WINTER 2004–2005

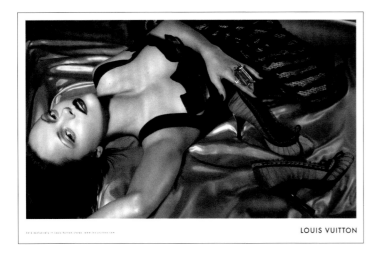

SPRING-SUMMER 2005

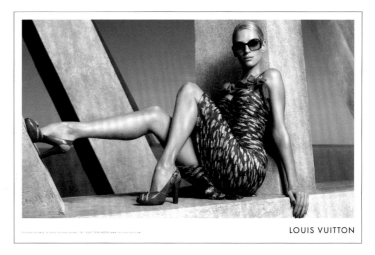

7 PUBLISHED ADS

PHOTOGRAPHERS
Mert Alas & Marcus Piggott
STYLIST
Katie Grand
MODELS
Scarlett Johansson, Diane Kruger, Christina Ricci, Chloë Sevigny
MAKEUP
Charlotte Tilbury
HAIR
Guido

11 PUBLISHED ADS

PHOTOGRAPHERS
Mert Alas & Marcus Piggott
STYLIST
Katie Grand
MODEL
Uma Thurman
MAKEUP
Charlotte Tilbury
HAIR
Guido

AUTUMN-WINTER 2005–2006

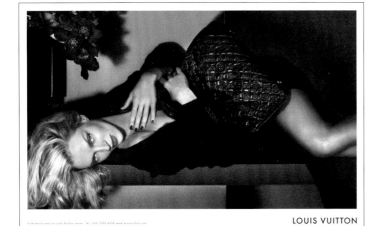

SPRING-SUMMER 2006

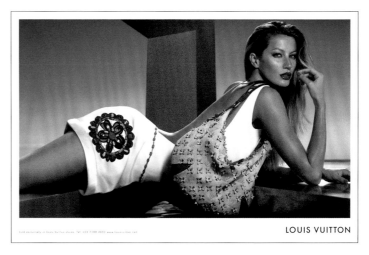

10 PUBLISHED ADS

PHOTOGRAPHERS
Mert Alas & Marcus Piggott
STYLIST
Katie Grand
MODEL
Uma Thurman
MAKEUP
Charlotte Tilbury
HAIR
Guido

10 PUBLISHED ADS

PHOTOGRAPHERS
Mert Alas & Marcus Piggott
STYLIST
Katie Grand
MODEL
Gisèle Bündchen
MAKEUP
Charlotte Tilbury
HAIR
Oribe Canales

AUTUMN-WINTER 2006–2007

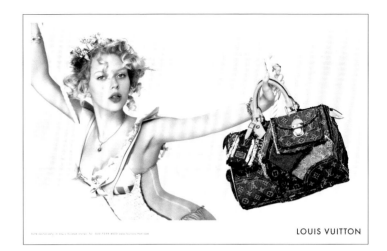

SPRING-SUMMER 2007

9 PUBLISHED ADS

PHOTOGRAPHERS
Mert Alas & Marcus Piggott
STYLIST
Katie Grand
MODELS
Naomi Campbell, Du Juan, Kate Moss, Daria Werbowy, Raquel Zimmermann
MAKEUP
Charlotte Tilbury
HAIR
Guido

11 PUBLISHED ADS

PHOTOGRAPHERS
Mert Alas & Marcus Piggott
STYLIST
Katie Grand
MODEL
Scarlett Johansson
MAKEUP
Charlotte Tilbury
HAIR
Oribe Canales

AUTUMN-WINTER 2007–2008

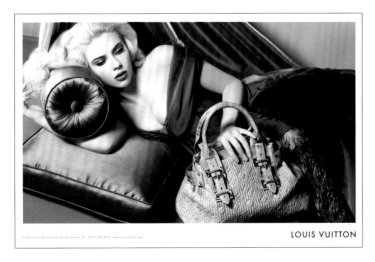

SPRING-SUMMER 2008

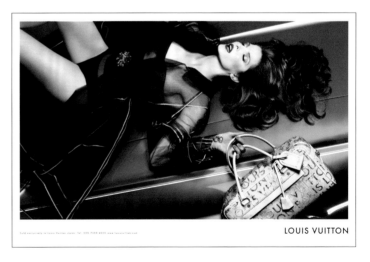

12 PUBLISHED ADS

PHOTOGRAPHERS
Mert Alas & Marcus Piggott
STYLIST
Katie Grand
MODEL
Scarlett Johansson
MAKEUP
Charlotte Tilbury
HAIR
Guido

14 PUBLISHED ADS

PHOTOGRAPHERS
Mert Alas & Marcus Piggott
STYLIST
Katie Grand
MODELS
Naomi Campbell, Eva Herzigova, Angela Lindvall, Claudia Schiffer, Stéphanie Seymour, Natalia Vodianova
MAKEUP
Lucia Pieroni
HAIR
Oribe Canales

AUTUMN-WINTER 2008–2009

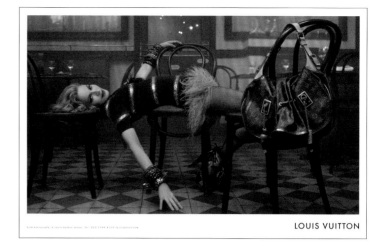

LOUIS VUITTON

11 PUBLISHED ADS

PHOTOGRAPHERS
Mert Alas & Marcus Piggott
STYLIST
Katie Grand
MODEL
Eva Herzigova
MAKEUP
Charlotte Tilbury
HAIR
Luigi Murenu

SPRING-SUMMER 2009

LOUIS VUITTON

5 PUBLISHED ADS

PHOTOGRAPHER
Steven Meisel
STYLIST
Marie-Amélie Sauvé
MODEL
Madonna
MAKEUP
Pat McGrath
HAIR
Garren

AUTUMN-WINTER 2009–2010

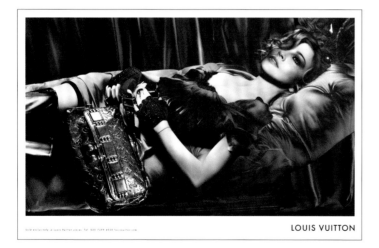

LOUIS VUITTON

7 PUBLISHED ADS

PHOTOGRAPHER
Steven Meisel
STYLIST
Marie-Amélie Sauvé
MODEL
Madonna
MAKEUP
Pat McGrath
HAIR
Guido

SPRING-SUMMER 2010

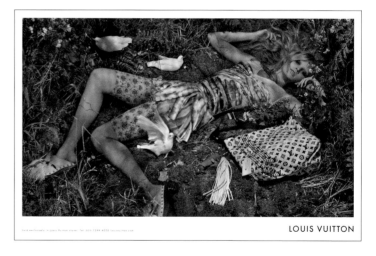

LOUIS VUITTON

10 PUBLISHED ADS

PHOTOGRAPHER
Steven Meisel
STYLIST
Marie-Amélie Sauvé
MODEL
Lara Stone
MAKEUP
Pat McGrath
HAIR
Guido

AUTUMN-WINTER 2010–2011

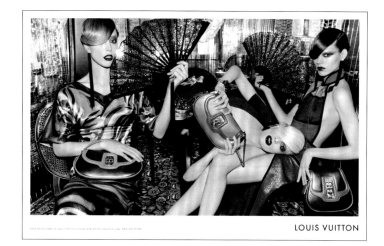

LOUIS VUITTON

7 PUBLISHED ADS

PHOTOGRAPHER
Steven Meisel

STYLIST
Karl Templer

MODELS
Karen Elson, Christy Turlington, Natalia Vodianova

MAKEUP
Pat McGrath

HAIR
Guido

SPRING-SUMMER 2011

LOUIS VUITTON

7 PUBLISHED ADS

PHOTOGRAPHER
Steven Meisel

STYLIST
Karl Templer

MODELS
Freja Beha Erichsen, Kristen McMenamy, Raquel Zimmermann

MAKEUP
Pat McGrath

HAIR
Guido

AUTUMN-WINTER 2011–2012

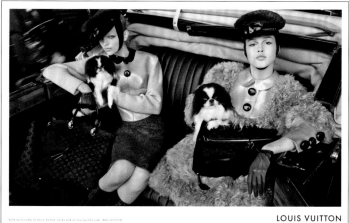

LOUIS VUITTON

9 PUBLISHED ADS

PHOTOGRAPHER
Steven Meisel

STYLIST
Karl Templer

MODELS
Zuzanna Bijoch, Daphne Groeneveld, Gertrud Hegelund, Nyasha Matonhodze, Anaïs Pouliot, Fei Fei Sun

MAKEUP
Pat McGrath

HAIR
Guido

SPRING-SUMMER 2012

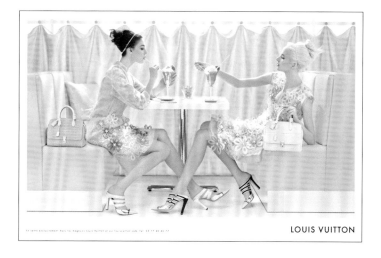

LOUIS VUITTON

10 PUBLISHED ADS

PHOTOGRAPHER
Steven Meisel

STYLIST
Karl Templer

MODELS
Kati Nescher, Daria Strokous

MAKEUP
Pat McGrath

HAIR
Guido

THE SHOWS

1998–2012

AUTUMN-WINTER 1998–1999

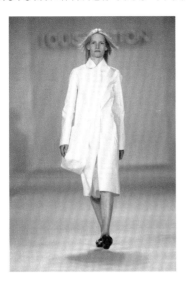

50 LOOKS

PRESENTATION DATE Monday, March 9, 1998, 2:30 p.m.
LOCATION La Grande Halle de la Villette 211,
Avenue Jean Jaures, Paris 19ᵉ Arrondissement

MAKEUP *Dick Page for Jed Root Inc.*
HAIR *Guido for Nicky Clarke*
PRODUCTION *KCD–WAB*
LIGHTING *Thierry Dreyfus*
MUSIC *Frédéric Sanchez*

SPRING-SUMMER 1999

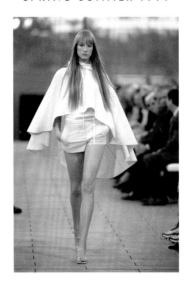

61 LOOKS

PRESENTATION DATE Monday, October 12, 1998, 2:30 p.m.
LOCATION Serre de l'Orangerie, Parc André Citroën,
Rue de la Montagne de la Fage, Paris 15ᵉ Arrondissement

MAKEUP *Pat McGrath*
HAIR *Eugene Souleiman for TONI&GUY*
PRODUCTION *KCD–WAB*
LIGHTING *Thierry Dreyfus*
MUSIC *Frédéric Sanchez*

AUTUMN-WINTER 1999–2000

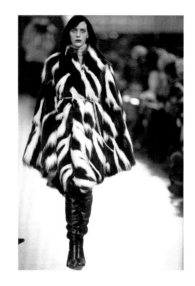

90 LOOKS

PRESENTATION DATE Monday, March 8, 1999, 2:30 p.m.
LOCATION Serre de l'Orangerie, Parc André Citroën,
Rue de la Montagne de la Fage, Paris 15ᵉ Arrondissement

MAKEUP *Pat McGrath*
HAIR *Eugene Souleiman*
PRODUCTION *La Mode en Images—KCD*
LIGHTING *Masao Nihei*
MUSIC *Frédéric Sanchez*

SPRING-SUMMER 2000

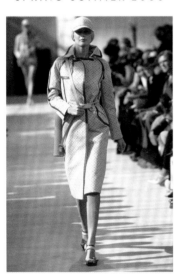

83 LOOKS

PRESENTATION DATE Monday, October 4, 1999, 2:30 p.m.
LOCATION Serre de l'Orangerie, Parc André Citroën,
Rue de la Montagne de la Fage, Paris 15e Arrondissement

MAKEUP *Pat McGrath*
HAIR *Eugene Souleiman*
PRODUCTION *La Mode en Images—KCD*
LIGHTING *Masao Nihei*
MUSIC *Frédéric Sanchez*

AUTUMN-WINTER 2000–2001

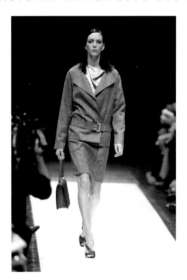

66 LOOKS

PRESENTATION DATE Monday, February 28, 2000, 7:30 p.m.
LOCATION Serre de l'Orangerie, Parc André Citroën
Rue de la Montagne de la Fage, Paris 15ᵉ Arrondissement

MAKEUP *Pat McGrath*
HAIR *Eugene Souleiman for TONI&GUY*
PRODUCTION *La Mode en Images—KCD*
LIGHTING *Masao Nihei*
MUSIC *Frédéric Sanchez*

SPRING-SUMMER 2001

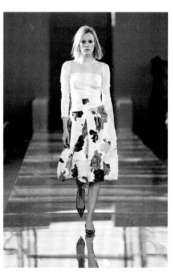

LOOKS 4 for men and 63 for women

PRESENTATION DATE Wednesday, October 11, 2000, 4:30 p.m.
LOCATION Serre de l'Orangerie, Parc André Citroën,
Rue de la Montagne de la Fage, Paris 15ᵉ Arrondissement

MAKEUP *Pat McGrath*
HAIR *Eugene Souleiman for TONI&GUY*
PRODUCTION *La Mode en Images—KCD*
LIGHTING *Masao Nihei*
MUSIC *Frédéric Sanchez*
PRINTS, GRAPHICS, AND ART *Stephen Sprouse*
HATS *Philip Treacy*

*"Marc Jacobs would like to dedicate this
collection and presentation to Christine Rezard."*

AUTUMN-WINTER 2001–2002

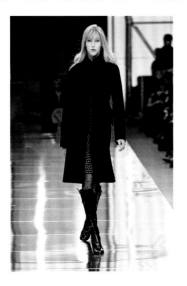

53 LOOKS

PRESENTATION DATE Monday, March 12, 2001, 2:30 p.m.
LOCATION Serre de l'Orangerie, Parc André Citroën,
Rue de la Montagne de la Fage, Paris 15ᵉ Arrondissement

MAKEUP *Pat McGrath*
HAIR *Eugene Souleiman for TONI&GUY*
PRODUCTION *La Mode en Images—KCD*
LIGHTING *Masao Nihei*
MUSIC *Frédéric Sanchez*
EMBROIDERY *Atelier Montex*
HATS *Philip Treacy*

SPRING-SUMMER 2002

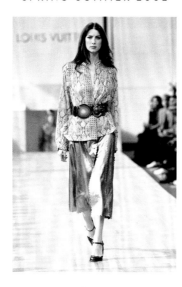

48 LOOKS

PRESENTATION DATE Monday, October 8, 2001, 2:30 p.m.
LOCATION Serre de l'Orangerie, Parc André Citroën,
Rue de la Montagne de la Fage, Paris 15ᵉ Arrondissement

MAKEUP *Pat McGrath*
HAIR *Eugene Souleiman for TONI&GUY*
PRODUCTION *La Mode en Images—KCD*
LIGHTING *Masao Nihei*
MUSIC *Frédéric Sanchez*
COLLAGE AND ART *Julie Verhoeven*
EMBROIDERY *Atelier Montex*

AUTUMN-WINTER 2002–2003

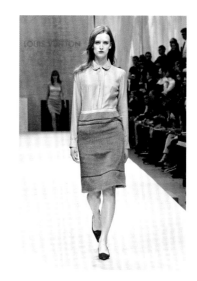

49 LOOKS

PRESENTATION DATE Monday, March 11, 2002, 2:00 p.m.
LOCATION Serre de l'Orangerie, Parc André Citroën,
Rue de la Montagne de la Fage, Paris 15ᵉ Arrondissement

MAKEUP *Pat McGrath*
HAIR *Eugene Souleiman for TONI&GUY*
PRODUCTION *La Mode en Images—KCD*
LIGHTING *Masao Nihei*
MUSIC *Frédéric Sanchez*
EMBROIDERY *Atelier Montex*
FURS *Saga Furs of Scandinavia*

SPRING-SUMMER 2003

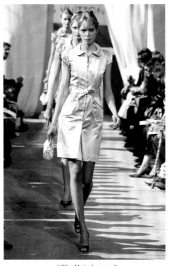

"The Hairdressers"
62 LOOKS

PRESENTATION DATE Monday, October 7, 2002, 2:00 p.m.
LOCATION Serre de l'Orangerie, Parc André Citroën,
Rue de la Montagne de la Fage, Paris 15ᵉ Arrondissement

MAKEUP *Pat McGrath*
HAIR *Eugene Souleiman for TONI&GUY*
PRODUCTION *La Mode en Images—KCD*
LIGHTING *Masao Nihei*
MUSIC *Frédéric Sanchez*
EMBROIDERY *Atelier Montex*

*"A very special thank you to Takashi Murakami
for a most joyous collaboration."*

AUTUMN-WINTER 2003–2004

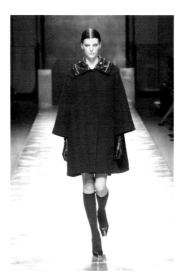

51 LOOKS

PRESENTATION DATE Monday, March 10, 2003, 2:30 p.m.
LOCATION Serre de l'Orangerie, Parc André Citroën,
Rue de la Montagne de la Fage, Paris 15ᵉ Arrondissement

MAKEUP *Pat McGrath*
HAIR *Eugene Souleiman for TONI&GUY*
PRODUCTION *La Mode en Images—KCD*
LIGHTING *Masao Nihei*
MUSIC *Frédéric Sanchez*
EMBROIDERY *Atelier Montex*

SPRING-SUMMER 2004

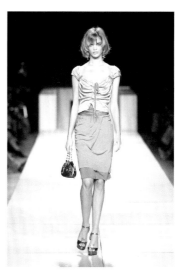

49 LOOKS

PRESENTATION DATE Sunday, October 12, 2003, 3:00 p.m.
LOCATION Serre de l'Orangerie, Parc André Citroën,
Rue de la Montagne de la Fage, Paris 15ᵉ Arrondissement

MAKEUP *Pat McGrath*
HAIR *Eugene Souleiman for TONI&GUY*
PRODUCTION *La Mode en Images—KCD*
LIGHTING *Philippe Cerceau*
MUSIC *Frédéric Sanchez*
EMBROIDERY *Atelier Montex*

AUTUMN-WINTER 2004–2005

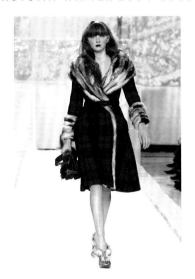

54 LOOKS

PRESENTATION DATE Sunday, March 7, 2004, 3:00 p.m.
LOCATION Serre de l'Orangerie, Parc André Citroën,
Rue de la Montagne de la Fage, Paris 15ᵉ Arrondissement

MAKEUP *Pat McGrath*
HAIR *Eugene Souleiman*
PRODUCTION *La Mode en Images—KCD*
LIGHTING *Philippe Cerceau*
MUSIC *Frédéric Sanchez*
HATS *Patricia Underwood*

*"This Collection is dedicated to
the loving memory of our friend Stephen Sprouse."*

SPRING-SUMMER 2005

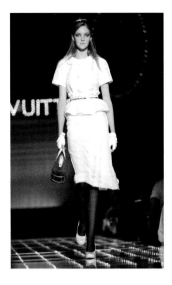

53 LOOKS

PRESENTATION DATE Sunday, October 10, 2004, 3:00 p.m.
LOCATION Serre de l'Orangerie, Parc André Citroën,
Rue de la Montagne de la Fage, Paris 15ᵉ Arrondissement

MAKEUP *Pat McGrath*
HAIR *Eugene Souleiman*
PRODUCTION *La Mode en Images—KCD*
LIGHTING *Philippe Cerceau*
MUSIC *Frédéric Sanchez*

AUTUMN-WINTER 2005–2006

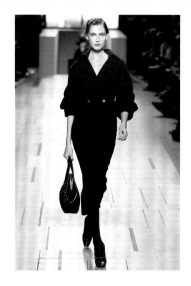

54 LOOKS

PRESENTATION DATE Sunday, March 6, 2005, 3:00 p.m.
LOCATION Serre de l'Orangerie, Parc André Citroën,
Rue de la Montagne de la Fage, Paris 15ᵉ Arrondissement

MAKEUP *Pat McGrath*
HAIR *Guido for Redken*
PRODUCTION *La Mode en Images—KCD*
LIGHTING *Philippe Cerceau*
MUSIC *Frédéric Sanchez*

SPRING-SUMMER 2006

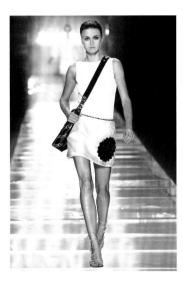

57 LOOKS

PRESENTATION DATE Sunday, October 9, 2005, 6:00 p.m.
LOCATION Petit Palais, Avenue Winston Churchill,
Paris 8ᵉ Arrondissement

MAKEUP *Pat McGrath*
HAIR *Guido for Redken*
PRODUCTION *La Mode en Images—KCD*
LIGHTING *Philippe Cerceau*

*"Louis Vuitton is proud to announce that the evening's
sounds are brought to you by the inimitable styling of
Pharrell Williams. Enjoy."*

AUTUMN-WINTER 2006–2007

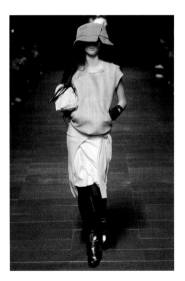

53 LOOKS

PRESENTATION DATE Sunday, March 5, 2006, 8:00 p.m.
LOCATION Petit Palais, Avenue Winston Churchill,
Paris 8ᵉ Arrondissement

MAKEUP *Pat McGrath*
HAIR *Guido for Redken*
PRODUCTION *La Mode en Images—KCD*
LIGHTING *Philippe Cerceau*
MUSIC *Jus Ske*

*"For Stephen Sprouse, who is gone but never forgotten;
our leopard print designed by Stephen Sprouse
for Louis Vuitton in the year 2000."*

SPRING-SUMMER 2007

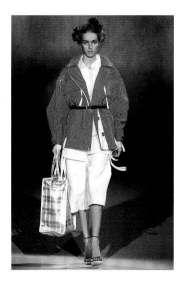

54 LOOKS

PRESENTATION DATE Sunday, October 8, 2006, 3:00 p.m.
LOCATION Petit Palais, Avenue Winston Churchill,
Paris 8ᵉ Arrondissement

MAKEUP *Pat McGrath*
HAIR *Guido for Redken*
PRODUCTION *La Mode en Images—KCD*
LIGHTING *Philippe Cerceau*
MUSIC *Frédéric Sanchez*
VIDEO *Ange Leccia*

AUTUMN-WINTER 2007–2008

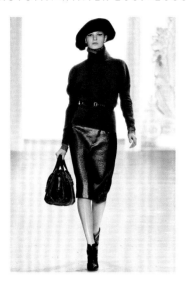

52 LOOKS

PRESENTATION DATE Sunday, March 4, 2007, 3:00 p.m.
LOCATION Cour Carrée du Louvre,
Porte Saint-Germain de l'Auxerrois,
Rue de L'Amiral de Coligny, Paris 1ᵉʳ Arrondissement

MAKEUP *Pat McGrath*
HAIR *Guido for Redken*
PRODUCTION *La Mode en Images—KCD*
LIGHTING *Philippe Cerceau*
MUSIC *Frédéric Sanchez*

SPRING-SUMMER 2008

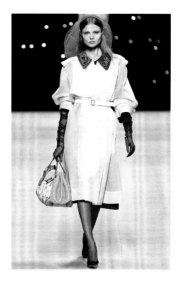

70 LOOKS

PRESENTATION DATE Sunday, October 7, 2007, 7:30 p.m.
LOCATION Cour Carrée du Louvre,
Porte Marengo, Rue de Rivoli,
Paris 1ᵉʳ Arrondissement

MAKEUP *Pat McGrath*
HAIR *Guido for Redken*
PRODUCTION *La Mode en Images—KCD*
LIGHTING *Philippe Cerceau*
MUSIC *Daft Punk*

"Louis Vuitton After Dark" in collaboration with Richard Prince

AUTUMN-WINTER 2008–2009

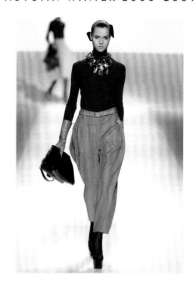

49 LOOKS

PRESENTATION DATE Sunday, March 2, 2008, 3:00 p.m.
LOCATION Cour Carrée du Louvre,
Porte Saint-Germain de l'Auxerrois,
Rue de L'Amiral de Coligny, Paris 1ᵉʳ Arrondissement

MAKEUP *Pat McGrath*
HAIR *Guido for Redken*
PRODUCTION *La Mode en Images—KCD*
LIGHTING *Philippe Cerceau*
MUSIC *Steve Mackey*

SPRING-SUMMER 2009

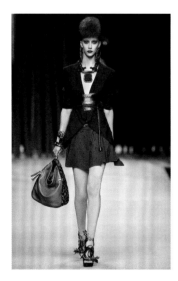

52 LOOKS

PRESENTATION DATE Sunday, October 5, 2008, 2:30 p.m.
LOCATION Cour Carrée du Louvre,
Porte Marengo, Rue de Rivoli, Paris 1ᵉʳ Arrondissement

MAKEUP *Pat McGrath*
HAIR *Guido for Redken*
PRODUCTION *La Mode en Images—KCD*
LIGHTING *Philippe Cerceau*
MUSIC *Steve Mackey*

AUTUMN-WINTER 2009–2010

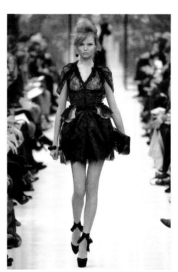

62 LOOKS

PRESENTATION DATE Thursday, March 12, 2009, 2:30 p.m.
LOCATION Cour Carrée du Louvre,
Porte Marengo, Rue de Rivoli, Paris 1ᵉʳ Arrondissement

MAKEUP *Pat McGrath*
HAIR *Guido for Redken*
PRODUCTION *La Mode en Images—KCD*
LIGHTING *Philippe Cerceau*
MUSIC *Steve Mackey*

SPRING-SUMMER 2010

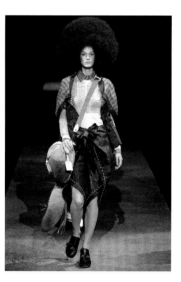

55 LOOKS

PRESENTATION DATE Wednesday, October 7, 2009, 2:30 p.m.
LOCATION Cour Carrée du Louvre,
Porte Marengo, Rue de Rivoli, Paris 1ᵉʳ Arrondissement

MAKEUP *Pat McGrath*
HAIR *Guido*
PRODUCTION *La Mode en Images—KCD*
LIGHTING *Philippe Cerceau*
MUSIC *Steve Mackey*

AUTUMN-WINTER 2010–2011

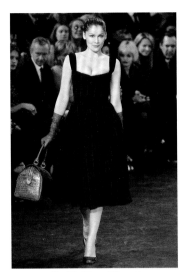

"And God Created Woman"
54 LOOKS

PRESENTATION DATE Wednesday, March 10, 2010, 2:30 p.m.
LOCATION Cour Carrée du Louvre,
Porte Saint-Germain de l'Auxerrois,
Rue de L'Amiral de Coligny, Paris 1er Arrondissement

MAKEUP *Pat McGrath*
HAIR *Guido*
PRODUCTION *La Mode en Images—KCD*
LIGHTING *Philippe Cerceau*
MUSIC *Steve Mackey*

SPRING-SUMMER 2011

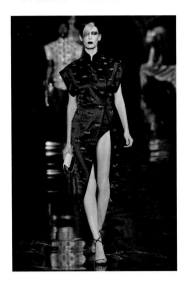

67 LOOKS

PRESENTATION DATE Wednesday, October 6, 2010, 2:30 p.m.
LOCATION Cour Carrée du Louvre,
Porte Marengo,
Rue de Rivoli, Paris 1er Arrondissement

MAKEUP *Pat McGrath*
HAIR *Guido*
PRODUCTION *La Mode en Images—KCD*
LIGHTING *Philippe Cerceau*
MUSIC *Steve Mackey*

*"The relation between boredom and camp taste cannot be over-
estimated. Camp taste is by its nature possible only in affluent societies,
in societies or circles capable of experiencing the psychopathology
of affluence."* —SUSAN SONTAG

AUTUMN-WINTER 2011–2012

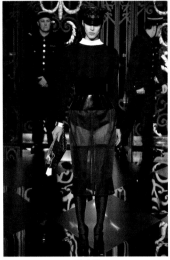

"Fetish"
67 LOOKS

PRESENTATION DATE Wednesday, March 9, 2011, 10:00am
LOCATION Cour Carrée du Louvre,
Porte Saint-Germain de l'Auxerrois,
Rue de L'Amiral de Coligny, Paris 1er Arrondissement

MAKEUP *Pat McGrath*
HAIR *Guido*
PRODUCTION *La Mode en Images—KCD*
LIGHTING *Philippe Cerceau*
MUSIC *Steve Mackey*

"fetish also fetich *[fe-tish] n (F & Pg ; F* fétiche, *fr. Pg* feitiço,
fr. feitiço *artificial, false, fr. L.* facticius *facticious)*
1. An object believed to have a magical power
2. Something to which one is irrationally devoted
Origin: 1605–15; earlier fateish < *Portuguese* feitiço *charm,
sorcery (noun), artificial (adj.) < Latin* facticius *factitious;
replacing* fatisso, fetisso < *Portuguese, as above"*

SPRING-SUMMER 2012

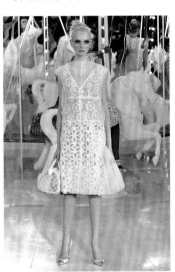

48 LOOKS

PRESENTATION DATE Wednesday, October 5, 2011, 10:00am
LOCATION Cour Carrée du Louvre,
Porte Saint-Germain de l'Auxerrois,
Rue de L'Amiral de Coligny, Paris 1er Arrondissement

MAKEUP *Pat McGrath*
HAIR *Guido for Redken*
PRODUCTION *La Mode en Images—KCD*
LIGHTING *Philippe Cerceau*
MUSIC *Steve Mackey*

V FOR VUITTON

[1] The three revolutions were in 1830, 1848, and 1870–1871; the two republics were established in 1848–1851 and 1870–1940. The five wars of the Second Empire were in Crimea (1854), China (1857), Italy (1859), Syria (1860), Mexico (1862), and Prussia (1870).

[2] Quoted in Georges Valance, *Haussmann le grand* (Paris: Flammarion, 2000), 191.

[3] In 1856, the buildings in the rue Saint-Honoré were renumbered. The former no. 327 now corresponds to no. 213 of the same street.

[4] The street was opened in the seventeenth century, extending the rue Neuve-des-Petits-Champs. First called rue Neuve-des-Capucins, then rue Neuves-des-Capucines, in 1881 it became rue des Capucines.

[5] According to Sébastien Bottin, *Almanach-Bottin du Commerce de Paris, des départements de la France et des principales villes du monde* (Paris: Bureau de l'Almanach du commerce, 1855).

[6] Denis Diderot and Jean d'Alembert, *Encyclopédie ou Dictionnaire raisonné des sciences, des arts et des métiers*, 1st ed. (Paris, 1755), s.v. *emballeur*.

[7] Ibid.

[8] Ibid., cf. *emballage*.

[9] The letterhead on Maréchal's invoices spell out the use of these techniques.

[10] Werner Plum, *Les expositions universelles au 19ème siècle, spectacles du changement socio-culturel*, trans. Pierre Gallissaires, from the German (Bonn-Bad Godesberg: Friedrich-Ebert-Stiftung, 1977), 6.

[11] Henri Clouzot, *Des Tuileries à Saint-Cloud: L'art décoratif du Second Empire* (Paris: Payot, 1925), 114.

[12] Plum, op. cit., 11.

[13] M. Teston, *Exposition Universelle de 1867 à Paris: Rapports du Jury international*, ed. Michel Chevalier, vol. 4, *Groupe IV*, (Paris: Imprimerie administrative de Paul Dupont, 1868), 501.

[14] In 1866, the population of France numbered about 38 million.

[15] Patent no. 74,557, January 18, 1867, SGDG (*Sans Garantie du Gouvernement*, or "Without Government Guarantee").

[16] *Le Figaro*, September 8, 1889.

[17] A few decades later, Madeleine Vionnet, the grande dame of couture—and, like Vuitton, a native of the Jura—also patented all her models. In *Le Figaro* of August 12, 1930, she expressed her views on the subject: "It is not so much a matter of collecting damages: above all, we want our intellectual property to be respected."

[18] Listing in the *Catalogue général officiel de l'exposition universelle de 1889 à Paris*, (Lille: L. Danel, 1889), category 39, 5.

[19] Béatrice de Andia, "Quartier Haussmannien, cité idéale," *Autour de l'Opéra: Naissance de la ville moderne* (Paris: Action artistique de la Ville de Paris, 1995), 23.

[20] The Gare Saint-Lazare serves the ports of the English Channel from Dieppe to Cherbourg and Le Havre, where the ships from England and the Americas dock. His English-speaking clientele have always remained faithful to the Vuitton brand.

[21] "M. Worth rue de la Paix" appears in the Vuitton firm journal of 1872, for the purchase of a trunk that was clearly intended for a client, since it is specified that the bill be sent to the Hôtel de l'Empire.

[22] Paul Jarry, *Les magasins de nouveautés: Histoire rétrospective et anecdotique* (Paris: André Barry et Fils, 1948), 49.

[23] *Le Figaro*, April 22, 1886.

[24] Patent no. 216,823, October 19, 1891, SGDG (*Sans Garantie du Gouvernement*, or "Without Government Guarantee").

LAYETIER–COFFRETIER–EMBALLEUR: THE SOURCES OF A SPECIALIZED KNOWLEDGE

[1] Many examples mentioning the use of *layettes* in the fifteenth and sixteenth centuries have been published, particularly in Victor Gay, *Glossaire archéologique du Moyen Age et de la Renaissance* (Paris, 1887–1928), vol. 2, 73; and Henry Havard, *Dictionnaire de l'ameublement et de la décoration depuis le XIIIe siècle jusqu'à nos jours* (Paris, 1887–1890), 283–285.

[2] René de Lespinasse and François Bonnardot, *Les métiers et corporations de la ville de Paris. XIIIe siècle. Le livre des métiers d'Etienne Boileau* (Paris, 1879), 134–136 (article on *gainiers*).

[3] The Archives Nationales preserve ordinances for *coffretiers-malletiers* for the years 1479 (Y [5], fol. 69v) and 1480 (ibid, fol. 72), as well as a report on the execution of a ruling of Parlement (August 14, 1481) in favor of these artisans and against the saddlers and harness manufacturers, who were attempting to encroach on their profession (ibid., fol. 162v). See also: René de Lespinasse and François Bonnardot, *Les métiers et corporations de la ville de Paris*, Vol. 3: *XIVe–XVIIIe siècle. Tissues, étoffes, vêtement, cuirs et peaux, métiers divers* (Paris, 1897), 483–494 (article on *coffretiers–malletiers*).

[4] In 1282 the *écriniers* received eight articles of bylaws from Guillaume de Hangest, *prévôt* (provost) of Paris. Lespinasse and Bonnardot, *Les métiers et corporations de la ville de Paris*, vol. 3, 497–498.

[5] Paris, Archives Nationales, Y 6 (4), fols. 155 and 158. The 1527 bylaws for the *écriniers-layetiers* are published in Lespinasse and Bonnardot, *Les métiers et corporations de la ville de Paris*, vol. 3, 498–500.

[6] Lespinasse and Bonnardot, *Les métiers et corporations de la ville de Paris*, vol. 3, 500–501.

[7] February 27, 1673: ruling of Parlement confirming the judgment of September 6, 1669, declaring that master *layetiers* could apply locks to their own products without being visited by locksmiths; ibid., vol. 3, 501.

[8] *Encyclopédie ou dictionnaire raisonné des sciences, des arts et des métiers … par M. Diderot et M. d'Alembert* (Paris, 1751–1780), vol. 9, 328.

[9] André-Jacob Roubo, *L'art du layetier* (Paris, 1782), 28. The nineteenth-century manuals for *layetiers* also provide valuable information on the trade. See also Bien-Aimé's *Notice historique sur les layetiers-emballeurs* (Paris, 1836), 16, and Nosban and Maigne's *Nouveau manuel complet du menuisier en bâtiments et du layetier-emballeur* (Paris, 1838), 345–408.

[10] The slotted carton has a distinctive closing mechanism: the lid fits perfectly into a wedge-shaped slot in the bottom part of the carton and thus locks into place.

FASHIONS ARE SO FRAGILE! CARTONS, BOXES, AND TRUNKS FOR GOWNS AND ACCESSORIES: A CHALLENGE FOR NINETEENTH-CENTURY PACKAGERS

[1] Patent applications for commercial specialties were often filed with the qualifier "S.G.D.G.," *Sans Garantie du Gouvernement* (Without Government Guarantee).

[2] Brigitte Lainé, *Objets, 1860–1910: Dessins de modèles de fabriques déposés*, Archives de Paris, Paris, 1993.

[3] Joseph Tiné, packer in the rue des Colonnes, Paris. Patent granted July 16, 1844, for a system for packing trimmed gowns.

[4] *Au Paradis des dames, nouveautés, modes et confections, 1810–1870*, Paris-Musées, Paris, 1992.

[5] Elisabeth A. Coleman, *The Opulent Era: Fashions of Worth, Doucet, and Pingat*, Thames and Hudson, New York, 1989.

[6] *Album d'articles de voyages d'après les modèles de messieurs Godillot père et fils, brevetés malletiers du roi* (Paris, 1842), lithographs by Alexis Godillot, who manufactured general travel items, 278, rue St. Denis. Nine plates: the first six plates display eighty-six colored images of trunks, boxes for gowns, bags, and suitcases.

[7] *Au Paradis des dames* …, 50–52. From the late 1860s on, stores, boutiques, dressmakers, and milliners used labels stamped with the name of the owner or maker.

LOUIS VUITTON (1821–1892): A BIOGRAPHY

[1] The Bienne mill is located in Lavancia, some twenty kilometers from Anchay (researched by Sophie Dalloz-Ramaux).

[2] Serial number 4872, mustered May 17, 1811 in the 52nd regiment; served in the Spanish Campaign of 1812-13; taken prisoner November 1, 1813 at Pamplona (Service historique de la Défense, SHD/GR 34YC); Medal of Sainte Hélène; pension certificate, August 15, 1869 (Paris: Archives Nationales, LH 3279).

[3] Marriage contract, February 3, 1840. Provisions of paternal inheritances: "buildings, wood, and loan" for Constant, redeemable stock for his betrothed, plus a dowry of 2,000 francs (Paris, Archives Nationales, ET/CXIII/927); Vuiton estate, December 3, 1876 (Departmental Archives of the Yvelines, 3E8/239).

[4] Lease of March 21, 1846, extended March 19, 1858. Documents missing from the central records office (study XCVII). The two spellings "Vuitton" and "Vuiton" can be used for the ascendants of Louis and Constant. The latter chose "Vuiton" for his company name.

[5] His first wife, Augustine Marguerite Edmée Collet, died in Paris on July 22, 1838.

[6] Baptism of Louis Lucie Vuitton, January 29, 1840, parish of Saint-Louis d'Antin (researched by Bernard Ogliastro).

[7] His father, François Maréchal, a wine grower, died April 13, 1808, the year after his son's birth (March 23, 1807; municipal records of Saint-Bris-le-Vineux).

[8] Initial lease, September 8, 1831; apartment, January 9, 1837; second shop, July 3, 1835 (Paris: Archives Nationales, ET/XCI/1736, 1791, and 1777).

[9] Postmortem inventory, November 18, 1872 (Paris: Archives Nationales, ET/CXVIII/1126).

[10] Sale, May 6, 1850; constitution of the Vuitton & Darblet Company, May 24, 1850 (Archives Nationales, Paris, ET/LXXIX/688).

[11] Tribunal Correctionnel de la Seine, July 1, 1853, chamber 7; see bankruptcy 10827 (Archives de Paris, D11U3 161).

[12] Romain Maréchal had two heirs: Romain Raymond, born July 17, 1845; and Léon Lucien, born June 14, 1847.

[13] Purchase of the mill, November 20, 1834; sale, September 20, 1853 (Departmental Archives of the Hauts-de-Seine, DQ16 7582, 8157, and 8159).

[14] Parriaux patents, November 6, 1840; October 14, 1849, no. 8695; March 20, 1851, no. 11080 (Institut National de la Propriété Industrielle; hereafter INPI).

[15] Court decision, January 31, 1853, voided during the Commune. See postmortem Parriaux inventory, March 19, 1852, and succession, March 16, 1853 (Departmental Archives of the Val-de-Marne, 2E/CXXVI/279 and DQ18 454).

[16] Notebook, 1852 (Archives de Paris, D14 1220). The patronymic is written with one or two t's, depending on the document. The content of the tax documents is revealing: Louis is recorded as "Wilton," corrected first to "Uiton," then to "Vuiton."

[17] Transfer of lease, November 30, 1854, taking of possession January 1, 1855 (Archives Nationales, Paris, ET/LXXXVII/1587, researched by Alain Cointat).

[18] Trust deed, October 8, 1853 (Archives Nationales, Paris, ET/CX/966). Leases were established by signed private agreement. In 1869, the linen manufacturer Frank took over the shop after Louis. His lease was for fifteen years, probably the same length as Louis's, which would therefore have taken effect in early 1854.

[19] Lease, December 3, 1858 (Archives Nationales, Paris, ET/CX/1030).

[20] *Dictionnaire biographique des grands commerçants et industriels*, vol. 1, Paris, Henry Carnoy, 1895, 87.

[21] Purchase by Chalimbaux, November 15, 1856, and sale to the Vuittons, March 31, 1859 (Archives Nationales, Paris, ET/LII/947).

[22] Public records, 1854–1880 (Archives de Paris, DQ18 543).

[23] Notebook, 1852 (Archives de Paris, D1P4 967).

[24] Marriage license, January 26, 1865 (municipal records of the 2nd Arrondissement of Paris).

[25] Debenture bond, November 19, 1866; extension, November 20, 1876 (Archives Nationales, Paris, ET/LII/985).

[26] Private lease agreement, December 15, 1884; lease listing, postmortem Rabec inventory, August 6, 1895. Georges Vuitton acquired the business September 7, 1895; auction registry, August 14, 1895 (Archives Nationales, Paris, ET/LXII/1369 and ET/LXII/1370).

[27] Lease, March 26, 1872, entry into possession, January 1, 1872 (Archives Nationales, Paris, ET/VIII/1774).

[28] Sent to Philip Le Faivre, Saint Clément, 29 Main Road, Eden House, census of 1871 (National Archives, Kew, RG10 5760).

[29] Marriage contract, August 12, 1875, included a dowry of 10,000 francs (Departmental Archives of the Hauts-de-Seine, 3E/COU_464).

[30] Serial number 3890, recruitment 1877, called up November 5, 1875, discharged October 28, 1900, with the rank of warrant officer of the general-in-chief (Archives de Paris, D4R1 189).

[31] Sublet, December 18, 1871; lease, July 1, 1872; Notebook, 1862 (Archives de Paris, D1P4 195).

[32] Sale and constitution of the Billot & Lombard company December 25, 1876 (Departmental Archives of the Yvelines, 3E8 239).

33 Purchase, auction registry, July 31, 1864, auction of August 7, 1864; sale, July 14, 1877, for 6,000 francs (Departmental Archives of the Hauts-de-Seine, 3E/COL_364).
34 Patrelle patents: flavored toffee, March 22, 1856, no. 26964; Patrelle panama hat, May 31, 1869, no. 85854; product for cleaning fabrics, November 28, 1876, no. 114806, (INPI).
35 Sales and marriage contract, November 3, 1880 (Archives Nationales, Paris, ET/LII/1057 and ET/XXXVII/1004).
36 Sale, March 24, 1882, and lease, March 30, 1886 (Archives Nationales, Paris, ET/LII/1064 and ET/LII/1087).
37 Judgment of the Tribunal Civil de la Seine, March 24, 1890, chamber 5 (Archives de Paris, DU5 792).
38 Statute, November 14, 1891 (Municipal Archives of Asnières, 5Q16ter).
39 The numbering is continuous beginning January 1, 1880. Prior to that, it was annual: from 1 to 2389 for the year 1878; from 1 to 2137 for 1879.

FASHION ON THE MOVE!

1 Aux Trois Quartiers, fall and winter seasons, 1876.
2 In 1869, crinoline disappeared completely from the feminine wardrobe in favor of the *tournure*, a type of bustle.
3 *La Mode Illustrée*, May 1864.
4 Honoré Sclafer, *Le Paysan riche*, Librairie Sartorius, Paris, 1874.
5 Élisabeth Celnart, *Manuel des dames ou l'art de l'élégance sous le rapport de la toilette, des honneurs, de la maison, des plaisirs, des occupations agréables*, Roret, Paris, 1833.
6 Marie de Saverny (Marie d'Arjac), *La femme hors de chez elle: en voyage, à la campagne*, Bureau de la revue de la mode, Paris, 1878.
7 Ibid.
8 Victor Basière's periodical, *La Nicostrata, chez Eyssautier et chez tous les marchands de nouveautés*, Paris, 1843.
9 Marie de Saverny, (Marie d'Arjac), *La femme hors de chez elle: en voyage, à la campagne*, Bureau de la revue de la mode, Paris, 1878.
10 Ibid.
11 Comte de Reiset, *Mode et usages au Temps de Marie-Antoinette, livre-journal de Madame Eloffe*, tome 1, 1787–1793, Firmin-Didot et Cie, Paris, 1885.
12 From 1856 to 1870, each year the Imperial Court spent three to six weeks at Compiègne, and the guests were invited there in "series."
13 Princesse de Metternich, *"Je ne suis pas jolie, je suis pire."* Souvenirs, 1859–1871, collection "La lettre et la plume," Poche, Paris, 2008.
14 Ibid.
15 Pierre Véron, *La comédie du voyage*, E. Dentu Editeur, Paris, 1863.

MARC JACOBS: FROM A TO B AND BACK

1 Between 1985 and 1986, Sketchbook was a line of moderately priced sportswear financed by Ruben Thomas, Inc., a fashion company on Seventh Avenue. From 1986 to 1988, the Marc Jacobs label was financed first by Jack Atkins; then by the Epoc 3 company; and then by the American subsidiary of Onward Kashiyama.
2 Ellen Saltzman, senior vice president of Saks Fifth Avenue, in Bernadine Morris, "Jacobs Taking Over As Designer at Ellis," *The New York Times*, November 23, 1988.
3 Bernadine Morris, "Jacobs Taking Over As Designer at Ellis," *The New York Times*, November 23, 1988.
4 Only Anne Klein underwent a successful succession, thanks to Donna Karan and Louis Dell'Olio, who designed the collections from 1974 to 1984.
5 Bernadine Morris, op. cit.
6 Marc Jacobs, in Bernadine Morris, "Perry Ellis Americana," *The New York Times*, June 25, 1991.
7 Marc Jacobs, in Anne-Marie Schiro, "Style Makers: Steven Meisel—Photographer," *The New York Times*, March 19, 1989.
8 Robert Duffy, in Woody Hochswender, "Patterns," *The New York Times*, March 7, 1989.
9 Bernadine Morris, "Restraint from Calvin Klein, Youthful Chic from Ellis," *The New York Times*, November 1, 1989.
10 Bernadine Morris, "Reviews/Fashion; Klein and Ellis Define the Spectrum of Style," *The New York Times*, April 8, 1992.
11 "The Guru of Grunge," *Women's Wear Daily*, November 11, 1992.
12 Liz Gessner and Heidi Lender, "New York Picks Up the Beat," *Women's Wear Daily*, November 2, 1992.
13 Ibid.
14 Ibid.
15 Marc Jacobs, in Dan Shaw, "To Make His Own Marc," *The New York Times*, February 28, 1993.
16 Suzy Menkes, "A Youthquake Shapes the Future, but What Is There to Wear Now?" *International Herald Tribune*, March 7, 1994.
17 Ibid.
18 Michael Gross, "Euro Dizzy," *New York Magazine*, April 5, 1993, 45–46.
19 Laurence Benaïm, "Paris redevient la vitrine mondiale de la mode," *Le Monde*, Tuesday, March 14, 1995.
20 Suzy Menkes, "All the World Is on Stage for Paris Fashion Shows," *International Herald Tribune*, October 14–15, 1995.
21 Mariella Righini, "Ils secouent les vieilles griffes. Mode: les nouveaux mercenaires," *Le Nouvel Observateur*, March 19, 1998, 100.
22 Rose Marie Bravo, president of Saks Fifth Avenue, in Amy M. Spindler, "Vuitton and Jacobs Seen in Ready-to-Wear Deal," *The New York Times*, January 7, 1997.
23 Marc Jacobs, in Colin McDowell, "In love with Marc Jacobs," *Sunday Times*, April 25, 2004, Style section, 26.
24 Marc Jacobs, in Sarah Mower, "Marc, Perry and Louis Too," *Arena Homme +*, Spring-Summer 2001, 259.
25 Marc Jacobs, in Armand Limnander, "On the Marc," *Harper's Bazaar*, February 2004, 164.
26 Gerard Lefort, "Au menu: les premiers vêtements de Vuitton, les tutus à la Degas de Drezen et les ponchos," *Libération*, March 11, 1998, 37.
27 Julie K. L. Dam, "The New Kids on the Walk," *Time*, March 23, 1998, 95.
28 Marc Jacobs, in Sarah Mower, "Marc, Perry and Louis Too," *Arena Homme +*, Spring-Summer 2001.
29 Susan Orlean, "Breaking Away," *Vogue* (US) September 1992, 526.
30 Marc Jacobs, interview by Murray Healy, September 2007.
31 Bruna Basini, "L'enfant chéri des marques," *Le Journal du Dimanche*, December 26, 2009, 4.
32 Marc Jacobs, in Laurence Benaïm, "La passion ne s'achète pas," *Le Monde*, May 21, 2003.
33 Marc Jacobs, in Patrick Cabasset, "Marc Jacobs sacre J. Lo," *L'Officiel*, October 2003, 76.
34 Marc Jacobs, in Jamie Huckbody, "Shooting from the Hip," *I.D. Magazine*, February 2003, 85.
35 Marc Jacobs, in "Qu'est-ce que la création?," *Libération*, Special fashion supplement Winter 2001–02, October 6, 2001, 60.
36 Marc Jacobs, in Sarah Mower, "Louis Vuitton," Style.com, March 2, 2008, http://www.style.com/fashionshows/review/F2008RTW-LVUITTON/.
37 Marc Jacobs, in Benaïm, "La passion ne s'achète pas."
38 Ibid.
39 Marc Jacobs, in "Qu'est-ce que la création?," *Libération*, Special fashion supplement Winter 2001–02, October 6, 2001.
40 Marie-Pierre Lannelongue, "Bernard Arnault et Marc Jacobs: luxueuse rencontre. Vuitton se met à l'heure," *Elle* (France), December 9, 2002, 177.
41 Marc Jacobs, in Harriet Quick, "Super Marc," *Vogue* (UK), November 2010, 236.
42 Mower, op. cit., 328.

IN HIS OWN WORDS: MARC JACOBS ON THE COLLABORATIONS

1 Jonathan Wingfield, "L'affaire est dans le sac," *Numéro*, February 2003.
2 *Marc Jacobs on Takashi Murakami*. Museum of Contemporary Art, Los Angeles, 2008.
3 Jamie Huckbody, "Shooting From the Hip," *ID Magazine*, February 2003, 80.
4 Wingfield, op. cit.
5 Huckbody, op. cit.
6 Ibid. 85
7 Wingfield, op. cit.
8 Ibid.
9 *Marc Jacobs on Takashi Murakami*. Museum of Contemporary Art, Los Angeles, 2008.
10 Niru Ratnam, "Interview," *ID Magazine*, February 2003, 88.
11 Huckbody, op. cit., 80.
12 Ibid.
13 Wingfield, op. cit.
14 Ratnam, op. cit.
15 Loïc Prigent, *Marc Jacobs & Louis Vuitton*, documentary, Arte, France 2007.
16 Huckbody, op. cit., 85.
17 Ratnam, op. cit.
18 op. cit., 88.
19 Ibid.
20 Wingfield, op. cit.
21 Huckbody, op. cit., 85.

SPROUSE, MURAKAMI, PRINCE IN CONTEXT

1 LV product card, Spring-Summer 2003 show "Le procédé de sérigraphie."

BOOKS

Autour de l'Opéra: Naissance de la ville moderne. Paris: Action artistique de la Ville de Paris, 1995.
Bien-Aimé. *Barème du layetier: Manière de compter le bois qui entre dans les caisses et de les confectionner.* Paris: edited by the author, no date given.
———. *Notice historique sur les layetiers-emballeurs.* Paris: edited by the author, 1836.
Ollendorff, Paul. *Carette, Souvenirs intimes de la cour des Tuileries.* Paris: 1889.
Les cathédrales du commerce parisien: Grands magasins et enseignes. Paris: Action artistique de la Ville de Paris, 2006.
Celnart, Élisabeth. *Manuel des dames ou l'art de l'élégance, sous le rapport de la toilette, des honneurs, de la maison, des plaisirs, des occupations agréables.* Paris: Roret, 1833.
Clouzot, Henri. *Des Tuileries à Saint-Cloud : L'art décoratif du second empire.* Paris: Payot, 1925.
Cointat, Alain. *Les souliers de la gloire, Alexis Godillot (1816–1893) l'exceptionnelle réussite d'un fidèle de Napoléon III.* Toulon: Les presses du Midi, 2006.
Fonkenell, Guillaume. *Le palais des Tuileries,* Arles: Honoré Clair, 2010.
Guides-Cicerone. *Paris illustré : Son histoire, ses monuments, ses musées, son administration, son commerce et ses plaisirs, Nouveau guide des voyageurs.* Paris: Hachette, 1855.
Havard, Henry. *Dictionnaire de l'ameublement et de la décoration depuis le XIIIe siècle jusqu'à nos jours, 4 vol.* Paris: Librairies-imprimeries Réunies, May & Motteroz, 1887–1890.
Hérisson, Maurice d'. *Journal d'un officier d'ordonnance : Juillet 1870-February 1871.* Paris: Paul Ollendorff, 1885.
Jarry, Paul. *Les magasins de nouveautés : Histoire rétrospective et anecdotique.* Paris: André Barry & fils, 1948.
Léonforte, Pierre and Éric Pujalet-Plaà. *100 malles de Légende Louis Vuitton.* Paris: La Martinière, 2010.
Lespinasse, René de and François Bonnardot. *Les Métiers et corporations de la ville de Paris: XIIIe siècle, Le Livre des Métiers d'Etienne Boileau.* Paris: Imprimerie Nationale, 1879.
de Lespinasse, René and François Bonnardot. *Les Métiers et corporations de la ville de Paris : XIVe–XVIIIe siècles, Tissus, étoffes, vêtement, cuirs et peaux, métiers divers.* Paris Imprimerie Nationale, 1897.
Libron, Fernand and Henri Clouzot. *Le Corset dans l'Art et les Mœurs du XIIIe au XXe siècle.* Paris: F. Libron, 1933.
Metternich-Sándor Pauline. *Je ne suis pas jolie, je suis pire. Souvenirs, 1859–1871.* Paris: Le Livre de Poche, 2008 (1922).
Nosban, Maigne. *Nouveau manuel complet du menuisier en bâtiments et du layetier-emballeur, 2 vol.* Paris: Roret, 1838.
Pasols, Paul-Gérard. *Louis Vuitton : La naissance du luxe moderne.* Paris: La Martinière, 2005.
Plum, Werner. *Les expositions universelles au 19ème siècle, spectacles du changement socio-culturel: Aspects sociaux et culturels de l'industrialisation, traduit de l'allemand par Pierre Gallissaires.* Bonn-Bad Godesberg: Friedrich-Ebert-Stiftung, 1977.
Reiset, Gustave-Armand-Henri de. *Modes et usages au temps de Marie-Antoinette: Livre-journal de madame Éloffe, 2 vol.* Paris: Firmin-Didot, 1885.
Roubo, André-Jacob, *L'Art du layetier.* Paris: Moutard, 1782.
Saverny, Marie de (Marie d'Ajac). *La Femme hors de chez elle: en voyage, à la campagne.* Paris: Bureaux de La Revue de la mode, 1878.
Schroeder-Gudehus, Brigitte and Anne Ramussen. *Les fastes du progrès: Le guide des Expositions universelles 1851–1992.* Paris: Flammarion, 1992.
Valance, Georges. *Haussmann le grand.* Paris: Flammarion, 2000.
Véron, Pierre. *La Comédie du voyage.* Paris: E. Dentu, 1863.
Vuitton, Georges. *Le Voyage depuis les temps les plus reculés jusqu'à nos jours.* Paris: E. Dentu, 1894.
Vuitton, Henry-Louis. *La malle aux souvenirs.* Paris Mengès, 1984.

ARTICLES

Brachet Champsor, Florence. "Les Grands Magasins et le mode," *Les cathédrales du commerce parisien: Grands magasins et enseignes.* Paris: Action artistique de la Ville de paris, 2006, 143–151.
Delio, E. "L'Exposition de M. Louis Vuitton." Havre exposition, June 25, 1887, 118.
Vuitton (Louis), and Louis Vuitton fils (Geaoges Vuitton). *Dictionnaire biographique des grands commerçants et industriels,* vol. 1. Paris: Henry Carnoy, 1895, 86–88.

EXPOSITION CATALOGS

Musée de la Mode et du Costume, Les accessoires du temps: ombrelles et parapluies. October 24, 1989–January 14, 1990. Paris: Palais Galleria, 1989.
L'invitation au voyage: Autour de la donation Louis Vuitton. May 18–August 30, 1987. Paris: Musée des Arts Décoratifs, 1987.
Musée de la Mode et du Costume, Sous l'empire des crinolines 1852–1870. November 29, 2008–April 26, 2009. Paris: Palais Galleria, 2008.

UNIVERSAL AND INTERNATIONAL EXPOSITION CATALOGS

Exposition Universelle de 1867 à Paris: Rapports du Jury international publiés sous la direction de M. Michel Chevalier, vol. IV, Group IV, Vêtements (tissus compris) et autres objets portés par la personne. Classes 27 à 39. Paris: Imprimerie administrative de Paul Dupont, 1868.
Exposition Universelle de 1867 à Paris: Catalogue officiel des exposants récompensés par le jury international. Paris: E. Dentu, 1867.
Exposition maritime Internationale du Havre, 1868: Rapport du jury international et catalogue officiel des exposants récompensés. London, Paris, and Le Havre: J. M. Johnson & Sons, Dentu, Bourdignon, 1868.
Ribeyre, F. *Les annales de l'Exposition du Havre, Le Havre.* Paris: Imprimerie du Courrier du Havre, Paul Dupont, 1868.
Exposition Universelle Internationale de 1878, à Paris: Catalogue officiel, liste des récompenses. Paris: Imprimerie nationale, 1878.
Sriber, Alphonse. *Exposition universelle internationale de 1878 à Paris: Rapports du jury international, France, Ministère de l'agriculture et du commerce, GROUPE IV, Classe 41, Rapport sur les objets de voyage et de campement.* Paris: Imprimerie Nationale, 1881.
Exposition maritime internationale du Havre 1887: Catalogue général officiel. Le Havre: Société anonyme du journal le Havre, 1887.
Ministère du commerce et de l'industrie: Exposition Universelle de 1889 à Paris, Direction générale de l'exposition, Comité d'admission. Paris: Imprimerie Nationale, 1887.
Catalogue général officiel de l'exposition universelle de 1889 à Paris. Lille: L. Danel, 1889.
Exposition Universelle Internationale de 1889, à Paris, Liste des récompenses. Paris: Imprimerie nationale, 1889.
Sriber, Alphonse. *Exposition Universelle Internationale de 1889 à Paris: Rapports du jury international, France, Ministère du commerce, de l'industrie et des colonies, Groupe IV, Tissus, vêtements et accessoires, Classes 39.* Paris: Imprimerie Nationale, 1891.

COMMERCIAL CATALOGS

Louis Vuitton. Paris: P. Hauducœur, 1892.
Louis Vuitton. Paris: P. Hauducœur, 1897.

ACADEMIC PUBLICATIONS

Lapointe, Marie-France. *Une perception historienne contemporaine des grands travaux du Second Empire (1852–1870), Mémoire de maîtrise en Histoire, Faculté des Lettres.* Quebec: Université Laval, 2007.

BOOKS

Foley, Bridget. *Marc Jacobs*. Paris: Assouline, 2004.
Gasparina, Jill, Glenn O'Brien, Taro Igarashi, Ian Luna, Valerie Steele. *Louis Vuitton: Art, Fashion and Architecture*. New York: Rizzoli International Publications, 2009.
Padilha, Roger and Mauricio Padilha. *Stephen Sprouse*. New York: Rizzoli International Publications, 2009.

ARTICLES

Bacrie, Lydia. "Marc Jacobs: Un Américain à Paris." *L'Express Mag*, 7, March 2005, 14–17.
Barrera, Giorgio. "Marc of a Masterpiece." *The Financial Times*, November 3, 2007, 44–48.
Basini, Bruna. "L'enfant chéri des marques." *Le Journal du Dimanche*, December 26, 2009, 4.
Baudot, François. "Marc Jacobs chez Vuitton: Un Américain à Saint-Germain-des-Prés." *Elle*, November 1, 1999, 124–131
Benaïm, Laurence. "La passion ne s'achète pas." *Le Monde*, May 21, 2003.
———. "Paris redevient la vitrine mondiale de la mode." *Le Monde*, March 14, 1995.
Betts, Kate. "The School of Cool." *Time*, February 23, 2004, 52–53.
Boury-Heyler, Sandrine and Farid Chenoune. "Marc Jacobs: la mode sans bagages." *Mixte*, Spring-Summer 2002, 54–56.
Cabasset, Patrick, "Marc Jacobs sacre J. Lo," *L'Officiel*, October 2003, 76–77.
Cartner-Morley, Jess and Nathalie Lamoral. "The Marc of Luxury." *The Guardian*, March 2, 2002, 71–73.
Cole, Bethan. "The Gospel According to St. Marc." *ID Magazine*, March 2000, 234–239.
Comita, Jenny. "Cool and the Gang." *Vogue* (US), November 2003, 240–248.
Coppet, Anita. "La mode Vuitton, un luxe signé Marc Jacobs." *Marie-Claire*, #582, February 2001, 186–191.
Dam, Julie K. L. "The New Kids on the Walk." *Time*, March 23, 1998, 95.
Diatkine, Anne. "Double étiquette." *Libération*, March 4, 2005, 40.
Dombrowicz, Laurent. "Un Américain à Paris." *Citizen K International*, March 2005, 324–329.
Duffy, Robert. "Marc Jacobs." *Interview*, September 2010, 188–195.
Foley, Bridget. "Vuitton's Big Adventure." *Women's Wear Daily*, February 19, 1998, 4–5.
Freeman, Hadley. " Bye Bye J. Lo, Hello Naomi, " *The Guardian*, January 9, 2004, 10–11.
Frétard, Dominique. "Vuitton prend la mode en bagage." *Le Monde 2*, January 22, 2005, 60–62.
Gessner, Liz et Heidi Lender. "New York Picks Up the Beat." *Women's Wear Daily*, November 2, 1992.
Grilli, Silvia. "Le Donne? Angeli Caduti." *Panorama*, February 2, 2004, 152–155.
Gross, Michael, "Euro Dizzy." *New York Magazine*, April 5, 1993, 45–46.
Haskell, Robert. "Jacobs." *W*, January 2005, 134–137.
Heller, Zoe. "Annals of Style: Jacobs's Ladder." *The New Yorker*, September 22, 1997, 106–116.
Holgate, Mark. "Subway series." *New York Magazine*, November 20, 2000.
Hochswender, Woody "Patterns." *The New York Times*, March 7, 1989.
Huckbody, Jamie. "Shooting from the hip." *ID Magazine*, February 2003, 79–85.
Lalanne, Olivier. "Images de Marc." *Vogue France*, June–July 2001, 166–171.
Lannelongue, Marie-Pierre. "Bernard Arnault et Marc Jacobs: Luxueuse rencontre / Vuitton se met à l'heure." *Elle*, #2971, December 9, 2002, 178–179.
Lefort, Gérard. "Au menu: les premiers vêtements de Vuitton, les tutus à la Degas de Drezen et les ponchos." *Libération*, March 1, 1998, 37.

Levy, Ariel. "Enchanted." *The New Yorker*, September 1, 2008, 90–98.
Limnander, Armand. "On the Marc." *Harper's Bazaar*, February 2004, 164–169.
Luther, Marylou. "Les créateurs américains débarquent en Europe." *L'Officiel*, March 1997, 44.
———. "Marc Jacobs chez Vuitton: le premier américain au panthéon LVMH a un agenda bien chargé." *L'Officiel*, May 1997, 35.
Martin-Bernard, Frédéric. "Simplement luxe." *Upstreet #31*, Autumn-Winter 2001, 122–125.
Martin, J. J. "Marc on Top." *Harper's Bazaar*, September 2007, 504–511.
Menkes, Suzy. "A Youthquake Shapes the Future, But What is There to Wear Now?" *International Herald Tribune*, March 7, 1994, 12.
———. "All The World is On Stage for Paris Fashion Shows." *International Herald Tribune*, October 14–15, 1995.
———. "Future Chic: New Kids on the Block." *International Herald Tribune*, September 9, 1997.
McDowell, Colin. *In Love with Marc Jacobs*." *Sunday Times* Style section, April 25, 2004, 26.
Morris, Bernadine. "Jacobs Taking Over as a Designer at Ellis." The *New York Times*, November 23, 1988.
———. "Restraint from Calvin Kelin, Youthful Chic from Ellis." The *New York Times*, November 1, 1989.
———. "Perry Ellis Americana." *New York Times*, June 25, 1991.
Mouzat, Virginie. "Où, qui, quand, quoi, comment?" *Le Figaro*, January 14, 2003, 14.
Mower, Sarah. "Marc, Perry and Louis too." *Arena Homme +*, Spring-Summer 2001, 256–259 and 328.
———. "Louis Vuitton." Style.com, March 2, 2008.
O'Brien, Glenn. "Marc Jacobs." *Interview*, June–July 2008.
Orlean, Susan. " Breaking away," *Vogue* (US), September 1992, 526.
Peret, Evgenia. "Something about Marc." *Vanity Fair*, April 2004, 300–304 and 326–328.
Porter, Charlie. "Jacobs' Ladder." *ID Magazine*, November 2006
Prigent, Loïc. "Marc de Luxe." *Vogue* (France), February 2009, 210–215.
Quick, Harriet. "Super Marc." *Vogue* (UK), November 2010, 232–237
Quilleriet, Anne-Laure "Le Paris réussi de Marc Jacobs." *L'Express Styles*, September 13, 2007, 44–48.
Raper, Sarah and Weisman Katherine. "Vuitton's Big Adventure." *Women's Wear Daily*, February 19, 1998, 1.
Ratman, Niru. "Interview." *ID Magazine*, February 2003, 86-88.
Reardon, Ben. "Jacobs' Ladder." *ID Magazine*, September 2006.
Ricci, Christina. "Les liaisons dangereuses." *Pop #5*, Autumn–Winter 2004, 170–173.
Rickey, Mélanie. "Marc Jacobs: I'm Living the Dream I Had a Long Long Time Ago." *Grazia* (France), May 26, 2008.
Righini, Mariella. "Ils secouent les vieilles griffes. Mode: les nouveaux mercenaires," *Le Nouvel Observateur*, March 19, 1998, 100.
Rojek, Saveria. "Marc Jacobs / Vuitton lui doit son lifting." *Paris Match*, July 3, 2003, 4–7.
Sépulchre, Cécile. "Paris s'éveille." *L'Officiel*, March 1998, 12–14.
Shaw, Dan. "To make his own Marc," *New York Times*, February 28, 1993.
Schiro, Anne-Marie. "Style Makers; Steven Meisel–Photographer." The *New York Times*, March 19, 1989.
Singer, Sally. "Paris Match," Vogue (US), February 2000, 240–248
———. "The VH1/Vogue fashion awards." *Vogue* (US), November 2001, 164–167.
Socha, Miles. "LVMH, Jacobs Sign 7-Year Deal." *Women's Wear Daily*, December 10, 2001, 4–6.
Spindler, Amy M. in "Vuitton and Jacobs Seen in Ready-to-Wear Deal." The *New York Times*, January 7, 1997.
Trebay, Guy. "Familiar, but Not: Marc Jacobs and the Borrower's Art." The *New York Times*, May 28, 2002, B8.
Utz, Philip. "French Connection," *Numéro*, May 2001, 64–67.
Van Lamswerde, Inez and Matadin Vinoodh. "Marc of Genius, " *Harper's Bazaar*, September 2001, 378–397.

Webb, Iain R. "Americans in Paris," *Elle* (UK), September 1999, 46–47.
———. "We love Marc", Elle (UK), March 2003, 138–142.
Wilson, Eric. "Marc Jacobs: Seizing the Moment," *Women's Wear Daily*, November 17, 2004, 8–9.
Wingfield, Jonathan. "L'Affaire est dans le sac." *Numéro*, February 2003, 113–115.

ARTICLES BY DATE

"New York Picks Up the Beat," *Women's Wear Daily*, November 2, 1992.
"The Guru of Grunge." *Women's Wear Daily*, November 11, 1992.
"Qu'est-ce que la création?" *Libération*, Fashion supplement Winter 2001–02, October 6, 2001, 60.
"12 question for Marc Jacobs." *V* magazine, February 2004.
"Marc Jacobs: LV et Marc." *A Nous Paris*, April 23, 2007, 10.

ACKNOWLEDGMENTS

WE WOULD LIKE TO THANK THE FOLLOWING INDIVIDUALS FOR THEIR GENEROUS CONTRIBUTION TO THIS PUBLICATION:

TERI AGINS, MERT ALAS, HUGH ALEXANDER, GRACEY ALLDREDGE, ROSSELA D'ANTONA, SANTIAGO BARBERI GONZALEZ, MARIE BARTHÉLÉMY, DOMINIQUE BILLARD, GUILLAUME BOUTELOUP, FLORENCE BRACHET CHAMPSAUR, PHILIPPE BRUNET, MATT CARROLL, LAURE CHABANNE, JEAN-MARIE CLARKE,VINCENT COCHET, ALAIN COINTAT, JEAN-MARC COMBE, ANAÏS COMPTE, PETER COPPING, PIERRE-YVES CORBEL, CHRISTIAN DA COSTA NOBLE, PIEDADE DA SILVEIRA, SOPHIE DALLOZ-RAMAUX, ROXANE DEBUISSON, MARC DESTI, JEAN-DENYS DEVAUGES, BENEDICT DUMONT, CHRISTIAN DUPREY, GINO EGIDIO, KÉVA EPALE, STEFANIA FARAH, SANDRINE FASOLI, ÉLISE FAU, RACHEL FEINSTEIN, MARTA FERNANDEZ, SAM GAINSBURY, SAMUEL GARAS, ANNIE GAUCHET, REMY GIMPEL, RENÉ GIMPEL, XIMENA GOLBIN, NATHALIE GOURSEAU, CATHERINE GRANGER, KATIE GRAND, THÉRÈSE GUILLAUME, PATRICIA GUYARD, SAMUDRA HARTANTO, VALÉRIE HUBERT, DAVID HUGHES, VIRGINIE INGUENAUD, MIKAEL JANSSON, KATIA KHRISTICHENKO, ROMAIN LACROIX, BENOÎT LAGARDE, PERRINE LATRIVE, JEHANNE LAZAJ, MARC LEBOITEUX, JEAN-MARC LERI, FATIMA LOULI, ALEXANDRA MACHADO, PHILIPPE MARCELLESI, VALÉRIE MARCHAL, AGNÈS MASSON, DANIÈLE MASSON VUITTON, ANNICK MATZNEFF, TOBY MCFARLAN POND, PATRICIA MEARS, CAMILLE MICELI, CLAUDINE MIZZI, ANNE-MARIE MONARDI, DUNG NGO, BERNARD OGLIASTRO, CHRISTINA PASSARIELLO, ISABELLE PÉBAY-CLOTTES, MARION PERCEVAL, RITA PERRAUDIN, FLORENCE QUIGNARD, CATHERINE RABET, RUPI RANDHANA, PAULINE ET STEFAN REYNIAK, MARIO RIVA, FRANÇOISE RIVIÈRE, JED ROOT, SYLVIE ROY, JEAN-PIERRE ROYER, PAUL SCHIMMEL, TABITHA SIMMONS, DAVID SIMS, MAISIE SKIDMORE, MILES SOCHA, LAURE STARCKY, ANDERS THOMSEN, SANDRINE TOIRON, CLAIRE TOUCHARD, ROMAIN TARDY, MARTINE TRELAUN, VINCENT TUCHAIS, PIERRE TZENKOFF, JEAN-CHARLES VIRMAUX, SAM WARD, JANE WHITFIELD, ANNA WHITING, MAGNUS VON WISTINGHAUSEN

THE ARCHIVES DÉPARTEMENTALES DES HAUTS-DE-SEINE
THE ARCHIVES DÉPARTEMENTALES DU JURA
THE ARCHIVES DE PARIS
THE ARCHIVES DÉPARTEMENTALES DE LA SEINE-MARITIME
THE ARCHIVES DÉPARTEMENTALES DU VAL-DE-MARNE
THE ARCHIVES DÉPARTEMENTALES DES YVELINES
THE INSTITUT NATIONAL DE LA PROPRIÉTÉ INDUSTRIELLE
THE OLD CEMETERY OF ASNIÈRES
THE LIBRAIRIE CHAMONAL

—

AT LOUIS VUITTON, SPECIAL THANKS TO:

ALEXANDRE ANGOT, PIETRO BECCARI, AUDE BOURGÈS-MAUNOURY, DIANE DESSERTENNE, PATRICK DUVAL, JACQUES FLORET, ANNE-CÉLINE FUCHS, JUN FUJIWARA, ISABELLE DES GARETS, JULIEN GUERRIER, MARION HORB, ANTOINE JARRIER, FLORENCE LESCHÉ, JULIE DE LIBRAN, JULIEN MALHOMME, JEAN-MARC MANSVELT, BLEUE-MARINE MASSARD, MARC MAUCLAIR, FAYE McLEOD, AUDE MESRIÉ, NOELIE MOCHEN, MAUREEN PROCUREUR, JULIEN SOYEZ, ANSEL THOMPSON, VALÉRIE VISCARDI, FABRIZIO VITI, PATRICK-LOUIS VUITTON, EMMA WINTER, MARIE WURRY

AND PARTICULARLY YVES CARCELLE, MARC JACOBS, AND ISABELLA CAPECE GALEOTA

—

I WOULD LIKE TO THANK JEAN-FRANCIS LAGET FOR HIS INVALUABLE SUPPORT THROUGHOUT THIS ADVENTURE
AND FINALLY I DEDICATE THIS BOOK TO AUGUST AND MATIAS
P.G.

NOTES ON THE AUTHORS

Véronique Belloir
IS THE CURATOR OF FASHION AND TEXTILE COLLECTIONS 1800–1939, LES ARTS DÉCORATIFS, PARIS

Denis Bruna
IS THE CURATOR OF PRE-NINETEENTH CENTURY FASHION AND TEXTILE COLLECTION, LES ARTS DÉCORATIFS, PARIS

Jo-Ann Furniss
IS A JOURNALIST AND EDITOR BASED IN LONDON

Pamela Golbin
IS THE CHIEF CURATOR, TWENTIETH-CENTURY AND CONTEMPORARY FASHION AND TEXTILE, LES ARTS DÉCORATIFS, PARIS

Murray Healy
IS EDITOR OF *INDUSTRIE* MAGAZINE AND SENIOR EDITOR OF *LOVE* MAGAZINE

Éric Pujalet-Plaà
IS AN ASSISTANT CURATOR, LES ARTS DÉCORATIFS, PARIS

Delphine Saurat
IS AN ART HISTORIAN BASED IN PARIS

Françoise Tétart-Vittu
IS THE FORMER HEAD OF THE PRINT DEPARTMENT, PALAIS GALLIERA, MUSÉE DE LA MODE DE LA VILLE DE PARIS

FIRST PUBLISHED IN THE UNITED STATES OF AMERICA IN 2012 BY

Rizzoli International Publications, Inc.

300 Park Avenue South
New York, NY 10010
www.rizzoliusa.com

ISBN-13: 978-0-8478-3757-1
LIBRARY OF CONGRESS CONTROL NUMBER: 2011946178
© 2012 RIZZOLI INTERNATIONAL PUBLICATIONS, INC.
TEXTS © THEIR RESPECTIVE AUTHORS

PROJECT EDITOR *Dung Ngo*

ART DIRECTORS *Lee Swillingham & Stuart Spalding at Suburbia*
DESIGN DIRECTOR *Jacob Wildschiødtz*
DESIGNER *Elina Asanti*

PICTURE RESEARCHERS *Allison Power, Delphine Saurat*
Kristen Roeder, Mandy Delucia
COPY EDITOR *Jennifer Milne*
TEXT COORDINATOR *Jessica Fuller*
TRANSLATORS *Jean-Marie Clarke, Jane Marie Todd*
PRODUCTION *Kaija Markoe*

FOR LOUIS VUITTON

DIRECTOR OF THE HERITAGE DEPARTMENT *Antoine Jarrier*
PUBLICATIONS DIRECTOR *Julien Guerrier*
EDITOR *Valérie Viscardi*
PICTURE LIBRARY DIRECTOR *Marie-Laure Fourt assisted by Anne-Céline Fuchs and Camille Nicolas*
HERITAGE COLLECTIONS MANAGER *Marie Wurry, assisted by Bleue-Marine Massard*
INVENTORY COORDINATOR *Nathalie Frohmeyer*
COLLECTIONS COORDINATOR *Hélène Favrel*
ARCHIVES MANAGER *Florence Lesché*

DISTRIBUTED TO THE U.S. TRADE BY RANDOM HOUSE, NEW YORK

PRINTED AND BOUND IN ITALY

2012 2013 2014 2015 / 10 9 8 7 6 5 4 3 2 1

This publication accompanies the exhibition Louis Vuitton / Marc Jacobs
Les Arts Décoratifs, Paris, March 9– September 16, 2012

LES ARTS DÉCORATIFS

PRESIDENT
Hélène David-Weill

DIRECTOR-GENERAL
Marie-Liesse Baudrez

DIRECTOR OF THE MUSEUMS
Béatrice Salmon

DIRECTOR OF DEVELOPMENT
Renata Cortinovis

CURATOR OF THE EXHIBITION
Pamela Golbin
Chief Curator of Twentieth-century and Contemporary Fashion and Textile

ASSISTED BY *Éric Pujalet-Plaà & Delphine Saurat*

CREATIVE CONSULTANT
Katie Grand

EXHIBITION DESIGN
Samantha Gainsbury & Joseph Bennett